AN ECONOMY OF COLOUR

MANCHESTER
UNIVERSITY PRESS

An economy of colour

Visual culture and the Atlantic world,

1660–1830

EDITED BY

GEOFF QUILLEY AND KAY DIAN KRIZ

Manchester University Press

Manchester and New York

distributed exclusively in the USA by Palgrave

Published by Manchester University Press
Oxford Road, Manchester M13 9NR, UK
and Room 400, 175 Fifth Avenue, New York, NY 10010, USA
http://www.manchesteruniversitypress.co.uk

Distributed exclusively in the USA by
Palgrave, 175 Fifth Avenue, New York,
NY 10010, USA

Distributed exclusively in Canada by
UBC Press, University of British Columbia, 2029 West Mall,
Vancouver, BC, Canada V6T 1Z2

British Library Cataloguing-in-Publication Data
A catalogue record for this book is available from the British Library

Library of Congress Cataloging-in-Publication Data applied for

ISBN 0 7190 6005 2 *hardback*
 0 7190 6006 0 *paperback*

First published 2003

11 10 09 08 07 06 05 04 03 10 9 8 7 6 5 4 3 2 1

Typeset by
D R Bungay Associates, Burghfield, Berks

Printed in Great Britain
by the Alden Press, Oxford

Contents

REVOLUTIONIZING ATLANTIC IDENTITIES

List of illustrations

Notes on contributors

Darcy Grimaldo Grigsby is Associate Professor of History of Art at the University of California Berkeley and author of *Extremities: Painting Empire in Post-Revolutionary France* (Yale University Press, 2002). Recently she has published on Guillaume Guillon-Lethière's *Oath of the Ancestors*, in *Yale French Studies* 101 (2002). She is currently working on two books, *Creole Looking* and *Colossal Engineering, Colossal Empire* (reconnecting the Statue of Liberty, Suez Canal, Eiffel Tower and Panama Canal).

Kay Dian Kriz is Associate Professor in the Department of History of Art and Architecture at Brown University. Her book, *The Idea of the English Landscape Painter: Genius as Alibi in the Early Nineteenth Century* (Yale University Press), was published in 1997. *Slavery, Sugar and the Culture of Refinement*, her current book project, concerns visual culture and the British West Indies.

Stephanie Pratt is Senior Lecturer in the History of Art at the University of Plymouth and is a member of the Crow Creek Dakota Tribe. She is currently at work on a book *Surveying the Savage: British Art and the American Indian, 1700–1825*, for Oklahoma University Press.

Geoff Quilley is Curator of Maritime Art at the National Maritime Museum, Greenwich. He has published articles on eighteenth-century British marine imagery and art, nation and empire, and is currently completing a book on British art and the maritime nation, c.1775–1810.

Keith Sandiford is Professor of Eighteenth-Century Literature at Louisiana State University. His recent research and publications have applied critical and theoretical approaches from cultural studies to interpreting colonial West Indian texts. He is the author of *The Cultural Politics of Sugar* (Cambridge, 2000), and his essays have appeared in such journals as *The Eighteenth Century: Theory and Interpretation*, and *Essays in Literature*.

Helen Weston is Professor of History of Art at University College London. She is the author, with William Vaughan, of *Jacques-Louis David's 'Marat'* (1999), and

author of numerous articles on David, Girodet, Boilly, Prud'hon, Mayer and Benoist for *RES*, *The Oxford Art Journal* and various French publications. She is currently working on a book-length study of French colonial portraits during the French Revolution and the Saint-Domingue slave rebellions.

Roxann Wheeler is Associate Professor of English at Ohio State University. She is the author of *The Complexion of Race: Categories of Difference in Eighteenth-Century British Culture* (University of Pennsylvania Press, 2000). Her journal articles and other essays have treated the cultural history of race in Britain, British representations of Africa, and the novelistic treatment of racial difference.

Marcus Wood is a painter, performance artist and Reader in English and American studies at the University of Sussex. He is author of *Blind Memory: Visual Representations of Slavery in England and America 1780–1865* (Routledge and Manchester University Press, 2000) and *Slavery Empathy and Pornography* (Oxford University Press, 2002).

Acknowledgements

We should like to thank all those involved in the publication of this book at Manchester University Press for their unstinting support and patience during its production. We also gratefully acknowledge the Provost's Office at Brown University for providing supplementary funding for the illustrations.

Introduction:
visual culture and the Atlantic world,
1660–1830

Geoff Quilley and Kay Dian Kriz

Our title, 'an economy of colour' is intended to refer, more or less explicitly, allusively or ironically, to the vexed history of visual culture in the early-modern Atlantic world. We are specifically interested in exploring the relation of visual culture and aesthetics to the trade in goods and human bodies that sustained the Atlantic economies of the two major colonial powers in Europe, Great Britain and France. This relation informs all the essays in this book; the opportunities it presents for a new and productive re-writing of cultural history are ones with which all the authors here are engaged. In drawing attention to what has, until recently, been an overlooked geographical and historical context for understanding the development of European art and other forms of visual culture, we invite a critique of the writing of art and cultural history as a material practice with ideological consequences. In seeking to redress this history of exclusion and marginalization, we take seriously Edward Said's provocative challenge in *Culture and Imperialism* to reconnect the history of western culture with the history of western imperialism. Such a project is concerned with analysing

> how the processes of imperialism occurred beyond the level of economic laws and
> political decisions, and – by predisposition, by the authority of recognizable cultural
> formations, by continuing consolidation within education, literature, and the visual
> and musical arts – were manifested at another very significant level, that of the
> national culture, which we have tended to sanitize as a realm of unchanging intellec-
> tual monuments, free from worldly affiliations.[1]

As Said notes, imperialism operates through consolidation across multiple disciplines. But within the realm of culture, it also works through diffusion, surrogation, and disavowal. These multi-directional processes undermine any fixed notion of 'nation' or 'national culture'. Joseph Roach has theorized this fluidity in terms of a push–pull dynamic that emerges

as communities construct themselves by both expanding their boundaries and working back from them. They pull back by excluding or subordinating the peoples those larger boundaries ostensibly embrace. Such contradictory intentions remain tolerable because the myth of coherence at the center requires a constantly visible yet constantly receding perimeter of difference. Sometimes this perimeter is a horizon; more often it is a mirage ... [whose] mythic and potentially bloody frontiers must be continually negotiated and reinvented.[2]

As this passage suggests, the visual is crucial to maintaining this fluctuating 'mirage' or 'horizon' of difference.

By taking up the problem of visuality and visual culture in the Atlantic world not only does this collection address a lacuna in eighteenth-century art historical studies, but also in the interdisciplinary study of eighteenth-century colonialism and imperialism. In historical studies visual images still operate largely as unmediated 'evidence' of the material conditions under which colonization proceeded. But as Roach suggests and post-colonial theorists such as Homi Bhabha have long argued, questions of colonial authority are invariably bound up with the visualization of difference that is not a transcription of the Real but a representation having material effects.[3] While Bhabha eloquently analyses the ambiguities and conflicts that arise out of the process of visualization, 'the visual' remains a concept that is actualized primarily in the domain of writing.

The issue of visuality unites all the essays in this collection: how the experience of the Atlantic world – whether represented as loco-descriptive, as in George Robertson's views of Jamaica (the subject of Quilley's essay), or imagined, as in Géricault's *Raft of the 'Medusa'* (analysed by Darcy Grimaldo Grigsby) – comes to be 'see-able' for and in a given culture, and according to that culture's codes of visual representation. Thus, this book is not simply concerned with bringing attention to neglected or marginalized art and artists. Rather, it explores the ways that a particular visual culture impinges on the production of visual imagery and the subsequent writing of history and art history. On the one hand, established forms of visual culture available in the long eighteenth century were largely unable to accommodate the slave trade, and in particular the middle passage, hence these cataclysmic events became almost invisible and virtually unrepresentable (completely so within the formal structures of many artistic genres) for western modernity. On the other, the writing of art history has avoided analysing the contribution of visual images to discourses that are ethically problematic and riddled with taboos, such as the parallel and overlapping histories of slavery and pornography (the subject of Marcus Wood's investigation). Visuality in this sense is not determined solely by reference to visual artefacts, but is constructed also through written texts, as Bhabha has shown. Thus, Keith Sandiford's study of Richard Ligon's *True and Exact History of the Island of Barbados* analyses how the colonizer's experience of the colonized other is represented by the writing of the visible and thereby subject to mediation through the specific conditions and limits of the formal systems of written language. As a text whose afterlife, like Hans Sloane's *Natural History of*

Jamaica (the focus of Kriz's essay), was its value for the eighteenth century as a foundational work of colonial history, Ligon's book points us once again to the enormously complex area surrounding the relationship of text to image in the writing of the history of visual culture.

There have been numerous studies devoted to visual imagery in a colonial context; however, most have focused on the mid-to-late nineteenth century and have centred on representations of colonial India, North Africa and the Middle East.[4] Even the two most recent studies of visual imagery relating to the Atlantic world, Beth Fowkes Tobin's *Picturing Imperial Power* (1999) and Marcus Wood's *Blind Memory* (2000) only examine images produced within the British colonies (or former colonies, in the case of the United States) during and after the last quarter of the eighteenth century.[5] By placing visual culture within the context of a much longer colonial and imperial history, beginning in the later seventeenth century, we acknowledge the fact that the (very) long eighteenth century was an era of massive imperial expansion, and that France and Britain were the leading and richest powers of Europe thanks to their emphatic development as colonial and imperial nations.[6]

The pre-eminence of France within the Atlantic world was not the only factor influencing the decision to extend the geographic scope of this collection from essays focused solely on Britain and its Caribbean and North American colonies to two pieces dealing with the French colonial enterprise. The inclusion of these two essays also permits a comparison of the sometimes strikingly different concerns, opportunities and challenges facing artists operating within French and British imperial systems of visual production. Throughout the period in question these two European nations were locked in a heated competition for colonial territory, colonial profits, and the reputation of having the richest and most extensive empire in the Americas, but they went about the process of colonization very differently and conceptualized it in very different terms. The visual images produced by the two nations and their colonies participated in the production of these diverse modes of making, maintaining and, importantly, contesting imperial power in their colonies. These differences in the conceptualization of the colonial subject and colonial territory were only exacerbated by the revolutions in the American colonies and in France, as both Grigsby and Weston effectively demonstrate. The mulatto elite that was so important to the course of revolution in Saint-Domingue and to the type of portraiture Helen Weston analyses in her essay, for example, had no British counterpart. The subject of Grigsby's essay, Géricault's *Raft of the 'Medusa'* offers an ideal example of the way in which geography matters, within Europe as well as without it: after its exhibition in Paris, the *Raft* journeyed across the 'English' Channel and was placed on exhibit in England and Ireland.[7] Its reception in post-abolition, pre-emancipation Britain was inevitably conditioned by domestic debates about slavery in the British colonies and history painting in Britain, engaging a quite different set of ideological and aesthetic issues from those Grigsby so cogently sets out in her analysis of the work's production and reception in France.

This focus on the two major colonial powers operating within the Atlantic world necessarily involves exclusions, which in no way are intended to minimize the importance of other European states, notably Spain and Holland, as forces in Atlantic colonialism and its visual cultures. The continual Spanish presence in the Caribbean, in the militarized strongholds of Cuba and Santo Domingo, contributed decisively to the West Indies being, throughout the long eighteenth century, both the catalyst and the theatre for commercial confrontation and colonial warfare. Dutch Atlantic interests, as displayed in Surinam, the setting for soldier and writer John Stedman's activities analysed here by Marcus Wood, on the other hand, were more piecemeal and less colonial in character in the sense of the maintenance of a permanent, controlling metropolitan presence in non-metropolitan territory. Dutch mercantilism, characterized by the commercial interaction of the metropolis with independent, supposedly sovereign states, via quasi-autonomous, self-regulating companies of merchants and ship-owners, was in any case firmly focused on maintaining a monopolistic grip on the enormously lucrative spice market in the East Indies. It is also the case that, by the eighteenth century, both Spain and Holland were being progressively eclipsed as imperial powers by the economic and military ascendancy of Britain and France. This had its own cultural consequences: as Dian Kriz argues in her essay, the Spanish in Jamaica had, by the beginning of the eighteenth century, become translated into a memorial presence associated overwhelmingly, in the eyes of the subsequent British colonists, with the extermination of the indigenous Arawak population during the sixteenth century. This trans-Atlantic memory provided the substance for the infamous 'black legend', the ultimate paradigm of colonial barbarity, on to which could be displaced British guilt and anxieties over the abuses and atrocities of the slave system. To focus on French and British Atlantic exchanges, therefore, is also to recognize the Atlantic world as a series of 'lieux de mémoires' of earlier phases of colonial activity by both these and other European countries.

While the relationship between art and the Atlantic world has not been extensively treated by scholars, the relationship between art and European commerce has received intensive attention. Indeed, this collection is deeply indebted to those art and cultural historians of the eighteenth century who have analysed the signal importance of the circulation of goods, people and ideas on the inter-related histories of culture and commerce. Notable contributions to this body of original and provocative scholarship include David Solkin's *Painting for Money* (1993), Ann Bermingham and John Brewer (eds.), *The Consumption of Culture, 1600–1800: Image, Object, Text* (1995), Brian Allen (ed.), *Towards a Modern Art World* (1995), Mark Hallett's *The Spectacle of Difference* (1999), Iain Pear's more sociologically based *The Discovery of Painting* (1988), and Katie Scott's *The Rococo Interior* (1996).[8] However, the significance of commerce in relation to visual culture has overwhelmingly been in terms of its value as an idea or ideology rather than its historical actualization as a transoceanic practice conducted on other continents than 'the Continent' and on islands other than Great Britain.

In the case of France, art historical studies have, until recently, followed the model of political and cultural histories obsessed with the Revolution as narrowly restricted to the geographical boundaries of France. Therefore, art and cultural historians have devoted scant attention to the impact of the French Revolution on the colonies and to the effect of colonial commerce on French art. A consequence of this focus on domestic politics is that localized readings of works by a well-established canon of great masters continue to dominate French scholarship. The two essays on French art in this collection serve to expand the terms under which the nation and the revolution were understood: Helen Weston's analysis of Lethière's *The Oath of the Ancestors* interrogates the notion of revolution and the nation in the context of that other 'French Revolution', occurring in Haiti in 1804, while Darcy Grimaldo Grigsby shows how Géricault's *Raft of the 'Medusa'* explores the tensions between the commerce and consumption of human bodies and the idea of the liberal state. Widening the geographical and conceptual focus of French art historical studies will also, in the future, require serious consideration of the function and meaning of media (prints, decorative arts) and genres (such as landscape and topography) that have been largely neglected.

In British studies the emphasis on the ideology of commerce derives in part from the influence of Marxist historians, notably E. P. Thompson, in assigning commerce a class-based political value as a determining factor in the development of industrial capitalism. Scholars such as J. G. A. Pocock have also framed the significance of commerce within a larger history of philosophical ideas and political thought, central to which has been the principle of civic humanism.[9] Somewhat ironically, its lineage from Greco-Roman and Florentine Renaissance political philosophy marks out civic humanism as an international concept, or at least a cosmopolitan one. Yet, in necessarily referring itself back to classical Athens or Rome as the foundational sources of western politics and civilization, civic humanism betokens an internationalism that is highly specific (to a patrician elite) and narrowly defined (according to western political criteria). As such, the very concept of civic humanism as a methodological key to analysing eighteenth-century culture has entailed the marginalization of the no less complex, but perhaps more amorphous, history of protean internationalism developing in the long eighteenth century as a result of colonial settlement, imperial expansion and transoceanic commerce.

The discourse of civic humanism does, however, usefully draw attention to important divisions in a polity that not only exhibited a virulent and unifying Francophobia, against which first Englishness then Britishness were positively defined, as Linda Colley has argued, but also experienced divisive antagonisms between a politically empowered, largely aristocratic liberal elite and an expanding, financially empowered class of merchants and traders.[10] Despite the fact that many aristocratic families had investments in the slave trade and other colonial interests, which bound them to merchants and traders politically and economically, they vigorously sought to distinguish themselves socially and culturally from those

involved with commerce, industry and trade. And, as Kathleen Wilson has argued, the merchant and professional artisan classes displayed an often jingoistic patriotism and an anti-aristocratic bias, based upon a perceived betrayal on the part of the governing patrician elite of the nation's commercial interests, including its huge investment in overseas trade and colonial markets.[11] These interests, attachments and group identities were not nationally defined, or, rather, they complicate any definition of the nation that we now try to impose upon this period and culture. Commercial and patriotic ideologies were more likely to be shared horizontally between British merchants and their fellow traders and ideologues in the Americas, than vertically with an aristocracy keen to put as much social distance between themselves and their economic 'inferiors' as possible. Such complex transoceanic alliances between members of the merchant classes goes some way to explaining why potteries in the region of Liverpool in the 1770s and 1780s were producing pottery transfer-printed with pro-Revolutionary emblems for export to the American colonies.[12]

For their part, American colonists justified their revolutionary cause on the basis of their now being more English than the English. Underpinning the Declaration of Independence was the conviction that the principle of 'Englishness' was being carried forward more virtuously in America, the 'new found land', than it could be in the retrograde, decadent mother country. Equally, throughout the century West Indians mostly saw themselves as English or French first and foremost, before any subsidiary colonial identity they assumed.[13] There is, therefore, no clear means of defining 'which nation?' or 'whose nation?' for this period, when invoking the 'imagined communities' of England or France.[14]

To historicize British or French art in the reductive geographical terms of the British Isles or continental France is, therefore, profoundly to misunderstand the eighteenth-century concepts of Englishness, Britishness or Frenchness that applied (albeit differently nuanced) to the wider Atlantic world as much as to the metropolis. It is symptomatic of this reluctance of art history to engage with the wider cultural sphere of the Atlantic world that the recent scholarship on an artist as important as John Singleton Copley, whose career offers such an invitation to consider visual cultural interchange between Britain and the Americas in an integrated, homogenous way, has separated his life into distinct phases, of his time in America and his later career in England. Such a decision implies that the separation can be made unproblematically, indeed that the separation of an artist's career according to geographical criteria is a natural one. It also presents the move from the colony to the metropolis as a move also from raw, but as yet unfulfilled, artistic potential to the full, sophisticated and refined flourishing of a great metropolitan talent, who produced the ideologically complex (and thoroughly transoceanic) *Brook Watson and the Shark*.[15]

In contradistinction to the model provided by a Pocockian notion of civic humanism, Joseph Roach's theorizing of a circum-Atlantic world usefully introduces the notion of a transcontinental, transoceanic arena of circulation, in

which goods, ideas and people were cycled and re-cycled continuously between Europe, Africa and the Americas. The circuits of Atlantic exchange also involved, more or less indirectly, Baltic and Mediterranean states also, as well as the Levant. Inevitably, any clear distinction between east and west implied in the focus upon the Atlantic is somewhat disingenuous, especially in the eighteenth-century context. Luxury commodities from the east, such as fabrics or porcelain, of course found their way to the Atlantic periphery, while western goods, sugar, coffee, and wine were shipped to British, French or Portuguese settlements in India. Hogarth's *Progresses*, which have been analysed in terms of their critique of luxury and the fascination for foreign goods, also make visible the hybridization wrought by such circuits of east–west exchange. A case in point is the figure of the black child wearing 'oriental' attire who enters the harlot's boudoir in Plate II of *A Harlot's Progress* (1732), or his alter-ego, the be-turbanned black child who laughingly mocks the behaviour of his white mistress in the levée scene of *Marriage-à-la-Mode*. By the early eighteenth century these black figures dressed in silks and feathered turbans (who were common features of portraits and conversation pieces as well as Hogarth's modern moral subjects), could no longer be counted on to evoke the orientalized world of the Moors, as they had been in the Renaissance. 'Un-moored' by the impact of the European trade in sub-Saharan slaves to plantations in the Americas, these figures represented a new breed of 'other', whose domestication within metropolitan space (physical and representational) depended upon a process of exoticization that, Hogarth gleefully suggests, never fully succeeded.

The identification, therefore, of the Atlantic as a special sphere of cultural, economic and social relations must be formulated in relation to a concept of the east that is critically analysed from the perspective both of the eighteenth century and of the present day. Philip Lawson long ago noticed the 'missing link' of the imperial context in modern studies of eighteenth-century Britain, observing that where consideration was given to the 'imperial dimension' this was overwhelmingly and misleadingly weighted towards colonial and revolutionary America, at the expense of India and the east. One reason for this emphasis has been:

> the common language and cultural ties that exist for twentieth-century scholars peering back into Britain's colonial past to deal with America rather than India. How much more simple it is to weave American grievances into the mouths of London radicals in the 1760s, as opposed to dealing with the unique protestations of Muslims and Hindus experiencing the rougher edges of colonial rule in India.[16]

Equally importantly, it is clear that 'interest in the struggle for American independence, and the break with Britain, reflects the dominant position of the United States in the world today': the discourse and discipline of history, no less than any other form of western culture, have been informed and transformed by half a century of cold-war politics founded on the premise that the worlds of east and west are irredeemably cleft.[17] The oppositions and antitheses by which the

mutual attitudes between east and west were characterized for most of the twentieth century are therefore largely anachronistic for the eighteenth, in spite of early-modern Europe's suspicious association of the Orient with luxury, enervation and effeminization to a supposedly virile western civilization. But luxurious enervation was also very much associated with the climate and plantocratic lifestyle in the West Indies, and, therefore, is better conceptualized as a generic, immanent problem to empire as a system, as well as being symptomatic of a European suspicion of the non-European world in general. For writers as different as Adam Smith, Montesquieu, Richard Price or J.-G. Herder, 'empire' could be understood as a total concept, which, though realized differently in practice according to contingent local circumstances and requirements, was subtended in all its manifestations by the common defining factor of the unqualified pre-eminence of the metropolis, and of the colonial empire's satellite relation to the dominant imperial centre, the material economic growth of which was its ultimate end.

There were, of course, features distinguishing the Atlantic world from other forms of colonial enterprise. The sheer extent and character of European settlement of North America were unparalleled in any other part of the world until the nineteenth century. Similarly, the practices of slavery and the slave trade underpinning the economies of Europe, Africa and the Americas were unique to the Atlantic world, both in their diasporic scale and in their redefinition and re-identification of people and places.

Insofar as the African slave was crucial both to the political and financial economy of the 'Black Atlantic' all the essays in this volume examine, in various ways, the visual construction of black identities in this period, and in so doing confront the vexed problem of how eighteenth-century culture visualized, in Michael Craton's telling phrase, the invisible man.[18] In the work of Hugh Honour and others the image of the black in the fine arts has been surveyed iconographically.[19] This scholarship has noticed the prevalent but marginalized and subordinate artistic role taken by Africans, whose function was to naturalize and legitimate European political and cultural hegemony and validate the developing criterion of whiteness representing that hegemony. The essays here offer an expansion and rethinking of this project, extending visual analysis beyond iconography by taking advantage of the insights of neo-Marxist, post-structuralist and post-colonial theory in order to interpret paintings, prints and texts that feature blacks as their principal subject. However, the Black Atlantic is but one component of an 'economy of colour' that involved displacements, hybridizations and creolizations of populations other than Africans and Europeans, which formed as a result of colonial settlement and slavery. Pratt, Wheeler and Kriz each analyse the tensions and ambiguities that arise in the representation of Indians in the Caribbean and on the North American mainland within an increasingly reductive economy of colour inclined to visualize the relationship between European self and American other in terms of black and white.

In addition, these and other authors in the collection seek to expand the focus of earlier scholarship by also considering Atlantic identities in what has conventionally been seen as the marginalia of art history, namely, that is, print culture: Wheeler and Pratt examine illustrated novels, Sandiford and Kriz analyse the hybrid colonial genre that combines voyage narrative with natural and civil histories, and Wood takes up John Gabriel Stedman's personal narrative of a slave revolt in Surinam. All of these essays share a common concern with intertextuality; they consider the (often conflictual) relationship between visual images and a written text with which they are proximate, or otherwise associated (such as the landscapes by Robertson and the Jamaica history by William Beckford that Quilley examines).

If history as a discourse is the product of modernity, it also reciprocally produces, represents and narrates modernity to and for itself. Yet, as Paul Gilroy has forcefully argued, the 'double consciousness' of modernity suffuses the history of art and visual culture as well as – perhaps more than – any other type of history. The very definitions of 'culture', 'class', 'civilization' or 'nation', which are all entailed in the cultural value of art and its histories, have all depended, and still depend, upon the establishment of cultural difference through an exclusion exercised increasingly in the long eighteenth century through 'economy' and 'colour'. Though produced within the institutional authority of academia, this book invites a reconsideration of the history of art and visual culture, which can properly attend to that history's extra-academic significance and urgency. At the time of writing, the front-page in the *Guardian* reads 'The terrible truth about the ship of slaves', headlining a report on the ship *Etireno* carrying a live cargo of transported child slaves around the coast of west Africa, notably Benin, where, as the report is keen to point out, 'the African slave trade began'.[20] The transformations, translocations, exchanges and deracinations within the Atlantic world, often inhuman and degrading, are not simply historical; to enquire how the production of history and visual culture – in formulating, representing and surrogating circum-Atlantic identities – was complicit in, or resistant to, the Atlantic slave trade is still sadly relevant to the present.

An 'economy of colour' refers, then, to visuality in the history of modernity: at precisely the moment when the social, economic and political institutions of the modern west were coming into form, the character of their essential underpinning by the black Atlantic was being bleached and historically suppressed. At the same time that increasingly – one might say, hysterically – complex codifications and categorizations of skin colour were being articulated for the benefit of the economy of the slave trade, cultural difference in the Atlantic world was progressively represented along racial lines, in polarized and reductive terms of 'blackness' and 'whiteness'. In short, the economy of colour was drawn in black and white. The mechanisms and reasons for this are what this book addresses.

Notes

1 Edward W. Said, *Culture and Imperialism* (London, Vintage, 1994), pp. 12–13.

2 Joseph Roach, *Cities of the Dead: Circum-Atlantic Performance* (New York, Columbia University Press, 1996), p. 39.

3 Homi K. Bhabha, 'Of mimicry and man', in *The Location of Culture* (London, Routledge, 1994), p. 89.

4 Prominent among such studies have been: John MacKenzie, *Orientalism: History, Theory, and the Arts* (Manchester, Manchester University Press, 1995); Reina Lewis, *Gendering Orientalism: Race, Femininity and Representation* (London and New York, Routledge, 1996); Anne McClintock, *Imperial Leather: Race, Gender and Sexuality in the Colonial Conquest* (London and New York, Routledge, 1995); Julie F. Codell and Dianne Sachko Macleod (eds.), *Orientalism Transposed: The Impact of the Colonies on British Culture* (London, Ashgate, 1998); Mary Anne Stevens (ed.), *The Orientalists, Delacroix to Matisse: European Painters in North Africa and the Near East* (London, Royal Academy of Arts, 1984); Donald A. Rosenthal, *Orientalism: The Near East in French Painting, 1800–1880* (Rochester NY, Memorial Art Gallery of the University of Rochester, 1982); Christine Peltre, *Orientalism in Art*, trans. John Goodman, (New York and London, Abbeville Press, 1998).

5 Beth Fowkes Tobin, *Picturing Imperial Power: Colonial Subjects in Eighteenth-Century British Painting* (Durham NC and London, Duke University Press, 1999); Marcus Wood, *Blind Memory: Visual Representations of Slavery in England and America 1780–1865* (Manchester, Manchester University Press, 2000). For investigations of the earlier period see also David Dabydeen, *Hogarth's Blacks* (Manchester, Manchester University Press, 1987); and for an important analysis of the role of aesthetics in forming the idea of race in this period see David Bindman, *Ape to Apollo: Aesthetics and the Idea of Race in the Eighteenth Century* (London, Reaktion Books, 2002).

6 It is important to stress that 'colonialism' and 'imperialism' are by no means synonymous, and we adopt here the distinction between these terms made by Edward Said, inasmuch as '"imperialism" means the practice, the theory, and the attitudes of a dominating metropolitan centre ruling a distant territory; "colonialism", which is almost always a consequence of imperialism, is the implanting of settlements on distant territory … In our time, direct colonialism has largely ended; imperialism … lingers where it has always been, in a kind of general cultural sphere as well as in specific political, ideological, economic, and social practices': Said, *Culture and Imperialism*, p. 9.

7 For a full account of the *Raft* in England see Lee Johnson, 'The "Raft of the Medusa" in Great Britain', *Burlington Magazine*, 96 (1954), 249–54.

8 David Solkin, *Painting for Money: The Visual Arts and the Public Sphere in Eighteenth-Century England* (New Haven and London, Yale University Press, 1993); Ann Bermingham and John Brewer (eds.), *The Consumption of Culture, 1600–1800: Image, Object, Text* (London and New York, Routledge, 1995); Brian Allen (ed.), *Towards a Modern Art World* (New Haven and London, Yale University Press, 1995); Mark Hallett, *The Spectacle of Difference: Graphic Satire in the Age of Hogarth* (New Haven and London, Yale University Press, 1999); Iain Pears, *The Discovery of Painting: The Growth of Interest in the Arts in England, 1680–1768* (New Haven and London, Yale

University Press, 1988); Katie Scott, *The Rococo Interior: Decoration and Social Spaces in Early Eighteenth-Century Paris* (New Haven and London, Yale University Press, 1995). See also Thomas Crow, *Painters and Public Life in Eighteenth-Century Paris* (New Haven and London, Yale University Press, 1985).

9 See especially J. G. A. Pocock, *The Machiavellian Moment: Florentine Republican Thought and the Atlantic Republican Tradition* (Princeton NJ, Princeton University Press, 1975). As the title of this book makes clear, Pocock is at pains to emphasize how the tenets of civic humanism were transferred to the colonial American context and informed revolutionary ideology. With regard to art history, the most significant application of Pocock's analysis has been John Barrell, *The Political Theory of Painting from Reynolds to Hazlitt: 'The Body of the Public'* (New Haven and London, Yale University Press, 1986).

10 Linda Colley, *Britons: Forging the Nation 1707–1837* (New Haven and London, Yale University Press, 1992), pp. 33–100. See also Gerald Newman, *The Rise of English Nationalism: A Cultural History 1740–1830* (London, Weidenfeld and Nicholson, 1987).

11 Kathleen Wilson, *The Sense of the People: Politics, Culture and Imperialism in England, 1715–1785* (Cambridge, Cambridge University Press, 1995), pp. 151–63 and passim.

12 Alan Smith, *The Illustrated Guide to Liverpool Herculaneum Pottery 1796–1840* (London, Barrie and Jenkins, 1970), p. 58.

13 See Bernard Bailyn, *The Ideological Origins of the American Revolution* (Cambridge MA and London, Harvard University Press, 1992), pp. 79–93. On West Indian 'Englishness', see Edward Long, *The History of Jamaica*, 3 vols. (London, T. Lownes, 1774).

14 Linda Colley, 'Whose nation? Class and national consciousness in Britain, 1750–1830', *Past and Present* 113 (November 1986), 97–117; Benedict Anderson, *Imagined Communities: Reflections on the Origin and Spread of Nationalism* (London, Verso, 1983).

15 See principally: Jules Prown, *John Singleton Copley*, 2 vols.: I. In America, 1738–1774; II. In England, 1774–1815 (Cambridge MA, Harvard University Press, 1966); Carrie Rebora *et al.*, *John Singleton Copley in America* (New York, Metropolitan Museum of Art, 1995); Emily Ballew Neff, *John Singleton Copley in England* (London, Merrell Holberton, 1995). On *Watson and the Shark*, see particularly Albert Boime, *The Art of Exclusion: Representing Blacks in the Nineteenth Century* (London, Thames and Hudson, 1990), pp. 22–36 and Guy McElroy, *Facing History: The Black Image in American Art 1710–1940* (Washington DC, Corcoran Gallery of Art, 1990).

16 Philip Lawson, 'The missing link: the imperial dimension in understanding Hanoverian Britain', *The Historical Journal*, 29:3 (1986), 749.

17 *Ibid.*

18 Michael Craton, *Searching for the Invisible Man: Slaves and Plantation Life in Jamaica* (Cambridge MA and London, Harvard University Press, 1978). The invocation of the 'Black Atlantic' is, of course, indebted to Paul Gilroy's highly influential *The Black Atlantic: Modernity and Double Consciousness* (London, Verso, 1993), but see also the important critique of Gilroy's book, in particular his notion of 'double consciousness' and usage of the Middle Passage as metaphor, by Joan Dayan, 'Paul Gilroy's slaves, ships, and routes: the Middle Passage as metaphor', *Research in African Literatures*, 27:4 (Winter, 1996), 7–14.

19 Besides the works already cited by Dabydeen, Bindman, Boime, Wood, see especially
 Hugh Honour, *The Image of the Black in Western Art*, vol. 4: *From the American
 Revolution to World War I* (Cambridge MA and London, Harvard University Press,
 1989).
20 *The Guardian* (21 April 2001), p. 1.

IDENTIFYING THE ATLANTIC WORLD:
TEXTUALITY, VISUALITY
AND HYBRIDITY

1

Envisioning the colonial body: the fair, the carnivalesque and the grotesque

Keith Sandiford

As a concept to think with, the category of the circum-Atlantic offers to the critical imagination a rich fund of possibilities contained in the elasticity of its geographical reference. Similarly, the category threads its polysemous ramifications into the practices and productions of history, the second correlate in that binary so instrumental in the shaping of colonial human identities. The convergence of circum-Atlantic historiography with the aesthetic and rhetorical objectives of visualization affords an occasion to map certain values constitutive to the production of history and identity in the colonial contexts that are this anthology's objects of study. In its ostensible project of producing the history of a single island colony, Richard Ligon's *True and Exact History of the Island of Barbados* (1657; 1673) illustrates the degree to which that convergence destabilizes any pretensions to a pure, single, unitary object, even as it reveals multiple functions for the techniques of visualization deployed in the text.

Thus, the colonial body envisioned in that history is neither imagined nor produced solely from the objective events or observable processes taking shape in a nascent sugar colony. In pursuing the putative object of a unitary history, Ligon recuperates a 'true and exact' account from the diverse sources of his own subjectivity, from a permanent archive of dominant myths and meaning systems shared with individuals of identical nationality, and from the differently coded phenomena of lived experience in the circum-Atlantic colonial arenas represented in the *History*. This essay will analyse specific patterns of visualization produced in the *History* to show that important aspects of its structural identity are forged from the pre-existing conceptual orders of the fair, the carnivalesque and the grotesque. Because these categories all share common social relations by virtue of their situation in 'low' domains of cultural value, the definitively higher mimetic desires of a 'true and exact' representation never escape the structural inflections of such low domains: this analysis will show them to be unconsciously inscribed in the body of

Ligon's colonial history, a body thereby rendered hybrid by definition of its discursive values. The dynamics of interiority implied above explain in part this essay's bias towards discursive rather than pictorial visualizations. Ligon's text is liberally illustrated with the latter kind. The great majority of these display the island's flora and fauna. My discussion of the sugar works (the *ingenio*) benefits from two large-scale drawings of this machinery, which Ligon produces with meticulous artistic skill and dramatic visibility. However, as scenes depicting the Cape Verde incidents and those representing slaves at work and play lack the support of complementary graphics, my discussion of them will rely on the author's distinctive gifts for word painting.

Ten years prior to the appearance of the *History*, certain circum-Atlantic contingencies that were to shape the text's discursive visualizations converged in Ligon's personal life. In early August 1647, a royalist refugee fleeing the intestine broils of the English civil war, Ligon made an intermediate stop in the Cape Verde Islands.[1] Displaced by what he described as a 'barbarous riot' in which he lost all his worldly possessions, the refugee from historical crisis, painter by training and future historian by opportunity, was destined ultimately for Barbados where he would seek to repair his broken fortunes as a plantation manager in the service of another royalist, Colonel Thomas Modiford. The Cape Verdes and Barbados are situated along two axes of the triangle that circumscribed the travel and supply routes for the commerce between Britain and her slave colonies in the West Indies. The foregoing sketch intimates a number of critical relationships that informed the construction of circum-Atlantic identities and are subsequently developed in the *History*.

The Barbados enterprise would assure Ligon's future as the colony's first historian, but it would supply only a temporary reprieve from the vagaries of personal fortune. Some time after Ligon's return to England in 1650, he was committed to the Upper Bench Prison for debts. A letter (contained in the text's dedication) from that place – dated 12 July 1653 and addressed to Dr Brian Duppa, Bishop of Salisbury – provides evidence that he used the space of confinement to write the *History* and to continue his painting and drawing activities. That document also details the author's ambitious plans for illustrating the *History* and records his regrets that the actual results would resemble 'a piece of wild Grotesco, or loose extravagant Drolorie' due to poor lighting and lack of privacy.

Ligon's *True and Exact History of the Island of Barbados* would become the second earliest account of the colonial settlement and plantation of England's then most profitable sugar colony.[2] As such, Ligon's book was to be the primary source for subsequent knowledge of the island for some time to come. His accounts of the colony's early growth, of the politics and economics of plantation management, of the particulars of sugar cultivation and the foundational role of slavery in establishing the prosperity of the first planter class were key instruments in inscribing Barbados in the early modern popular and literary imagination. Indeed, his *History* was the primary English source for the Inkle and Yarico story that was to take on

such a phenomenal iconic autonomy, itself becoming the textual embodiment and intersection of the circum-Atlantic themes of British proto-capitalist ethics, inter-racial romance and colonial slavery. If the *History* derives its contemporary and later significance from these self-evidently important discursive elements, its value as a visual object is equally undisputed. Ligon's skill in painting and drawing endowed the volume with the concrete cartographic visualization of the island, dis-playing its physical shape, its material resources, natural as well as man made: the map is dotted with human, animal and vegetative images giving graphic testimony to the work of nature as well as to the design of colonizing culture. If the map is the centerpiece of the author's visual impulses, his liberal drawings and illustrations of the island's flora and fauna similarly reflect this unique concern with visualizing this new-found world for the aesthetic, intellectual and emulative purposes of diverse interests in his audience. Not the least among the illustrations of physical objects critical to charting the history of the major productive activity (sugar making) is his highly particularized representation of the *ingenio* or sugar works, which, in the terms of the present discussion, effects the colonial author's often exaggerated desire for presence, and produces the *History*'s visualization of the proto-industrial grotesque.

It is appropriate to provide here some rationale for theorizing the way the *History* stages at the colonial margins certain visual images distinctively associated with the traditional popular culture of the metropolitan centre. Two key approaches to understanding the dynamic mediation of identity in the elaboration of symbolic productions such as written histories may be derived from Lacanian psychoanalysis and cultural theories of national identity.[3] What I have described earlier as 'dominant myths' and 'meaning systems' may here be codified under the single Lacanian rubric of those systems of signification from which individual sub-jects are constituted and from which the symbol-making mechanisms of the sub-ject are drawn. The signifiers of these systems define and structure the subject's visualization of images, the ascription of meanings, the shape of culture and the ideologies that undergird it. All of those provide narrative tropes that live in (and that are variously assembled by) the subject's unconscious. The conceptual struc-ture resulting from these functions – which Lacan formulates as an intersection of the Symbolic, the Imaginary and the Real – is produced in Ligon as a migration in which are commingled the visual spectacles of the fair, the symbolic energies of the carnivalesque and the conflictive desires of the grotesque. To represent the chal-lenges of acculturation Ligon evolves a subjectivity drawn from a cultural body already 'overridden' by the language of these visualizations. For the project of writing a colonial history, he reproduces a colonial body newly 'overwritten' by the desires of a private self and those of a social class attempting to invent an identity. Some of Ligon's most graphic visualizations have at their core the determined objectives of self-fashioning, and the hybridization of these images by elements drawn from both metropole and colony emphasize the collusive role of those sources in the formation of colonial identity. In Ligon's case, his self-fashioning is

pursued by mapping personal desire for a re-imagined colonial identity on to the perceived social class superiority of his sponsor/employer Colonel Thomas Modiford, and two of Modiford's investment partners, Major Hilliard and Colonel James Drax.[4]

If Lacan helps to explain the unconscious, symbolic meanings inherent in the visual appearance of fair, carnivalesque and grotesque images on the foreign scene of colonial power, Homi Bhabha and Mikhail Bakhtin interrogate any assumption that such visualizations function merely for their representational or mimetic values. The crucial interplays of overwritten/overridden bodies (of historian, text and colony) verify the critique that these visualizations are mediated by hybridized elements. This hybridity produces those instabilities in the semiotic system of the text, generating further visualizations. The effect of all these successive visualizations is to naturalize the images themselves.[5] As a set of techniques recovered in colonial historiography, then, visualization can be theorized as a strategy that imbricates specific practices and problems of representation. The critique to be developed in the present essay will stress the inevitability of hybridization, not only in the objective images represented but also in the very subjective acts of perception and interpretation.

Fittingly, Bhabha supplies the most authoritative buttress for this position when he defines the nature of the colonial world as 'half made' or intrinsically 'heterogeneous', a condition that guarantees the inability of the colonial power to represent itself as a 'plenitude' or 'full presence'.[6] And that inability reproduces itself in a colonial discourse that is split into two attitudes towards external reality: one taking reality into consideration, the other disavowing reality and replacing it by a product of desire that repeats and rearticulates 'reality' as 'mimicry'.[7]

The re-presentations of conventional images migrated from the core to the periphery are visualizations that, in Bhabha's terms, mask their true relation to the figures of camouflage and mimicry when deployed in a colonial text such as Ligon's *History*. This attitudinal split gives rise most often to Ligon's most resolute visualizations, and those in turn produce a palpable tension in the subject, torn between the choice of either representing the scene before him with literal fidelity or re-presenting (re-visualizing) it in terms of some other dominant meaning system, or according to the techniques of some other 'author'. For Ligon, whose impulses to represent are commonly informed both by the obligations of the historian and the imaginative habits of the painter, this split and this tension are often experienced and reproduced as a Bakhtinian species of hybridity reinterpreted by Robert J. C. Young as the 'ability of one voice to unmask or ironize the other within the same utterance'.[8] Typically in Ligon's *History*, when these two hybridized voices desire to produce the commonplaces of colonial landscape (re-imagined in traditional pastoral terms), they do so in visualizations that are distinctive for their evocation of spectacle, lush natural colour and diversity. In its unmasking function, it is most frequently the voice of the painter that unmasks the voice of the historian.

From these conceptual and theoretical frameworks it is now possible to formu-
late the definitions and functions of visualization that will make meaningful the
critical reading of specific practices and problems of representation in Ligon's
History. On the most basic level, visualization will denote those narrative tech-
niques whose principal end is to produce colonial reality in graphic and pictorial
modes of representation. This definition will appear typically in loco-descriptive
passages, scenes and settings that approximate the qualities of traditional pastoral,
that aim to represent the exotic difference or otherness of colonial topographies
and human physiognomies. Visualization will also define particular ways of seeing
and making seen imposed by those differences. Some natural effects of this partic-
ularity reside in the individual subjectivity of the historian whose visualizations
may be as much the product of things seen as they may be the result of failures to
see or difficulties in seeing and making seen. In this respect Ligon participates in
the shared challenges of the colonial author in making the alien the same, in repre-
senting the unrepresentable. Visualizations arising from these conditions produce
ambivalences in the object relations and narrative contents of the *History* that sug-
gest an attitude to colonial reality described by Meredith Skura as a 'distortion'
which disavows and replaces that reality.[9] As this analysis and its supporting theo-
retical buttresses will establish, those differences and the imperatives of negoti-
ating power in colonial domains are always permeated by pre-existing unconscious
symbolisms which structure the visualizations. This relation to the unconscious
reveals one of the strategic functions of visualization in the imagination and repro-
duction of identity, an identity whose constituents may be traced to fecund sources
of hybridity derived from both core and periphery.

The three categories of the fair, the carnivalesque and the grotesque embody
domains of thought and culture that illuminate the place of the circum-Atlantic in
the formation of colonial conceptual order. Indeed, it is possible to describe at least
a functional (if not systematic) correspondence between the geographical order
each place (England, the Cape Verdes and Barbados) occupies in the circum-
Atlantic trajectory of Ligon's *History* and the relation of principal images to each
respective conceptual order. The circum-Atlantic is thus mapped both visually and
conceptually in the textualization of colonial identity. In their joint and several
valencies, the fair, the carnivalesque and the grotesque function not only as potent
sources from which to appropriate wholesale visualizations; they also, in their
being mixed, constitute that expression of hybridization described as the evolution
of 'new combinations and strange instabilities in a given semiotic system'.[10] This
capacity for a structure that combines mixture with instability is especially relevant
to the context of economic and intellectual production in the mid-seventeenth-
century sugar colony of Barbados, at once an area of emergent growth and eco-
nomic uncertainty, and a prime setting for texts concerned with the search for
cultural legitimacy and other questions problematizing life at the cultural margins.
The visualization potentials of the fair, the carnivalesque and the grotesque figura-
tively inscribe the possibilities for imaginatively migrating these meaning systems

from centre to margins and vice versa. Together the three categories construct a textual system in which the semes of foreignness can be deployed.[11]

In its complex of social, economic and political relations the fair offers itself as a cultural signifier of the symbolic unconscious from which Ligon's subjectivity could draw the resources to confront foreignness. The business that occasioned the stopover Ligon and his party made in the Cape Verdes was the buying of horses and slaves. From their early sixteenth-century status as a slave entrepôt for the Portuguese, through the subsequent centuries of English involvement in the trade, the Cape Verdes figured importantly in the supply of slaves to the plantation colonies and in the commercial activities collateral to plantation economies. It is this mediatory figuration of the place in the colonial economy of exchange that establishes my relation of the place to the traditions of the fair. Cornelius Walford in his valuable treatise on *Fairs Past and Present* (1883) posits the connection in Roman Britain between the holding of fairs and the organization of markets. From their earliest appearance in fourth-century Greece, fairs were, in Walford's words, 'infamously distinguished for a traffic in slaves'. Evidence for their continued association with slavery shows that the same activities were carried on at public markets and fairs in North German towns around the close of the tenth century, and that commercial activities of Portuguese merchants in the prosperous entrepôt of Antwerp in the sixteenth century were greatly aided by the development of fairs.[12]

Though Ligon devotes about one-fifth of the text to a narrative and descriptive account of the stopover in the Cape Verdes, it is significant that he suppresses the evidence of slave trading, deferring images of slaves and slavery until the Barbados narrative proper. Three episodes from the Cape Verdes account combine the documentary impulses of historiography with the aesthetic and visual impulses of painting to exemplify practices of visualization arising from pointed selection and suppression of images. A Portuguese colonial governor (known as the Padre), his concubine and twin fifteen-year-old virgin sisters are the central figures, whose skin colouring, body images, and relations to ambient space engender the rich visual imagery of the Cape Verdean pretext. The complex racial, political and cultural hybridities embodied in each of these figures confront Ligon's historical and painterly imagination with enigmas of identity that prove elusive of codification. This elusiveness produces responses ranging from repellent caricature to orientalized fetishism to prelapsarian idyllicism. Together the episodes dramatize the hybridization of race, politics and culture in this mediatory space; they serve as pretexts to the greater narrative of identity redefinition and territorialization that the *History* inaugurates for the British West Indian settlement. Elsewhere I have developed an extended discussion of certain relationships among these episodes.[13] Here I will revisit only the passage describing the Padre and extend the analysis to illustrate the visualization techniques and objectives inherent in the episode. In the narrative-descriptive passage that follows, Ligon and his party prepare to meet the Padre for the first time:

About the hour that our stomachs told us, it was full high time to pay Nature her due, we lookt about us, and perceived at a good distance, a horse coming towards us, with a man on his back, as hard as his heels could carry him; and within a very little time, made a sudden stop at the *Padres* house from whose back (being taken by two Negroes) was set on the ground a great fat man, with a gown on his back, his face not so black as to be counted a *Mollotto*, yet I believe full out as black as the Knight of the Sun; his eyes blacker, if possible, and so far sunk into his head, as with a large pin you might have prick't them out in the nape of his neck. Upon his alighting we perceiv'd him very much discomposed, for the pace he rid, was not his usual manner of riding, as by our enquiry afterwards we understood; and that he very seldom rid at all, but his business having held him over long, caus'd him to take horse, who intended to come a foot, and being mounted, (and he none of the best Horsemen,) was made subject to the will of his horse.[14]

In this description, the figure of the Padre visualizes the combined economies of all three categories framing this analysis. Together with the discursive economies of race, colour, class and culture by which the Padre is defined oppositionally against the identity of the historian and his party, this visualization also engenders the second half of Bhabha's attitudinal split. By making his corporeal presentation the object of a vicious onslaught of ridicule and contempt, Ligon disavows the deference that would be customarily due to the highest civil power in the colony. That respect denied, the Padre is replaced by a kind of mimic man image, a re-articulation of reality that serves to invent the legitimacy of English aspirations to imperial ascendancy over the Portuguese.

That there is an almost certain political motivation for such deliberate selection and suppression of emphasis, for the privileging of visual over discursive criteria, is strongly substantiated by the following facts. In his capacity as governor, the Padre had used his good offices to defuse a tense stand-off between his brother Bernardo and the English colonists. At the moment of his appearance in the extract he is about to show his generosity again by extending to them the hospitality of his table, though none of this immunizes his circum-Atlantic (Afro-European) ethnicity from English racial attack. The functions of visualization here are therefore complex and hybridized. The voices of the historian and the painter unmask and ironize each other within the same utterance.

The argument for political motivation can be further supported by considering the way this episode symbolically re-visualizes the fair as a fiercely contested discursive space. Here some rationale is in order for thinking of the fair and the colony in identical terms. Fairs, like colonies (and the Cape Verdes particularly so), were situated at the crossroads of commerce. Stallybrass and White remind us that their close association with marketplaces made them function as the 'intersection of economic and cultural forces', distribution points for goods and travellers, sites of exchange for commodities and commerce.[15] The Padre's ungainly bulk, his transformation into a figure of fun and ribaldry, a sideshow for the entertainment of a travelling party of class-conscious Englishmen, positions this image within the

same order as those 'strange sights', 'enormities and misdemeanours' often cited by moral and political censors who persistently called for the suppression of Bartholomew Fair and others like it.[16] Moreover, it should be recalled that the fair was often the site of very vigorous squabbles between Crown and Church, Church and civil authorities, local authorities and individuals for control of charter rights, tolls, tariffs, and the regulation of public behaviour within the festive confines.[17] Ligon's racial scorn and undisguised contempt for Portuguese territorial rights here are visualized in the deliberate reduction of the Padre's personal and social consequence by having the physical presence of the Padre's horse privileged over the Padre's person, both in point of narrative priority and constitutional vigour.

As a category, this kind of visualization effects a kind of exclusion by inclusion. It is designed to redeem colonial society from its identification with low others. Such oblique assignment of images (like the Padre's) to the realm of the unrepresentable may be theorized as essential to the civilizing process in characteristically unstable spaces like the circum-Atlantic Cape Verdes. To see the circum-Atlantic in this way provides an approach to understanding the processes by which those pre-existing, dominant meaning systems may migrate and be transferred between domains. Stallybrass and White illuminate the point of transferability as well as the point (developed earlier) about oblique visualizations and visualizations by exclusion. They write:

> It is not the case that discursive material is transmitted intact between existing, fully formed discursive spaces which act as donors or hosts. *Whole domains* are constructed in interconnection with each other … Sites and domains of discourse, like the theatre or the author's study or the marketplace, are *themselves* hierarchized and ranked, emerging out of an historical complex of competing domains and languages each carrying different values and kinds of power. Writing about a fair … could be as much an act of dissociation from, as a sign of engagement with, its festive space.[18]

This episode's visualization of history as carnivalesque is strikingly produced in the structures of inversion, the topos of high brought low, and parodies of authority associated with costume and other symbols of rank. With the horse represented as the first object to appear in the English guests' visual field, the normal order of rider–horse relations is reversed, and that world-turned-upside-down privilege is inscribed grammatically as 'a horse coming toward us with a man on his back'. Notably, too, the Padre's relationship to his clothes is inverted with similar effects: he is shown 'with a gown on his back' rather than wearing a gown. The amorphous lump that is his body slumps over the back of a horse galloping furiously, without benefit of human control, until it 'made a sudden stop at the *Padres* house'. There the Padre is further objectified by being 'taken' from the back of his horse and set on the ground by two Negroes, the usage 'taken' being more a sign of the rider's utter effeteness and debility than of his power and place in his own domain. And that inverted order persists in the representation of almost everything else concerning the Padre: his food and drink, his mistress, the enviable prospect of his

house, all enjoy a higher valuation than his personhood in the cultural hierarchy visualized within this episode. The Padre is unceremoniously dethroned from his high place of civil authority in St Jago and resolutely repositioned approximating the domain of the low carnivalesque.

The defining carnivalesque pursuit of levity and celebratory laughter may afford some temporary immunity for this suspension of hierarchy. But one has to look to the implications of the grotesque to explain the deeper discursive meaning of visualized excess in this episode. Few images in the *History* invite us to descend so far into the colonialist historian's unconscious as Ligon's pointed representation of the colour and set of the Padre's eyes: 'blacker, if possible [than the Knight of the Sun's], and so far sunk into his head, as with a large pin you might have prick'd them out in the nape of his neck'. Here the excess of personal scorn seems so palpable and the language so thoroughly saturated with racial revulsion, one might well ask, what deeper political impulses could stir such violent energies?

The descent into the ridicule and excesses of grotesquerie may be traced to their origins in the unconscious. For this context we may borrow Anthony Wilden's summation of the Lacanian unconscious as 'the repository of personal and social myths, as the locus of socially approved hostilities, illusions, and identifications'.[19] The Padre's creolized features would have evoked in the minds of readers the polyvalent sign of the exotic, with its power to engender dissociation of identity and to encode alterity. Embodied in such a figure, the pretensions and threat of a rival colonial power could be properly reduced to their symbolic absurdity.

The confluence of the economies of the fair, the carnivalesque and the grotesque in this single episode codes the Cape Verdes with a metonymic value that prefigures the role of hybridity in the formation of circum-Atlantic identities, and in the imagination of circum-Atlantic historiography. In their study, Stallybrass and White show how the fair staged the carnivalesque in ways that both reflected and determined power relations and popular attitudes over periods including the seventeenth century. Here in the Cape Verdes episode, the fair slips into the visual field of the historian as he attempts to domesticate the still nascent and unfamiliar idea (in Ligon's mind) of the colony. At the same time it would have confronted the colonizing party and subsequent readers of the *History*, in effect, Ligon's imagined community, with their deeply rooted desire for and relation to its hybridity.[20] The Padre's gross bulk and weight evoke those suggestive associations with degradation, protuberance and excessiveness that Bakhtin defines as the fundamental attributes of the grotesque.[21]

As he situates the substantive narrative of Barbados in the bodily centre of the *History*, Ligon again taps the complex cultural reservoir of the fair to domesticate the exotic visual features of local life such as the brisk, bustling commerce of shipping ports in colonial Barbados, and the variety of sports, games and entertainments practised by plantation slaves.[22] It is significant that, once again, close analysis of the incidence and relationships of the categories deployed in this part of the *History* reveals a very determined pattern of selection and suppression,

approbation and reprobation. For the present purposes I shall confine the focus
here to Ligon's images of African male slaves abstracted from the rigours of daily
labour, their bodies visualized ostensibly only for their aesthetic and athletic
values. Narrowing the focus thus shows a decided bias for fair and carnivalesque
signifiers to the exclusion of the grotesque. And within that bias there is evi-
denced a further bias for positive or softer visual values.

Unlike the techniques used in the Cape Verde episode, the emphases here are
designed less to dissociate the historian subject and his class-identified audience
from the exoticism and alterity of the slaves' bodily *habitus* and more to domesticate
those visual differences in palatable conformity with the experience and desire of
interested audiences back home, at the centre. Unlike the torpid, effete figure of the
Padre, the figures of African male slaves as they appear in Ligon's descriptions of
his early years in Barbados are almost all prized and privileged for their robustness
and superior athleticism. It is noteworthy that from the ranks of the total slave pop-
ulation, he recovers a suspiciously high number of leapers, wrestlers and fencers.
Even certain 'Portugal Negroes', seen on Colonel Drax's plantation, despite their
likely provenance from the Cape Verde (and therefore generically identified with
the Padre), win his admiration for their 'comeliness' and 'skill' in fencing.[23] 'Their
manner of wrestling is, to stand like two Cocks, with heads as low as their hips; and
thrusting their heads one against another, hoping to catch one another by the leg,
which sometimes they do'.[24] Leaping, wrestling, fencing and acrobatics are three
specific activities from the inventory of fair performance sports. To ascribe these
replications to mere coincidence would be to discount the potency of social institu-
tions to reproduce themselves across space and time, and to inform the products of
the intellect and imagination. Even though here too the hybridized split is to be
remarked in the invocation of the economy of the fair, the visualization stresses per-
formativity, theatricality, and raw corporeality. That the signifying economy of the
fair should materialize on to the scene of colonial slavery may be rationalized from
the implications of Lacan's concepts of the Imaginary and the Unconscious. That
the production of history is so heavily overwritten by the visual economy of the fair
extends the hybridized formations of circum-Atlantic identity to Barbados. In this
illustration the hybridity is inscribed both in the formal modes of presentation and
in the cultural objectives for which the imaginary and the unconscious structures
of the fair are appropriated.

Besides those listed earlier, Ligon claims for the Barbados slaves a high level of
skills in swimming and acrobatic sports. The next excerpt describes a set of swim-
ming activities staged for the entertainment of white masters and black slaves alike:

Excellent Swimmers and Divers they are, both men and women. *Collonel Drax* (*who
was not so strict an observer* of Sundayes as to deny himself lawful recreations) would
sometimes, to shew me sport, upon that day in the afternoon, send for one of the
Muscovia Ducks, and have her put into his largest Pond, and calling for some of his
best swimming *Negroes*, commanded them to swim and take this Duck; but forbad
them to dive, for if they were not bar'd that play, they would rise up under the Duck,

and take her as she swome, or meet her in her diving, and so the sport would have too quick an end. But that play being forbidden, the duck would make them good sport, for they are stronger Ducks, and better Divers by far than ours: and in this chase, there was much of pleasure, to see the various swimmings of the *Negroes*; some the ordinary wayes, upon their bellies, some on their backs, some by striking out their right leg and left arm, and then turning on the other side, and changing both their leg and arm, which is a stronger and swifter way of swimming, than any of the others.[25]

The visualizations produced in this excerpt carry specific cultural objectives bound up with the invention of colonial identity and colonial value. Those objectives are mediated by the hybridized voices of the painter and the historian, and arise from conditions in the young colony that naturally produce ambivalences in subject–object relations (slavery, racial differences). The visual imagery of slave athletes displaces the reality of bodies whose chief function is coerced productive labour, and whose status is social death and dehumanization. The historian's work abandons its strict disciplinary boundaries for a paradigm of visualized ethnography that normalizes orders and relationships in such a way as to endow them with an appearance which Jonathan Dollimore calls the 'unalterable character of natural law'.[26] So while the clear inferences of animalistic and primitive associations hang heavily over these performances, and while the whole narrative of sensuality and savagery historically used to represent and order Africans in the European imagination are recovered in the description, it is the communal, celebratory dimensions of the fair that are offered here. And the reason is that, in point of history, Barbados is now established as an unchallenged English domain. Ligon's design is to promote it as a peaceful, uncontested space, with an orderly community of masters and slaves living in harmony and collaborating to create and disseminate economic and social value. Bodies that would therefore otherwise be classified as marginal are assigned indivisible constitutive value in the complex transactions of producing value for the rarefied ideal of the metropole. This promiscuous production of social bodies dramatizes the significant coding mechanisms by which meaning may be extrapolated from the part to the whole and back to the part in the construction of the colonial body. Visualization functions to deconstruct the text's design, to make the unfamiliar familiar. It domesticates the signs of alterity and foreignness from marginal forms. Its practices reproduce those signs in palatable conformity with the experience and desire of interested audiences back home, at the centre. David Richards accords this production of conventional forms in colonial arenas a theoretically significant value, identifying it as a means of domesticating the erotic.[27] In other words, the favourable attributes or native mores of African male slaves are appropriated to the 'dominant social order or status quo'.[28]

If in these descriptions of male slaves the grotesque appears to retreat before the precedence of fair and carnivalesque motifs, or to be effaced by more urgent social objectives, it makes a striking return in the visualizations that depict images of black female slaves. This radical division and separation reinforces the split dynamic of hybridity; but the grotesque also carries with it certain signs that solidify the

metonymic value of a single colony like Barbados in the constitution of a larger conceptual space like the circum-Atlantic. The return of the grotesque focuses the role of feminine agency in the processes of constituting masculine private identity and collective patriarchal power, and reflects anxieties that are interpretable on the level of tensions between aesthetic and economic systems. In the passage that follows, the historian desires to render in less than one hundred words a totalizing narrative of the history of black female slaves. The fiction of a totalizing account rendered in these terms is indicative of the role of feminine agency in the construction of imperial discourses and the partial nature of power in the discourses themselves.

> The young Maids have ordinarily very large breasts, which stand strutting out so hard and firm, as no leaping, jumping, or stirring, will cause them to shake any more, than the brawn of their arms. But when they come to be old, and have five or six Children, their breasts hang down below their Navels, so that when they stoop at their common work of weeding, they hang almost down to the ground, that at a distance, you would think they had six legs.[29]

The sheer ambitious impossibility of the historian's desire attests to the magnitude of the object of study and the intractable problematics of representing, let alone achieving that object.

Such a pronouncedly different gendering of visualizations between masculine and feminine images encodes strategic objectives. Marked by grotesque distortions, the visualizations frame the feminine as a 'multiple' body, identified with 'the marginal, the low and the outside from the perspective of a classical body'.[30] Symptomatic of these problems of representing the female (and especially the black female), these visualizations belong to the category earlier associated with difficulties in seeing and making seen. Bhabha defines problems of this order as motivated by the 'scopic drive' of the colonialist male gaze, which desires to totalize but which is at the same time restricted by its inherent inability (its partiality and lack), because the other (in this case, the female) is ultimately unrepresentable. She is that other 'which repeatedly resists signification'.[31] Grotesque visualizations belong to that larger ensemble of discursive practices shown to qualify the portrayal of black characters in early modern texts. While the black male's overt physicality with its implied threats of defiance and militancy can be aestheticized into theatrical and athletic diversions, or assimilated to normative male white power, the female threat as visualized in the above passage resides in her reproductive power, a power Linda Boose, in writing about these discursive practices, weights thus: 'Within Europe's symbolic order of dominance and desire, the black woman destroys the system, essentially swallowing it up within the signification of her body'.[32]

Just as in the images of wrestling and swimming certain harsher realisms of bodies principally intended for hard labour were elided to make visible a more benign side of colonial plantation society, so in this visualization that so resolutely misshapes the female slaves' bodies there is an elision of certain unspeakable realisms which ironically serve to make visible the role of feminine agency in the

two related categories of patriarchy and individual male identity.[33] In this case the separation of black feminine agency (which stands here for the generic feminine) from white patriarchal power is signalled by the narrow reduction of their self-presentation in fertile years to the fetishized signs of their sexual and reproductive functions (hard, firm, strutting breasts) and in their post-fertile years to a grotesque phantasm (distended, leg-like breasts). Two kinds of power are defined by this kind of separation and negation: the collective power of patriarchy and the power of the individual identity reproduced as the historian. In both cases the separation is meant to exclude the signs of gender and racial differences from the hierarchy of power in colony and empire. As Ania Loomba argues, 'There is a historical dependency between patriarchalism and racism. In Europe the increased emphasis on heterogeneity of people and groupings ... occurs alongside the escalation of patriarchal discourses on the separateness of female identity from masculine'.[34]

In both cases there is an implicit segregation of the values of labour associated with each gender and racial category. The female is expressly and uniquely relegated to the reproductive labour of producing children for the slave economy. The white male subject signifies his exemption from that role and status by the aesthetic distance he adopts in order to produce these visualizations. He further separates his role and status in a distinctly self-conscious presentation of his own higher order of intellectual labour as the historian of these sights and processes. Nancy Armstrong and Leonard Tennenhouse have set down a formulation of colonial labour which is especially illuminating for this connection between orders of colonial labour and their visualization: 'The categories of labor that organize the new world are defined by the most fundamental distinction of all: between those who work only with their bodies and those whose labor is invisible because it is intellectual'.[35]

Feminine agency similarly assumes a key function in producing tensions between aesthetic and economic systems. These tensions are externalized in proportions inverse to the systems' material valuation: the aesthetic is favoured with greater visibility, tending in passages like the one that follows to undercut, even to interrogate by philosophical ratiocinations, the definitively higher material value of the economic activities with which it interplays.

> [There in Barbados] the skins of women ... are so sweaty and clammy, as the hand cannot pass over, without being glued and cemented in the passage or motion; and by that means, little pleasure is given to, or received by the agent or patient: and therefore if this sense be neither pleased in doing nor suffering, we may decline it as useless in a Country, where down of Swans, or wool of Beaver is wanting.[36]

Coming after a substantial central account of sugar cultivation, manufacture and economics, this passage forms part of an extended section on the suitability of other sports and recreations to the Barbados climate, and the sensuous pleasure that other trees, shrubs and flowers might give to the colonist. The feminine, so intensely objectified earlier in mainly grotesque visualizations, is here made to hold the key, to mark the criterion of measurement, for the survival of some scheme of sensory value

that holds the survival of culture itself. Here the female body is still being objectified as 'patient' for its potential to serve the gratification of the male 'agent'. Here too that body is radically separated from authorizing status by the scientific voice of the historian in the coded tag 'we may decline it as useless'. Amariglio and Callari make the point that objectifying and differentiating are key parts of the process of forming selves, becoming agents, of differentiating the self from others: 'The constitution of agents as 'selves' differentiated from 'others' is the result of both economic and noneconomic processes'.[37] What validates these selves and their agency is status in a social hierarchy underwritten by economic power. Colonies are predicated on maximizing the economic value of natural resources, some of which may afford aesthetic pleasure. That relationship places these two values at least in uneasy tension, if not in ideological antagonism. The natural landscape and its human contents are revisioned as a marketplace where each commodity has value to the extent that it can be visualized and objectively appraised. It was a radical change in the object relations of Ligon's private economy that drove him to a speculative quest through the circum-Atlantic (he was stripped of all his worldly possessions in 'a barbarous riot'). It was the aesthetic economy of his painter's vision that enabled particular modes of visualizing that quest. Both of these facets in his individual constitution inform his visualizations in Barbados. From this we may extrapolate that Ligon's ability to objectify is synonymous with the ability to visualize.[38] The practices of visualization in the *History* are critical constituents in the history of the author's subjectivity.

What these visualizations of the grotesque body mean for the conceptual bearings of this analysis can now be synthesized as follows: the two sets of images (the sweaty, clammy skins and the black deformed breasts) project some of the most graphic and repellent visions of colonial culture on to the female body. From the ambivalences of economic value and aesthetic anxiety the images construct a distinctly gendered complex discourse formation which recuperates some of the salient definitions of Bakhtin's 'discursive norms of the grotesque body'. Stallybrass and White list among those norms: impurity (in the sense of dirt and mixed categories), heterogeneity, protuberant distension, exorbitancy, decentred and eccentric arrangements, gaps, orifices and symbolic filth, materiality and parody.[39] Sweaty, clammy skins image the loathing for dirt, sweat and other natural bodily secretions (impurity) that so uniquely defined the bourgeois desire for pure social origins, their solicitude to be dissociated from the threat of dilution (heterogeneity) and corruption so commonly projected on them by their social betters. Such abnormal elongation (protuberant distension) of black female breasts may well be the natural result of heavy breast feeding (exorbitancy) to satisfy the unnatural production demands of slavery. Both passages bespeak the hyperactive fantasies of ambivalent desire: the aesthetic preoccupations skirt the margins of the eccentric, and the economic relations problematize the difference between the essence of an exotic entity and its commodified or exchange value. The mixture of attraction and repulsion, of pleasure and disgust, displays the vagaries of a consciousness tossed back and forth across circum-Atlantic domains of possibility.

These conflictive economies visualized in two economically significant but aesthet-ically peripheral sites reveal the hybrid sources from which those sites both draw their conceptual identity and mediate the identity of the metropolitan centre. In a critique rooted in the factors of anxiety and division (conditions which intensely afflicted the West Indian planter elites), Stallybrass and White describe these rela-tionships in terms that are both lucid and allusive:

> The grotesque physical body is invoked both defensively and offensively because it is not simply a powerful image but fundamentally constitutive of the categorical sets through which we live and make sense of the world ... 'What is socially peripheral may be symbolically central'.[40]

It is symbolically central to the conceptual logic of this essay that the visualization of grotesque imaging in the Barbados narrative appears on the scene of labour, for it is through this connection that the forms, processes and meaning systems that sus-tain the colonial system and prefigure their transformation can be theorized. Ligon's voyeuristic visualizations appropriate the young female slaves' breasts as fetishes for scopophilic consumption and the pendulous breasts of older slaves as sites of displacement for male desire.

To appreciate the plot and pattern of these diversions, some further contextual-ization of the scene of labour in which the breasts are described should prove useful. Prior to presenting those images, Ligon made some tentative and desultory references to the actual work of preparation and planting the sugar cane, but these usually occurred in contexts so manipulative of reader response, so subsidiary to the matter at hand, or so heavily preoccupied with aesthetic or otherwise mysti-fying aspects of his narrative as to blur the full visualization of the labour required to produce the cane. The description of exaggerated distension is one such diver-sionary strategy that appears just as the narrative logic threatens to detail the rigour of unremitting toil necessary to prepare a field for planting and the subsequent application of intensive methods to produce the sugar. The author indicates that continuous planting all year round requires 'Canes ... to be planted at all times that they may come in, one field after another; otherwise, the work will stand still'.[41] Just then, Ligon shifts the focus away from the harsh vision of oppressive toil to the visualization of erotic fantasy coupled with grotesque imagery (the one suggested by a description of firm supple breasts on young female slaves, the other by the pen-dulous, leg-like breasts of older labouring women). From there, the description moves deftly and swiftly on to another phase of sugar production, representing the proto-industrial structures of the equipment used for grinding, boiling and crystal-lization. Descriptions of these structures may be reduced to two categories: one effaces the full presence of the slave with her fetishized body parts, the other oblit-erates that presence with the complex materiality of proto-industrial agency.

Illustrating the first category, the next passage visualizes the sheer physicality of the proto-industrial complex. But as a meaning system, that complex subsumes within itself key constituents of bourgeois capitalist ideology – incessant work,

rational order and efficiency, and a myth of progress supporting related class and individual idealisms – transplanted to a colonial plantation and evolving with peculiar inflections of the circum-Atlantic.

> The manner of grinding them [the sugar canes], is this, the Horses and Cattle being put to their tackle, they go about, and by their force turne (by the sweeps) the middle roller; which being Cog'd to the other two, at both ends, turne them about; and they are three, turning upon their Centres, which are of Brass and Steel going very easily of themselves, and so easie as a mans taking hold of one of the sweeps with his hand will turne all the rollers about with much ease. But when the Canes are put in between the rollers, it is a good draught for five Oxen or Horses; a *Negre* puts in the Canes of one side, and the rollers draw them through to the other side, where another *Negre* stands, and receives them; and returns them back on the other side of the middle roller, which draws the other way.[42]

Here the natural energies of horses and cattle are yoked to the mechanical power of brass and steel. The obvious mediation of human skill, judgment and intelligent supervision by the slaves over the whole process is minimized both in point of verbal proportion and of the racialized differentiation of the labour performed by the category 'Negre'. This racialization and differentiation carry with them important signifiers for theorizing the constituting elements of the circum-Atlantic in Ligon's *History* and in the broader domain of colonial discourses where this conceptual category is visualized. As Maureen Quilligan notes:

> The racism of the transatlantic slave trade carried on by England (as well as, of course, other European Powers) allows culture broadly to redefine the heroism of work, relegating to the realm of non-human thinghood a manual labor placed beneath the 'Good Works' of nascent capitalist entrepreneurs.[43]

The work of the animals and the reiterated easy coordination of sweeps, rollers and cogs are visualized as a mystified image of cosmic harmony itself. The grotesque of violence and horror is transmuted into a fetishized image eliciting something of the religious awe and reverence of the most worshipful fetishist. The alignment of beast and machine objectively visualizes important elements of the plantation elites' economic and cultural capital. Through contextualization, illustration and theoretical interpretation we can see how the *History* advances the objectives of visualization nearer to their logical *telos*. The symbolic displacement of female breasts serves the impulse to deny the true cause of their exorbitancy as well as to refigure them as phalluses, the most potent symbols of male power. Marxist readings of the dynamics of fetishism in capitalist-industrialist economic systems are instructive. In a number of them that have informed my thinking in this part of the essay, not only the phallus, but also the machine and capital are identified as objects fetishized in the bourgeois capitalist mind. One such reading, Hal Foster's essay on mid-seventeenth century Dutch still life painting, is illuminating for this analysis of Ligon, both for Foster's focus on a common historical context and for his interpretation of the breast fetish's potential to be recovered as a phallus.[44] Moreover, Foster's essay offers a critique that

displays how the intellectual and aesthetic impulses of pictorial work can subsume other values reflecting the dynamics of interplay, paradox and exchange, dynamics that structure the complex meaning systems recoverable in Ligon's visualizations. Grasping this very intriguing analogical relationship, we can then understand Ligon's propensity to overwrite the degraded and dehumanizing aspects of slave labour with aesthetic or philosophical digressions, in the way this phallic fetish metamorphoses into the mechanistic complex of the sugar works.

According to Ligon's account, special planning and design strategies must be exercised in selecting a site for the sugar works or *ingenio*. Situated on the brow of a hill, or the highest ground on the plantation, the *ingenio* looms in massive pre-eminence above the other structures:

> the Ingenio itself, which is the *Primum Mobile* of the whole work, [includes] the Boyling-house, with the Coppers and Furnaces, the Filling room, the Still-house, and Cureing-house; and in all these, there are great casualties. If any thing in the Rollers, as the Goudges, Sockets, Sweeps, Cogs, or Braytrees, be at fault, the whole work stands still; or in the Boyling-house, if the Frame which holds the Coppers, (and is made of Clinkers, fastned with plaister of *Paris*) if by the violence of the heat from the Furnaces, these Frames crack or break, there is a stop in the work, till that be mended. Or if any of the Coppers have a mischance, and be burnt, a new one must presently be had, or there is a stay in the work. Or if the mouths of the Furnaces, (which are made of a sort of stone, which we have from *England*, and we call it there high gate stone) if that, by the violence of the fire, be softned, that it moulder away, there must new be provided, and laid in with much art, or it will not be. Or if the bars of Iron, which are in the floor of the Furnace, when they are red hot (as continually they are) the fire-man, throw great shides[45] of wood in the mouths of the Furnaces, hard and carelessly, the weight of those logs, will bend or break those bars, (though strongly made) and there is no repairing them, without the work stand still; for all these depend upon one another, as wheels in a Clock. Or if the Stills be at fault, the *kill-devil* cannot be made.[46]

Clearly the objective of this detailed visualization is to impress the mathematical precision of site planning and the rational ordering of architectural and processual relationships among the boiling house, the copper vats, the furnaces, the filling room, the still house and the curing house.

This whole mechanistic complex so constructs and privileges its own fantasy (by its sheer size and consequence) as to mute Ligon's candid but horrific admission that 'in all these [mechanical structures] there are great casualties', a reference to the very common accidents of slaves losing their limbs in the sugar mill rollers, being burnt in the furnace fires, or scalded by hot water from the huge cauldrons. Again, it is notable how the grotesque of violence and horror, so intrinsically a part of this production economy, is re-appropriated by similar diversionary strategies to mark this proto-industrial complex, distinguished by its salient images of size, mass and power as a masculinist myth differentiated from the feminine scene of stooping, manual work. These structures, then, are figured to bear an essential relationship to the

construction of individual and class identity from the hybrid sources that defined the circum-Atlantic. That the grotesque is able to be theorized as this continuously self-reformulating meaning system is apparent in Bakhtin's account:

> The last thing one can say of the real grotesque is that it is static; on the contrary it seeks to grasp in its imagery the very act of becoming and growth, the eternal incomplete unfinished nature of being. Its images present simultaneously the two poles of becoming: that which is receding and dying, and that which is being born; they show two bodies in one, the budding and the division of the living cell.[47]

Descriptions of the equipment used to manufacture the sugar become implicated in strategies that identify the early modern proto-capitalist ethic of productive work with the masculinist assumptions underpinning Ligon's intellectual work as historian. This reading of the grotesque reveals its conceptual hybridity and produces the inherent contradictions of early-modern capitalism. As the visualization of sugar production both reveals and negates the manual, servile agency of feminine labour, it reveals also the increasing role of mechanization and the desire to soften and civilize an important authenticator of circum-Atlantic culture, with the mediatory work of writing colonial history.

This reading recovers jointly the autonomic energies of the *History* and the historian's nascent consciousness of his role in promoting the Barbados frontier of the circum-Atlantic as a paradigm to elevate the social profile and advance the emulative interests of an emergent colonial bourgeoisie. Each point along the geographical trajectory described by the notion of the circum-Atlantic offers complex material and conceptual possibilities, but never divorced from challenges to pre-existing systems of political, social and private order. Ligon's own personal crisis intensified the desire to fix a stable vision of order in all these spheres. The fair, the carnivalesque and the grotesque serve as powerful spurs to the visualizing imagination. Ligon's text attempts to forge, under a rubric pretextually denominated 'history', what Paul Brown calls a 'coherent discourse adequate to the complex requirements of British colonialism in its initial phase'.[48] That coherence must accommodate the productivities of positive work and leisure (the machine and recreational sports), as well as the images of distaste and loathing intimately bound up with them (the Padre and the female slaves). The circum-Atlantic provides the kind of fluid conceptual and material space that allows for the free play of signifiers that shape the narrative dynamic of the *History* and its ideological teleology. This free play constructs a space in which the text can solidify itself as one of the founding discourses on various forms of cultural production in the circum-Atlantic. The pretextual assumptions of 'history' proffer the mainly political and economic relations of that category. But the pre-existence in the historian's mind of specific dominant conceptual orders or meaning systems appropriate this space to solidify the historian and the elites he publicizes as a distinct and proper class. In the *History*, then, the production and circulation of visual images become inseparable from the production and publicity of individual and social identities.

Notes

1 The geographic location of these islands, some fourteen in number, makes them an almost definitive embodiment of circum-Atlantic identity. They served as both liminal and medial spaces for the movement of travellers and shipping in the triangular route connecting Europe with the slave marts of Africa and the slave plantations of the West Indies. The intersection of human contacts through race mixing, commercial activities, and political rivalries made the Cape Verdes a crucial vantage point from which to visualize the sources of material and discursive hybridity.

2 In this essay, I have used the text of the second edition, and in quotations from that have preserved Ligon's original spelling and punctuation: Richard Ligon, *True and Exact History of the Island of Barbadoes* (London, P. Parker and T. Gily, 1673)

3 This paragraph foregrounds critical Lacanian concepts that provide interpretive support for my reading of Ligon. For my critique of Ligon's subjectivity and symbol-making, see Jacques Lacan, *Speech and Language in Psychoanalysis*, trans. Anthony Wilden (Baltimore, The Johns Hopkins University Press, 1981), p. 250. For the formulations of the Symbolic, the Imaginary and the Real, see Lacan, *Speech and Language in Psychoanalysis*, pp. 3–4, 192. For my construction of overwritten/overridden structures, I am indebted to Shari Zimmerman's reading of Lacanian theory in her essay, 'Pubis angelical: where Puig meets Lacan', *Critique*, 39 (1997), 65–80 (77–8).

4 Ligon lived on a plantation with Modiford for three years, during which time he was responsible for the business affairs of the plantation. Colonel (later Sir Thomas) Modiford was prominent in early West Indian political life, serving briefly as governor and then member of the Council of Barbados, and from 1664 to 1670 as governor of Jamaica. Major Hilliard was a joint owner with Modiford of a 500-acre plantation. Colonel Drax was another leading planter in early Barbados. The combined political power, social status and economic wealth these three men wielded in the colony transformed them into symbols of that emulative cultural value which Ligon's *History* visualizes and promotes. See also Hilary Beckles, *A History of Barbados: From Amerindian Settlement to Nation State* (Cambridge, Cambridge University Press, 1990), pp. 21–3.

5 Peter Stallybrass and Allon White, *The Politics and Poetics of Transgression* (Ithaca and London, Cornell University Press, 1986), p. 58.

6 Homi Bhabha, 'Signs taken for wonders: questions of ambivalence and authority under a tree outside Delhi, May 1817', in Henry Louis Gates (ed.), *Race, Writing and Difference* (Chicago, University of Chicago Press, 1986), pp. 163–84 (168).

7 Homi Bhabha, 'Of mimicry and man: the ambivalence of colonial discourse', *October*, 28 (1984), 125–33.

8 Robert J. C. Young, *Colonial Desire: Hybridity in Theory, Culture and Race* (Routledge, 1995), p. 20.

9 Meredith Anne Skura discusses distortion as a discursive strategy serving the political purpose of making the New World fit into a schema justifying colonialism in 'Discourse and the individual: the case of colonialism in *The Tempest*', *Shakespeare Quarterly*, 40:1 (1989), 45.

10 Stallybrass and White, *Politics and Poetics*, p. 58.

11 Homi Bhabha, 'The Other question: difference, discrimination and the discourse of colonialism', in Francis Barker, Peter Hulme *et al.* (eds.), *The Politics of Theory:*

Proceedings of the Essex Conference on the Sociology of Literature (Colchester, University of Essex, 1982), p. 196.

12 Cornelius Walford, *Fairs, Past and Present: A Chapter in the History of Commerce* (New York, Augustus M. Kelley, 1968), pp. 3–11.

13 For a full discussion of the three episodes, see my essay 'The pretexts and pretenses of hybridity in Ligon's *True and Exact History of Barbados* (1657; 1673)', *Journal of Commonwealth and Postcolonial Studies*, 8:2 (forthcoming).

14 Ligon, *History*, p. 10.

15 Stallybrass and White, *Politics and Poetics*, pp. 28–30.

16 Walford, *Fairs*, p. 199.

17 David Kerr Cameron, *The English Fair* (Gloucestershire, Sutton Publishing, 1998), pp. 38–40.

18 Stallybrass and White, *Politics and Poetics*, p. 61.

19 Jacques Lacan, Speech and Language in Psychoanalysis, trans. Anthony Wilden (Baltimore and London: John Hopkins University Press, 1981), p. 226.

20 For some account of the sources of hybridity in English national identity that will illuminate my position here, see Benedict Anderson, *Imagined Communities: Reflections on the Origin and Spread of Nationalism* (London, Verso, 1983), pp. 20–1.

21 See Bakhtin's presentation of these attributes in *Rabelais and His World*, trans. Helene Iswolsky (Bloomington, Indiana University Press, 1984), pp. 19–21.

22 Similar visualizations involving the activities of commerce and aesthetic strategies to serve ideological ends are discussed in my *Cultural Politics of Sugar: Caribbean Slavery and Narratives of Colonialism* (Cambridge, Cambridge University Press, 2000), pp. 28, 138–42.

23 Ligon, *History*, p. 52.

24 Ligon, *History*, p. 50.

25 Ligon, *History*, pp. 52–3.

26 Jonathan Dollimore, 'Introduction', in Jonathan Dollimore and Allen Sinfield (eds.), *Political Shakespeare: New essays in Cultural Materialism* (Ithaca, Cornell University Press, 1985), pp. 2–17 (7).

27 David Richards, *Masks of Difference: Cultural Representations in Literature, Anthropology and Art* (Cambridge, Cambridge University Press, 1994), p. 80.

28 Dollimore, 'Introduction', p. 7.

29 Ligon, *History*, p. 51.

30 See Stallybrass and White, *Politics and Poetics*, p. 23. The deconstruction of the totalizing tendencies in colonial discourses through the diagnoses of lack or partiality has been given significant examination in recent theory. See Graham Huggan, 'A tale of two parrots: Walcott, Rhys, and the uses of colonial mimicry', *Contemporary Literature*, 35:4 (1994), 645; Bhabha discusses the idea of partial presence in 'Of mimicry and man', p. 127; and Richards in *Masks*, pp. 110–11.

31 Bhabha, 'Of mimicry and man', p. 127.

32 Linda Boose, 'The getting of a lawful race: racial discourse in early modern England and the unrepresentable Black Woman', in Margo Hendricks and Patricia Parker (eds.), *Women, 'Race', and Writing in the Early Modern Period* (London and New York, Routledge, 1994), p. 47.

33 Kathleen Biddick locates similar generic patterns of visualization in the 'rhetoric' of texts, which she says can provide clues to '[the text's] engendering, to the historical

processes it renders invisible in order to make some category visible': see 'Genders, bodies, borders: technologies of the visible', *Speculum*, 68 (1993), 390.

34 Ania Loomba, *Gender, Race, Renaissance Drama* (Delhi, Oxford University Press, 1992), p. 45.

35 Nancy Armstrong and Leonard Tennenhouse, *The Imaginary Puritan: Literature: Intellectual Labor and the Origins of Personal Life* (Berkeley and London, University of California Press, 1992), p. 112.

36 Ligon, *History*, p. 107.

37 Jack Amariglio and Antonio Callari, 'Marxian Value Theory and the problem of the subject: the role of commodity fetishism', in Emily Apter and William Pietz (eds.), *Fetishism as Cultural Discourse* (Ithaca and London, Cornell University Press, 1993), pp. 186–216 (209).

38 In Amariglio and Callari's assertion that 'individuals may come to the market with an ability to objectify', the 'ability' may be redefined for Ligon as a 'predisposition' enhanced by his social and political positionings: *ibid.*, p. 209. Hal Foster also writes of this oscillation between poles of economic and aesthetic interest, characterizing it as a 'peculiar coexistence of apparently opposite value systems': see his 'Art of Fetishism', in Apter and Pietz (eds.), *Fetishism as Cultural Discourse*, pp. 251–65 (260n.).

39 Stallybrass and White, *Politics and Poetics*, p. 23.

40 *Ibid.*

41 Ligon, *History*, p. 55.

42 Ligon, *History*, p. 90.

43 Maureen Quilligan, 'Freedom, service and the trade in slaves: the problem of labor in *Paradise Lost*', in Margareta De Grazia, Maureen Quilligan and Peter Stallybrass (eds.), *Subject and Object in Renaissance Culture* (Cambridge, Cambridge University Press, 1996), pp. 213–34 (219).

44 For discussions of the fetishized genitals' implication in capitalist formation, see Foster, 'Art of Fetishism', p. 261; Pietz, 'Fetishism and materialism: the limits of theory in Marx', in Apter and Pietz (eds.), *Fetishism as Cultural Discourse*, pp. 119–51 (129–30); Amariglio and Callari, 'Marxian Value Theory', p. 188.

45 According to the *Oxford English Dictionary*, a shide is a piece of wood split off from timber; a board, plank or beam.

46 Ligon, *History*, pp. 55–6.

47 Bakhtin, *Rabelais and his World*, p. 52.

48 Paul Brown, '"This thing of darkness I acknowledge mine": *The Tempest* and the discourse of colonialism', in Dollimore and Sinfield (eds.), *Political Shakespeare*, pp. 48–71 (48).

Colonial exchanges: visualizing racial ideology and labour in Britain and the West Indies

Roxann Wheeler

In *Other Tribes, Other Scribes: Symbolic Anthropology in the Comparative Study of Cultures, Histories, Religions, and Texts* (1982), James Boon observes that there were numerous reported encounters between Europeans and Others that never, in fact, happened. He contends that we cannot say that these writers simply lied or misrepresented what they saw. Rather, 'the explanation lies in the fact that cultures meet indirectly, according to conventional expectations of the cultures themselves'.[1] Boon refers to eyewitness accounts, but his point may be usefully extended to the encounters that were the staple of much eighteenth-century fiction, drama and poetry.

This essay explores one of the stranger occurrences in eighteenth-century literary and visual texts. In various versions of the most popular colonial stories, the identity of the Caribbean character inexplicably changes from Indian to African. In Boon's terms, Britons' conventional expectations about human variety did not always sharply distinguish Indians from black Africans, a phenomenon that persists into the nineteenth century. The exchangeability between Indians and Africans occurred in public performances, literary texts, advertisements and other illustrations. For example, the seventeenth-century London lord mayor pageants featured plays at inaugural celebrations, and they routinely included black actors. The livery company to which the incoming lord mayor belonged commissioned a dramatist or poet to write a libretto, complete with description of the scenes, speeches, and cast. Throughout this period, people of African descent were dressed as Indians, accessorized with feather headdresses and pipes of tobacco. Sometimes the black actors personated actual Indians, and sometimes they were dressed as Indians to represent allegorical figures or abstract ideas.[2] Contemporary tradecards also commonly superimposed Africans and Indians in tobacco advertisements, as is evident in pictures of Indians with dark bodies and short, curled hair, crowned with feathers, who are smoking tobacco.[3]

The scores of plays and pantomimes involving the Harlequin figure on the British stage also indicate the ease with which these two colonial figures were interchanged. Harlequin, a stock character from the Italian *commedia dell'arte*, was originally a wily, black-masked European servant given to disguise. On the eighteenth-century stage, this labile lackey figure with an attitude embraced both black Africans and Indian chiefs, as the titles of some of the popular Harlequin plays suggest: *Harlequin Cherokee, or, the Indian Chiefs in London* (1772); *The Choice of Harlequin, or, the Indian Chief* (1782); *Harlequin Mungo* (1788); and *A Description of Furibond, or, Harlequin Negro* (1807). The cross-fertilization apparent in the Harlequin figure has been ignored in much of the literature on Harlequin, though he has been claimed as a precursor to minstrelsy.[4] The early modern origin of Harlequin is sixteenth-century Italy, not colonial slavery, and it is more appropriate to view the Harlequin figure as mutable, incorporating various ethnographic types as well as fanciful figures, such as wizards and giants, even in the nineteenth century. While the Harlequinades and the London lord mayor pageants indicate a routine visual exchangeability of Africans and Indians at public spectacles, the two most popular manifestations of this phenomenon are undoubtedly the colonial-cum-urban legend of Inkle and Yarico, and Friday, the Caribbean Islander from Daniel Defoe's *Robinson Crusoe* (1719).

Cases of traded identity occur most memorably in these two apocryphal stories of the eighteenth century: the account of love betrayed into slavery entitled 'Inkle and Yarico', popularized in *Spectator* 11 (1711), and Daniel Defoe's *Robinson Crusoe*. Both of these popular tales take place in the Caribbean and feature the relationship between an Englishman and an obliging native islander, and both of these stories were tirelessly retold in a variety of genres and translated into other European languages.[5] Yarico and Friday are the most intriguing examples of the ease with which Indians and Negroes were, on occasion, exchangeable figures in literary and visual media.

Several twentieth-century literary studies call attention to the confusion that British writers evinced about whether Yarico was a Caribbean islander or an African maiden, and it is worth recapping the history of Yarico's various depictions to establish a primary explanation for the apparent slippage between two ethnographic types. In the versions of the story that pre-date *The Spectator*, and in *The Spectator* version itself, the female protagonist is undisputedly a native woman. Yarico is a plantation slave in the earliest versions, but in *Spectator* 11 she is initially a woman of distinguished rank whom the Inkle figure sells into slavery at the end of the story. The *Spectator* Yarico is an Indian from the main of America who rescues the young English businessman Inkle from death at the hands of her own countrymen.[6] Hiding him in a cave, Yarico falls in love with Inkle. Inkle promises Yarico a life of urban luxury in England, but when he is once again among Europeans, he betrays Yarico by selling her into Barbadian slavery to recoup the financial losses he accrued while absent from business. The two main characters became common types in British cultural references; for instance, in *Vindication of the Rights of*

Woman (1792), Mary Wollstonecraft lambasts parents who 'make an Inkle' out of a child.[7]

After 1711, Yarico fluctuates between African and Indian identities in various versions, and sometimes she is both Indian and African in the same poem. In the Countess of Hertford's poem of 1725, Yarico's people live on an island and they cannibalize the English, which are standard indications that she is an Indian. Nevertheless, she is called both a 'negroe virgin' and an 'Indian maid', a blurring of identities that Stephen Duck's 1736 rendition repeats. Duck elaborates this superimposition through the details of Yarico's appearance: she has a 'downy head', but it is crowned with feathers.[8] While 'downy' connotes fluffiness, almost all contemporary descriptions of Indians refer to their lank hair. Duck's racial confusion does not stop here; he makes Yarico an Indian, a Moor and a Negro in the same stanza. Literary historian Wylie Sypher explains the Moorish Yarico: English artists commonly dressed Negro characters in Islamic and Oriental dress in the seventeenth and eighteenth centuries, a practice that, he claims, ennobled Negroes and made them fit for domestic British consumption in the literature and painting of the day.[9] In the anonymous 1734 version, Yarico is simply a 'negroe' maiden, and in Edward Jerningham's 1766 more exotic rendering, Yarico, with 'jetty' complexion and 'woolly' hair, hails from the biblical Nubia, a location that conjures up early Christian converts.[10]

One compelling and obvious explanation for the repeated slippage between African and Indian concerns the generic usage of *Indian*. When eighteenth-century Britons called native people of present-day Africa, Australia and Papua New Guinea 'Indians' in novels, poems, or travel narratives, they did not really see Indians but a people primitive and savage in comparison to Europeans. The native of the Americas had already become the quintessential savage, and thus the erroneous geographic name connoted a range of meanings from 'simple' to 'uncivil'. That so many contemporary writers imagined Yarico as an Indian princess and/or as a Negro maid is not as contradictory as might appear at first glance since the same figure could be savage (Indian) royalty and a virginal Negro. Wylie Sypher claims that the confusion between Indian and Negro results not only from the generic nature of 'Indian', but also from the generic nature of 'Black', a British habit of reference encompassing people from parts of Asia, Africa and America.[11] Nomenclature alone, however, does not adequately elucidate the phenomenon of traded identities.

During the remainder of the century, Yarico is an Indian in some versions and an African in others. In George Colman's wildly popular 1787 operatic version of *Inkle and Yarico*, there is, arguably, the most creative mixture of circum-Atlantic fusion.[12] The copper-coloured, arrow-carrying Yarico is an Indian, but she inexplicably comes from a group of people other characters describe variously as 'black', 'savages', 'Negroes', and '[American] natives'. Furthermore, there is no explanation about why Yarico's Indian servant Wowski, who hails from the same tribe, has black-coloured skin, speaks in stereotypical black stage dialect, and appears as an African in the illustrations accompanying the textual versions (see

figure 1). Contemporary critics complained about the oddity of Wowski's puta-
tively Polish name but not the ethnic jambalaya surrounding her and Yarico's
appearance and linguistic differences.[13]

One explanation for the dissimilarity between Yarico and Wowski is that the ser-
vant Wowski is visibly and linguistically distinguished from the higher-ranked
Yarico for dramatic effect (she speaks a stage pidgin that Yarico does not). Elizabeth
Inchbald, one of the play's early editors, assumed that the author George Colman
was either careless or uninformed because there was an apparent mismatch between
Yarico and her setting. In 1808, Inchbald criticizes Colman for 'the scene at the com-
mencement of the opera, instead of
Africa, is placed in America'. Ignoring
Colman's indebtedness to Steele and
Ligon, Inchbald adds that he ought to
recall that 'slaves are imported from
Africa, and never from America'.[14] In
her mind, Yarico was undisputedly an
African because she was sold as a slave.
Even though Inchbald seems unaware
of the slave trade in Indians, it appears
in an offhand incident that reveals
Inkle's calculating nature: in an
American forest, Inkle wonders 'if so
many natives could be caught, how
much they might fetch at the West
Indian markets'?[15] This short line,
repeated twice, verifies that Indian
slavery had not been completely
expunged from larger cultural
memory by 1787. As I address later, the
slave trade in Indians is a little remem-
bered phenomenon, but it is vital to
understanding the substitution of an
African Yarico for an Indian one.

A strange counterpart to Yarico's
written transformation into an African
slave is her visual transformation into a
white, partially naked maiden. During
the same historical period, she is also
illustrated as a beautiful brown Indian
(see figure 2).[16] Clearly, Yarico was a
sentimental and sympathetic figure to
contemporary audiences as a white,
copper or black maiden. Frank

1 Robert Cruikshank and George Wilmot Bonner,
'Come let us dance & sing', engraving; from George
Colman, 'Inkle and Yarico', in *Cumberland's British
Theatre*, vol. 16 (London, 1827).

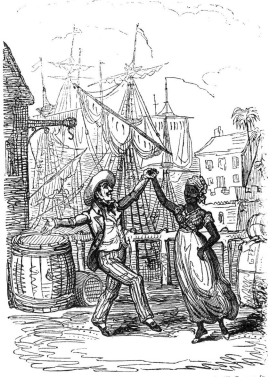

R. *Cruikshank. Del.* G. *W. Bonner, Sc*

Inkle and Yarico.

Trudge	Come let us dance and sing,
and	While all Barbadoes bells shall ring :
Wowski	Love scrapes the fiddle string,
	And Venus plays the lute.

Act III. Scene 3.

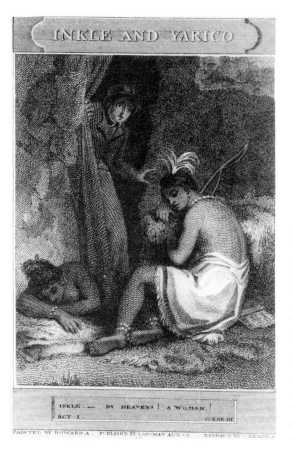

INKLE AND YARICO

INKLE.—— BY HEAVENS ! A WOMAN !
ACT . I . SCENE III.

PAINTED BY HOWARD.A . PUBLISH'D BY LONGMAN AND CO ENGRAV'D BY J HEATH.A

2 A. Howard, engr. J. Heath, 'By Heavens! A
Woman!', engraving; from George Colman, 'Inkle
and Yarico', in *Inchbald's British Theatre*, vol. 20
(London, 1808).

Felsenstein's *English Trader, Indian Maid* (1999) reprints the major versions of 'Inkle and Yarico'; the book cover repeats the eighteenth-century tendency to rewrite Yarico as black: underneath the book's title is an engraving showing a Negro Wowski. The volatility of Yarico's written and visual representation also occurs in one of the most popular novels of the century.

Daniel Defoe's Friday is the case *par excellence* of traded identity. Given the vast amount of critical attention to *Robinson Crusoe*, it is surprising that Friday's mutable appearance has garnered little commentary.[17] As in early eighteenth-century depictions of Yarico's origins, the novel is adamant that Friday is a native islander. *Robinson Crusoe* offers myriad affirmations that the main character is in the Caribbean and that Friday comes from a Carib tribe. The most obvious clue that Friday is a native islander occurs when the novel describes him as a long-haired, olive-coloured Indian:

He was a comely handsome fellow, perfectly well made; with straight strong limbs, not too large; tall and well shaped … twenty six years of age. He had a very good countenance, not a fierce and surly aspect; but seemed to have something very manly in his face, and yet he had all the sweetness and softness of an European in his countenance too, especially when he smiled. His hair was long and black, not curled like wool; his forehead very high and large, and a great vivacity and sparkling sharpness in his eyes. The colour of his skin was not quite black, but very tawny; and yet not of an ugly yellow nauseous tawny, as the Brasilians, and Virginians, and other natives of America are; but of a bright kind of a dun olive colour, that had in it something very agreeable, tho' not very easy to describe. His face was round and plump; his nose small, not flat like the negroes, a very good mouth, thin lips, and his fine teeth well set, and white as ivory.[18]

To eighteenth-century Britons, Crusoe's detailed observation of Friday carries positive connotations, including his seeing European features in Friday's visage. Crusoe's physical description of Friday distinguishes him from a stereotypical

Negro after the fashion of racial taxonomies. Notably, Crusoe also differentiates Friday from a stereotypical cannibal in terms of attitude and skin colour. What we have here is, in James Boon's terms, an encounter that could never have taken place. The historian Philip Boucher contends that this idealized portrait of Friday is a physically flattering picture by European standards. According to Carib custom, Friday would have likely had ear and lip plugs, a flattened forehead and nose, as well as facial scarification and red paint.[19] Crusoe's hybrid physical description embraces Friday's multiple narrative roles: he is alternately Crusoe's labouring slave, willing servant, affectionate companion, as well as fellow Christian. Like Colman's Yarico, Friday is visibly packaged to elicit contemporary sympathy and to minimize the extent of his cultural and physical variation from a European norm.

Since the novel defines Friday's delicate features and beautiful colour so precisely, the first illustration of Friday as a Negro is surprising. In the 1720 frontispiece to *Serious Reflections of Robinson Crusoe*, the third and final volume of the novel, Friday and the Caribees have black bodies and short, curly hair.[20] Beginning his illustrated life as a black man, Friday is physically undifferentiated from the other savages, but he is dressed like Crusoe (see figure 3). Indeed, this was not solely a visual phenomenon since several abridged versions of *Robinson Crusoe* that appeared in the eighteenth century assign Friday a pidgin speech most characteristic of black servants appearing on the stage – like Wowski, or Mungo from Isaac Bickerstaff's

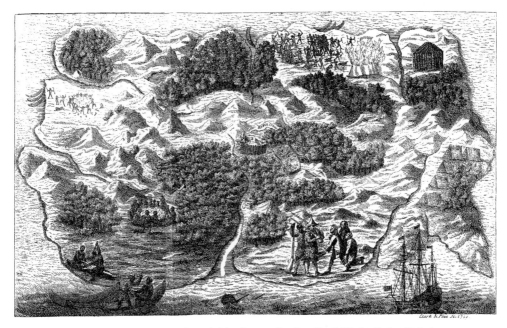

3 Clark and John Pine, 'Map of Robinson Crusoe's island', engraving; from Daniel Defoe, *Serious Reflections during the Life and Surprising Adventures of Robinson Crusoe* (London, 1720).

The Padlock (1768). By the 1780s, however, the illustrated Friday is an idealized Caribbean Indian, which reflects the novel's description more closely.

Friday usually appears in the later eighteenth century without other background cannibals and is almost always shown naked with long hair, though his colouring fluctuates. In the frontispiece to a 1785 edition of the novel, Friday is a brown but otherwise Europeanized Indian. Naked, he crouches in submission to the clothed and armed Crusoe. Similarly, in the frontispiece to a 1790 edition of the novel, 'Robinson Crusoe rescuing and protecting Friday', Friday is a naked, brown, noble savage (see figure 4). Another version of Friday as an idealized Caribbean Indian occurs in a 1790 illustration 'Robinson Crusoe first sees and rescues his man Friday', but in this example, Friday is a light-complected Grecian type (see figure 5). The birth of an Indian Friday in the illustrations of the 1780s is perfectly in keeping with a generally greater attention to human typology detectable in natural history, and adaptations of the novel also reveal a greater interest in making Friday seem more like an Indian. For instance, in Joachim Heinrich Campe's *The New Robinson Crusoe* (1792), Crusoe regards Friday as a friend, not a slave, and the description of Friday, though shortened, adds some accessories to authenticate his native origins: 'In his ears he wore various feathers and shells, an ornament on which he seemed to lay no small value'.[21]

Notably, Friday's illustrated history in the nineteenth century continues to seesaw between his being depicted as an African and an Indian.[22] Even in the twentieth century, some critics, such as J. M. Coetzee and Toni Morrison, have transformed Friday into an African to make a political point.[23] In general, Defoe's novel emphasizes Friday's resemblance to Europeans, but the illustrations and subsequent rewritings feature his proximity either to naked Indians or to black Africans. The novel and its illustrations promoted different colonial stories and intensified confusion

4 Charles Ansell, engr. Barlow, 'Robinson Crusoe rescuing & protecting Friday', engraving; from Daniel Defoe, *Robinson Crusoe* (London, William Lane, 1790).

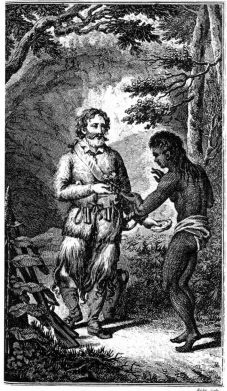

ROBINSON CRUSOE
Rescuing & Protecting Friday.

Published as the Act directs June 10 1790, by William Lane, Leadenhall Street.

about cannibals, Indians, and African slaves.

Both literary and art historians have noted the substitution of Africans for Indians. Benjamin Bissell, Wylie Sypher, and Hugh Honour account for this exchange-ability by the influence of European politics and literary traditions, such as the noble savage motif and the *chansons de geste*. The *chansons de geste*, a European genre born of the Crusades, recounts the deeds of Christian knights clashing with the Moors. In the sixteenth century, the transposition from the context of Spaniards defeating darker-skinned Moors to Spaniards subduing black Indians is due to the coincidence of the expulsion of the Moors from Spain and Columbus's discovery of America in the 1490s. Religious and political energy, Honour convincingly argues, was transferred from one situation to another and so were the images; this process helps to explain the black Indians in some sixteenth-century paintings, but it is elsewhere that we must look for the particular transformation of Indians into Negroes.[24]

Scholars have long noted that Britons frequently confused Africans

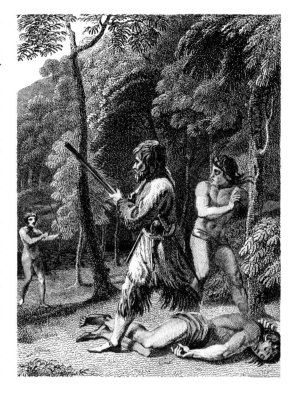

5 Thomas Stothard, engr. Thomas Medland, 'Robinson Crusoe first sees and rescues his man Friday', engraving; from Daniel Defoe, *Robinson Crusoe* (London, John Stockdale, 1790).

and Indians because of the noble savage tradition that embraced Native Americans, Pacific Islanders, and Africans. The generic nature of savagery thus resulted in a visual and discursive exchangeability of black Africans and native Islanders: 'Since the noble Negro [of eighteenth-century literature] is only one incarnation of noble savagery, he shares with the South Sea Islander and the American Indian many of his talents and features. Indeed, many anti-slavery writers evidently did not distinguish the noble Negro from the noble Indian'. Adding that traded identities also stem from a cultural toleration for contradiction, Sypher suggests that Britons were able to accommodate simultaneously both a fantasy version and other, more realistic depictions of Africans out of a cultural will to believe in the noble Negro despite evidence to the contrary.[25]

Peter Hulme provides one of the most insightful interpretations of the literary conventions governing the association between the Indian Yarico and Africa in *Colonial Encounters* (1986). Arguing that the *Aeneid* is a structuring reference for the themes of native hospitality and European betrayal, and that North Africa (Carthage) is a suppressed but significant corresponding location to the West Indies, Hulme provides cogent evidence for the connection of Dido and Aeneas to subsequent colonial encounters.[26] Furthermore, Hulme claims that Barbados is the terminal point for all versions of 'Inkle and Yarico' because 'alone of the English sugar islands, it had no native population at the time of English settlement'.[27] According to Hulme, the Barbadian setting for Inkle and Yarico's story evinces a cultural desire to erase the violent English settlement of Carib lands. The first and most intensely cultivated island, Barbados initially imported the greatest number of African slaves; this preferred location for colonial encounters also explains the ease by which Yarico (or Friday) can be turned into a Negro slave figure.

Another important factor influencing the propensity to substitute Africans and Indians is the signification of skin colour. Early modern artists did not always distinguish between Europeans and either Indians or Africans in terms of skin colour or other obvious ethnographic details; this practice affects the depiction of Yarico, Friday and other native people. One explanation for the Europeanized illustrations (and textual details) of Yarico and Friday derives from the model of the human figure adopted by artists. Hugh Honour claims that there were white Indians in early modern illustrations because the available visual model for naked people was Greek and Roman statuary.[28] For example, Theodore de Bry's famous sixteenth-century illustrations of Americans, which were frequently copied and reprinted in ensuing centuries, meant that this practice 'very widely diffused the idea that America was peopled by a race barely distinguishable, physically, from the ancient Greeks'.[29] This way of picturing American men as naked, beardless versions of Europeans helped foster a sense of visual resemblance between the two groups; the lack of clothing or the brandishing of a human limb was crucial to signifying the differences central to the painting or illustration. Native people of the Americas were commonly depicted as naked or in antic postures, but not always as having a colour distinct from Europeans.

The influence of classical models on the depiction of Africans has provoked some critics to wonder about skin colour as an important mark of racial difference. Typical of the bemusement toward early modern artistic practice is Hans-Joachim Kunst's complaint in *The African in European Art* (1967) that the African figures frequently fail to be distinguished adequately from the European ones:

> However, earnestly as he [the European artist] tries to convey convincingly the characteristic features of the individual races, we cannot help feeling that he merely applied these features as personal attributes to set models of the human figure in traditional poses, such as he might have found among Italian painters. For instance, the African, depicted naked and from behind, is standing strictly in accordance with the classical laws of counterpoise. ... It requires little imagination to visualize [Hans]

Burgkmair [(1473–1531)] drawing his African according to a classical copy-book model and then equipping him with armrings and spear and other attributes of a foreign and less sophisticated race.

He goes on to cite the racial confusion that I am analysing, something he cannot reconcile with the genius of the artist:

> Moreover, however conscientiously Burgkmair may have followed the descriptions he was given in providing his exotic tribes with individual features and characteristics, it is very suspicious that these features are the same as those currently attributed to 'wild men' and other denizens of the world of fantasy at that time. This shows that the African was looked upon as belonging to a world beyond that of reality.[30]

While Kunst attributes this failure to record reality to the artist's indebtedness to classical ideas, I believe, in addition, that it is precisely to racial ideology that we must look to explain this phenomenon. The use of Greek models reflects the assumption that skin colour and spears, for instance, are add-ons which, in turn, suggests that Europeans perceived humans as physically similar.

Dark skin colour was optional in visual depiction of black slaves and savage Indians, but nakedness was absolutely crucial in denoting them. Art historians explain that in the fourteenth through sixteenth centuries, the influential Portuguese accounts of African voyages feature nudity as the most distinctive characteristic of the societies newly discovered by Europeans, a phenomenon reflected in colonial illustrations: 'Neither Islam nor central Asia had presented such a divergence from Western mores'.[31] An example of nudity standing in for a host of differences occurs in Theodore de Bry's 'Spanish treatment of fugitive black slaves' (see figure 6). The white colour of the Spaniards and slaves is the same; naked

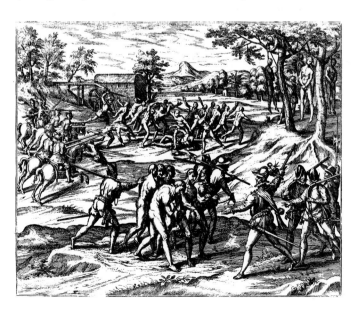

6 Theodore de Bry, 'Spanish treatment of fugitive black slaves', engraving; from *Grands Voyages* (Frankfurt-am-Mayn, 1585), pr. 5.

bodies and manacles denote black slaves.[32] The sensibility that perceives scanty clothing as more indicative of significant difference than skin colour manifests itself throughout the eighteenth century. I contend that non-civil status persists in being more important to a conception of race than skin colour in Britain certainly, and even, arguably, in the West Indies, for some time.

That skin colour and savagery do not correspond in any simple way, even in the eighteenth century, is captured in the frontispiece to the extremely popular *Collection of Voyages and Travels ... Compiled from the Library of the Late Earl of Oxford* (1745). 'A description of the habits of most countries in the world' purports to be a taxonomy of civil and savage societies, represented by heterosexual couples, and it shows the most typical expression of British interest in other people of the time period – in the variety of dress and its indication of local manners (see figure 7). The top row shows various Asiatics, the second line represents northern Europeans, and then the scheme of four lines of people representing the variety on each of the four continents breaks down. In lines three and four, Spaniards, Moors, and Scottish Highlanders appear with the societies Britons considered the least civil. Partial nudity links white Americans and black Africans, but the Hottentots and Negroes are singled out as the only non-white people. The details of dress, background flourishes of civilization or nature, and even posture signify global variation more surely than attention to complexion. The persistent failure to associate Indians with dark-coloured skin in a variety of documents and illustrations before the 1770s makes the exchangeability between Americans and Negroes seem even more mysterious.

These literary and aesthetic explanations offer much in the way of mythic structures and generic conventions that illuminate the flexibility with which Europeans approached the depiction of colour, ethnic origins, or the location of specific populations. They are incomplete, however, without a fuller exploration of eighteenth-century racial ideology and colonial labour practices. The rest of this essay analyses these historical phenomena to elucidate more fully the periodic Negroization of native Caribbean literary characters.

A primary factor explaining the apparent carelessness with which Britons could translate Indians into Africans is the fact that when most Britons referred to skin colour or human variety in general, they did not yet conceive them as deep or rigid constructs. Stories frequently told in eighteenth-century documents testify to a superficial notion of human variation. Among the most popular anecdotes was the susceptibility of noses, head shape, and skin colour to environmental changes and to human manipulation. Many Europeans believed that black Africans and native Americans had wide nostrils because as children, they were carried on their mothers' backs; the constant rubbing of the infant's nose against the mother's back flattened the nose's 'natural' shape. Another type of commonly told tale involved colour mismatches between parents and their children. Many physicians observed that American and African newborns had reddish but light-coloured skin, like Europeans, and that they became darker gradually with exposure to the air – over a period of days, weeks, months, and even years.[33]

As these beliefs suggest, then, the observed fluidity of skin colour made it an unpredictable indicator of identity throughout the eighteenth century. British attempts to describe and represent the indigenous people of the Caribbean and Americas highlight the imprecise way that Britons perceived complexion. Indians appear as copper, tawny, white, and black in written texts and in illustrations. Some Europeans believed Indians who appeared to be have darker complexions were really white because they were only artificially coloured by ointments, dirt and the like.[34] Even for the majority of Britons who thought that climate influenced physical appearance and who thus held that exposure to the sun and other natural elements made skin darker, Indians were perceived to be quite similar in colouring to the Portuguese, Spaniards and Italians. Their precise colour was never as important to

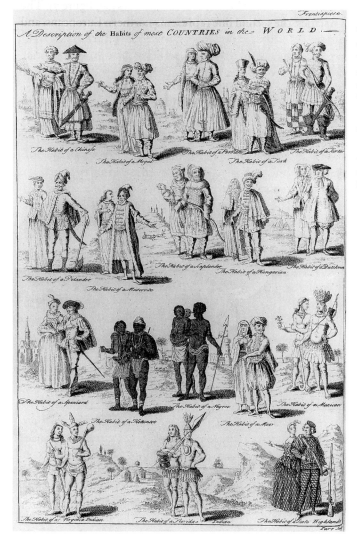

7 Nathaniel Parr, engr., 'A description of the habits of most countries in the world', engraving; from T. Osbourne, *A Collection of Voyages and Travels ... Compiled from the Library of the Late Earl of Oxford* (London, 1745).

Europeans as their scanty clothing, simple living conditions, oral culture or religious practices.

It was commonly believed that exposure to civil manners and a different climate could produce startling changes in countenance and bearing. In *An Essay on the Causes of the Variety of Complexion and Figure in the Human Species* (1787), Samuel Stanhope Smith provides the example of a fifteen-year-old Indian attending the College of New Jersey. Because of his exposure to Anglo-Americans and to intellectual study, this young man was gradually acquiring 'the agreeable expression of civil life'.[35] Smith observes that his facial features had softened to reflect more civilized emotions and ideas and that his colour had even lightened considerably. These stories, which were the staple of contemporary scientific enquiry, attest to a superficial conception of skin colour and to the way that cultural habits were believed to shape appearance. As Oliver Goldsmith put it, demonstrating ethnocentric optimism at its best, 'all those changes which the African, the Asiatic, or the American undergo, are but accidental deformities, which a kinder climate, better nourishment, or more civilized manners, would, in a course of centuries, very probably remove'.[36]

Most writers maintained that merely artificial differences distinguished black Africans from Europeans. Several natural historians observed, as Buffon did, that 'in a succession of generations, a white people transported from the north to the Equator, would undergo this change [to blackness], especially if they adopted the manners, and used the food, of the new country'.[37] It was commonly reckoned that it would take about ten generations for Englishmen in the torrid zone to turn into Negroes or for Negroes in England to turn into northern Europeans. Even when some writers boldly declared that climate could not be responsible for the variety of skin colours, they usually looked to other external factors, such as mode of government, to explain a people's nature or complexion.

What accounted for such an elastic concept of complexion? Most Britons regarded physical distinctions as superficial and changeable, but they treated culture and government as endemic to a people's character. In cultural terms, particularly in scientific inquiry, a focus on the body's surface was relatively recent in the eighteenth century. Most Europeans had a holistic view of the body and environment, believing that physical appearance resulted from the influence of climate and diet, and even from one's class position. Moreover, bodies were perceived as far more changeable over a lifetime and even on a daily basis than our own fairly rigid and anatomical notion of bodies today. To Britons, civil distinctions of language, government, clothing, customs and, most particularly, religion made one set of people distinct from others in ways far more profound than skin colour. In addition to climate and institutional factors, Britons had a vague sense that long-term racial intermixture changed people's appearance and character, but they did not yet have a vocabulary to discuss this in biological or genetic terms. Even the extensive late eighteenth-century colonial literature mentioning mulattoes suggests that while these people gave rise to discussions of heredity and race much more than any other

group, their appearance and behaviour were most frequently discussed in terms of the power structures of slave society.[38]

If the various versions of 'Inkle and Yarico' and *Robinson Crusoe* demonstrate that the Caribs' relation to Africans and Europeans was not firmly established in representational practice, then racial taxonomies show that it was not well established in the budding science of natural history either. The taxonomy was a method of organizing the natural world that assumed its recognizably modern form during the late eighteenth century.[39] Most taxonomies were preoccupied with plants and animals, but classificatory systems that included humans appeared with greater frequency after 1770. The increasing attention to people did not, however, signal a unified view of what constituted salient human differences: among natural historians, there was not only considerable disagreement about how many varieties of the human race there were, but also which criteria should be used to distinguish among them.

American Indians were one of the most difficult groups for Europeans to place because the colour of their skin was subject to considerable debate as was their nature. Their place in taxonomies fluctuated accordingly. Based on their perceived physical resemblance to Europeans, Indians began their classificatory life in the same category with Europeans, which is evident in François Bernier's 'A New Division of the Earth, According to the Different Species or Races of Men Who Inhabit It' (1684). In one of the first modern taxonomies based on physical appearance, Bernier included American Indians with Europeans in a group that also embraced the people of North Africa, Thailand, and the northern inhabitants of East India.[40] Similarly, Richard Bradley speculated in *A Philosophical Account of the Works of Nature* (1721) that among the globe's inhabitants, Indians were most similar to Europeans. His classification is typical of the trend toward broad and idiosyncratic divisions before Buffon's *Natural History, General and Particular* (1749). In the very short section on humans, Bradley imagined the world divided into two kinds of white men (with and without beards), two kinds of black men (with curly hair and with straight hair), and the intermediate category of mulattoes. Indians occupied the category of white men without beards.

By the mid-eighteenth century, this view of Americans had largely changed, and they were separated from Europeans in most classifications.[41] Linnaeus's famous tenth-edition explication of Homo Sapiens in *A General System of Nature* (1758) makes Americans one of four kinds of humans. Linnaeus's description resembles the narrative vision of Friday in *Robinson Crusoe*: Americans were copper-coloured with straight black hair and wide nostrils, and their stature was nobly erect; they were stubborn and regulated by customs rather than laws, but they were content and free. This treatment of Indians amply developed the bare mention of people in the first edition (1735), which simply distinguished humans by four colours.

When Oliver Goldsmith penned his enormously popular *An History of the Earth and Animated Nature* (1774), he described six varieties of humans distinguished by their single most important characteristic: skin colour. In discarding

Buffon's claim that stature was as important as complexion, Goldsmith ushered in
an era of racial classification with which we still grapple today. Even though
Goldsmith privileged the colour of bodies, he continued the precedent set by
Linnaeus and Buffon of comparing people based on stature and temperament, not
to mention cultural achievement; and, like Buffon, he organized his descriptions
of people based on geographical location. Tellingly, Goldsmith sandwiches the
description of Americans between Negroes and Europeans, viewing them as dis-
tinct in colour, manners, and behaviour from other populations; he finds little
variation among Indians themselves, claiming that savage appearance and man-
ners are uniform.[42] Excluding illustrations of Europeans or East Indians, whom
Goldsmith claimed were most similar to each other, the first British edition fea-
tures single illustrations of an American, African, Laplander, and Asiatic next to
the relevant textual sections. The first American edition, however, has a fron-
tispiece of the major human varieties, which includes an American, two types of
Africans, a Laplander, and an Asiatic (see figure 8). The increasing tendency to
specify visible, bodily distinctions, typical of the most popular eighteenth-century
taxonomies, no doubt largely contributed to Friday's being illustrated as a recog-
nizable Indian in the 1780s.

The emergence of a new dominant racial ideology in natural history is captured
in the contrast between the treatment of human beings in the first and second edi-
tions of *The Encyclopaedia Britannica*. Indians and Africans are at first singled out
as the only coloured people and latterly as the two populations most intimately
connected on the American continent. In the 1771 first edition, the world's

8 'American, Negro, Hottentot, Laplander, Chinese', engraving; from Oliver Goldsmith, *An History of the
Earth and Animated Nature* (Philadelphia, 1795).

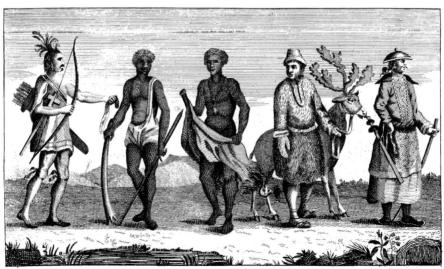

AMERICAN. NEGRO. HOTTENTOT. LAPLANDER. CHINESE.

inhabitants are barely mentioned, except for a brief and neutral reference to the skin colour of native Americans and of Negroes under the entries for *America* and *Africa*. Neither Europe nor Asia warranted reference to the skin colour of their inhabitants.

In the second edition (1781), there is an explosion of information about human typology, and there is a very revealing arrangement of the material that has bearing on the tendency to confound Africans and Indians. At the conclusion to *Negroes*, which was virtually the same in 1771 and 1781, there is a cross-reference to *America* and to *Colour of the Human Species*. The revamped 1781 entry for *America* devotes ample space to the native inhabitants and reflects a keener interest in their skin colour and character than ten years before. Appearing for the first time in 1781, *Colour of the Human Species* confirms that skin colour is indeed the most important feature distinguishing among humans, but that it is, nonetheless, merely a superficial characteristic. The entry concludes that no difference in complexion, stature or disposition signals any conclusive evidence about a group's basic humanity. Nevertheless, the cross-references that link *Negroes*, *America* and *Colour of the Human Species* suggest that black Africans, Indians, and non-white skin colour are intimately connected in the British cultural imagination in a way not extended to other groups.

The silent term linking these new world people to the land is, of course, *slave*. Forced labour and deracination connect Africans and Indians and help account for the British tendency to substitute one population for the other in visual and written representation. Possibly the most cogent reason for the visual exchangeability of Africans and Caribbean Islanders was labour-hungry planters who enslaved both groups. This practice involved temporary and hereditary enslavement as well as the transportation of captive people between colonies. As David Eltis reminds us, there were several kinds of slavery in the various parts of the empire. In British North America, the Caribbean and Brazil, Africans became the more significant labour force during the mid- to late seventeenth century, but they never entirely replaced a simultaneous enslavement of Indians; the French Canadians retained Indian slaves throughout this period, apparently because of the prohibitive cost of African slaves.[43]

Europeans often considered Indians and Africans indistinguishable as a labour force.[44] It was common for North American colonists to ship Indian slaves – either captured or sold to them by their enemies – to the West Indies where they were exchanged for African slaves who had no local compatriots to challenge their plight.[45] The slave trade in Indians to other North American colonies and to the Caribbean forestalled rebellion and lesser forms of resistance, such as running away, and it helped to secure the political dominance of Europeans in some key areas.[46] This exchange policy held true for New England as well as Virginia and South Carolina. One historian records that tens of thousands of indigenous Americans had been shipped to Barbados and other West Indian colonies by the early eighteenth century.[47]

Throughout the early colonial period, West Indian landowners imported Indians from Central and South America as well as North America. In the decade after 1712, there was a significant traffic in Indian slaves of various origins in the Caribbean: 'the British purchased more than 2,000 Catholic Indian and 'mestizo' slaves from the Miskito Indians of Nicaragua and other slaves were purchased from Indians in Darian (Panama). In the period 1674–1701, 51 out of 600 estates in Jamaica included Indian servants or slaves'.[48] Thus, when Friday and Yarico hit the British literary scene in their most popular forms, there had recently been considerable trade in Indian slaves. The ongoing exchange of one set of Indian bodies for another and of Indians for Africans was part of a European effort to secure a large and docile labour force necessary for monoculture crops, such as sugar in the West Indies.

Another indication that Africans and Indians were, at some level, undifferentiated as labour units occurs in seventeenth-century Barbadian law. It was customary for indentured Christian Europeans to serve four years and then be given a previously agreed upon sum of money or equivalent goods to establish themselves as free; but 'the Negros and Indians (of which latter there are but few here [Barbados]) they and their generation are Slaves to their owners to perpetuity'.[49] That Yarico and Friday were first envisioned as natives rather than Africans corresponds to the earliest European labour practices in the Caribbean, in which landowners purchased labour power however they could get it.

As David Galenson notes about the labour supply in English America, 'after 1730 the supply of Amerind slaves fell off'.[50] Thus, Yarico and Friday represented part of the slave trade that shaped the Atlantic world of the seventeenth century and beyond, but one that was superseded in numbers by Africans once there was a turn to a single-crop profit system of sugar plantation. The cultural and sexual crossings that resulted from this exchange of labour force – of moving Indian bodies from South, Central and North America to the West Indies and vice versa – makes for a seventeenth- and eighteenth-century world far more mixed (up) than we generally concede.

Because of the large number of slaves vital to profitable sugar production, the Caribbean colonies were the ones Britons most closely associated with slavery, and the Yarico and Friday figures embrace the histories of both enslaved people. From the 1660s onward, African slaves outnumbered Englishmen on most islands. At this time, the category of *slave* begins undergoing dramatic changes: slavery became more customarily permanent and hereditary in the latter seventeenth century, a condition that signified abject difference from free Britons and that was a real as well as ideological force. These historical changes afford some insight into Friday's and Yarico's transformation in the early illustrations and cultural memory. Even though colonists enslaved both Indians and Africans, by the publication of *Robinson Crusoe* (1719), *slave* was a condition most particularly associated with Africans in the Caribbean, partly because most Indians were still considered members of sovereign tribes and partly because their enslavement was never as visible to

Britons.[51] In *Colonial Encounters*, Peter Hulme accounts for the persistent connection of Friday and black Africans. Crusoe's relationship to Friday, he argues, functions as 'a veiled and disavowed reference to the more pressing issue of black slavery'.[52] Thus, confusion between Caribees and Africans arises because Indians are the focus of the novel when Africans had become the most significant labouring population in the Atlantic world. Similarly, Yarico's transformation from Indian to African first occurs in the 1720s, a decade in which the African slave trade increases enormously over previous time periods and stabilizes considerably.

Most readers remember Friday and Yarico as slaves, and thus they recall them as having black complexions. Black skin colour and slavery was an association that was cemented in the British colonies only during the late seventeenth century by custom and in the 1740s by Jamaican law. By then, Caribbean Indians were no longer considered candidates for enslavement. The ubiquitous automatic connection between black complexion and slavery occurred somewhat later in Britain. As several literary historians note, Colman's revival of *Inkle and Yarico* coincided with the first wave of widespread public interest in abolishing the African slave trade in the late 1780s.[53] According to the play's prologue and other hints, the actress who played Wowski, and likely Yarico too, blacked her face for performance.[54] Consequently, it seems, Yarico was mostly remembered as a black character, which is evident in offhand references to her in a variety of late eighteenth-century documents. For example, Charles Macpherson recounts being persuaded that he was temperamentally unsuited to make his fortune in the Guinea slave trade. At a family friend's instruction, he reads *The Spectator* 'Inkle and Yarico' aloud, in which Yarico was undisputedly an Indian. He reports the conversation: '"And is it by such lessens and examples as these, Madam, that you would have me better my fortune?" – And why not, Charles? said I, forcing a laugh to conceal my emotions; Yarico was a different colour; and blacks, you know, are bought and sold in Africa and the West Indies like horses and oxen. After a pause, he sighed, and, in the most emphatic manner said, "Yes; and it is there, it seems I am to make my fortune!"'[55] One irony that confirms the racial confusion Yarico generates is that Macpherson declines to join the African slave trade following his appropriately sentimental reaction to 'Inkle and Yarico', but he inexplicably decides to go to St Christopher's instead to make his fortune.

The overdetermination of the category *slave* is not the only explanation for a Negroized Indian. Indian and African resistance to European domination may also account for the slippage. The movement of bodies from Europe and Africa to the Americas and between the Americas and the Caribbean gave rise to many blended identities. This hybridity is nowhere more evident than in the people who were known throughout Europe as the Black Caribs. Several slave shipwrecks between the sixteenth and eighteenth centuries resulted in the Carib Indians assimilating the survivors, especially on the island of St Vincent.[56] Other African fugitives lived in a neighbouring nation of Maroons. On St Vincent alone, there were about 4,000 Black Caribs at the end of the seventeenth century and possibly double that a century

later.[57] According to Hilary Beckles, 'the main obstacle to Barbadian expansionism in the Windwards was the Carib's militant anticolonial stance'.[58] Despite the fact that Black Caribs spoke the same language as their Yellow Carib compatriots, adopted their cultural practices, and did not distinguish themselves by colour or interests, Europeans persisted in dividing the two populations into native Yellow Caribs and the more sinister Black Caribs; in fact, they occasionally referred to Black Caribees as 'Negroes' or 'Blacks'.[59] The confusion about Caribs and Africans did not, then, result solely from British colonial policy of substituting an imported labour force of Africans for the indigenous one. It resulted both from European political motives and from a blended identity arising from maroonage and other forms of resistance to European assimilation.[60]

These colonial conditions as well as British racial ideology urge the conclusion that the representation of racial difference was not stable in eighteenth-century culture despite the reality of British domination of the slave trade and the Caribbean region. Many contemporary texts point to a cultural uncertainty about what constitutes significant difference among humans. British concepts of subordination and saleability seem to overwrite the racial representation of the native islanders Friday and Yarico at various points in the eighteenth and nineteenth centuries. The exchanges, contradictions and downright carelessness in Britons' references to New World Others are all cogent evidence for not seeing race and slavery or race and colonialism as always coherently linked at this time. The cases of traded identities that I have examined indicate that there are severe limitations to the assumption that there is a coherent economy of colour in Britain. Studying these persistent yet underexplained eighteenth-century phenomena suggests that we have only begun to recover historical variations in the intensity of racial ideology and colonialism.[61]

Notes

The NEH and John Carter Brown Library generously funded the research for this essay. Susan Danforth, Jim Egan, and especially Dian Kriz have all offered valuable suggestions for revision.

1 James Boon, *Other Tribes, Other Scribes: Symbolic Anthropology in the Comparative Study of Cultures, Histories, Religions, and Texts* (Cambridge, Cambridge University Press, 1982), p. ix.

2 Peter Fryer, *Staying Power: The History of Black People in Britain* (London, Pluto Press, 1984), pp. 26–30.

3 David Dabydeen, *Hogarth's Blacks: Images of Blacks in Eighteenth-Century English Art* (Athens, University of Georgia Press, 1987), pp. 86–7, 95 includes tobacco tradecards with Negroized Indians.

4 Henry Louis Gates, Jr contends that the Harlequin figure is, at heart, a slave figure, but this manifestation of Harlequin was one of many at the time. See *Figures in Black: Words, Signs, and the 'Racial' Self* (Oxford, Oxford University Press, 1987), pp. 51–2 and the illustrations following p. 58. A more historically precise rendition of this point

is Brander Matthews' claim in *A Book About the Theater* (New York, Charles Scribner's Sons, 1916), that the Italian comedy of masks and Negro minstrelsy have 'many points of resemblance' (p. 225). According to John O'Brien, 'Harlequin Britain: eighteenth-century pantomime and the cultural location of entertainment(s)', *Theatre Journal*, 50:4 (1998), 489–510, the overall cultural work that Harlequin performed on the eighteenth-century British stage was to help define Britishness by negation (p. 508).

5 For an excellent interpretation of the ties that bind these two stories, see Peter Hulme, *Colonial Encounters: Europe and the Native Caribbean, 1492–1797* (London, Methuen, 1986), chapters 5 and 6, especially p. 258.

6 The *Spectator* version cites Richard Ligon, *A True and Exact History of the Island of Barbadoes* (London, 1673) as the original; another possibility is Jean Mocquet, *Travels and Voyages into Africa, Asia, America, the East and West Indies*, trans. Nathaniel Pullen (London, 1696 [1617]). Frank Felsenstein includes various versions of the story in *English Trader, Indian Maid: Representing Gender, Race, and Slavery in the New World. An Inkle and Yarico Reader* (Baltimore, Johns Hopkins University Press, 1999). Felsenstein's introduction features the exchangeability between African and Indian Yarico but does not explore the historical explanations of it (15–19). There is at least one other version that he does not include, which may be found in John Oldmixon, *The British Empire in America*, 2 vols. (London, John Nicholson *et al.*, 1708). Oldmixon's rendition is faithful to Ligon, but he rearranges some details to lend greater coherence to the events of the tale. Previous literary scholars have mentioned the racial confusion in the Inkle and Yarico story: Benjamin Bissell, *The American Indian in English Literature of the Eighteenth Century* (New Haven, Yale University Press, 1925), p. 139; Hoxie Neale Fairchild, *The Noble Savage: A Study in Romantic Naturalism* (New York, Columbia University Press, 1928), p. 81; Lawrence Marsden Price, *The Inkle and Yarico Album* (Berkeley, University of California Press, 1937), pp. 10, 18.

7 Mary Wollstonecraft, *Political Writings*, ed. Janet Todd (Toronto, University of Toronto Press, 1993), p. 193.

8 Felsenstein, *English Trader, Indian Maid*, pp. 91, 93 and 130, respectively.

9 Wylie Sypher, *Guinea's Captive Kings: British Anti-Slavery Literature of the Eighteenth Century* (New York, Octagon Books, 1969 [1942]), pp. 26, 247.

10 Felsenstein, *English Trader, Indian Maid*, pp. 103, 158 and 161, respectively.

11 Sypher, *Guinea's Captive Kings*, p. 106.

12 Felsenstein, *English Trader, Indian Maid*, records that Colman's *Inkle and Yarico* 'was unquestionably the most popular English comic opera of the late eighteenth century, and with the exception of Richard Brinsley Sheridan's *School for Scandal* (1777), the most widely performed new play on the London stage during the last quarter of the century' (p. 167).

13 The anonymous *Critical Review*, 64 (1787) comments on the oddity of giving Wowski 'an American girl, ... a Polish name, and ... in one of the songs, ... a Polish lover'. *The Monthly Review*, 77 (1787) also notes that 'the Polish denominations of Wowski, and Pownatowski, are ... very flagrant mistakes' (Felsenstein, *English Trader, Indian Maid*, p. 191).

14 Felsenstein, *English Trader, Indian Maid*, pp. 18 and 19.

15 Felsenstein, *English Trader, Indian Maid*, p. 177.

16 For illustrations of Yaricos with white and brown complexions, see Price, *The Inkle and Yarico Album* and Felsenstein, *English Trader, Indian Maid*.

17 See my treatment of Friday in *The Complexion of Race: Categories of Difference in Eighteenth-Century British Culture* (Philadelphia, University of Pennsylvania Press, 2000), pp. 77–88.

18 Daniel Defoe, *Robinson Crusoe* (London, Penguin Books, 1985), pp. 208–9.

19 Philip Boucher, *Cannibal Encounters: Europeans and Island Caribs, 1492–1763* (Baltimore, Johns Hopkins University Press, 1992), notes the largely fictional depiction of Friday (pp. 126–7).

20 In referring to the first illustrators of the novel, George Layard does not remark upon the national change in Friday or the Caribs into Negroes; instead, he comments on the way that illustrators disregarded the narrative in terms of depicting Crusoe and the timeline of events. See his 'Robinson Crusoe and its illustrators' *Bibliographica*, 2:4 (London, Kegan Paul, Trench, Trubner and Co., n.d.), 181–203, p. 185. David Blewett, *The Illustration of Robinson Crusoe* (Gerrards Cross, Colin Smythe, 1995), notes that the engravers did not have access to the novel when making the first illustrations (p. 28). This fact, however, does not account for the persistence of Negro Fridays in the nineteenth-century illustrations nor the persistent textual rewritings of Friday as a Negro in eighteenth-century abridged versions.

21 Joachim Heinrich Campe, *The New Robinson Crusoe: An Instructive and Entertaining History* (Philadelphia, W. Woodhouse, 1792), vol. 2, p. 26.

22 It is no surprise that Friday becomes a Harlequin figure in at least two pantomimes. In Richard Brinsley Sheridan's version, staged throughout the 1780s, Friday is an Indian savage. In Henry Byron's *Robinson Crusoe; or Harlequin Friday and the King of the Caribee Islands* (1860), Friday is a Negro allied with Crusoe against the Indian cannibals. In the nineteenth century, Friday is often a black African in the visual artwork, a phenomenon apparent in Blewett, *Illustration of Robinson Crusoe*.

23 J. M. Coetzee, *Foe* (London, Secker and Warburg, 1986) and Toni Morrison, *Race-ing Justice, En-gendering Power: Essays on Anita Hill, Clarence Thomas, and the Construction of Social Reality* (New York: Pantheon Books, 1992) transform Friday into an African.

24 Hugh Honour, *The New Golden Land: European Images of America from the Discoveries to the Present Time* (New York, Pantheon Books, 1975), p. 21.

25 Sypher, *Guinea's Captive Kings*, pp. 105 and 106, respectively. Jean Vercoutter, *The Image of the Black in Western Art* (New York, Morrow, 1976), vol. 2, also gives credence to the effect of the noble savage tradition on visual representation. The metamorphosis of Indian into African originates from the persistent perception that 'The "primitive" and the "savage" come from every continent except Europe' (p. 251).

26 Joshua Reynolds and Henry Fuseli both painted Dido with a European complexion. Her visual appearance is best explained by the tendency to include North Africans in racial taxonomies with Europeans, a habit of thinking that changed during the mid-nineteenth century but continues today in standard American racial categorizing.

27 Hulme, *Colonial Encounters*, p. 239.

28 In a suggestive essay, 'The wild man', in Christian Feest (ed.), *Indians and Europe* (Aachen, Rader Verlag, 1987), pp. 5–36, Susi Colin forcibly contends that the iconographic tradition associated with European representation of wild men also influenced the depiction of Indians. According to Colin, European wild men were naked, hairy, and indulged in a host of non-civil pursuits (pp. 6–7). Thus, there were at least two influential visual traditions that disregarded distinctions in skin colour between Europeans and Indians.

29 Honour, *The New Golden Land*, p. 77.

30 Hans-Joachim Kunst, *The African in European Art* (Bad Godesberg, Inter Nationes, 1967), pp. 19–20.

31 Vercoutter, *The Image of the Black in Western Art*, vol. 2, pp. 248–9.

32 In some versions of de Bry, the slaves were hand-painted a peachy flesh colour. See examples at the John Carter Brown Library.

33 On physical explanations for the shape of noses and on gradual changes in colour, see Georges Louis Leclerc, Comte de Buffon, *Natural History: General and Particular* (London, T. Cadell and W. Davies, 1812 [1749]), vol. 3, pp. 165, 175, 439–40; Henry Home, Lord Kames, *Six Sketches on the History of Man* (Philadelphia, Bell and Aitken, 1776), p. 17.

34 This belief was also on occasion extended to Africans, particularly Hottentots. See Buffon, *Natural History*, vol. 3, p. 400. On the artificial colour of Indians, see Buffon, *Natural History*, vol. 3, p. 415. As is made clear in Peter Hulme and Neil Whitehead (eds.), *Wild Majesty: Encounters with Caribs from Columbus to the Present Day* (Oxford, Clarendon Press, 1992), pp. 53, 68, sixteenth- and seventeenth-century travellers commonly noted the Indians' applied colour.

35 Samuel Stanhope Smith, *An Essay on the Causes of the Variety of Complexion and Figure in the Human Species* (Philadelphia, Robert Aitken, 1787), p. 61.

36 Oliver Goldsmith, *An History of the Earth and Animated Nature in Four Volumes* (Philadelphia, Carey, 1795), vol. 2, p. 380.

37 Buffon, *Natural History*, vol. 3, p. 406.

38 Bryan Edwards, *The History, Civil and Commercial, of the British West Indies* (London, J. Stockdale, 1793) and all subsequent editions offer this common sociological explanation.

39 See Beth Fowkes Tobin, *Picturing Imperial Power: Colonial Subjects in Eighteenth-Century Painting* (Durham, Duke University Press, 1999), chapters 5 and 6, for the place of taxonomy in eighteenth-century botanical and ethnographic illustration.

40 In 'A new division of the Earth, according to the different species or races of men who inhabit it', *Journal des Sçavans* (1684), in T. Bendyshe (ed.), *Memoirs Read Before the Anthropological Society of London, 1863–4* (London, Longman, 1865), pp. 361–62, François Bernier writes that the Americans are 'olive-coloured, and have their faces modelled in a different way from ours. Still I do not find the difference sufficiently great to make of them a peculiar species different from ours' (p. 362).

41 See Alden T. Vaughan, 'From white man to redskin: changing Anglo-American perceptions of the American Indian', *American Historical Review*, 87:4 (1982), 917–53 for an analysis of an eighteenth-century shift in representations of Indians, particularly as it applies to Euro-Americans. He gives extensive documentation about Europeans viewing Indians as naturally white and thus artificially coloured by paints and other ointments. While I find much to agree with in terms of Vaughan's argument about Indians, he has simplified British views of Africans.

42 Goldsmith, *History of the Earth*, vol. 2, p. 374.

43 David Eltis, 'Europeans and the rise and fall of African slavery in the Americas: an interpretation', *American Historical Review*, 98:5 (1993), 1339–423, p. 1402.

44 In many cases, the lives of colonists depended on distinguishing between local, friendly natives and their historical enemies. My point concerns the general shortage of labour in the colonies and the willingness of landowners to secure able bodies – no matter whose.

45 Winthrop Jordan, *White Over Black: American Attitudes Toward the Negro, 1550–1812* (New York, W. W. Norton and Co., 1977), p. 90.

46 Almon Wheeler Lauber, *Indian Slavery in Colonial Times within the Present Limits of the United States* (New York, 1913), reports that reselling Indians to the West India islands existed in the Carolinas, Virginia, and New England, from the beginning of the colonies (pp. 169, 185, 187). Also see Gary Nash, *Red, White, and Black: The Peoples of Early North America* (Upper Saddle River NJ, Prentice Hall, 2000), p. 109 for the selling of Indians between Massachusetts and the West Indies. Nash reports that the Indian slave trade reached its peak in the first decade of the eighteenth century in the southeastern American colonies. After six years' worth of raids into the Floridas, 'Some ten to twelve thousand Timucuas, Guales, and Apalachees, were caught in the net of English slavery. Marched to Charleston, they were sold to the slave dealers and shipped out to all points in England's growing colonial empire' (p. 121). In the first decade of the eighteenth century, nearly one-fourth of all slaves in South Carolina were Indian (Eltis, 'Europeans', p. 1402).

47 Jack D. Forbes, 'Mustees, half-breeds and zambos in Anglo North America: aspects of Black-Indian relations', *American Indian Quarterly*, 7:1 (1983), 57–83, p. 66.

48 Forbes, 'Mustees', p. 69.

49 Vincent Harlow (ed.), *Colonising Expeditions to the West Indies and Guiana, 1623–67* (London, Bedford Press, 1925), p. 45.

50 David Galenson, *Traders, Planters, and Slaves: Market Behavior in Early English America* (New York, Cambridge University Press, 1986), p. 49.

51 As early as 1680, Morgan Godwyn observed in *The Negro's and Indians Advocate* (London, J.D., 1680) that *slave* had come to signify 'Black' in Barbados, but this was the only island where there were no indigenous people to enslave: 'Negro and Slave, being by custom grown Homogeneous and Convertible; even as Negro and Christian, Englishman and Heathen are by the like corrupt Custom and partiality made Opposites' (p. 36).

52 Hulme, *Colonial Encounters*, p. 205.

53 Notable interpretations of this phenomenon stem from Wylie Sypher's *Guinea's Captive Kings*.

54 Felsenstein, *English Trader, Indian Maid*, p. 173.

55 Charles Macpherson, *Memoirs of the Life and Travels of the Late Charles Macpherson, Esq. in Asia, Africa, and America* (Edinburgh, John Brown, 1800), pp. 77–8.

56 Nancie Gonzalez, 'From cannibals to mercenaries: Carib militarism, 1600–1840', *Journal of Anthropology Research*, 46 (spring 1990), 25–39, p. 25. The distinction that Crusoe makes between Friday's colour ('very tawny') and the other cannibals' ('ugly yellow nauseous tawny') inverts a common distinction Europeans made between the gentler Yellow Caribs, a.k.a. Island Caribs, and the reputedly more aggressive Black Caribs. Black Caribs posed a significant threat to England's dominance by periodically allying with the French and by waging war with Britain on their own in the last thirty years of the eighteenth century.

57 Boucher, *Cannibal Encounters*, p. 95.

58 Hilary Beckles, *White Servitude and Black Slavery in Barbadoes, 1627–1715* (Knoxville, University of Tennessee Press, 1989), p. 163.

59 Peter Hulme's recent work on the eighteenth-century Caribs makes a compelling case for viewing the British distinction between these two sets of people as spurious and

motivated by the desire to justify removing them from their lands. I have borrowed from 'Black, white, and yellow in the Caribbean' (pp. 4, 11 especially), a paper Hulme delivered at Culture and Power in the Global System, University of Aberdeen, 26 November 1999.

60 That Europeans often confounded Black Caribs and African slaves is borne out by a remark made by Louis XIV about the maroon communities of Black Caribs: 'It would be much in the interest of the islands if all these negroes could be destroyed so that those who have the desire to run away would no longer have an assumed haven': Boucher, *Cannibal Encounters*, p. 103.

61 For the theoretical development of why we should study the historical variations in the intensity and quality of racism and colonialism, see Stuart Hall, 'Gramsci's relevance for the study of race and ethnicity', in *Stuart Hall: Critical Dialogues in Cultural Studies*, eds. David Morley and Kuan-Hsing Chen (London, Routledge, 1996), 411–40; Ann Laura Stoler, 'Rethinking colonial categories: European communities and the boundaries of rule', *Society for Comparative Study of Society and History*, 31 (1989), 134–61; and Nicholas Thomas, *Colonialism's Culture: Anthropology, Travel and Government* (Oxford, Polity Press, 1994).

3

From Cannassatego to Outalissi: making sense of the Native American in eighteenth-century culture

Stephanie Pratt

In this chapter I intend to probe the relationship between texts and images as bearers of meaning and the impact this relationship had on illustrative images of the American Indian produced in the period from 1700 to 1820. To concentrate on the American Indian is immediately to raise questions about the economic framework and mercantile relations with which this volume is concerned. For, although some Native Americans were enslaved for work on the early plantations, their iconographic representation in European culture is overwhelmingly concerned with their existence outside any commercial or mercantile frame. As the aboriginal peoples of the new world, their presence was, of course, quite distinct from late-coming Europeans and their African slaves. It might be imagined, therefore, that the pictorial devices used to signify the American Indian would have little of relevance to contribute to our understanding of the iconography of the Atlantic trade. Despite the long-established inter-tribal trading networks and the successful colonial exploitation of this extensive Native American economy, most European images of the American Indian recapitulated the idea of a timeless noble or ignoble savage, at one with nature and innocent of change. We might argue, indeed, that the American Indian exists as the third point of a triangle whose other vertices constitute the (over-)civilized free European and the subjugated slave.

This essay will focus on the implications of this constructed identity. It is commonly accepted in contemporary scholarship that the lived experience of one culture, its alterity, can find accommodation with another culture only through a process of transformation. In the case of Native Americans, this transformation was largely achieved by representing them predominately under the sign of the exotic, a category of understanding which was imbricated in the wider relations obtaining between Europe and the Americas. In the give and take of the colonial situation, the forced or negotiated appropriation of land, hostile or amicable encounters, competitive or co-operative exploitation of resources, the reality of

European–Indian relations produced a tangle of confused and contradictory experience. In these labile circumstances, the figure of the Native American, as an imaginative construct, should be viewed as a unifying concept that attempts to substitute for this complex and confusing world a stable and ordered alternative. Here we might invoke Homi Bhabha's critique of colonial discourse, where he describes the exotic as a representational effect produced in the context of cultural colonialism.

> Produced through the strategy of disavowal, the *reference* of discrimination is always to a process of splitting as the condition of subjection: a discrimination between the mother culture and its bastards, the self and its doubles, where the trace of what is disavowed is not repressed but repeated as something *different* – a mutation, a hybrid. It is such a partial and double force that is more than the mimetic but less than the symbolic, that disturbs the visibility of the colonial presence and makes the recognition of its authority problematic.[1]

What Bhabha usefully articulates is the possibility that the image of the Native American carries within it the needs and anxieties of its originators. The attributes accorded to American Indians can thus be read as products of the colonial situation and a detailed examination of them may help illuminate the tensions in that situation. Bhabha notes that what is disavowed is repeated as 'something different', but not incommensurably defamiliarized: it is both familiar and other, thus mutant or hybrid. If the Native American image is mutable and impossible to secure, as I shall argue, then this very instability might be understood as registering European anxieties about the superiority of their culture and the moral legitimacy of their occupation of America.

Although my argument will focus upon what in one sense might be termed 'ethnographic incorrectness' in illustrations of Native Americans, this is not intended as some sort of empirical closure on further analysis. Recent scholarship has revealed the ideological underpinning of the very concept of ethnographic 'accuracy' in the human sciences, and the misrepresentations of native peoples, particularly through exhibition, that have been perpetrated in the name of ethnology.[2] However, it is arguable that an incipient move towards the discipline of ethnography was a feature of this period, as Europeans attempted to classify peoples within the colonial situation, and it can be posited as a mode of enquiry that calls these illustrations into question. Indeed, these images' hybridical alternative to ethnography's strategy of representational categorization by reference to concepts of accuracy and authenticity, against which visual and verbal descriptions could be derogated as inaccurate or inauthentic, is what requires scrutiny in its own right. In examining some representative images of the eighteenth and nineteenth centuries the task, then, is not to censure them for lack of ethnographic 'accuracy' but rather to call on them as witnesses for the European appropriation of America.[3]

I have chosen three examples of visual illustration of the American Indian: Richard Corbould's 1786 illustrations to John Shebbeare's novel, *Lydia; or Filial*

Piety (1755), the illustration of an 'Indian Warrior' from Thomas Anburey's *Travels Through the Interior Parts of America, in a Series of Letters* (1789), and two illustrations by Richard Westall of 1822 created for Thomas Campbell's poem, *Gertrude of Wyoming*, first published in 1809.[4] These illustrations offer particularly apposite examples of the tendency towards hybridity in many images of Native Americans made during this era. Their analysis in conjunction with the several different forms of literary expression in which they appear as illustration takes further the discussion of hybridity as an aspect of the colonial discourse and as it impacts on the relationship between image and text.[5]

It would be conventional to classify Campbell's poem, Shebbeare's novel and Anburey's narrative of travel according to an ascending scale of factual content or empirical observation – with poetry at the bottom typifying an imaginative and less naturalistic form, and the narrative of travel at the top of the scale epitomizing an objective, factual and unequivocal representation of places, events and peoples. The novel's narrative style and structure, using the yardstick of factual content or 'truth to nature', would rest somewhere between that employed in the seemingly scientific empirical narrative of travel and the personal inspirational verse found in the poem. Yet while a superficial reading might suggest these divisions, this innocent appraisal of the three genres is impossible to sustain once they are subject to closer scrutiny. As we shall see, the tidy demarcations implicit in their classification by genre are, in fact, illusory. There is, instead, a tendency towards hybridity in poems, novels and travel accounts of this period, which throws all such distinctions into doubt. As I will argue, hybridity is the signifying feature of their illustration, too; and it registers an important element in the Native American's encounter with Europe, the impossibility of stabilizing identity. In Bhabha's formulation, hybridity as a sign of difference, when related to the colonial subject, seems to inflect these narratives, first-hand accounts and literary fictional representations, as they relate to colonial encounters made in American space. In their turn, the illustrations made to accompany these hybridized texts are further complicated by a representational *modus operandi* that fuses together qualities and attributes taken from different European and non-European peoples. The inclusion of illustrations in these texts will thus be considered not necessarily as incidental editorial embellishment but as an integral part of the work's overall impact on its reader/viewer. What I propose to demonstrate is that, notwithstanding claims advanced in written texts about eyewitness accuracy or the utilization of authoritative accounts, this presumed desire for empirical truth is often undercut by the accompanying illustrations. Here, European traditions of representation offer an image of the American Indian that confirms stereotypical expectations, effectively cancelling what the written text proposes. That two such seemingly opposed representational strategies could co-exist in place and time offers grounds for further analysis of the European perception of the Native American.

A well-known early example of the tendency to hybridize forms of expression in English literature concerning the colonies is provided by Aphra Behn's novella,

Oroonoko; or The History of the Royal Slave (first published in 1688). This early novel is appropriate for setting a context of representation in its treatment of travel to the Americas and the colonial situation, where slavery, ideas of race and notions of inherent nobility mix and become amalgamated within the narrative. Behn attempts to distinguish her work from the many other accounts of travel which were beginning to appear with more and more frequency in the later seventeenth century and which continued as a dominant, highly popular genre throughout the eighteenth. She is clear that her text is not a work of fiction but rather based on her first-hand experiences in Surinam and on interviews with key witnesses. 'I do not pretend, in giving you the history of this royal slave, to entertain my reader with adventures of a feign'd hero ... I was my self an eye-witness to a great part of what you will find here set down; and what I cou'd not be witness of, I receiv'd from the mouth of the chief actor in this history, the hero himself'.[6] The author had indeed been to Surinam in the British West Indies from late 1663 to early 1664. However, over twenty-five years passed before she was to produce the novel *Oroonoko* and in the meantime another text on the subject of travel in Surinam appeared in 1667. According to Peter Weston, it is possible that Behn may have turned to George Warren's *Impartial Description of Surinam upon the Continent of America* (1667) to help supplement her own fading memories.[7] Behn elides her own fictional work with the history writing of others and in doing so creates a hybrid text that is neither a seemingly complete fiction nor a disinterested empirical text. Other writers revealed a similar ambiguity about the presentation and nature of their own narratives.[8]

Behn's main character in *Oroonoko*, is the eponymous 'royal African prince' who becomes enslaved. Prince Oroonoko is described as a prince of Coromantian (Nigeria in modern terms) but his physical description is equivocal.

> He was pretty tall, but of a shape the most exact that can be fancy'd: The most famous statuary cou'd not form the figure of a man more admirably turn'd from head to foot. His face was not of that brown rusty black which most of that nation are, but a perfect ebony, or polished jett ... His nose was rising and Roman, instead of African and flat. His mouth the finest shaped that could be seen; far from those great turn'd lips, which are so natural to the rest of the Negroes. The whole proportion and air of his face was so nobly and exactly form'd, that bating his colour, there could be nothing in nature more beautiful, agreeable and handsome.[9]

These same hybridized attributes are what help to distinguish his 'nobility' from the rest of the slave population described in the novella.[10] Oroonoko's sliding category of identity, melding idealized and African attributes, is a device to locate his character in representational tropes, tracing his nobility in the lineaments of physical grace and facial perfection. Behn's recourse to 'the most famous statuary' as the ultimate comparison locks Oroonoko's character into a classicized frame. As I shall demonstrate, this same pattern of amalgamation of different typologies and idealized European qualities recurs in other texts and, in like manner, signals the colonial encounter.

Aphra Behn went on to write another American-based narrative, *The Widow Ranter; or, the History of Bacon in Virginia* (1689), performed as a play on the Restoration stage in the same year. However, this time the narrative was set in Virginia in the Northern colonies and her 'noble' Native American character was called Semernia, a royal personage and 'Queen of the Indians'. A mezzotint of the actress Anne Bracegirdle in the role of 'The Indian Queen' (figure 9) may represent Semernia, and provides an apt visual equivalent to the combination of different genres found in Behn's writings.[11] Her cherub-like male attendants are given black skin colouring, alluding to the presence of African slaves in colonial America. Joseph Roach has argued that this mezzotint portrait addresses issues of miscegenation between Indians and African slaves, their consanguinity and a building up of strength in numbers on the part of 'others' within the colonial situation. He suggests that the intermixing of communities outside those of European bloodlines made for menacing and subversive presences in the colonies.[12] This was, of course,

9 Thomas Smith, engr. W. Vincent, *The Indian Queen*, c.1700, mezzotint.

The Indian Queen

T. Smith ex. W. Vincent fe.

a fear that was ever present. Yet, this reading seems over-determined, especially in the context of Anne Bracegirdle's evidently European identity. More plausible is the image's witnessing a reworking of an older iconographic tradition. It is known that Behn had herself loaned the King's Theatre a set of feather headdresses and feather garments which originally had been presented to the author when in Surinam.[13] The adornment of the black child-like figures in feather headdresses and skirts may allude to the play's performance, but these feathered costumes also revivify the long-standing allegorical image of America, the continent, as a feather garmented Indian woman. The American Indian Queen or Princess of the allegorical tradition was typically Europeanized in appearance and Anne Bracegirdle has been fitted to that role. However, being an English woman, the 'otherness' appropriate to a truly exotic Native American could not be integrated in her person. Instead, it is hypostasized and displaced on to the bodies of her attendants. The original allegorical image thus splits into signs of nobility and signs of otherness. The conceit that allows Oroonoko or Semernia as literary characters to be both noble and exotic is not maintained in visual representation. This same fault-line can be detected in other illustrations.

The first of these comes from a work of travel literature. The narrative of Thomas Anburey's *Travels Through the Interior Parts of America, in a Series of Letters* (1789) recounts events experienced by the author, who was a British officer under the command of the Earl of Harrington, Viscount Petersham, Colonel of the Twenty-Ninth Regiment of Foot during the Revolutionary Wars in America. Anburey describes the nature of American Indian warfare and declares his own acceptance that a war in the woodlands requires Indian-style methods and strategies.

> Every Indian is a hunter, and their manner of making war is of the same nature, only changing the object, by skulking, surprising and killing those of their own species, instead of brute creation. There is an indisputable necessity of having Indians, where Indians are employed against you, unless we had men enough of our own trained up in that sort of military exercise, as our European discipline is of little avail in the woods against savages ... They fight, as those opposed them fight; we must use the same means as our enemies, to be but on an equal footing with them.[14]

Anburey's explanation of the motivation behind Indian warfare simplifies what appears to Europeans as 'savage' and cruel practices. He makes an analogy between the Indians' use of war paint and feather adornment to go into battle and the artificial decorations used by the contemporary fop in British culture. In this way he satirizes British customs as well as trivializing the Native American modes of going to war painted and dressed in the skins of bulls, which Anburey considers 'outré'.[15] The illustration of 'An Indian warrior, entering his wigwam with a scalp' is displayed alongside the text of Anburey's letter twenty-eight written from the British camp at Lake Champlain and dated 24 June 1777 (figure 10).[16] In this engraving a young Indian man is shown standing in the foreground wearing a breechcloth tied to leggings which cover most of his legs and lower body. His upper body is naked

except for a strap across his chest to which is attached a powder horn and knife-case. He is adorned with bands or cuffs on his wrists and upper arms, a necklace with gorget attached and earrings. His curly dark hair is twisted and pulled up into a topknot on his head. In his left hand he holds a hatchet or tomahawk and in his right he holds a scalp, presumably recently removed from an enemy he has defeated in battle. In the background, tiny figures of Native Americans are shown firing weapons at assailants not shown in the picture while another Indian figure, with similar hair and accoutrement as the central figure, is shown scalping an enemy sol-

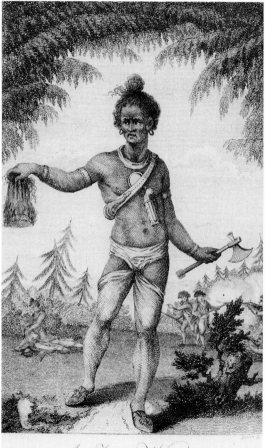

10 Barlow, 'An Indian warrior entering his wigwam with a scalp', engraving; from Thomas Anburey, *Travels through the Interior Parts of America, in a Series of Letters* (London, 1789).

An Indian Warrior

Entering his Wigwam with a Scalp.

dier. The viewer is thus given a sequence of events from Indians firing on an enemy, to an Indian scalping a European, to the central figure who enters his 'wigwam' with a scalp. In spite of its mention in the title, a wigwam is nowhere in evidence. Yet, given that the title clearly states that the 'Indian Warrior' is entering his wigwam, the only reasonable inference to be drawn is that the viewer is positioned close to or even inside that wigwam and the scalp is brandished for our delectation, as friend or ally. The spatial ambiguity of our position finds an echo in the moral ambiguity concerning the taking of scalps as an acceptable act of modern warfare.

Such a reading of the image, I would suggest, could only have operated subliminally for, in fact, the most salient feature of the image is the pose of the Indian warrior in the same stance as the *Apollo Belvedere* (figure 11). The reference to the *Apollo Belvedere* is a puzzling inclusion and seems to disrupt the main narrative, which is concerned with the brutality of irregular warfare rather than the classical ideal of the Apollo. As is well known, however, the identification of the Indian warrior with Apollo was something of a routine manoeuvre in the eighteenth century. Contemporary interpretations of the *Apollo Belvedere* commented on the

APOLLO. *Bild von Delphis und Oraculum im Päpstl. Garten Belvedere.*

11 Joachim von Sandrart, engr. Richard Collin, 'Apollo Belvedere', engraving; from Joachim von Sandrart, *Teutsche Akademie, der Bau Bild und Mahleren Kunste* (first edition, 1675).

pose of the sculpture exemplifying a bowman having loosed his arrow, in reference to Apollo's prowess as a hunter. Some interpretations went further, linking this pose with the story of Apollo's striking down Niobe and her children.[17] In either case, however, as hunter or as wrathful god, from the mid-eighteenth century onwards writers were prepared to find Apollo's counterpart in Native Americans.[18] Winckelmann's *Thoughts on the Imitation of Greek Works in Painting and Sculpture* (1755) refers to Apollo's ideal of perfect form in motion by calling up an image of the 'Indian ... in pursuit [of] the hart'.[19] In the same year, John Shebbeare in his novel *Lydia* made the same connection even more forcefully (*Lydia* is discussed later in this essay).[20] One, or both, of these texts may have prompted Benjamin West's remark in Rome in 1760 when viewing the *Apollo Belvedere* for the first time: 'My God! How like it is to a young Mohawk Warrior!'.[21] Barlow's illustration for Anburey's *Travels*, then, recapitulates an idea of some thirty years standing. Yet, notwithstanding the association of Apollo's ruthless destruction of Niobe with contemporary Indian warfare, the coming together of a bloody scalp and a hatchet with the most famous idealized form of male beauty can only be seen as an impossible union. Barlow's illustration forces into prominence what the oxymoron 'Noble Savage' attempts to smooth over. In its hybrid character, the realities of tribal warfare and the idealism of classical art refuse to blend into the concept that 'Noble Savage' proposes. Furthermore, following Bhabha, we might note how this image disturbs contemporary European notions of war as an arm of state policy, conducted according to rules and traditional observances. The nobility of conflict is thrown into doubt by this revelation of butchery as the essence of armed combat. As with contemporary worries about settlers 'going native', so even the conduct of war has lost its civilized veneer in an American setting.[22]

This image in Anburey's account seems to push to breaking point the analogy first iterated by Aphra Behn that a handsome, young native hero's features might be compared to the sculpted visage of a classical warrior. For Behn, as later for Winckelmann and Shebbeare, the description holds together within the text as the reader is able to conceive any number of possibilities of the appearance of the hero; but it collapses when rendered visually. Here, in Barlow's visual representation of 'The Indian Warrior', the idealization of such a figure collides with other information, rooted in contemporary knowledge of irregular warfare and subject to other presumptions about Native American cruelty. The impossibility, the instability, of this representation is compounded by its extremely insecure ethnography. The hybridity of Behn's Oroonoko finds an echo in the miscellany of attributes included by Barlow. The Indian Warrior has black curly hair, full lips and a dark complexion. Rather than referring directly to North American tribal groups situated at Lake Champlain and the surrounding area and known to have taken part in Revolutionary War skirmishes, such as the Mohawk, Oneida and other North Eastern Woodlands tribes, this Indian warrior seems to bear African traits or to be at best representative of Native American groups situated near the Southern colonies and at times allied to the French (Creek, Cherokee or Choctaw Indians).[23] It is intriguing to speculate how this composite figure was produced.[24]

Overall, the impact of the image rests on the uneasy accommodation made between what is thought to be real and that which can only be pure invention. It is this masking of the real within the ideal and the issue of hybridity that marks the texts and illustrations I have chosen to discuss; for the American situation, in particular, seems to have prompted writers and artists alike to attempt a blending of cultural expectations with colonial experience, as a response to a confusing and labile situation. It was inevitable perhaps that writers such as Anburey and artists such as Barlow should have attempted to provide a European framework to make sense of Native American culture but that framework fitted too awkwardly for the illusion to hold.[25]

The epistolary form of this account provides an autobiographical element in the narrative, for Anburey's experiences are recounted first-hand and this produces the effect of empirical knowledge and spontaneous record. It is now, however, generally accepted that Anburey's text is spurious in nature.[26] Thus, in spite of his being present in America during many of the incidents which he discusses, Anburey's *Travels* attempts to mimic other more well-known and frequently cited texts, such as Jonathan Carver's *Travels Through the Interior Parts of North America, in the Years 1766, 1767 and 1768*, published in 1778, itself indebted to several previously published works. Anburey's sleight of hand was not unique, especially with regard to travel literature concerning America.[27] His recycling of earlier texts is thus of a piece with Barlow's recourse to extant representational typologies of the exotic when imagining his Indian Warrior.

Travel literature as a genre of expression has received much critical attention in recent years and does not need extensive treatment here. However, one of the most

important critical revisions to the history of travel writing has been the linking of the discourses of travel with the larger projects of colonial enterprise and the growing predominance of scientific thought during the eighteenth and nineteenth centuries. More than thirty years on from Percy Adams' initial appraisal, the field has been further enhanced by current approaches that highlight the narrative and discursive tensions within eighteenth-century travel writing, suggesting that the characteristic hybridity of such writing is a necessary response to the discursive domain it attempts to inhabit. For instance, Tzvetan Todorov emphasizes the structural feature of colonialism as a constituent of all travel writing about the Americas. Similarly, Mary Louise Pratt has shown that the personal narrative (novel form) and the scientific treatise (documentary account) share the same impulse: 'in travel literature ... science and sentiment code the imperial frontier in the two eternally clashing and complementary languages of bourgeois subjectivity'.[28] Essentially, this tendency within travel literature to blend different modes of discourse marks its narratives as appropriate sites for the examination of colonial attitudes and perceptions.

As a genre, travel literature had in fact always been susceptible to criticism. Writers such as Tobias Smollett and Jonathan Swift satirized travel writing as a literary genre and popular fad. In *The Expedition of Humphry Clinker* (first published in 1771), Smollett attacks the fickle taste of the 'town' of London. 'Then there have been so many letters upon travels lately published – What between Smollett's, Sharp's, Derrick's, Thicknesse's, Baltimore's, and Baretti's, together with Shandy's Sentimental Travels, the public seems to be cloyed with that kind of entertainment'.[29] The exaggerated account of Indian captivity provided by Lieutenant Lismahago in *Humphry Clinker* serves to point up how seemingly factual accounts were, in truth, merely the occasion for sensational narratives, designed to titillate their readers' appetites. What the satirical account emphasizes is the uncertainty of the travel account. The piling up of detail and eyewitness authenticity can only be taken on trust by a readership ignorant of American life. What remains as a constant theme is America as a place of wonder, of excess and of difference. The subheading of John Shebbeare's first chapter in *Lydia; or Filial Piety* (1755) sums up in two short descriptions many of these extreme qualities which were becoming associated with the American environment: 'Strange folks in strange lands. Patriotism, heroism, fainting, dying, loving, sentiment and generosity, all amongst Indians in America'.[30]

The North American Indian plays a central role in Shebbeare's *Lydia*, in the figures of Cannassatego and Yarico, its Indian protagonists. As in many works of fiction based on events in America, Shebbeare almost certainly authenticated his account of Native Americans in *Lydia* by turning to an important work of documentary writing, Cadwallader Colden's *The History of the Five Indian Nations depending on the Province of New-York in America* (published in four parts between 1727 and 1755).[31] However, when it came to describing Cannassatego and Yarico, notwithstanding his references to the Five Nations of Iroquois, 'the ancient nations

of the Onnondagans and Cayugans', Shebbeare departs from Colden and invokes European references to bring his creations to life. He explains Cannassatego's swiftness of foot as 'like the bird of Jove'; Decanesora, the best friend of Cannassatego, is on the contrary, slow, like a 'British mastiff'.[32] Such comparisons, albeit trivial in themselves, reveal the need to ground exotic description in an English reader's world. Obviously Shebbeare, in turning to Colden's record of events in colonial New York, was impressed by the descriptions of the oratorical powers of both Cannassatego and Decanesora. Given Colden's description of the latter as 'resembling much the bustos of Cicero', Shebbeare decided to allow his 'Cannassatego' to exhibit the senatorial and distinguished presence that in the *History* had been attributed to both men.[33] In his descriptions of the physical appearance of the American Indian figures in *Lydia*, these references are taken further. Shebbeare likens the Indians to sculptural works of art with Cannassatego being specifically compared to the *Apollo Belvedere*. Yarico is described less specifically but still in sculptural terms, with a 'bosom as hard as wax' and a 'shape so exquisitely finished'. Cannassatego and his Indian lover thus become living and breathing sculptural forms, he 'with the air, attitude and expression of the beauteous statue of Apollo, which adorns the Belvidera palace in Rome' and she a Venus in buckskins.[34]

This comparison, still novel in 1755, needed justification. Shebbeare's readers were well aware that Native Americans were darker skinned than Europeans and he seems to have felt the need to defend his sculptural analogies. Shebbeare explains:

> though the fair complexion of the European natives was not to be found in this warrior [or his beloved], yet his shape and countenance precluded the perceiving of that deficiency, the perfection of form and expression of his visage were such that the Grecian sculptors of the famous statue of Laocoon, or the fighting gladiator, might have studied him with instruction and delight.[35]

Apart from appearing to have taken Winckelmann at his word, Shebbeare also invokes the same problematic that Aphra Behn first voiced in 1688. Behn's Oroonoko also appeared the perfection of form; but he, too, suffered from a slight 'imperfection' which needed to be ignored or played down: his black complexion. In the description of Behn's royal slave, one could admire him completely as a perfect specimen of mankind, 'bating his colour'. Cannassatego, too, is to be admired despite the 'deficiency' of his complexion. In drawing his audience's attention to a quality that Cannassatego's shape and countenance would preclude them from perceiving, Shebbeare helps the reader understand their own subjectivity as a site of difference. Cannassatego is like Europeans insofar as he resembles the *Apollo Belvedere*, but he is emphatically not one of them.

Shebbeare's invocation of ideal form is so explicit that one might imagine his illustrators simply enacting graphically his verbal description. It is therefore of more than ordinary interest that the illustrations created to accompany the novel do not classicize the figures in any straightforward manner, revealing rather different

concerns. Richard Corbould's full-page plate depicting the reunion of 'Yarico and Cannassatego' from the 1786 edition of *Lydia* (figure 12) exemplifies this.[36] The immediately striking thing about this image is that the figures are not distinctly Native American; indeed, it is difficult to ascertain their identities at all. Instead, they are amalgamated types that are compilations of several qualities, 'American Indian' being just one factor in the mixture. Their costumes are intriguing in that while they are not dressed in contemporary late-eighteenth century fashions, they are nevertheless Europeanized in appearance and give no indication that they hail from a completely 'new' world. The figure of Cannassatego is dressed in undecorated fabric which functions in the image much more like drapery than would the animal skins that the text describes.

Around his shoulders this covering forms a cape tied at the neck. From Shebbeare's text we learn that the fabric and the 'casque' Cannassatego wears on his head are made from the skin of a wolf and his cape is formed by tying the two forepaws of the dead animal around his neck.[37] These textual and illustrative signs are obviously intended as references to the exotic, but Corbould's image might easily pass as one of the heroes from Greek or Roman mythology, a Hercules or Mars, rather than a figure from contemporary life. (Hercules, too, we remember tied an animal skin, the Nemean Lion, round his shoulders to act as a cape and tunic.) Yarico's clothes, similarly, bear little likeness to Native American costume; nor do they appear influenced in any way by the contemporary representations of American Indian diplomatic delegations in portraits and portrait engravings produced regularly throughout the eighteenth century (figure 13). Both figures are adorned with ostrich feather headdresses instead of the feathers of any birds then known to be indigenous to the Americas. Ostrich feathers, often used in contemporary theatre costume to signify exotic

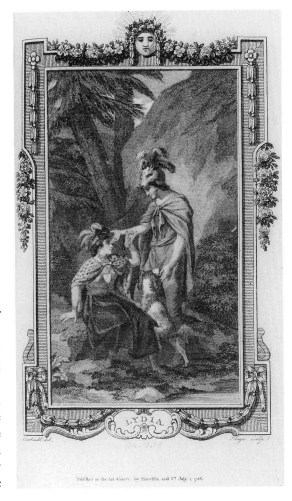

12 Richard Corbould, engr. Angus, 'Lydia', engraving; from John Shebbeare, *Lydia; or Filial Piety* (London, 1786), plate 4.

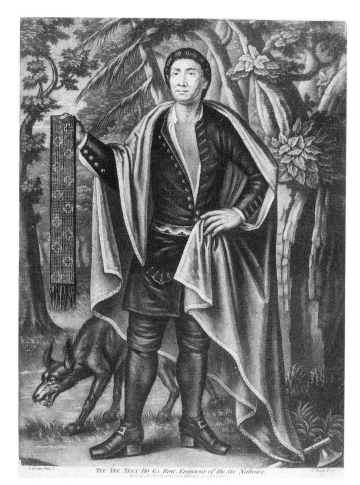

13 Jan Verelst, engr.
Jean Simon, *Tee Yee
Neen Ho Ga Row,
Emperour* [sic] *of the
Six Nations,* 1710,
mezzotint.

TEE. YEE. NEEN. Ho. GA. Row. *Emperour of the Six Nations.*

luxury were long known to Europeans as signifiers of the tropics, as seen in William
Vincent's print of Anne Bracegirdle, discussed above.

Corbould's representations of American Indians are therefore distinguished by
their non-specificity, making no clear reference to any particular tribal or ethno-
graphical content; nor do they reveal awareness of other more documentary visual
sources of information such as the painted portraits and portrait prints that had
appeared before this date.[38] Corbould, like Shebbeare, attempts to give
Cannassatego and Yarico an identification that would make sense to a European;
but whereas Shebbeare makes rhetorical use of historical data and ethnographic
'exactitude' to anchor his characters in a seemingly 'real' situation, Corbould
makes no such attempt. As a result, the image parades the uncertainties latent in
Shebbeare's mixture of European cultural values and Native American realities.
One can only assume that Corbould made use of the hints Shebbeare provided to
produce the illustrations, but their indeterminacy reminds us of Shebbeare's

equivocation when treating the characters of Cannassatego and Yarico.[39] As we have seen, Shebbeare's account oscillates between ethnically specific information and a classicizing frame of reference. Corbould's confused illustration might be seen as a demonstration of the muddle inherent in Shebbeare's presentation.

The third text under consideration is Thomas Campbell's *Gertrude of Wyoming*. The poem tells the tragic story of a young boy, Henry Waldegrave, who is orphaned after a recent battle on the American frontier. Hiding up a tree with his dying mother, he is eventually found by Outalissi, an Indian man from the Oneida tribe (one of the six 'Nations' of the Iroquois). Outalissi then brings Henry to Albert, a friend of Henry's mother.[40] Albert's only daughter is Gertrude and eventually she and Henry fall in love. Gertrude's untimely death in the so-called Wyoming Valley Massacre of 1778, during the Revolutionary Wars in America, is the tragic climax of the poem. The narrative of *Gertrude of Wyoming* is thus quasi-historical in linking the experiences and feelings of the principal protagonists with frontier history and events of national significance. The Wyoming Valley Massacre was given a full description in Isaac Weld's *Travels through America* (1796), which was the text used by Campbell to authenticate his narrative.[41]

Richard Westall's 1822 engravings for *Gertrude of Wyoming* are among the earliest illustrations of the poem (figures 14, 15).[42] Both scenes illustrated here relate to crucial meetings between the major characters in the poem. The title page depicts the introduction of Henry Waldegrave and Outalissi to Albert and Gertrude. Westall obviously made an attempt to produce a literal transcription of Campbell's initial treatment of Outalissi as Albert and Gertrude see

> An Indian from his bark approach their bower,
> Of buskin'd limb, and swarthy lineament;
> The red wild feathers on his brow were blent,[43]

Campbell's text is evidently not sufficiently descriptive to produce a determinate image and Westall makes Outalissi a young man with dark skin, curly dark hair and a beard, the last two of which are inappropriate Native American attributes. The Native American accoutrement he wears is rather indiscriminate (draped and toga-like) and this lack of specificity is reminiscent of the ambiguity surrounding the figures of Cannassatego and Yarico from *Lydia*, discussed above. The inclusion of feather ornamentation on his head and the 'unstrung' bow and arrows are the only references in this image that help to identify the figure as Native American.

In the second plate, the scene depicted occurs later in the lives of Henry and Gertrude, after they both have grown into adulthood. Outalissi returns now to warn the reunited family of the coming raid on their homestead and while doing so is recognized by the settlers as the same Indian man who had brought Henry to safety all those years ago. Here, Outalissi is an aged man, with white hair, slimmer physique and even less distinctive accoutrement to give any indication of his status as a Native American chieftain. Stripped of all locational devices such as costume and feather adornment, he appears dislocated from history and the specific geography of

America. His curly short white hair and beard, draped tunic and the stiff pose he adopts as he sits and stares fixedly at the others align him more with the figures of Brutus or Cato than with an Oneida warrior leader from western New York state. America, as a place constituted through the texts written about it, was produced in a context of uncertainty, through the hybridization of literary genres. So here in these illustrations Westall seems uncertain about what he is depicting. This is all the more remarkable given Campbell's attempt to underpin *Gertrude of Wyoming* with historically reliable texts. It is worth considering, perhaps, that by 1822 the possibility of the American Indian as Noble Savage in the way that Barlow or Corbould had understood it was no longer tenable. Westall allows Outalissi a classical pose but this senatorial presentation is won at the cost of effacing his Native American identity. Westall seems to have taken Campbell's phrase 'swarthy lineament' as an invitation to render Outalissi as a dark-skinned and curly-headed individual.[44] His 'Outalissi' could have

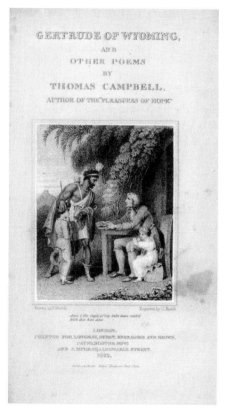 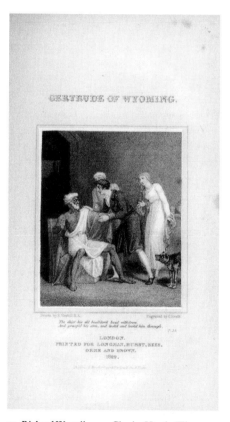

14 Richard Westall, engr. Charles Heath, 'And I, the eagle of my tribe have rush'd with this lorn dove', steel engraving; from Thomas Campbell, *Gertrude of Wyoming, and Other Poems* (London, 1822).

15 Richard Westall, engr. Charles Heath, 'The Chief his old bewilder'd head withdrew, and grasp'd his arm, and look'd and look'd him through', steel engraving; from Thomas Campbell, *Gertrude of Wyoming, and Other Poems* (London, 1822).

emerged just as easily from his own imagination and, as the text is itself partly an amalgam of the historical with the poetic, the artist, too, may have felt a desire to create an amalgam of different qualities for his visual rendition of the character. It is not stretching a point to assert perhaps that the possibility of Native American identity itself was so inflected by the hybridized status of its representations that the figure of Outalissi could be classical, Indian, Pacific and African all at once. This strange network of genealogies might even sum up the triple identity of America where the original inhabitants were giving ground to a new European culture reliant on a slave economy.

The displacement of the character and illustration of Outalissi from American Indian into something else is perhaps nowhere more profoundly signalled than in a further imaginative text. In 1826 a short novella was published anonymously under the title *Outalissi; a Tale of Dutch Guiana*. Dedicated to William Wilberforce, this work is now attributed to C. E. Lefroy. It is an anti-slavery text with the main character, Outalissi, 'different from the others' in his appearance, his way of carrying himself and his very strong, deep emotions. He does, in fact, turn out to be a king of his people, but is tricked by European slavers and sold into slavery with all his fellow villagers. In tried and tested fashion, his physique is compared to statuary, he is at one point called a 'noble savage' and, in relation to his body's form, mere clothing would have been 'ridiculous, and as much misplaced on Outalissi, as upon the statue of the Apollo Belvedere'.[45] It seems that Lefroy has been able to combine from many sources, including Aphra Behn, John Shebbeare and Thomas Campbell, a character of truly perfect proportions and noble qualities and sentiments. In a circularity that epitomizes the problems of hybridical representations and the mixing of typologies, this admirable Black African man is a noble slave, like Behn's Oroonoko, a beautiful specimen of mankind like Shebbeare's Cannassatego and an ardent friend to the white European settlers, like Campbell's Outalissi. When facing death, Lefroy's Outalissi utters not a word, but the description of him is apposite:

> As monumental bronze unchang'd his look,
> A soul that pity touch'd, but never shook,
> Train'd, from his tree-rock'd cradle to his bier,
> The fierce extremes of good and ill to brook;
> Impassive – fearing but the shame of fear –
> A stoic of the woods – a man without a tear.[46]

These lines of verse quoted within the text of Lefroy's novel are taken, significantly, from Campbell's *Gertrude of Wyoming*, and highlight particularly the ways in which borrowing from sources and changing or mixing characterizations was a process that happened without much self-examination. As if to acknowledge that the text is treading a somewhat careful path between real peoples and events and the full sway of imaginative fantasy, the editorial notes at the end of *Outalissi* state that when the author was in Surinam (Dutch Guiana), the 'occurrences [here] described' did not take place in the manner described. In fact, 'none [of them] took

place, except the fire of the town and shipping, and the execution of the Dutch sol-
dier, which events did really happen, but not co-temporaneously. The two pre-
ceding chapters [describing Outalissi's torture and death] must therefore in all
other respects be entirely fictitious'.[47] Something of the fictitious did creep in.
Lefroy's text, in its multiple references and ambiguous attitude to history and cul-
ture might be seen as the literary equivalent of Westall's image discussed earlier.

Although there may be elements in the visual representations of Native American
and Black African peoples that are cognizant of the colonial economy at this time and
its manifestations in wealth and expenditure, there are also elements of clear confu-
sion and lack of specificity indicating heedlessness and ignorance of the complexities
of the actual situation, which instead show a wish to substitute an amalgam or hybrid
type for any direct understanding and experience. In Wylie Sypher's seminal discus-
sion of anti-slavery literature of the eighteenth century he stressed the 'syncretism'
that could create a character termed both 'Negro' and 'Indian' in one and the same
description. Oroonoko and the somewhat later figure of Yarico appear to blur the cat-
egories of Native American and African in a 'complete disregard of ethnology and
anthropology' that suggests more than a mere mistaking of identities. It is rather a
consciously made choice in order to display the extremes of the human condition, its
most noble contrasting with its most base qualities. In Yarico, Sypher clearly finds
the female equivalent to Oroonoko. She is, in his terms, 'the beautiful Black Venus',
exhibiting both African and Native American attributes, and this same confusion is
repeated in many literary manifestations throughout the eighteenth century.[48] As we
have seen in the illustration of the Native American in relation to particular colonial
literary texts, a similar kind of syncretism takes place where Native American quali-
ties are either modified or disregarded in favour of a blend of other and often African-
inspired 'racial' attributes and qualities.

In the mid-nineteenth century, the historian Francis Parkman, writing on James
Fenimore Cooper's *The Last of the Mohicans* (1826), commented on the damaging
impact of writers such as Campbell and Cooper 'for the fathering of those aborig-
inal heroes, lovers, and sages, who have long formed a petty nuisance in our litera-
ture'.[49] Yet these petty nuisances might be regarded today as witnesses of the
characteristic understandings Europeans possessed of the American continent. In
this regard, it is a reasonable supposition to suggest that the illustrations we have
been considering are concretizations of the ordinary reader's response to these nar-
ratives. The difficulties faced by Barlow, Corbould and Westall and the hesitant or
contradictory nature of the images that they produced demonstrate the extent to
which pre-existent tropes, especially classicizing references, checked any turn
towards what we might consider an 'authentic' representation. In effect, these
illustrations operated as a form of editorial redaction.[50] Anburey claimed to be pro-
viding a first-hand account, while Shebbeare and Campbell took care to base their
narratives on extant histories. Their illustrators, then, might have been expected to
ground the image in a rhetoric of historical and ethnographic 'accuracy', sug-
gesting a metonymic relation to the American situation. Instead Barlow, Corbould

and Westall present images that are essentially metaphorical, working at one remove from the world the texts describe. This more generalizing and connotative approach calls into question the precise references embedded in the texts. Descriptions of places, peoples and events lose their specificity to be replaced by more abstract considerations. The illustrations, as a result, present an image of the Native American that is closer to the world of symbolic allegory than the historical 'realities' of the frontier that their texts presumed to describe.

Notes

I would like to thank both Professor Dian Kriz and Dr Geoff Quilley for their unstinting support in the production of this essay. Their very helpful and pertinent comments and advice have been of inestimable value.

1 Homi K. Bhabha, *The Location of Culture* (London and New York, Routledge, 1994), p. 111.

2 See especially Ward Churchill, *Indians Are Us: Culture and Genocide in Native North America* (Toronto, Between the Lines Press, 1994); Gerald McMaster, 'Museums and galleries as sites for artistic intervention', in Mark A. Cheetham, Michael Ann Holly and Keith Moxey (eds.), *The Subjects of Art History: Historical Objects in Contemporary Perspective* (Cambridge, Cambridge University Press, 1998), pp. 250–61.

3 Even after the Declaration of Independence, America as a geographical entity was imaginatively appropriated as the place where an essentially European culture was extirpating an existing way of life.

4 The 1786 edition of John Shebbeare's *Lydia; or Filial Piety*, which is the edition cited throughout this essay, was published in four volumes in *The Novelist's Magazine*, London, in the issues printed between 1785 and 1787. Other novels with Native American themes published in this series included Madame Graffigny's *Peruvian Tales* and Voltaire's *The Sincere Huron*. Thomas Anburey's *Travels through the Interior Parts of America* was reprinted in a second edition in 1791, which is also the edition cited in this essay, and then in a French edition, enriched with notes by M. Noel, in 1793. Thomas Campbell's poem, *Gertrude of Wyoming; a Pennsylvanian Tale*, published in 1809 in New York and London, went to nine editions by 1825, and by 1840 an edition of *The Poetical Works of Thomas Campbell* was printed by Edward Moxon with illustrations by such distinguished artists as J. M. W. Turner and the Dalziel brothers.

5 I have concentrated on English texts and their illustrators because they demonstrate the extent to which the original colonial settlements among Woodlands Indians retained their hold over an English reading public a generation after the loss of the American colonies; between them, they offer a neat demonstration of the confusions surrounding the figure of the Native American.

6 Aphra Behn, *Oroonoko, and Other Stories*, ed. Maureen Duffy (London, Methuen Press, 1986), p. 27.

7 Peter Weston, 'Some images of the primitive before 1800: identifying a potential radicalism', in *America in Literature* (London, Roehampton Institute, 1980), pp. 7–8.

8 See for instance Edward Kimber, *The History of the Life and Adventures of Mr. Anderson*, subtitled 'Containing his strange varieties of fortune in Europe and America.

Compiled from his own papers. [A Tale.]' (Dublin, 1754). This narrative is discussed in Benjamin Bissell, *The American Indian in English Literature of the Eighteenth Century* (New Haven, Yale University Press, 1925), pp. 87–9.

9 Behn, *Oroonoko*, p. 33.

10 The identification of 'Coromantian' as Oroonoko's place of origin highlights the 'racial' aspects of slave trading, in that an eighteenth-century readership may have been aware of distinctions made between African captives taken from differing regions and their supposed 'pedigree' as slaves. Coromantian (or Nigerian) peoples were thought to be the strongest and most fit for work but also the most rebellious. My thanks to Geoff Quilley for bringing this to my attention.

11 The subject of the print is either a representation of the actress in her role as Semernia or could refer to the main character in Dryden and Howard's play *The Indian Queen*, perhaps performed by Bracegirdle in its earliest stagings. See Emmett L. Avery (ed.), *The London Stage, 1660–1800*, vols. 1 and 2 (Carbondale, Southern Illinois University Press, 1960), where *The Indian Queen* is listed as an opera performance but the cast lists are unknown.

12 Roach argues that 'the blood of Indians and Africans' seems to have already been 'mixed' in the figures of the attendants to Semernia and that 'fecund liaisons between African slaves and Native Americans posed a different kind of menace to whiteness': Joseph Roach, *Cities of the Dead: Circum-Atlantic Performance* (New York, Columbia University Press, 1996), pp. 125–6.

13 Behn, *Oroonoko*, p. 28. Behn's description of the dress of Native Americans from this area in South America seems to rely on published accounts of travel to Brazil and other Amazonian regions. See discussions of images from sixteenth-century travel accounts in Hugh Honour, *The New Golden Land: European Images of America from the Discoveries to the Present Time* (New York, Pantheon Books, 1975), pp. 53, 63–5, and illus. 43, 52, 54 and 66.

14 Anburey, *Travels*, pp. 263–4.

15 Anburey, *Travels*, p. 258.

16 Anburey, *Travels*, pp. 258–68. The illustration is inserted between pp. 258 and 259.

17 See Francis Haskell and Nicholas Penny, *Taste and the Antique: The Lure of Classical Sculpture, 1500–1900* (New Haven and London, Yale University Press, 1981), catalogue no. 8, p. 150.

18 Comparisons between ancient Greco-Roman myths and gods and Native American beliefs and 'deities' were not new in the eighteenth century, had several precedents in writings of the mid-seventeenth century and were initiated as early as the sixteenth century. See the essay by Sabine MacCormack, 'Limits of understanding: perceptions of Greco-Roman and Amerindian paganism in early modern Europe', in Karen Ordahl Kupperman (ed.), *America in European Consciousness, 1493–1750* (Chapel Hill and London, University of North Carolina Press, 1995), pp. 79–129.

19 As translated from the German by Henry Fuseli (London, 1765) and reprinted in Lorenz Eitner (ed.) *Neo-Classicism and Romanticism: Vol. 1, 1750–1850* (London, Prentice-Hall, 1971), p. 6.

20 Shebbeare, *Lydia*, vol. 1, p. 6.

21 The incident concerning West and his first viewing of the statue was initially committed to print in a footnote to the poem by Richard Payne Knight, *The Landscape: A Didactic Poem in Three Books* (1794). For mention of Payne Knight's poem and West's

use of the pose of the *Apollo Belvedere*, see Matthew Craske, *Art in Europe 1700–1830: A History of the Visual Arts in an Era of Unprecedented Urban Economic Growth* (Oxford and New York, Oxford University Press, 1997), p. 265. West's by then famous reaction to this statue was reiterated in 1816 in John Galt's biography of the artist, and seems to play into his biographical image as the archetypal innocent artist, untrained and, therefore, unsullied by European values and customs. See John Galt, *The Life, Studies and Works of Benjamin West, Esq.* (London and Edinburgh, 1816), pp. 103–6, 115.

22 Greg Dening makes a similar point concerning the ways in which the then current amorous dalliances of members of English high society could be likened to the supposed open sexuality thought to be practised among the recently colonized Tahitian and Polynesian peoples. See *Mr. Bligh's Bad Language: Passion, Power and Theatre on the Bounty* (Cambridge, Cambridge University Press, 1992), pp. 266–7.

23 His topknot of hair is significant, as it is not usually seen in visual representations of North American tribal groups. However, the first expedition led by Captain James Cook under the auspices of the Royal Society to the New Zealand and Australian coastlines (1768–71) produced significant images, such as the important portrait head of a New Zealand man by Sydney Parkinson, which might have had an influence on this later illustration. Parkinson's image was reproduced in John Hawkesworth's 1773 account of Cook's *Voyages* and therefore would have been readily available as a source. However, in Parkinson's image the Maori man has been shown with very straight hair pulled up tightly into a knot on the top of his head whereas the Indian Warrior in Anburey's account is shown with loosely gathered distinctly curly hair, which hangs in locks from his top knot. For a discussion of the images produced as a result of Cook's voyages to the South Pacific and of Parkinson's image in particular, see Rüdiger Joppien and Bernard Smith, *The Art of Captain Cook's Voyages*, vol. 1: *The Voyage of the 'Endeavour' 1768–1771* (New Haven and London, Yale University Press, 1985). Parkinson's portrait of a New Zealand man is illustrated as Plate 35, p. 35. See also Roxann Wheeler's essay in this volume, which looks at other examples of ethnographically imprecise representations of non-European peoples in illustration and the blurring or vagueness of categories of race and difference for this period.

24 A possible source for the Native American accoutrement given by Barlow to the figure in Anburey's account is that depicted in the Townshend Monument of 1761 in Westminster Abbey. In this work, the sculpted 'Indian' support figures are thought to be based on Robert Adam's drawings of a captured Choctaw boy 'given' to George Townshend, the brother of the deceased. See John Fleming, 'Robert Adam, Luc-François Breton and the Townshend Monument in Westminster Abbey', *Connoisseur*, 150:65 (July 1962), 163–71; and Honour, *The New Golden Land*, pp. 128–9, with illustrations 120(a) and 120(b). Apart from these possible ethnographic sources, the figure in Barlow's plate exhibits what Beth Fowkes Tobin has identified as 'cultural cross-dressing' in that there are obviously European manufactured items in his dress which combine with Native Americans ones to create a hybridical and even subversive self-representation of the inevitable mingling of cultures on the frontier. See Beth Fowkes Tobin, *Picturing Imperial Power: Colonial Subjects in Eighteenth-Century British Painting* (Durham NC and London, Duke University Press, 1999), pp. 88–9, 96–101.

25 It was, on the other hand, a commonplace practice by the late eighteenth century to depict supposed 'primitive' peoples living distant to Europe in the guise or posture of classical sculptures, for instance in the portraits of Tahitians and other South Seas

Islanders by William Hodges and John Webber in the 1770s and Sir Joshua Reynolds' portrait of *Omai* (or Mai) of 1775. Similarly, Benjamin West's 'grand style' paintings *The Death of General Wolfe* (1770–1) and *Penn's Treaty with the Indians* (1771–2), which include images of Northeast Woodlands Indians, also reveal a tendency to depict Native Americans in classicizing attitudes and poses. As mentioned above in relation to the print of Anne Bracegirdle, a tradition of combining European physical features with Native American and feathered accoutrement already existed in the image of the allegory of America as feathered Indian princess.

26 Percy G. Adams lists Anburey's text as an example of those voyages which, up until the time of Adams' analysis, had not been described as imaginary because they 'follow the rules of the game so completely'. Adams proposed the term 'travel-liar' to describe the tendency he noted in the vast majority of the travel literature produced from the seventeenth to the early nineteenth century, in being partially, if not wholly, indebted to previous texts. Direct plagiarism of this kind did not appear to hamper a work's success. See Adams, *Travellers and Travel-Liars* (Berkeley, University of California Press, 1962), p. 143 and *passim*.

27 Anthony Pagden has noted how such plagiarism is actually a privileging of the European written histories (originally founded in a claimed empiricism) over that of the actual or direct experience of the colonial encounter. See Pagden's *European Encounters with the New World: From Renaissance to Romanticism* (New Haven and London, Yale University Press, 1993).

28 Tzvetan Todorov, 'The journey and its narratives', trans. Alyson Waters, in Chloe Chard and Helen Langdon (eds.), *Transports: Travel, Pleasure and Imaginative Geography, 1600–1830* (New Haven and London, Yale University Press, 1996), pp. 294–5. Mary Louise Pratt, *Imperial Eyes: Travel Writing and Transculturation* (London and New York, Routledge, 1992), p. 39.

29 Tobias Smollett, *The Expedition of Humphry Clinker*, ed. Angus Ross (Harmondsworth, Penguin Books, 1967), p. 29.

30 Shebbeare, *Lydia*, p. 5.

31 A speech given by chief 'Canassateego' of the Onondaga tribe of the Five Nations is recorded in Colden's later editions, where it is written that Canassateego met the Pennsylvania proprietors on 12 July 1742. This speech is reprinted in Wilcomb Washburn (ed.), *The Indian and the White Man* (New York, Anchor Books, 1964), pp. 329–34. Another of Shebbeare's Indian characters, Decanesora, is also derived from Colden's text. In Colden's *History*, Part II, there is mention of a 'Decanesora [who] had for many Years the greatest Reputation among the Five Nations for speaking, and was generally employed as their speaker': *History of the Five Indian Nations depending on the Province of New-York in America*, Part II (Ithaca, Cornell University Press, 1958 [1747]), pp. 95 and 141. The emphasis in Colden's account on Indian oratory and his comparisons of the Five Nations with certain figures from classical antiquity seems the most likely basis for Shebbeare's similar assertions.

32 Shebbeare, *Lydia*, p. 6.

33 For the comment about Decanesora and Cicero, see Colden, *History*, Part II, p. 140.

34 Shebbeare, *Lydia*, pp. 6 and 9.

35 Shebbeare, *Lydia*, p. 6.

36 This plate is interleaved between pages 238 and 239. It is signed by Corbould and was engraved by Angus.

37 Shebbeare, *Lydia*, p. 6.
38 The visual documentation of Native American delegations to London during the eigh-
 teenth century is discussed in Stephanie Pratt, 'Reynolds' "King of the Cherokees"
 and other mistaken identities in the portraiture of Native American delegations,
 1710–1762', *Oxford Art Journal*, 21:2 (1998), pp. 133–50.
39 It is well to remind ourselves also that the name Yarico was entirely an invented manifes-
 tation of literature. Her moniker rose to prominence in the eighteenth century via a text
 called 'The Story of Inkle and Yarico', depicting inter-cultural contact between a West
 Indian/Native American girl and a British sailor. According to Bissell the origin of the
 story may be found in one of three separate sources, an English source being Richard
 Ligon's *History of Barbados* (1673), but was popularly repeated in Richard Steele's
 article in *The Spectator* of 1711. A popular play *Inkle and Yarico* by George Colman, the
 Younger was also performed in the last quarter of the eighteenth century and after. See
 Wylie Sypher, *Guinea's Captive Kings: British Anti-Slavery Literature of the Eighteenth
 Century* (New York, Octagon Books, 1969), pp. 122–37, 224; and also Bissell, *The
 American Indian in English Literature*, pp. 138–40. See also Roxann Wheeler's essay in
 this volume.
40 The names 'Waldegrave', 'Albert' and 'Gertrude' all suggest that Campbell had
 intended them to read as descendants of original German immigrants who had come
 with the Moravian missionaries to this part of the Northeastern United States.
 Pennsylvania, which is the setting for this poem, had long been considered as a place
 where peaceful relations with the local Native American peoples had existed due to the
 influence of the Quakers who immigrated there. Thus, the influence of Christian belief
 and behaviour can be made to contrast with the brutalities suffered by particular com-
 munities at the hands of the 'savages'.
41 In the 1825 edition of Campbell's *Gertrude of Wyoming*, the poet issued the following
 advertisement, which precedes his poem in the text: 'Most popular histories of England,
 as well as of the American war, give an authentic account of the desolation of Wyoming, in
 Pennsylvania, which took place in 1778, by an incursion of Indians. The Scenery and
 Incidents of the following Poem are connected with that event ... In an evil hour, the
 junction of European with Indian arms, converted this terrestrial paradise into a
 frightful waste. Mr. Isaac Weld informs us, that the ruins of many of the villages, per-
 forated with balls, and bearing marks of conflagration, were still preserved by the recent
 inhabitants, when he travelled through America in 1796'. See Thomas Campbell,
 Gertrude of Wyoming, and Other Poems (London, Longman, Hurst, Rees, Orme, Brown,
 and Green, and J. Murray, 1825), fourth page after titleplate. It should be noted, how-
 ever, that Campbell's appeal to historical authentication was highly problematic and ide-
 ological. Joseph Brant, a Mohawk warrior loyal to the Crown, objected to the poem's
 description of the massacre, of his part in it, and its description of him as 'the Monster
 Brant'. He was eventually issued an apology, albeit posthumously, after Campbell met
 John Brant, Joseph's son. On the other hand, military historians place Brant at the attack
 on Cherry, a much more devastating defeat than at Wyoming, as he was riding with
 Colonel Butler's squads during the same period: evidently the appeal to historical
 authentication was not only ultimately indeterminate in any empirical sense, but could
 be used ideologically in the context of both European and Native American agency.
42 There are three engravings made by Westall for the ninth edition of Campbell's
 Gertrude, two of which depict scenes with the Native American character, Outalissi,

and are discussed in this essay. One of these is the titleplate. The other is interleaved between pages 34 and 35.

43 Campbell, *Gertrude of Wyoming*, verse XII, p. 7.

44 Outalissi's slim frame and short-cut curly hair and beard are perhaps reminiscent of some of the visual representations that were emerging from new explorations in the South Seas, such as Westall's own brother, William, had produced on the 1801 expedition to Australia led by Matthew Flinders. See Bernard Smith, *European Vision and the South Pacific* (New Haven and London, Yale University Press, 1985), pp. 189–97 and illus. 133.

45 C. E. Lefroy, *Outalissi, A Tale of Dutch Guiana* (London, J. Hatchard and Son, 1826), pp. 36–8, 236–7.

46 Outalissi's description here seems entirely in line with the kinds of representations of stoicism of the African in slavery as found in European literature and poetry from the 1770s to the end of the eighteenth century and coinciding with the high point of abolitionism. See, for example, Anonymous, *Jamaica, a Poem, in Three Parts. Written in that Island in the Year MDCCLXXVI* (London, 1777), particularly the classicising references found in Part III, lines 57 to 64. I am indebted to Geoff Quilley for bringing this poem to my attention.

47 Lefroy, *Outalissi*, p. 317 (concerning note T, p. 247).

48 Sypher, *Guinea's Captive Kings*, pp. 105–6, 108, 122.

49 Extract taken from Parkman's review as quoted in Washburn (ed.), *The Indian and the White Man*, pp. 439–41.

50 Recently, Henry Lowood has provided a fascinating account of the limitations and difficulties in conveying accurate information about America to sixteenth- and seventeenth-century European reading audiences. He reveals the extent to which publishers' control of new evidence about America was paramount to the ways in which this new information was presented to audiences. See Lowood, 'The new world and the European catalog of nature', in Karen Ordahl Kupperman (ed.), *America in European Consciousness, 1493–1750* (Chapel Hill and London, University of North Carolina Press, 1995), pp. 295–323.

VISUALIZING SLAVERY

Curiosities, commodities and transplanted bodies in Hans Sloane's *Voyage to ... Jamaica*

Kay Dian Kriz

Until very recently the human figure has been the primary focus of most art historical studies of the colonized Other and racialized subjectivities.[1] This is not surprising given the profound impact of Michel Foucault and other theorists of the body in critical analyses of colonial texts. While common sense also supports the notion that racialized power relationships are principally represented via images of the human body, scholars have recently begun to challenge this assumption and expand the field of visual inquiry to include landscape and natural history images, particularly in studies of India, Africa, and colonial America.[2] However, the West Indian colonies, so important to the economies of eighteenth-century England and France, have been remarkably resistant to studies of visual culture in general, and the little that has been produced still centres on images of the human figure.[3] The presence of a huge slave-labour force was one impediment to the production of celebratory images of the Caribbean colonies. Torn from their African homeland and forced to labour in a foreign land, slaves could not easily be rendered as natural features of the native landscape in the manner of English rustics or as local ethnographic curiosities, like the indigenous peoples of the Americas or even Africa.[4] There were, however, forms of visual imagery that represented through means other than the human figure the power relationships brought into play by slaves, their European masters, and indigenous peoples inhabiting the Caribbean colonies. One such group of images appeared in a work of natural history published early in the eighteenth century by Hans Sloane, an individual who is more widely remembered for being the founding father of the British Museum than for serving as personal physician to one of Jamaica's governors, the Second Duke of Albemarle. During the fifteen months Sloane lived in Jamaica (in 1687–88), he collected plant and animal specimens and hired draftsmen to produce sketches for a lavishly illustrated two-volume set titled *Voyage to the Islands Madera, Barbados, Nieves, S. Christophers, and JAMAICA, with the Natural History of the Herbs and Trees, Four-footed Beasts, Fishes, Birds, Insects,*

Reptiles etc. of the Last of Those Islands, published in two folio-sized volumes (vol. 1, 1707; vol. 2, 1725). In this essay I argue that this work, referred to here in its common short title form, the *Natural History of Jamaica*, can be seen not only as an attempt to catalogue plants and animals in the West Indies, but also to order and contain the diverse array of humans inhabiting the outer limits of an empire that was in flux. Although the story Sloane tells may take the form of a natural history, it is really a 'supernatural history' – a ghost story in which buried treasures and curious objects conjure up visions of the living, the banished and the dead. We will see that these particular people and objects prove remarkably resistant to a reordering of knowledge that attempts to stabilize and naturalize a network of power relationships through particular forms of classification and visual representation. Here I explore one aspect of the complex and highly fluid process by which multiple meanings are produced through visual representation: specifically, how certain images in Sloane's text become important sites for the staging of the conflict around the fixing and unfixing of power relations.[5] With one exception, the engraved plates in his *Natural History* do not picture human beings, which is not surprising, since 'man' became an object of natural history only later in the eighteenth century.[6] It seems all the more important, therefore, to understand how images of human artefacts, plants and animals helped articulate new and fraught relationships under construction in the Atlantic world.

The inability of a printed natural history such as Sloane's securely to define, and thus contain, the objects it pictures and describes runs counter to our modern, common-sense assumption that printing enables ideas to be fixed and reliably communicated through the publication of a single text, circulating in multiple copies. However, as Adrian Johns convincingly demonstrates, in the early modern period, 'far from the meaning of a book being fixed by the printing press ... [it is] something arrived at constructively, different communities pursuing interpretative conventions specific to their time and place'.[7] Sloane's *Natural History* is precisely this kind of unstable printed object – produced by a diverse array of individuals, and read, very likely in piecemeal fashion, by readers with widely different interests and capacities for engaging with the written and visual material on offer.

Despite this lack of fixity, institutions and individuals did attempt to mobilize printing as a way to confer authority by confirming particular forms of knowledge.[8] To enhance their professional authority and social status, physicians in seventeenth-century Europe used the medium of print to gain the respect of an international community of *literati*.[9] For a physician, establishing himself as a liberal gentleman meant publicizing the intellectual aspects of his field (for example, the close observation, description, and cataloguing of plants with potential medicinal value) and distancing himself from hands-on medical treatment. The significance of Sloane's *Natural History*, for its author and its public, depends upon the specific historical context in which it is read. Although the *Natural History* chronicles the physician's activities in Jamaica in the 1680s, a considerable time passed before the first volume was published in 1707; another eighteen years elapsed before the

second volume appeared. The historical circumstances of its publication, there-
fore, were somewhat different from that of its inception in the 1680s. After those
early years, Sloane's professional fortunes altered considerably and for the better –
by 1693 he was secretary of the Royal Society, and in 1712 he became Physician
Extraordinary to Queen Anne, continuing in that position under George I. He was
created a baronet in 1716, an honour rare among physicians at that time.[10] The
work thus served to confirm the professional status of a physician already highly
esteemed by his peers.

It would be a mistake, however, to see this publishing enterprise only as an
attempt to gain the esteem of *literati* in England, America and Europe. Another
obvious public for this work was the local British community of *virtuosi* that com-
prised of members of the Royal Society. Sloane not only served as secretary of the
Society from 1693 to 1713 and president from 1732 to 1741, but was deeply
involved in the publication of its *Philosophical Transactions* at the time that his
Natural History was being published and circulated. Although this organization
was dominated by titled and untitled gentlemen, courtiers, politicians, physicians
and the like, it also included a small contingent of merchants.[11]

One of the most active of these merchants was the apothecary and tea dealer
John Houghton, who published a weekly London newspaper, *A Collection for
Improvement of Husbandry and Trade*, from 1692 to 1703. Supplementing regular
lists of shipping in and out of the Port of London were feature articles designed to
promote various types of commercial ventures. In the issue for 20 December 1695
Houghton remarks on the large proportion of ships in the Port of London involved
in trade with the West Indies, and goes on to observe:

> In order to improve this *West-Indian* Trade, I believe it would be well worth while to
> have it some body's Business to make a good Natural History as well as can be, and to
> study how every thing therer [sic] may be improved, and what useful known matters
> grow in other Countries, that in Probability might grow there, and also to settle the
> *Guinea-Trade* for *Blacks*, which are the usefullest Merchandize can be carried
> thither, except *White-Men*.[12]

The publishing of West Indian natural history and 'settling' the African slave trade
are promoted here in the same breath, as closely associated activities that have a
direct bearing on the commercial fortunes of the nation. In this intertwining of the
commercial with the scientific, Houghton's newspaper and Sloane's eclectic natural
history can be seen as attempts to engage and to confirm the authority of very dif-
ferent types of readers: not only the liberal gentleman, schooled in the Latin classics,
but also the British man of commerce, whose economic mastery of the Caribbean
islands depended upon a pragmatic understanding of material that was diverse in
form as well as content. In the case of Sloane's illustrated folios, both written text and
the engraved images of plants, animals and human artefacts are constitutive of the
dominant discourse on this new colonial space and are inextricably linked.
Knowledge of the West Indies is predicated on the ability to read various types of

pictorial texts in conjunction with diverse written texts that are largely in English, but include crucial Latin insertions.[13]

Many earlier accounts of the West Indies, such as Gonzalo Fernández de Oviedo's *De la Natural Historia de las Indias* (1526) and Charles de Rochefort's *Histoire Naturelle et Morale des Iles Antilles de l'Amerique* (1665), also combined in an eclectic fashion descriptions and images of Caribbean flora and fauna with a commentary on the social life of the islands. However, Sloane's was the first major publication to combine a voyage-type commentary with a natural history catalogue in which plants and animals are identified by pre-Linnaean Latin tags that were often quite lengthy; these specimens are further described in English with extensive citations of other texts, and illustrated with 274 detailed engravings. Most of the engravings of plants are full scale and derive from tracings of living or dried specimens.[14]

Like all such illustrated books, the publication of the *Natural History of Jamaica* involved a diverse array of individuals. These included the scores of people – among them planters, African slaves, and Indians – who provided Sloane with plant and animal specimens.[15] Sloane hired a local amateur artist, the Reverend Garrett Moore, to travel around Jamaica with him and make on-the-spot sketches and drawings based upon collected specimens. Back in England, the Dutch artist Everhard Kick executed additional drawings and tracings from dried specimens. At least two engravers were involved in producing the plates: the Englishman John Savage and the highly regarded Flemish engraver Michael Van der Gucht. The project also required the services of unnamed printers and binders, and of course, Sloane, who directed all aspects of his publication, evident in the close coordination of plates and text.

In the introduction to Volume 2 the physician alludes to the collaborative nature of the publication in replying to charges by critics of Volume 1 that his illustrations are not exact. He explains that many of these images were made from dried plants, and

> that both the Person who fastened them into the Books, he who design'd them after-wards, and the Engravers have committed several Mistakes. I had observ'd Books of Natural History and Voyages to be so fill'd with Figures of Natural Productions made from relations by word of Mouth and Memory, that I was perhaps too nice in not cor-recting what was amiss, my Reason being, that if there were any Slips of that kind in the Prints, they were easily to be mended, by perusing their Descriptions.[16]

The author acknowledges the errors committed by these various individuals, but then offers a way of reading the text closely with the images as a corrective to these mistakes. The relationship between visual images and other forms of representa-tion is a complicated one, for while Sloane implies that his written descriptions possess more authority than the engravings, his insistence on making life-sized engravings from the tracings of actual plants derives from his dissatisfaction with images produced from 'relations by word of Mouth and Memory'.

Memory and descriptions passed by word of mouth cannot be dismissed quite so easily, however. The writing of history, natural or otherwise, is nothing if not the

reworking of various individual and communal memories, transmitted orally and via the written word and visual image. In the case of Sloane's *Natural History* these memories, drawn from widely varying times and places, inform the texts that accompany the images, animating the human artefacts and re-animating the plants and animals that are laid out with such apparent neutrality.

In his study of circum-Atlantic performance, Joseph Roach demonstrates that this type of re-embodiment, or 'surrogation', to use his term, is a key mechanism for the reproduction of Atlantic culture, identity and collective social memory. Surrogation is a complex process that occurs when crucial members of a society depart (through death or other means) and replacements are sought to fill the remaining vacancies. Such a process is rarely successful in exactly replicating the loss, since the substitute will either fail to fulfill expectations, or exceed them.[17] Roach's chief concern is with the written narratives, images, and performances that such attempts at replacement generate; these varied forms of representation and performance are constitutive of communal memories, which are then mobilized in the production of histories such as Sloane's.

This way of connecting the production of collective memory and history to the destruction and replacement of physical bodies can be usefully applied to the production of a West Indian natural history, which depends so heavily on the destruction of living plants and animals, their transformation into inert specimens, and their eventual 'replacement' by textual descriptions and full scale engravings. Furthermore, European colonization of the Caribbean involved a brutal series of human displacements and replacements, which led to the forging of memories and histories that depended upon active forgetting. Such attempts at erasure did not go uncontested. As Michel de Certeau has argued, the trace of what was excluded 'resurfaces, it troubles, it turns the present's feeling of being "at home" into an illusion'.[18] In the Caribbean context, such doomed efforts invariably were attempts to deal with various forms of violence, especially the violence involved in the enslavement and forced transportation of thousands of Africans from their homelands to the British West Indian colonies. The conflict within colonial histories such as Sloane's between the act of forgetting and the resurfacing of repressed and usually violent memories is driven not only by the guilty workings of the British collective unconscious; it is also fuelled by the pressure placed upon British colonizers by those whom they were attempting to subject or displace. In the case of Jamaica this pressure was exerted by Africans and their West Indian descendants, whose individual and collective acts of resistance ranged from armed rebellion to the parodying of European culture, and Spaniards, who formerly controlled Jamaica, and still were an active presence in the region.

Throughout Sloane's *Natural History*, conflict and violence are never far from the surface, as evidenced most clearly in the physician's dispassionate detailing of horrific slave punishments.[19] Violent narratives are a staple of New World travel literature and natural histories; what is striking about this text is the manner in which the fear of ubiquitous violence, emanating from the entire Jamaican ecosystem of

plants, animals, and humans, surfaces as latent content in the realm of the visual. In the discussion that follows I shall argue that it is in the strange disjunctions among particular images and between image and text that one can glimpse the traces of human conflict and resistance, most commonly expressed as the fear of a pervasive violence that is 'forgotten, but not gone'.[20]

Such tensions and disjunctions are apparent in the first plate of specimens (figure 16) to appear after the introduction to Volume 1.[21] Occupying a prominent position early in the text, this stunning double folio sheet was clearly designed to capture the visual attention of the reader/viewer. On the upper half of the sheet are two views of a land crab (from above and below), echoed in form, size and mass by a potsherd similarly shown verso and recto, placed in the lower half. These objects are rendered in a deep chiaroscuro that sets them off dramatically from the white background of the paper. A sense of three-dimensionality is conveyed via a multitude of finely engraved cross-hatchings and parallel lines that follow the contours of the crab's shell and pottery fragment. A consistent light source, originating above and to the right of the objects is indicated by the highlighted areas on the shard and, even more spectacularly, by the shadows of the claws that are cast on the exposed underside of the crab. The effect of the cast shadows on the crab is not simply to render the animal more comprehensible in three dimensions, but also to confirm that the drawing was produced at a particular moment, from an actual specimen placed on a flat surface and illuminated by a specific light source. This

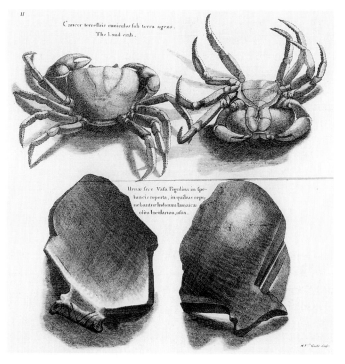

16 Michael van der Gucht, engr., 'Land crab and potsherd', engraving; from Hans Sloane, *Voyage to … Jamaica* (London, 1707), vol. 1, plate 2.

visual encoding of the material presence of the crab and shard serves to establish at the outset the scientific superiority of these engravings over those images, based upon memory, that the author had so strongly disparaged.

The similarity in treatment of the crab and the pottery shard (involving manipulations of both scale and form) invite the viewer to consider them both as natural history specimens that designate Jamaica as a strange and often dangerous space. The land crab, Sloane observes in his catalogue entry, looks like an ordinary European sea-crab, but makes burrows on land like a rabbit; it is good to eat, yet under certain circumstances, may be poisonous.[22] Throughout this account, the crab is both familiarized and made strange, represented as appealing and dangerous.

While the crab is identified in the illustration both by its Latin tag and common English name, the potsherd is described only in Latin as deriving from earthenware urns discovered in a cave containing the bones of an Indian who previously dwelled in Jamaica. In the discussion of these artefacts Sloane relates that near the plantation of a Mr Barnes were 'a human Body's Bones all in order, the Body having been eaten by Ants'; the skeleton lay in a cave that 'was fill'd with Pots or Urns, wherein were Bones of Men and Children'. Sloane describes the pots as dirty red and decorated with two parallel lines near the edge of the handles.[23] The account concludes with the comment that 'the *Negroes* had remov'd most of these Pots to boil their Meat in'.[24] Whereas in the Latin descriptor under the engraving it is Indians who are associated with the shards, in the Introduction the only identifiable bodies linked to them are those of Africans who transformed burial urns into cooking vessels for meat.

Thus the shard itself could signify quite differently for readers depending how they read these images: in conjunction with that of the poisonous crabs, with the Latin descriptor, if they had the ability to read Latin, and/or with that segment of the introduction discussing the artefacts. For Latin readers, the description of a dead Indian in a cave could conjure up visions of a distant Caribbean past when only native peoples populated the island, while the English text offers a more disturbing tale of carnivorous insects and Africans who remain active, ever-threatening presences. During the decades between Sloane's Jamaican sojourn and the publication of his two-volume *Natural History*, maroon communities made regular attacks on plantations, burning houses, killing whites, and carrying away livestock and slaves to the towns they established in the interior of the island.[25] The situation became so serious that in 1720 the Governor of Jamaica hired Miskito Indians, living off the coast of Honduras, to fight the maroons.[26] The combined efforts of the Miskitos and two British regiments were unsuccessful, for the maroon attacks continued unabated. In 1730 the Governor of Jamaica told the Assembly that the frontiers (that is, areas planters were attempting to settle toward the interior) were 'no longer in any Sort of Security [and] must be deserted'.[27]

Despite their visual assertiveness, the potsherd images do little to stabilize these alternative, but not contradictory readings between a seemingly pacific pre-colonial Jamaica and one racked with conflict between planters and militant communities of former slaves. The only things marking this object as a human artefact are the

crudely incised parallel lines that form a broken 'V' on its lower edge (although these markings along with the general shape of the shard also give it a shell-like appearance, further linking it to the crab).[28] These coarse incisions into the clay could be seen to display the technical primitiveness of their makers, especially when compared to the fine parallel and cross-hatched lines of the engraving that give the objects such a sense of volume and presence.

Both Africans and Indians had been in Jamaica prior to the arrival of the English, promoting further uncertainty about who made the pots and whose bones lay beside and inside them. As the well-known narrative of the Black Legend recounts, the Spanish slaughtered most of the indigenous people living on Jamaica, Cuba and Hispaniola in the sixteenth century when they resisted attempts at enslavement. Like other British writers on the New World, Sloane emphasizes the cruelty of the Spaniards towards the Indians, but also repeats the commonly held opinion that the Indians are not fit for 'slavish Work, and if checkt or drub'd are good for nothing'.[29] Imported Africans operated as a labour force capable of filling the cavity left by the Spanish genocide of indigenous islanders, for Africans, if properly disciplined, were reputed to be hard working. The disjunctions between visual image, Latin descriptor and English text effect a slippage between Indians and their African surrogates that unsettles the boundary between the living and the dead. In this instance, that boundary threatens to disappear altogether as the living appear to consume and supplant the dead through ingestion. While it was swarming ants that consumed the skeleton in the cave, and Caribs who were most famously characterized as cannibals, it is Africans who here are implicated in the act of cooking meat in pots containing the bones of their primitive predecessors.[30] For those Britons and Europeans intent upon rationalizing the terror of enslavement, there was a twisted colonial logic to this pattern of elision and substitution, whereby African cannibals replace flesh-eating Caribs. The cannibalism of Africans and Indians served as the ultimate sign of savagery so extreme that it could only be civilized by means of slavery. Enslavement by white Britons and Europeans, by this logic, was a necessary stage in the salvation, and ultimately, the 'liberation' of the Godless, man-eating savage.[31]

Reading such an image is obviously complicated by the way that written texts are mobilized in the act of interpretation. William Ashworth argues that sixteenth-century natural histories drew specifically upon the form of the emblem in producing knowledge about plants and animals.[32] Emblems consisted of a visual image, short label, and longer descriptive text. The moral of the emblem was not always apparent, and could often be worked out only by correctly interpreting all three elements. Although post-dating these emblematic natural histories by some hundred and fifty years, Sloane's text similarly depends upon interpreting images in tandem with their Latin and/or English labels and longer descriptive texts, now separated physically from the images. But, as we have seen, the triangulation between potsherd image, Latin descriptor and English text produces only an ambiguous and disturbing simulacrum of an emblematic moral that can neither speak openly of violence, nor fully repress it.

While the image of the potsherd alludes to an indigenous people who met a violent end, the culture of their African surrogates is imaged in the introduction to Volume I in a transcription of Afro-Caribbean music (figure 17). While this transcription is a form of writing, it also operates as visual image, distinguished from the text around it, that was meaningful even for those contemporary readers who could not read music. The descriptive above the music reads: 'Upon one of their Festivals when a great many of the Negro Musicians were gathered together, I desired Mr. *Baptiste*, the best Musician there to take the Words they sung and set them to Musick, which follows'.[33] This passage implies that Sloane and Baptiste were present at one of the festivals held in the slave quarters of a local plantation. Using the European system of notation Mr Baptiste attempted to transcribe the songs of different nations within Africa: two lines of music and words are reproduced under the label 'Angola', a single line (without words) designated as 'Papa', and an entire page given over to a Coromanti composition of ten lines.[34] Sloane sets the stage for the transcription by characterizing the performers in moral terms: 'The *Negros* are much given to Venery, and although hard wrought, will at nights, or on Feast days Dance and Sing; their Songs are all bawdy, and leading that way'.[35] In such a context the printed music becomes a visual sign of the slaves' sexual energy, an energy so excessive that it is undiminished by a life of forced and brutal labour.

The text that introduces Baptiste's musical transcription implicates its readers in a complex interplay of performances by inviting them to engage actively with the music in a manner that extends beyond registering moral disapproval of its

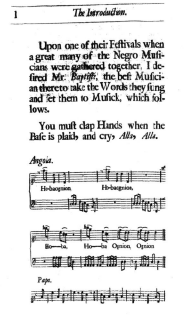

17 'Angola', 'Papa' and 'Koromanti', transcription of three African songs in Jamaica, engraving; from Hans Sloane, *Voyage to ... Jamaica* (London, 1707) vol. 1, pp. l–li.

bawdiness. The words inscribed just above the first line of music read: 'You must clap Hands when the Base is plaid, and cry, *Alla, Alla*'. The use of the pronoun 'you' invites the reader to participate in this Afro-Caribbean festival – fully to involve his or her body in clapping and crying out syllables that sound very much like invocations to a foreign god. These brief directives suggest that while refinement is a central dynamic of the sugar and slave trade – the refinement of black slave labour into the white sugar crystals that were such an integral part of the social rituals of polite culture in Britain and its colonies – the desire for savage pleasures also shaped the relationship between a nation of white masters and their African slaves. But those pleasures had also been refined by the very process of transcription and reproduction in a text that was designed to circulate on both sides of the Atlantic. One can only imagine what this 'Negro Music' would sound like within the walls of a London town house, picked out, perhaps, on a harpsichord, and chanted by English voices.

The musical instruments that the slaves themselves were said to have played at their gatherings are reproduced in a plate (figure 18) that appears among the introductory images and is also reproduced in the Natural History section of Volume 2. In the upper left quadrant of the sheet are three stringed wooden instruments, artfully arranged and grounded by a splash of shadow. The body of the two long-necked instruments is echoed formally by the enwreathed stalks of climbing vines and the neck by the thin, straight root of the *luteus* plant. These objects are rendered without shadow and directly abut the long-necked instrument closest to the viewer. Punning word play reinforces the visual cross-referencing of artefacts and natural specimens, since the Latin *luteus* literally echoes the English word Sloane uses to described the long-necked instruments ('lutes').[36]

The arrangement of the plant specimens also mimics other sorts of objects, used in rituals of slave punishment, not pleasure: ropes for binding resistant bodies and that most ubiquitous instrument of pain, the whip.[37] Indeed Sloane notes in his account of slave punishments that 'for Negligence, they are usually whipt by the Overseers with Lance-wood Switches, till they be bloody, and several of the Switches broken'.[38] This account closely follows the author's declaration on the preceding page that he could discern no religion among the Indians and Negros: 'Tis true they have several Ceremonies, as Dances, Playing, etc. but these for the most part are so far from being Acts of Adoration of a God, that they are for the most part mixt with a great deal of Bawdry and Lewdness'.[39] Just as the description of slave festivals seems to lead naturally to a detailing of slave punishments in the text, the visual interplay between the slaves' musical instruments and the arrangement of vines and roots that could connote lewd slave pleasures and slave punishments, serves to forge a seemingly natural link between these two activities. The hidden logic of such an association is that only harsh physical punishments will serve to contain a labour force of enslaved bodies that engage in such savage and wanton pleasures. In the section of the text specifically dealing with this plate Sloane underscores the savage, sexual and pagan nature of these performances by describing how the dancers tied rattles to their legs, and cow tails to their backsides

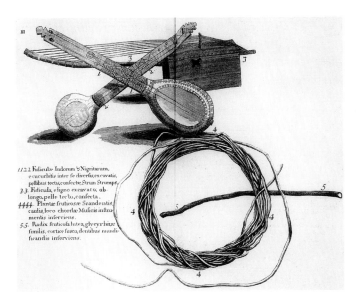

18 Depiction of
African 'lutes' and
Jamaican *luteus*,
engraving; from Hans
Sloane, *Voyage to ...
Jamaica* (London,
1707), vol. 1, plate 3.

and 'add[ed] such other odd things to their Bodies in several places, as gives them a very extraordinary appearance'.[40]

In an essay on the state of English reading preferences, first published in 1710, the Third Earl of Shaftesbury made starkly clear the apparent threat that overly graphic representations of the savage and the monstrous presented to the English reader. Shaftesbury railed against the modern preference for travellers' tales of exotic lands over the Greek and Roman classics: 'Our Relish or *Taste* must of necessity grow barbarous, whilst *Barbarian* Customs, *Savage* Manners, *Indian* Wars, and Wonders of the *Terra Incognita*, employ our leisure Hours, and are the chief Materials to furnish out a Library'.[41] Underlying this tirade is the fear that the civilizing process could operate in reverse, that colonial exchange could unleash savage appetites at home rather than bring refinements to the 'barbarians' encountered in the New World and elsewhere. Shaftesbury was not the only proponent of the 'ancients' to do battle with those 'moderns' that were writing about the New World. In 1709 William King published the third and final number of his short-lived satirical periodical, *Useful Transactions in Philosophy, and Other Sorts of Learning*; the entire fifty-seven page issue was a send-up of Sloane's first volume, titled 'Voyage to the Island of Cajamai in America'.[42] The reader is told in a publisher's introduction that the author of the 'Voyage to ... Cajamai' is a Dutchman, one Jasper Hans Van Slonenbergh, a transformation in nationality not lacking in significance for those aware of the negative opinion of Dutch character routinely registered within anti-commercial, civic humanist writings by *literati* such as Shaftesbury.[43] The antithesis of the high-minded ancient Greeks and Romans, the modern inhabitants of the Low Countries were often represented as practical but uncultivated, even boorish individuals, driven in their desire for personal wealth to

pursue a vigorous commerce. This Dutch crudeness characterized 'Van Slonenbergh's' account of Cajamai, for King later ironically defends the author's inclusion of 'observations which run sometimes a little upon *the nasty*, [and] are made from the meanest actions of mankind, and the very dregs of Nature'.[44]

Some of King's examples of this 'nastiness' are quoted verbatim from the medical histories appearing at the conclusion of the introduction to Volume 1. Indeed, this section of Sloane's text seems to offer strong evidence that Shaftesbury's and King's worst fears about the corruptibility of the white English body had already been realized in Jamaica. Resounding throughout these case histories is the message that dissolute behaviour, not the tropical climate, is a primary cause of illness and death among both the white and black population of the island. While blacks are frequently described as 'lusty' or suffering from venereal diseases, their white masters are repeatedly chastised for their overindulgence of alcohol, particularly rum punch.[45] This point was made quite graphically in the very first medical history, which describes the physician's failed attempts to treat a Captain Nowel who 'had drunk very hard, and was very thin of Flesh'.[46] The account ends with a horrific and bizarre inversion of the master/slave relationship, for it relates that the man's excessive drinking (of brandy and sugar) prevented him from taking solid food and reduced him to suckling at the breast of his black slave for sustenance.[47]

Taken as a whole, Sloane's medical histories trace a picture of ritual bonding among the white male population of Jamaica forged by regular bouts of late-night drinking. These celebrations of white masculinity involving rum punch and nocturnal merry-making may usefully be compared with the earlier description of the slave festival. Recall that in this account Sloane implicitly links the extraordinary transformations of the slave's bodies through costume and movement to their unbridled sexuality and irreligiosity. While the rituals of communal bonding among African slaves involved temporary and reversible transformations of the body via rattles and cow tails, the rites of homosocial bonding among the white male population of Jamaica threatened more permanent, and arguably more monstrous transformations of bodies weakened and often destroyed by the ingestion of those very commodities – rum and sugar – that the slave economy provided in such abundance.

Could this be the reason that Sloane's *Natural History* contains so few visual images directly relating to the production of sugar and its by-products? The sugar cane (figure 19) is not given the prominence of the fruit trees or jellyfish that are featured as curiosities in the plates following the introductory section of each volume. Indeed, sugar no longer could claim the status of a rarity, for the period that encompassed Sloane's sojourn in Jamaica and the production of his two-volume text saw the transformation of sugar from a precious luxury item, formed into elaborate sculptures decorating the tables of the wealthy, to a staple foodstuff in upper-class homes.[48] Sloane's catalogue entry on sugar acknowledges its commodity status by stating that the production and refinement of sugar is so well known that it does not bear repeating.[49] The visual treatment of the sugar cane, however, gives no hint of its central role in the Atlantic economy. Buried in the middle of Volume 1, with only its

Latin descriptor to guide viewers, the plant, with its delicate foliage, is virtually unrecognizable to all but those already familiar with it. Its most identifiable and economically important feature, the cane, has been eliminated by an amputation that was performed in the process of translating the specimen into a drawing, for the actual specimen still survives and boasts a stalk over six inches long. Such a decision was not dictated by the physical limitations of page size. For example, in the case of the grass labelled by Sloane '*gramen dactylon bicorne tomentosum*' (figure 20), the problem of fitting on to a single page a long-stemmed plant is solved by showing a segment of stem beside the foliated top. This solution was not adopted for the sugar cane. The truncation of the sugar cane, its reduction to a specimen marked by delicate foliage, seem to disavow its status as a commodity requiring hard labour to refine it into a product for the European table. In the process of making the sugar cane into a specimen and the specimen into an image, this most lucrative West Indian commodity has been refashioned as (just another) plant, its grass-like character emphasized not only by the elimination of the cane, but also by its insertion into that section of the natural history catalogue devoted to grasses and reeds.[50]

The only New World product to be portrayed as a commodity grown and harvested for profit is one that was not associated with British colonies. Plate 9,

19 Michael van der Gucht, engr., 'Arundo saccharifera' ['Sugar cane'], engraving; from Hans Sloane, *Voyage to ... Jamaica* (London, 1707) vol. 1, plate 66.

20 'Gramen dactylon bicorne tomentosum', engraving; from Hans Sloane, *Voyage to ... Jamaica* (London, 1707), vol. 1, plate 15.

appearing after the introduction to Volume 2 (figure 21), depicts Indians in Oaxaca harvesting cochineal beetles from prickly pear cactus plants. The red dye that was produced from the dried beetles was highly prized by Europeans, especially the Spanish; they collected it as tribute from the Indians, who cultivated the insects and cacti at various sites in Mexico.[51] Readers of Sloane's text who were familiar with the highly competitive market for New World commodities would appreciate the importance of cochineal, which had earned the Spanish profits in Mexico second only to silver.[52] As the only exporter of the extremely valuable dye, the Spanish had jealously guarded the secret of its origins. The true source of the red pigment was a topic of much speculation within the non-Spanish scientific and mercantile community, since the dried meal that comprised it was neither identifiably insect nor vegetable matter.[53] Sloane correctly identifies the beetle as the source of the dye in his text, a point that is reinforced in the print.[54] The superimposition of two views of the beetle in the upper right-hand corner of the landscape offers visual testimony that the secret was out, and therefore, theoretically, the Spanish could no longer claim sole rights to profit from this lucrative commodity. The fact that only Indians are represented in the image as the producers of cochineal dye further emphasizes

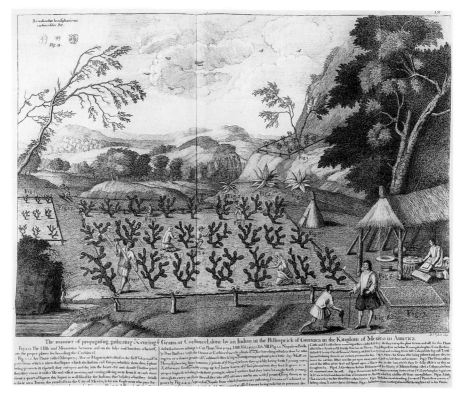

21 Michael van der Gucht, engr., 'The manner of propagating, gathering & curing the Grana or Cochineel', engraving; from Hans Sloane, *Voyage to … Jamaica* (London, 1725) vol. 2, plate 9.

Spanish vulnerability in this particular market.[55] Spaniards lacked the practical knowledge necessary to produce the dye, because the Indians pointedly resisted all attempts at standardizing the complex process of production.[56]

Set in Sloane's publication this curious Mexican landscape has the potential to call to mind other conflictual relationships beyond those of resistant Indians and tribute-seeking Spaniards.[57] The seemingly unrepresentable white English masters and their black African slaves also find their surrogates in these indigenous labourers working in the field and making tortillas. The image does not shrink from representing those relations of domination and submission that were so characteristic of colonial agrarian economies. But this is domination with a difference: in the foreground a native man doffs his hat and bows before another, identified in the text below the print as a cacique (chief) descended from Moctezuma. In a British publication about a colony based upon slave labour, this representation of courtly obeisance between freeborn Indians appears as a grotesque parody of European civility, rather than an utopian alternative to the plantation system that animated the Jamaican economy.

The authenticity of this depiction of a New World harvest is secured by the attribution of the original drawing to an indigenous artist on site in Oaxaca even though, according to Sloane, the engraving was not made from the original, but rather a copy that had been sent to the South Sea Company.[58] Although there is no way of knowing if an Indian actually produced the original drawing, my concern is what the stakes are in such an ascription. The fact that this engraving was allegedly based upon a drawing made on site by a native enhances both its value as a curiosity and its status as the empirical record of an eye-witness. The primitive hand and observing eye of the native artist are visually encoded as technical crudeness in the way the various elements of the composition fail to come together. The classicized landscape in the background loosely follows European conventions, based on academic seventeenth-century Franco-Italianate painting, for rendering the landscape as a series of receding planes framed by side screens of trees and hills. Incongruously placed before this classical backdrop are scenes showing various stages of cochineal production: growing the prickly pear cactus on which the beetles live, harvesting and drying the beetles, and fashioning the dried cochineal into tortillas. The spatial and temporal conflation of several stages in the production of the dye derives from a less aesthetically elevated pictorial tradition of representing agricultural production, evident in images of sugar-cane harvesting and refining that appear in the seventeenth-century New World accounts of William Piso, Jean-Baptiste du Tertre (see figure 22), and Charles de Rochefort.[59] While the background follows traditional Albertian perspective, the middle ground is steeply tilted forward, a documentary technique commonly used in Anglo-European estate portraiture, in order to render each of these processes as clearly and comprehensibly as possible.[60] Enhancing the incongruity of this image, with its odd amalgamations of various landscape genres and perspectival systems, is the disposition of human figures, which are unconvincingly introduced into the space of the foreground and undergo odd changes in scale

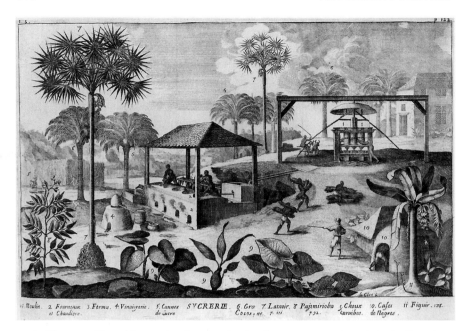

22 Le Clerc, engr., 'Sucrerie', engraving; from Jean-Baptiste du Tertre, *Histoire Générale des Antilles Habitées par les François* (Paris, 1667–71), vol. 2, following page 122.

in the middle ground. Three systems of representation, then, operate in this landscape, each serving to substantiate the authority of the image based upon different forms of knowledge: the knowledge of the 'primitive' eye witness, the refined and aestheticized knowledge of the Anglo-European cosmopolitan, and the commercially useful knowledge of the New World entrepreneur.

Just as the compositional incoherence of the cochineal harvest scene testifies to the multiple and often contradictory demands (commercial, aesthetic, scientific) placed upon it, so the *Natural History* as a whole is marked by incoherencies that attests to the diverse interests, desires and fears of its producers and readers. Not only do the engravings include an eclectic mix of artefacts, flora and fauna, but the text itself is a patchwork of genres, from scholarly citation and empirical description, to various sorts of anecdotal accounts and first-person narratives. As Katie Whitaker notes, these shifts of style and genre serve as a way of inciting the wonder and curiosity of the reader.[61] Whereas notionally natural histories were catalogues of all the plants and animals to be found in a particular area, their success and popularity, particularly among the wide public that Sloane was determined to address, depended upon the description and illustration of the unusual or curious, rather than the typical. Sloane acknowledged the need to feed this rage for novelty in the introduction to Volume 2, which he called more 'curious' than Volume 1 because it contained previously unrecorded descriptions of animals and figures of fruit trees from Peru and other parts of the world.[62]

The inability of these volumes to fix a set of secure meanings around human arte-
facts and natural specimens is in part due to the violent nature of the colonial enter-
prise in Jamaica. The failure also arises from a related demand placed upon this
particular type of publication. The scientific authority of the natural history requires
that flora and fauna be transformed into fully comprehensible objects. The wider
appeal of such a project, however, also depends upon the presentation of rarities that
had been associated with the Indies even before Columbus.[63] As Stephen Greenblatt
notes, such marvels embody both the fears and desires aroused by the strangeness of
a new world that exceeds European understanding.[64] Although the marvels and
monsters recorded by Columbus differ from those curiosities recorded by Sloane,
the problem of both retaining and containing their difference persists. If the curiosi-
ties represented become too thoroughly pacified in the process of visual and verbal
representation then their capacity for arousing the wonder and desire of the reader is
sharply diminished. Too little pacification threatens to expose an Otherness that
cannot be known and, even more worryingly, cannot be physically contained.

Other difficulties in the representation of curiosities arose from their vulnera-
bility to overexposure. Curiosities lose their status as rarities once their images and
descriptions are reproduced and circulated in texts such as Sloane's or once they
themselves are transformed into commodities such as sugar. The need to image
curiosities also explains why the African instruments are featured rather than sugar
cane, and why a scene of cochineal gathering replaces one of the sugar harvest.
Although there is evidence that Sloane may have downplayed sugar and empha-
sized other potential crops in order to promote a diversified Jamaican economy, by
the time his two volumes were published and circulated sugar's dominance over
other commodities was firmly established, a fact discernible not only in export sta-
tistics, but also the greatly increased numbers of African slaves transported there.[65]
In the context of a burgeoning sugar monoculture, then, these images offer up their
curious objects not simply as alternatives or replacements; they are also displace-
ments, surrogates for the raw materials and especially the slaves involved in the
production of the most important commodity to be traded on the world market in
the eighteenth century. Displaced but not erased, these memory traces of the plan-
tation economy return like unbidden ghosts to re-animate these uncanny surro-
gates that seem so anxious to disavow their existence. Unlike most ghosts, many of
the black slaves and white colonists who haunt this early eighteenth-century text
were neither dead nor newly departed at the time of its publication, but they were
banished from the realm of visual representation because of the pressing and very
different demands placed upon images versus words.

It is telling that the next major American natural history to appear after
Sloane's, Mark Catesby's *The Natural History of Carolina, Florida and the Bahama
Islands* (London, 1731–43), eschewed illustrations of human artefacts as a means of
engaging the curiosity and interest of readers; West Indian natural histories pro-
duced later in the century followed Catesby's example. One explanation of this
change is that Catesby and those who followed him were attempting to produce a

more systematic and scientific account of the natural world that privileged knowledge obtained through vision, and relied upon the physical description, ordering and imaging of normative and generalized specimens. This narrowing of the field of inquiry was closely associated with the professionalization of the life sciences, which relegated curiosities and emblematic images to the realm of popular culture and the domain of amateur pursuits. The fears of violence registered in the curious images that introduce Sloane's *Natural History* suggests that the pressure for this restructuring of scientific knowledge derived not only from learned amateurs and scientists vying for professional authority at the metropolitan centres of empire; it also arose from the colonial periphery, where subject peoples refused to submit peacefully to the 'natural order' of an economy based upon their exploitation and commodification.

Notes

This is a revised version of an article that appeared in *William and Mary Quarterly*, 3rd series, 57:1 (January 2000), 35–78. It is reproduced here by courtesy of the *William and Mary Quarterly*. Many thanks to Geoffrey Quilley for his suggestions and comments on this revised version of the essay.

1 Notable examples of works dealing with representations of Africans by various colonial powers are David Dabydeen's ground-breaking *Hogarth's Blacks: Images of Blacks in Eighteenth-Century English Art* (Athens, University of Georgia Press, 1987); Albert Boime's *The Art of Exclusion: Representing Blacks in the Nineteenth Century* (Washington DC, Smithsonian Institution Press, 1990); and Hugh Honour's *The Image of the Black in Western Art*, vol. 4: *From the American Revolution to World War I* (Cambridge MA and London, Harvard University Press, 1989).

2 See Amy Meyers, 'Picturing a world in flux: Mark Catesby's response to environmental interchange and colonial expansion', in Amy R. W. Meyers and Margaret Beck Pritchard (eds.), *Empire's Nature: Mark Catesby's New World Vision* (Chapel Hill, University of North Carolina Press, 1999), pp. 228–61; Beth Fowkes Tobin's chapter on natural history images of India in her *Picturing Imperial Power: Colonial Subjects in Eighteenth-Century British Painting* (Durham NC and London, Duke University Press, 1999), pp. 174–201; David Bunn, '"Our wattled cot": mercantile and domestic space in Thomas Pringle's African landscapes', in W. J. T. Mitchell (ed.), *Landscape and Power* (Chicago and London, University of Chicago Press, 1994), pp. 127–74.

3 For the French Antilles see Helen Weston's essay in this collection, and Viktoria Schmidt-Linsenhoff, 'Male alterity in the French Revolution: two paintings by Anne-Louis Girodet at the Salon of 1798', in Ida Blom *et al.* (eds.), *Gendered Nations: Nationalisms and Gender Order in the Long Nineteenth Century* (Oxford, Berg, 2000), pp. 81–106. One of the very few scholars to examine images of the British West Indies is Beth Fowkes Tobin; see her excellent chapter on Agostino Brunias in *Picturing Imperial Power*.

4 I discuss how Brunias's images of slaves and free people of colour complicate the category of the ethnographic in my forthcoming book, *Slavery, Sugar and the Culture of Refinement*.

5 The most thorough recent account of Sloane's *Natural History* is in Arthur MacGregor (ed.), *Sir Hans Sloane: Collector, Scientist, Antiquary, Founding Father of the British Museum* (London, British Museum, 1994).

6 Nicholas Hudson, 'From "nation" to "race": the origin of racial classification in eighteenth-century thought', *Eighteenth-Century Studies*, 29:3 (1996), 247–64, p. 251.

7 Adrian Johns, 'Natural history as print culture', in N. Jardine, J. A. Secord and E. C. Spary (eds.), *Cultures of Natural History* (Cambridge, Cambridge University Press, 1996), pp. 106–7.

8 Johns explores this issue at length in his *The Nature of the Book: Print and Knowledge in the Making* (Chicago and London, University of Chicago Press, 1998).

9 Anne Goldgar, *Impolite Learning: Conduct and Community in the Republic of Letters 1680–1730* (New Haven, Yale University Press, 1995), pp. 12–26.

10 MacGregor, *Sir Hans Sloane*, p. 15.

11 Michael Hunter, *The Royal Society and Its Fellows 1660–1770: The Morphology of an Early Scientific Institution* (Chalfont St Giles, British Association for the History of Science, 1994), p. 26.

12 John Houghton (ed.), *A Collection for Improvement of Husbandry and Trade*, 20 December 1695.

13 Sloane published an unillustrated Latin catalogue of Jamaican plants (*Catalogus Plantarum*) in London in 1696. Setting the later natural history in English and framing it with the account of the voyage, augmented with plates containing curious human artefacts, all can be seen as calculated to expand the readership for the book beyond this circumscribed circle of *cognoscenti*.

14 The plants acquired by Sloane in Jamaica were pasted into eight volumes that are now part of the massive Sloane Herbarium, housed in the Botanical Library at the Natural History Museum in South Kensington. One can easily make out indentations around those specimens that were traced in order to make drawings for the engravings.

15 Sloane, *Voyage to the Islands Madera, Barbados, Nieves, S. Christophers, and JAMAICA, with the Natural History of the Herbs and Trees, Four-footed Beasts, Fishes, Birds, Insects, Reptiles etc. of the Last of those Islands* (London, British Museum, 1707), vol. 1, preface (unpaginated).

16 Sloane, *Natural History*, vol. 2, viii.

17 Joseph Roach, *Cities of the Dead: Circum-Atlantic Performance* (New York, Columbia University Press, 1996), p. 2.

18 Michel de Certeau, *Heterologies: Discourse on the Other* (Minneapolis, University of Minnesota Press, 1986), pp. 3–4.

19 Sloane, *Natural History*, vol. 1, lvii.

20 Roach, *Cities of the Dead*, p. 31.

21 Most of the images that I will be considering are part of a group of eleven plates numbered separately from the 274 plates that comprise the 'Natural History' proper. The placement of these eleven plates – four in volume 1; seven in volume 2 – varies from copy to copy, but in all cases that I know of they precede the 274 sequentially numbered plates, testifying to their importance as images designed to capture the attention of readers. These select images include a map and landscape; the remainder depict human artefacts, exotic animals and plants.

22 Sloane, *Natural History*, vol. 2, p. 269.

23 Sloane, *Natural History*, vol. 1, lxx.

24 Sloane, *Natural History*, vol. 1, lxxi.

25 Maroon communities were originally composed of Africans and their descendants who were enslaved by the Spanish. After the British took possession of the island, these communities continued to be augmented by runaway slaves.

26 Mavis Campbell, *The Maroons of Jamaica, 1655–1796: A History of Resistance, Collaboration and Betrayal* (Granby MA, Bergin and Garvey, 1988), p. 54.

27 Report of Address to Assembly, *Journal of the House of Assembly, Jamaica*, 2 (1730), p. 708, cited in Orlando Patterson, *The Sociology of Slavery* (Rutherford, New Jersey, Fairleigh Dickinson University Press, 1969), p. 270.

28 I am grateful to Geoffrey Quilley for noting the similarity of the potsherd to the form of a shell.

29 Sloane, *Natural History*, vol. 1, xlvi.

30 While cannibalism featured in some Anglo-European accounts of Africa in the decades around 1700, cannibals were still strongly identified as Amerindians. See Peter Hulme, *Colonial Encounters: Europe and the Native Caribbean, 1492–1797* (London, Methuen, 1986) and Philip Boucher, *Cannibal Encounters: Europeans and Island Caribs, 1492–1763* (Baltimore, Johns Hopkins University Press, 1992).

31 Hulme, *Colonial Encounters*, p. 99.

32 William Ashworth, 'Natural history and the emblematic world view', in David Lindberg and Robert Westman (eds.), *Reappraisals of the Scientific Revolution* (Cambridge, Cambridge University Press, 1990), pp. 303–32, see especially pp. 311–18.

33 Sloane, *Natural History*, vol. 1, l.

34 Richard Rath notes that this is the first extended attempt to transcribe into European notation music that appears to originate from different African nations: Rath, 'African music in seventeenth-century Jamaica: cultural transit and transition', *William and Mary Quarterly*, 50:4 (October 1993), 700–26, p. 711.

35 Sloane, *Natural History*, vol. 1, xlviii.

36 Many thanks to Tom Gretton for pointing out this pun on 'lute'.

37 I would like to thank Caroline Arscott for her astute observations on the visual play between the arrangement of these natural specimens and objects of punishment.

38 Sloane, *Natural History*, vol. 1, lvii.

39 Sloane, *Natural History*, vol. 1, lvi.

40 Sloane, *Natural History*, vol. 1, xlix.

41 Anthony Ashley Cooper (3rd Earl of Shaftesbury), 'Advice to an author' (1710); reprinted in *Characteristics of Men, Manners, Opinions, Times, etc.* (London, 1727), vol. 1, p. 344.

42 [William King], 'Voyage to the island of Cajamai in America', *Useful Transactions in Philosophy and Other Sorts of Learning*, 3 (May–September 1709), pp. 1–57. This is reprinted in *The Original Works of William King, LL.D* (London, 1776), vol. 2, pp. 132–78.

43 David Solkin, *Painting for Money: The Visual Arts and the Public Sphere in Eighteenth-Century England* (New Haven and London, Yale University Press, 1992), pp. 50–1.

44 [King], 'Voyage', p. 135.

45 Sloane, *Natural History*, vol. 1, xxvi.

46 Sloane, *Natural History*, vol. 1, xc.

47 Sloane, *Natural History*, vol. 1, xci.

48 James Walvin, *Fruits of Empire: Exotic Produce and British Taste, 1660–1800* (Basingstoke, Macmillan, 1997), pp. 129–30.

49 Sloane, *Natural History*, vol. 1, p. 109. However, he goes into some detail in describing the process of sugar refining in the Introduction to this volume (pp. lx–lxii).

50 I am indebted to Kermit Champa for his perceptive comments on the placement of the sugar cane engraving in the natural history section.

51 Murdo J. Macleod, 'Forms and types of work, and the acculturation of the colonial Indian of Mesoamerica: some preliminary observations', in Elsa C. Frost *et al.* (eds.), *El Trabajo y los Trabajadores en la Historia de Mexico* (Mexico, El Colegio de Mexico, 1979), pp. 86–7.

52 Susan Fairlie, 'Dyestuffs in the eighteenth century', *Economic History Review* 17:3, (1965), p. 501, n. 2.

53 As Sloane indicates, some writers claimed that the cactus was the source of the dye (*Natural History*, vol. 2, pp. 152–4).

54 For the textual reference see Sloane, *Natural History*, vol. 2, vi.

55 In fact the Spanish maintained their control of the cochineal market until the end of the eighteenth century, when the first live beetles were smuggled out of Mexico (Fairlie, 'Dyestuffs', p. 502, n. 1).

56 Macleod, 'Forms and types of work', p. 87.

57 Macleod, 'Forms and types of work', pp. 86–9.

58 Sloane, *Natural History*, vol. 2, vi.

59 William Piso, *De Indiae Utriusque Re Naturali et Medica* (Amsterdam, Elzevirios, 1658), woodcut of sugar mill, p. 108; Jean-Baptiste Du Tertre, *Histoire Générale des Antilles Habitées par les François* (Paris, Thomas Jolly, 1667–71), engraving of sugar production, vol. 2. after p. 122; Charles de Rochefort, *Histoire Naturelle et Morale des Iles Antilles de l'Amerique* (Rotterdam, Arnout Leers, 1665), engraving of sugar mill, vol. 1, after p. 332.

60 Many thanks to Geoffrey Quilley for pointing out the connection of this perspective device to estate portraiture. See for example the work of Flemish artist Jan Siberechts, who undertook estate portraiture in England as well as his native Flanders.

61 Katie Whitaker, 'The culture of curiosity', in Jardine, Secord and Spary (eds.), *Cultures of Natural History*, p. 87.

62 Sloane, *Natural History*, vol. 2, iv.

63 Stephen Greenblatt, *Marvelous Possessions: The Wonder of the New World* (Chicago, University of Chicago Press, 1991), p. 74.

64 Greenblatt, *Marvelous Possessions*, p. 75.

65 The physician is quite explicit about this aspect of his publication: 'Another use of this History may be, to teach the Inhabitants of the Parts where these Plants grow, their several Uses, which I have endeavour'd to do, by the best Informations [sic] I could get from Books, and the Inhabitants, either *Europeans, Indians* or *Blacks*' (*Natural History*, vol. 1, lxvi). On increasing numbers of slaves, see Richard Dunn, *Sugar and Slaves: The Rise of the Planter Class in the English West Indies 1624–1713* (Chapel Hill, University of North Carolina Press, 1972), pp. 203–4 and 119.

5

Pastoral plantations: the slave trade and the representation of British colonial landscape in the late eighteenth century

Geoff Quilley

Most of the essays in this volume, for sound and important reasons, examine the issues surrounding the visual cultural construction of colonial identities through an analysis of the human figure in one guise or another. Since identity may be said fundamentally to be produced at the level of the individual, such analysis is an obvious requirement. Furthermore, given the increasing recourse among the commercial and colonizing nations of eighteenth-century Europe to somatics and the aesthetic as mechanisms by which individual identity was understood to be conjoined with the larger collectivity of the state or nation, the primacy of the individual body as the focus for analysis is also evident.[1] However, it is by reference not only to the sign of the human figure, but to a much wider set of signifying systems that cultural identities are formulated. Since around 1980, study of eighteenth- and early nineteenth-century British art has investigated the role of landscape in visual and literary culture as a cipher for highly complex sets of social and economic relations and identities, which through their displacement on to an established aesthetic convention of landscape representation, and its related poetic forms of pastoral, georgic and eclogue, are subject to a process of mystification.[2] Yet, by concerning itself exclusively with Britain, much of this scholarship has neglected the crucial role of landscape in the transnational discourse on empire and colonialism; and, as a corollary, to consider how landscape, as an imperial category through which both linkages and differences between metropolis and colony could be established, throws into flux the whole issue of what comprised British and colonial identity at this period.

This essay will focus upon the work of the relatively little-known landscape painter, George Robertson. The two series of engravings, published by John Boydell during the 1770s and 1780s, of Robertson's views of Jamaica and Coalbrookdale will be considered as a case study, to analyse how connection and difference among Britain, the West Indies and Africa – the three points of the 'Atlantic triangle' – were articulated through the discourse of and on landscape.

What I want to propose is that Robertson's views of Jamaica, in their more or less explicit associations with his patron William Beckford of Somerley, and in their connections with, and differences from, a metropolitan discourse of landscape, present a creolized landscape, which may be offered (though not unproblematically, as will be seen) as the environment for the full realization of the identity of the independent, indigenous, white creole planter.

Robertson's images are exceptional in several respects, as I shall explain, but first and foremost in simply providing visual representations of the West Indies. The paucity of visual material treating of the Caribbean colonies no doubt has something to do with artistic patronage. West India planters of the stature of William Beckford of Fonthill, for example, employed the most fashionable and talented artists of the contemporary, metropolitan social scene, as part of an absentee planter class, dissociating their display of cultural refinement from the source of their prosperity. Alternatively, while merchants involved in the slave trade certainly did buy paintings, they tended to buy them as cultural accessories, in order, again, to associate themselves further with the norms of taste and culture of the polite metropolitan society to which they aspired. Therefore they bought works by recognized artists usually of genteel subjects, particularly Dutch or French 'old masters'.[3] Art would thereby serve to distance the slave-trader from the source of his material means of acquiring it, in a culture where trade in general, not just slavery, was held in suspicion, and wealth supposed to be disinterested. Furthermore, the West India planter and the slave trader were not renowned for their concern with aesthetics, and it is therefore unlikely that they would have provided much of a source of artistic patronage.[4]

An exception to the conventional view of the planter as barbaric and unsophisticated was claimed for William Beckford of Somerley.[5] One admirer and apologist, recalling a visit to the Hertford plantation of 'Benevolus' in Jamaica, terms him a 'real West Indian'.[6] This appellation is a complex one, since by it the writer means at once a hybrid character, in whom the best aspects of European civilization are united with a natural colonial innocence. As Keith Sandiford has written, Beckford presents himself in his own writings as an ideal creole, a figure whose identification with the colony is so complete that he is a fully autonomous colonial subject.[7] Yet the creole is also the embodiment of the immanent destruction of such a hybrid ideal, whose integrity is doomed to be brought low by the very lack of civilized values in the colonial environment of which he is the product.[8] The realness, therefore, of the 'real West Indian' is oddly chimerical. On the one hand, 'Benevolus' is a 'man of taste and learning; and a description would but picture the elegance of European manners, turning all that the climate offers to the best advantage'.[9] It is worth noting here that this 'real' hybrid is formed from the interposition of 'European manners' into the colonial 'climate', and, by implication, the landscape: the raw material of the colony is realized – or, perhaps better, is creolized – in being transformed into a suitable ground for the cultivation of the 'real West Indian' – through a metropolitan perspective upon it, comprising 'conversation, books, music, drawing, riding,

bathing, fishing'.[10] On the other hand, the 'real West Indian' only confirms, by his very exceptionality, the true savage immorality of the colony: the author sees 'in Benevolus himself ... a fresh instance to establish it. The real West Indian, sooner or later, becomes a prey to the harpies of his country – his own heart is too honest and too open'.[11] This is undoubtedly a reference to the fact that Beckford was at this time in Fleet prison for debt, where he wrote his own *Descriptive Account of Jamaica* (1790). His imprisonment was the result of financial mismanagement, of natural disaster – notably, the 1780 hurricane, to which he devotes considerable space in the *Descriptive Account* – and to a degree, as his apologist here protests, of the exploitation of his weakened situation by his creditors.[12] By a remarkable irony, this ideal creole figure was presently in that sink of metropolitan disrepute, the debtor's gaol; a situation which might itself be read as a demonstration both of the degree of his vulnerability, and of the capacity for moral decline intrinsic to his social status as a Caribbean planter. In large part, therefore, the 'real West Indian' is a construction of a colonial *beatus ille*, that figure of classical pastoral and georgic poetry, who either existed in a state of prelapsarian grace in Arcadian nature, or was able to escape the commercial depradations and moral insecurities of civic life to an isolated rustic estate, where he could be restored to a true, harmonious accord with nature. This was, however, acknowledged to be unsustainable in the material actuality of colonial-metropolitan circumstances. The idea of the *beatus ille* here is not far-fetched: Beckford in his own description of Jamaica devotes some space to a discussion of this pastoral ideal.[13] Janet Schaw, likewise, drew on the same idea in her account of Antigua: 'It appears a delightful Vision, a fairy Scene, or a peep into Elysium; and surely the first poets that painted those retreats of the blessed and the good, must have made some West India Island sit for the picture'.[14]

Two observations need to be made immediately. First, this construction makes no allowance for the possibility that anyone but the creole gentleman-planter might be a 'real' West Indian. It relies upon a displacement of the history of the native Indian population (long since exterminated, of course, but whose traces were visible across Jamaica),[15] and of the contemporary actuality of a heterogeneous population of widely varied origins, including the transported slave, indigenous maroon, mulatto, metropolitan trader and factor, any or all of whom might claim to be equally as 'real' as 'Benevolus'.[16] Second, therefore, it brings starkly into question the issue of what could constitute the 'real' in the protean, fluid and unstable colonial environment.

It is surely not accidental in this context that the reality of this identity is substantially represented through reference to the landscape, nor that the landscape of the West Indies is such a constant and dominant concern in eighteenth-century accounts of the islands. To an extent, this is to be expected: the planter was 'realized' economically and materially through his exploitation of the land; and the evocation of the gentleman-planter as a type of *beatus ille* has clear associations with a pastoral landscape convention. It is also important to remember the substantial connections established by W. J. T. Mitchell and others between the discourses of landscape and imperialism. As Mitchell writes,

> Landscape might be seen ... as something like the 'dreamwork' of imperialism,
> unfolding its movement in time and space from a central point of origin and folding
> back on itself to disclose both utopian fantasies of the perfected imperial prospect and
> fractured images of unresolved ambivalence and unsuppressed resistance.[17]

Such general propositions, however, need to be qualified by a consideration of the particular representational strategies by which the 'dreamwork' inherent in Jamaican landscape could proffer a fixed and 'real' identity for the colonial presence and action upon it.

Beckford's *Descriptive Account* is overwhelmingly concerned with the landscape, which he treats in three ways: as a source of material, economic prosperity; as a pure repository of distinctively West Indian natural beauty, manifested in its spontaneous abundance and luxuriance, free of the intervention of human cultivation; and (thirdly and consequently) as an eminently suitable source for pictorial representation in landscape painting. While discussion of the land's productivity was common and longstanding, that of its beauty was less so, and its potential as a subject for landscape painting unprecedented. Beckford, instead, sees the colonies as perfect training grounds for the aspirant landscape artist.[18] To a significant degree, the discussion of visual representation is employed as a mechanism for linking his previous two descriptive tropes. However, it works within clearly defined and circumscribed limits: connecting the economic with the uncultivated landscape, materialized in the imposition of slavery into Jamaica's picturesque beauty, can only be aestheticized through an appeal to the 'low' particularities of Dutch painting, which, it seems, comprises the pictorial threshold for the representation of slaves:

> A negro village is full of those picturesque beauties in which the Dutch painters have
> so much excelled; and is very particularly adapted to the expression of those situa-
> tions, in which scenes of rural dance and merriment may be supposed with the
> greatest conveniency to have happened.[19]

The characterization of the slave population by reference to their 'rural dance and merriment' is a commonplace one, and coincides with Agostino Brunias's contemporary 'Dutch' representations of slaves in Dominica engaged in clearly Brueghelian scenes of dancing.[20]

In another telling description, Beckford sees the conversion of uncultivated to cleared land in terms of a gradual visual revelation of a black-and-white contrast created by the light upon the slaves' black bodies. Their labour, in which they 'sometimes throw themselves into picturesque and various attitudes', simultaneously discloses to the viewer the ordered landscape prepared for planting, reclaimed out of the woodland, and reveals the slaves in their proper place in the cleared landscape and retrieved from the darkness of the wilderness, where their black skin would have rendered them invisible: 'as the different clumps of vegetation begin to fall around them, the light is gradually induced, and shines in playful reflections upon their naked bodies and clothes; and which oppositions of black and white make a very singular, and very far from an unpleasing appearance'.[21] It is their labour which endows

the slaves with this pleasing visibility, as 'their gleaming hoes ... occasion the light to break in momentary flashes around them'.[22] Slave labour, however, is only thus visible as a 'picturesque' vision.

Beckford's appeal to Dutch painting to unite what may be seen as two oppositional constructions of the colonial landscape – the residual sense of the uncultivated colony as an unspoilt *tabula rasa*, as against its material exploitation through conversion of the land to plantation – corresponds in very broad terms to the poetic appreciation of the eighteenth-century West Indian landscape. In this, the linkage between the pastoral mode, which dwells upon the natural beauty and abundance of the landscape and typically avoids the presence of slavery, and the prosaic account, concerned with the mechanism of sugar production and the lifestyle of the plantocracy, is achieved through the interposition of what Karen O'Brien has termed 'imperial georgic'.[23] The georgic mode, furthermore, in negotiating the passage between pastoral and prosaic, also provided a vehicle to assert the natural integration of colony with metropolis, presenting the empire as an 'imaginative framework' (not to say, a 'dreamwork'), within which the 'regional, class and, occasionally, gender conflicts inherent in [the] subject matter' could be articulated and reconciled.[24] Yet, as O'Brien writes, the framework represented in imperial georgic was intrinsically unstable:

> from the outset, local economic and cultural conditions strained the georgic mode to the limits of its flexibility, and laid bare the processes of economic exploitation occluded in British georgic. In particular, the fact of slavery in the Southern states and West Indies could not be digested by georgic poetry ... its very presence broke the association between productive labor and civic virtue central to the tradition of imperial georgic.[25]

Thus O'Brien sees the eventual demise of the colonial georgic as being provoked by declining imperial confidence resulting from the loss of the American colonies, and in its being irreconcilable with the moral denunciations by the anti-slavery movement of the plantocratic exploitation of slave labour. Instead, what she identifies as a poetic turn to a 'new version of pastoral' and the form of the eclogue entailed a distancing and opposition between colony and metropolis, with the colonies presented to 'the metropolitan imagination as separate, remote *loci amoeni*, rather than as part of the continuous territories of the British Empire'. More significantly, the turn to pastoral-descriptive modes as representational structures 'implied that, whatever the depredations of slavery, the real value of the colony was guaranteed by its landscape: the land was both anterior and surplus to forms of labor'.[26]

As I have already suggested, this fracture between metropolis and colony was repeated in Beckford's representation as the creole gentleman-planter, but was able to be healed in the appeal to the fictive persona of the 'real West Indian': the latter's reality was, in turn, 'guaranteed' by its referral to landscape. What O'Brien neglects to mention, which Beckford's and others' descriptions emphasize repeatedly, is the necessarily *visual* register of the pastoral-descriptive mode. It would

seem, from the wealth of descriptions of the luxuriant abundance of the pastoral landscape, dating from the last quarter of the eighteenth century, that it was the *sight* of the landscape that guaranteed the colony's real value.[27] During this period Caribbean planters and visitors insist on the materiality of the landscape, as a form of reaction to the destabilizing effects upon the plantocracy's economy and constitution of the events of the American Revolution and the growing metropolitan anti-slavery campaign. Beckford's *Descriptive Account* presents this as an entrenched claim for greater creole autonomy manifested in a 'desire to verify Jamaica as a locus of authentic culture and civilization', which 'drew its virtue from local and translated sources, and defined itself against the creeping exhaustion and internal contradictions of Europe'. The foregrounding of the landscape and its depiction, as 'the indefeasible grounds on which the creole ethos stakes its claim' to authenticity, is crucial to Beckford's argument, and is necessarily tied to the presence of the creole spectator in the landscape: 'The activity of the perceiving subject is almost instantly identified as an attempt to colonize natural space and objects with covert emotional needs and political motives'.[28]

On the other hand, this vision could only be represented, to any significant degree, literarily: there are remarkably few eighteenth-century visual depictions of the West Indies. The immanent contradictions of the imperial georgic mode perhaps explain why there are so few images as Thomas Hearne's *A Scene in the West Indies* (figure 23).

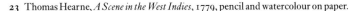

23 Thomas Hearne, *A Scene in the West Indies*, 1779, pencil and watercolour on paper.

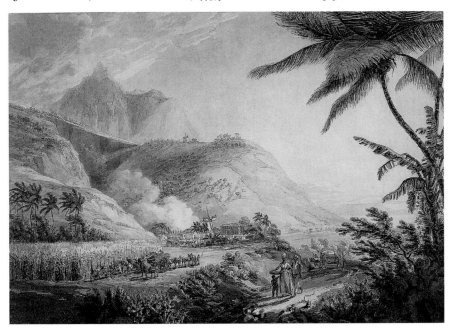

This is a rare early example of a highly finished and refined watercolour drawing depicting the processes of plantation management and sugar production, from the cutting of the cane to be carted to the boiling-house, to the delivery of barrels of sugar or molasses down the track to the harbour below for export back to England. Its degree of painterly sophistication, however, elevates it from the mundane level of a diagram, and the inclusion of contrapuntal elements such as the strolling group in the foreground, providing a sign of leisure to balance the labour taking place beyond them, endows the image with a degree of poetic reflection.[29] It is therefore comparable to imperial georgic poems such as James Grainger's *The Sugar-Cane* (1764), a blank verse account of sugar production. Yet, even in Hearne's overwhelmingly positive view of slave labouring conditions, there are insertions of the instabilities of imperial georgic, which at once familiarize and distance the colony. The foreground group is certainly a view of 'negroes as a sugar planter would have liked to have seen them, happy and content'.[30] They recall the stock peasant groups populating the rural English scenes of Thomas Gainsborough or Francis Wheatley (figure 24), and

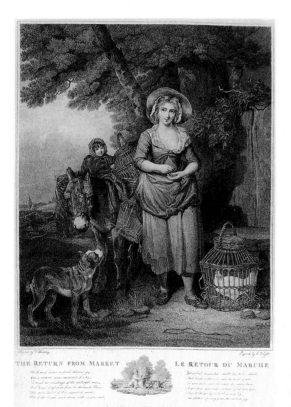

24 Francis Wheatley, engr. Knight, *The Return from Market*, mezzotint, published 21 April 1789 by T. Simpson.

perhaps are included to make the commonplace pro-slavery comparison between slaves and English labourers. Yet, this familiar vignette is undercut by the fact that the child is depicted in the act of urinating, which, together with his nakedness and placement beside the woman, evokes less Wheatley's genteel, ordered countryside than the unruly, transgressive and carnivalesque figures depicted by Hogarth in *The Enraged Musician* or *Boys Peeping at Nature*. In addition, the rocky pathway and encroaching weeds and prickly pear (which, with their prominence in the foreground, again function to exoticize the locale) suggest the difficulty of the land for cultivation. Also, the attention paid by the artist to the effects of the wind in the palm trees, while explaining the productive power of the windmills in the distance, also intimates the constant seasonal threat of hurricanes, which could reduce a plantation (such as Beckford's) to nought overnight.[31]

Hearne's image is exceptional in its treatment of slave labour, and in

providing a visual depiction at all of a West Indian landscape. While planters or travellers could readily turn their hand to prose, and occasionally poetry, few were able to do likewise with painting or drawing, at least for public reception.[32] The metropolitan–colonial split disguised by imperial georgic was materialized at a fundamental level in the very lack of artists willing to undergo the risks, discomforts and the potential moral and social stigma of pursuing a career in the West Indies.

Beckford's exceptionality as a 'real West Indian' is asserted once again in this regard: not just in placing such emphasis in his writing on pictorial idioms, by making comparisons, for example, between Jamaican landscape and the Roman Campagna or the works of Claude Lorrain, Nicholas Poussin and Salvator Rosa, but also in the fact that his *Descriptive Account* was clearly meant originally as something of a showcase for the display of the talents of his protégé, the artist George Robertson. The book is in part a paean to Robertson (who had died in 1788), containing early on a lengthy account of the man and his work.[33] The preface laments that the author's present circumstances, as a debtor in Fleet prison, prevent him from carrying out his intention, 'as a confirmation of the fidelity of the scenes which I have attempted to delineate, to have introduced engravings from some particular views of the Island that were taken on the spot' by Robertson.[34]

Beckford gives no indication of the number of illustrations he might have included, nor their possible subjects. But engravings of six of Robertson's paintings were published as a set by John Boydell in 1778, and it is likely, I think, that these would have featured in the *Descriptive Account*. Each is inscribed 'Drawn on the spot & painted by George Robertson', a declaration of topographical fidelity to 'the spot' (employing the same phrase as Beckford's preface) which associates the images with the author's intended use for engravings.[35]

Robertson's scenes correspond closely in tone and subject to literary descriptions of Jamaican rural scenery, particularly the rivers and the picturesque area known as Sixteen-mile Walk, which Beckford compares directly with 'Matlock and Dovedale (the scenery of which latter place they much resemble)', presenting landscape, once again, as the material correspondence between metropolis and colony.[36] Besides Beckford, the anonymous authors of *Jamaica, a Poem* (1777) and *A Short Journey in the West Indies* also dwell on the scenic qualities of Sixteen-mile Walk or the river Cobre, which forms its central focus.[37] All of these authors describe the landscape in ways corresponding to Robertson's pictures. *A View in the Island of Jamaica, of the Bridge crossing the River Cobre near Spanish Town* (figure 25) evidently depicts the same spot picked out in *A Short Journey* for its unsettling exoticism and sublimity; both representations highlight the 'flat wooden bridge' with 'neither wall nor rail, and scarcely raised above the water, which in rainy weather, overflows it many feet', leading to 'tremendous cliffs' that 'seem to make the passage doubtful' and are 'for miles, perpendicular precipices of wonderful height' supporting unnatural-looking trees, 'whose roots cling sideways to the rocks'.[38] The scene depicted in *A View in the Island of Jamaica, of Part of the River Cobre near Spanish Town* (figure 26) offers relief to the writer from this seeming impenetrability and 'the apprehensions of being

crushed to atoms between hills rushing together, or at least by their shaking off their overhanging rocks'; but the enormous boulders also are a reminder of the landscape's uncontainable threat and potency: 'many of those in the bed of the river, so large as to resist the force of constant torrents, were once hanging over the heads of passengers'.[39]

A further exoticizing inclusion in the pictures, noticeably absent from the texts, is the presence of slaves. It is remarkable how at home they appear in this threatening environment. In one sense, Robertson, like Beckford, familiarizes these landscapes by obviously referring them to the models of Salvator Rosa or Rubens.[40] This enabled their elision into a universal landscape aesthetic, picked up in contemporary reviews. The exhibition of Robertson's four Jamaican landscapes at the 1777 Society of Artists exhibition prompted one commentator to note:

> [The] Views in Jamaica, by *Mr. Robertson*, are entirely new objects in the Painting Way, as no Artist of Mr. Robertson's Abilities ever was in Jamaica before him. The Views are well chosen; the Variety of Trees discover great Skill in the Painter. His Touch is free, the Fore-ground of his Pieces well finished, and he has omitted nothing that could mark the Spots; they cannot fail of pleasing People who have been on the Island, since they do one who never was there, and only took Notice of them as being excellent Landscapes.[41]

25 George Robertson, engr. Daniel Lerpiniere, *A View in the Island of Jamaica, of the Bridge crossing the River Cobre near Spanish Town*, etching and engraving, published 25 March 1778 by John Boydell.

The assurance that the artist has 'omitted nothing that could mark the Spots' only emphasizes the degree of displacement of the social economy of slavery facilitated by the aesthetic. Robertson's, like William Hodges' contemporary views of the South Pacific, were noticed by reviewers for their novelty, with the implication that colonial expansion was presenting a need for revision of landscape aesthetics. The slave colony may have presented a new subject for art, but only within the established aesthetic structure, as the reviewer is at pains to point out. He hardly has any sympathetic attachment to the subject matter. On the contrary, they only attract him in the first place as 'excellent Landscapes'. The review thus sublimates any particular character of the landscape within the same homogenizing discourse of landscape aesthetics to which Beckford appeals, by which the representation of Jamaica may be judged on equal terms alongside those of Tahiti, Ireland or Dovedale, or alongside an imaginative recreation of English rusticity such as Gainsborough's *Watering Place* (1777).

Yet, this process of familiarization necessitates one of displacement and distancing at the same time. It hardly needs emphasizing that the commodification of the Jamaican landscape as picturesque is founded on a displacement of its material basis in plantocratic political economy: Sixteen-mile Walk offers itself to the pastoral gaze, in one sense as an *a priori* condition of its eligibility as a site of the pastoral, by its

26 George Robertson, engr. Daniel Lerpiniere, *A View in the Island of Jamaica, of Part of the River Cobre near Spanish Town*, etching and engraving, published 25 March 1778 by John Boydell.

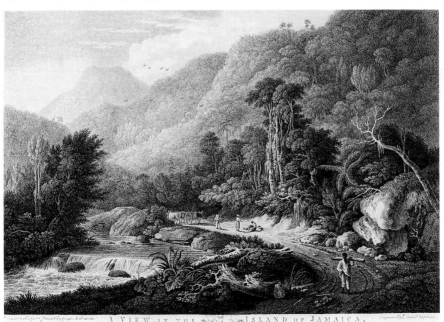

dissociation from the cultivated landscape, its disavowal of the plantation. As a genre, the pastoral proclaims a landscape apparently so rich that it dispenses with the need for cultivation: this is not a landscape represented in the Dutch pictorial tradition, but in an Italianate manner.[42] However, such disavowal must also call into question the very foundation of the colonial project: colonial land freed from any necessary association with cultivation, particularly in the context of the economic requirement for over-productivity in the West Indies, was, in O'Brien's phrase, 'both anterior and surplus to forms of labor'.[43] Displaced from a colonial economic value, the pastoral representation of the Jamaican landscape allows it to signify as both the site and object of civilized, creolized vision, and thus also as the validation of the identity of the gentleman, creole viewer.

The presence of slaves in such a landscape, however, would seem to violate the basic precept of the pastoral as a genre that disallows labour. Superficially, their inclusion in such easy, unhurried activity is an affirmation of Beckford's repeated claim that Caribbean slaves were better off than the labouring class in England.[44] Yet Robertson's depiction of them in 'a great variety of picturesque groups'[45] involves a double displacement: first, it sublimates the history of the slaves' enforced transportation from Africa, via the Middle Passage, which enabled their appearance in this 'fairy Scene'.[46] Furthermore, it creates a separation between them and the reason for their enslavement, to be the labour force on the plantations. As with colonial pastoral poetry, but in marked contrast to Hearne's imperial georgic vision, the presence of slavery in the landscape is conspicuously repressed. The figures are instead offered, in a variation upon conventional pastoral landscape painting, as staffage: marginal, incidental figures, forming 'a little business for the eye', as Thomas Gainsborough put it, to re-direct the viewer to the principal subject of the picture, the beauty of the landscape itself.[47] To this extent, their representation is, again, a refutation of the mercantile colonial imperative to exploit the land for profit. But then, their prominent visibility may also be read as oddly reassuring for the plantocrat. Beckford's description of slaves clearing the landscape, and being revealed to the viewer in terms of a black–white contrast 'as the different clumps of vegetation begin to fall around them', offers a telling comparison. For it is noticeable that the foreground figures are placed against a dark ground, characterizing them in terms of a heightened black–white contrast emerging from darkness, in the way that Beckford observes. This is not simply accidental: when Robertson shows English labourers in Coalbrookdale, for example *A View of the Mouth of a Coal Pit near Broseley* (figure 27), their activity is silhouetted against a light background. However, in none of Robertson's six Jamaican images are the figures shown labouring: the creolization of the landscape requires its slave population to be somehow released from servitude in order to be present in the pastoral environment.

On the one hand, Robertson, in creolizing the Jamaican landscape as pastoral, imports foreign figures (African slaves) into a genre of landscape whose figures were conventionally assumed to be native inhabitants (such as the shepherds of

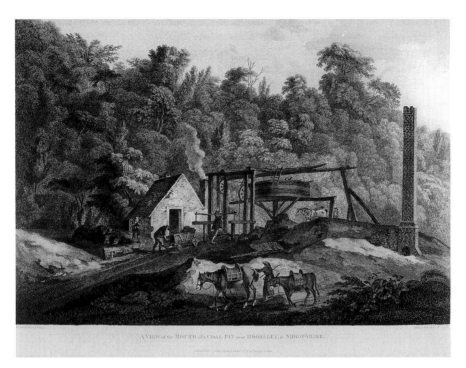

27 George Robertson, engr. Francis Chesham, *A View of the Mouth of a Coal Pit near Broseley, in Shropshire*, etching and engraving, published 1 February 1788 by John and Josiah Boydell.

Arcadia). Their naturalization into the Jamaican landscape is, in this sense, a refutation of their originary African identity (and is thus a breathtaking display of false consciousness), in favour of a creolized Caribbean identity. It is a visual representation that corresponds with Beckford's rationalization of the slave trade, in which 'African displacement ... is historicized as a natural precondition to the greater good of white-dominated civilization in Jamaica'.[48] On the other hand, the representation of the West Indies as pastoral also constitutes a projection of the landscape, as it were, back on to a mythical construction of African innocence preceding the Middle Passage. In a significant sense, it represents the slaves as though restored to a supposedly innocent, original African state.

If the West Indies could be construed by Janet Schaw and others as a form of earthly paradise, Africa was also conventionally described in a like manner. Indeed, one of the main Abolitionist strategies to counter such hubristic visions as Robertson's and Schaw's was simply to invert the terms of the 'paradise' argument, and amplify its moral, biblical connotations. A 1784 tract, for example, scorned the paradisiacal character claimed for the colony, where the slave's life 'day after day presents the same dreary situation of unrewarded toil, miserable food, and severe whippings, inflicted for trifling, and sometimes for imaginary offences', and contrasts it instead with a supposedly Edenic Africa:

When this situation is compared with the liberty, the ease, and the independence which the Africans enjoy in their own country, where, according to the relations of travellers, there seems to be a sort of exemption from the general doom of man to perpetual labour, and nature produces the fruits of the earth almost spontaneously, who but must condemn the rough hand of power which forces them, or the arts of treachery which entice them, to leave it![49]

The slave trade here is cast as a form of original sin, causing the expulsion of the natives of paradise, as a grim parody of the Fall, and condemning them to a life of endless slave labour. In Robertson's images, however, it is the Caribbean that is populated by Africans (importantly, there are no planters or factors included), who are at 'liberty' and 'ease', have 'independence' and 'a sort of exemption from the general doom of man to perpetual labour'. Africa and the slave trade, as with so many other forms of circum-Atlantic culture, become, in Joseph Roach's term, 'surrogated': in this case in the pastoral vision of Jamaican landscape.[50]

Surrogation, in Roach's analysis, is entailed in the creation of collective memory and cultural identity, specifically within the circum-Atlantic world, through a diachronic process of attempting to fill the 'cavities created by loss through death or other forms of departure' with 'satisfactory alternates'. However, owing to the selective and *extempore* nature of collective memory, surrogation 'rarely if ever succeeds', and involves instead the failure, suppression, translation and attempted erasure of memory. Cultural self-definition through the appeal to collective memory is necessarily founded upon forgetting. Surrogation, therefore, is an inherently unstable representational means, relying upon the continual re-enactment of performances (staged or otherwise) in order to produce its ideological effect.[51] In relation to Robertson's images, it may be suggested that the 'cavities' and losses opened up through the slave trade are filled by the re-presentation of African slaves as creolized surrogates in a landscape whose form appeals to notions both of harmonious civilization and of prelapsarian grace. The surrogation involved in producing this vision of landscape relies upon the erasure of the memory of the Middle Passage.

Similarly, colonial landscape may also be said to be 'performed', to the extent that it predicates, characteristically, a spectatorial presence and contribution – what Anthony Pagden has termed an 'autoptic imagination' – for it to be materialized and conceptualized as appropriated, colonized land. Pagden has argued that the repeated emphasis in early-modern travel accounts upon an authorial declaration of being or having been present in the exotic, non-European territory is an essential strategy for the cognitive assimilation and familiarization of the landscape, which precedes or accompanies its material possession as a colony.[52] Similarly, Beckford's and Robertson's purposes for images, and their stress on being 'on the spot', present them as necessary eye-witnesses to the 'performance' of the landscape of Jamaica as pastoral.

Yet, just as the construction of Beckford as the fully creolized 'real West Indian' relies upon the illusory union of irreconcilable values, so the creolized landscape

veers between the incompatible registers of the pastoral and the sublime. If, for the
author of *A Short Journey*, the widening prospect of the river Cobre depicted in
Robertson's print offered relief from the perils of overhanging, encroaching rocks,
this was of little ultimate comfort. In the final analysis, the picturesque landscape of
Sixteen-mile Walk resisted being assimilated into the pastoral vision:

> The pleasure that this scene affords is not of the gentle and agreeable kind, but like
> that raised by the sight of a lion roaring in his cage: – it is an awful, a tremendous plea-
> sure – the fiery eye, the paw and fangs; – gloom and precipitation are the principal
> images of the mind.[53]

It takes but a small imaginative leap to read the image of the caged (African?) lion as
a metaphor for the unspoken presence of a potent and volatile slave population on
the island. While this author refrained from making the political connection, the
writer of *Jamaica, a Poem* did so explicitly in his accompanying *Poetical Epistle*.

The erasure of the civilized values of commercial society in the West Indies con-
sequent upon the institution of slavery there leads the poet to defamiliarize the
view of the river Cobre and Sixteen-mile Walk, and to reject any similarity between
the colony and the metropolis in the form of the pastoral potential of their respec-
tive landscapes. Instead, the savageness of the environment comes to stand for a
severing of any connection with the beneficent and civilizing effects supposed to be
produced by the commercial British empire:

> Our Creoles here no rapid Severn brave,
> No Thames monarchial rolls his ample wave;
> No flood-crown'd vill erects its lofty head,
> No proud cascade reblooms the sun-scorch'd mead:
> A Cobre only furious rolls along,
> Alike unknown to commerce and to song![54]

But the alienation of the landscape from 'commerce' and 'song' leads to a direct
contemplation of the ever-present threat of slave rebellion, no doubt accentuated
by the background of the American War:

> Some Afric chief will rise, who, scorning chains,
> Racks, tortures, flames – excruciating pains,
> Will lead his injur'd friends to bloody fight,
> And in the flooded carnage take delight;
> Then dear repay us in some vengeful war,
> And give us blood for blood, and scar for scar.[55]

The visible presence of non-labouring slaves in Robertson's engravings, therefore,
and their naturalization in a landscape poised incompatibly between the familiar
and the exotic, may also be taken as a sign of the threatened surfacing of a savage
reality, and the impending collapse of the pastoral vision.

The extent of Robertson's ideological manipulation of the pastoral and imperial
georgic modes as structures for the representation of slavery and labour may be seen

more acutely by a comparison of his Jamaica scenes with his later views of the industrial landscape of Coalbrookdale. Though separated by a decade, these may be seen in some ways as complementary to the colonial images: they were also published as a set of six engravings, once again by Boydell; and given the similar circumstances of form and publication, it seems reasonable to suppose that Robertson would have taken the earlier set as a model for the production of the later images. These also, like the Jamaica views, appear to follow a loose thematic or narrative structure, which renders them cohesive as a set. The six scenes show various stages in the iron-making process at the rapidly expanding factories at Coalbrookdale, concentrated particularly upon the area of Broseley, from the extraction of coal (figure 27), to celebratory views of the finished product in the renowned Iron Bridge.[56] While there are clear compositional similarities with the Jamaican views, for example between *An Iron Work, for Casting of Cannon* (figure 28) and *A View in the Island of Jamaica of Part of the River Cobre near Spanish Town* (figure 26), such that the later series might be seen partly as a set of variations on the earlier landscape compositions, what is noticeable in the 1788 engravings is the studied and detailed insertion of labour into the otherwise romantic landscape.[57] This contrast between the industry and its natural setting corresponds to conventional accounts of Coalbrookdale, which, again similar to the representation of the Jamaican

28 George Robertson, engr. Wilson Lowry, *An Iron Work, for Casting of Cannon; and a Boreing mill, Taken from the Madeley side of the River Severn, Shropshire*, etching and engraving, published 1 February 1788 by John and Josiah Boydell.

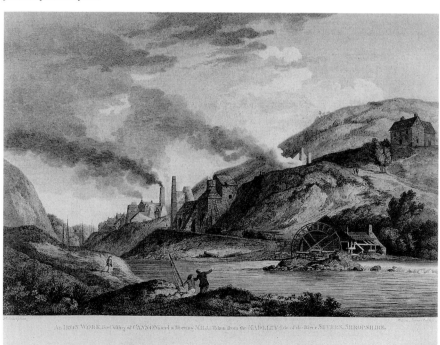

landscape, was viewed as a problematic combination of the beautiful and the sublime. However, these were not qualities taken to be inherent in the natural landscape itself, but resulted from its industrialization. Arthur Young, for example, in 1776 described Coalbrookdale as:

> A very romantic spot, ... a winding glen between two immense hills which break into various forms, and all thickly covered with wood, forming the most beautiful sheets of hanging wood. Indeed too beautiful to be much in unison with that variety of horrors art has spread at the bottom: the noise of the forges, mills, &c. with all their vast machinery, the flames bursting from the furnaces with the burning of the coal and the smoak of the lime kilns, are altogether sublime, and would unite well with craggy and bare rocks, like St. Vincent's at Bristol.[58]

An image such as *The Mouth of a Coal Pit near Broseley* (figure 27) similarly makes the contrast between the detailed concentration upon the varied abundance of trees in the background (again, a pictorial concern similar to the Jamaica scenes) and the insertion of labour in the foreground.

The most striking aspect of the Coalbrookdale scenes is their careful, almost didactic representation of the industrial process. *The Inside of a Smelting House* may be read as a stage-by-stage account of the manufacture of cannon, structurally similar to both Hearne's visual and Beckford's textual descriptions of sugar production. *An Iron Work, for Casting of Cannon* (figure 28) is narratively complementary to the *Smelting House*, offering not just a daytime exterior counterpart to the nocturnal interior scene, but also indicating the wider commercial and navigational context in the masts of the vessels in the left distance ready to transport the cannon and other iron goods downstream to Bristol and beyond: Coalbrookdale is seen to be at the heart of a georgic vision in providing for the maintenance and expansion of Britain's maritime empire. Once again, the compositional arrangement of the smoking chimneys of the Calcutts ironworks, the corn mill, and the offices up on the hill, with the masts in the background, associates this scene more closely with Hearne's imperial georgic (figure 23) than Robertson's own pastoral colonial vision. To classify a view of Midlands industry as 'imperial georgic' is perhaps not to stretch the term too far, given the correspondences of Robertson's Coalbrookdale scenes to Hearne's Antiguan and his own Jamaican ones: it may be to provoke the viewing of other domestic landscape representation of this period in an openly imperial context. It is pertinent here to remember the role of imperialism in providing a material and ideological context for the re-evaluation of domestic landscape. As W. J. T. Mitchell has written, the historical narratives generated by the semiotics of landscape precisely correlate with the discourse of imperialism:

> Empires move outward in space as a way of moving forward in time; the 'prospect' that opens up is not just a spatial scene but a projected future of 'development' and exploitation. And this movement is not confined to the external, foreign fields toward which the empire directs itself; it is typically accompanied by a renewed interest in the re-presentation of the home landscape, the 'nature' of the imperial center.[59]

Robertson's Jamaica and Coalbrookdale scenes, therefore, may be understood in this sense as reciprocal representational elements within a larger discourse of imperial landscape and the pastoral and georgic modes, and within a larger cycle of circum-Atlantic exchanges. For, as with the views of Jamaica, the presence of a surrogated Africa is also implicated in the masts clearly visible in *An Iron Work, for Casting of Cannon* (figure 28), in the implied transportation of cannon and ships' equipment to Bristol, a principal slave-trading port, from the Calcutts ironworks owned by Alexander Brodie, who specialized in the 'manufacture of cannon and ships' stoves'.[60] Furthermore, iron manufactures were a standard of currency for the buying of slaves on the African coast for transportation to the American and Caribbean colonies.[61] What is remarkable, of course, is Robertson's astonishing inversion of values in the representation of labour between the slave colony and the ironworks: this has to do with the fact of a wage economy at Coalbrookdale, where the comparatively high workers' wages were cited as the cause of improvement in the 'lower Class of People' in the region, than where 'perhaps chearfulness and contentment are not more visible in any other place ... A pleasing Proof this, that Arts and Manufactures contribute greatly to the Wealth and power of a Nation, and that Industry and Commerce will soon improve and People the most uncultivated Situation'.[62]

Such improvement is evidently not available for the unwaged slave labourers in Jamaica: their insertion into a creolized pastoral landscape necessarily fixes them into their condition of enslavement, despite their representation (in order for their integration into the pastoral genre) as non-labouring. There are further displacements and surrogations here: the irony is that, in the conventional visual tradition of pastoral, particularly that derived from the French Rococo of Watteau and Boucher, which was adopted in England notably by Francis Hayman and Thomas Gainsborough, idle figures in a pastoral landscape stand as surrogates for an aristocratic presence assuming the role of Arcadian shepherds.[63] Here the casting of slaves as pastoral figures accentuates the bifurcated meanings of idleness, interconnecting and contrasting the leisured idleness supposedly proper to the condition of the aristocrat or planter with the improper, transgressive and punishable idleness of the slave. Taken collectively, the six views each of Jamaica and Coalbrookdale offer a bizarre re-working of the common eighteenth-century binary moral narrative of 'industry and idleness', where, as with the inevitability of the fate of Hogarth's idle apprentice, the idleness of the slaves in the pastoral landscape serves to confirm them in their fitness for the condition of slavery.[64] The industry of their English counterparts, on the other hand, appeals to the core ideological tenets of meritocracy and improvement, so crucial to the maintenance of a commercial empire. Whereas the creolization of the Jamaican landscape in Robertson's views involves supplanting the social and political culture of slavery with a pastoral vision, the depiction of labour at Coalbrookdale entails an irruption of an antithetical industrial economy into a pre-existent picturesque environment. The foregrounding of that industry is seen to interfere with the landscape's aesthetic

potential. It is also worth noting that in his Coalbrookdale scenes the artist is not concerned to specify that they were drawn 'on the spot': the 'autoptic imagination' is not required here, not only because this subject, unlike the West Indies, is one which might be expected to be familiar to contemporary viewers, but also because an active spectatorial presence is not key to establishing the authenticity and stability of the political landscape represented.

Alternatively, the reversals here could be taken as a series of displacements or surrogated circum-Atlantic exchanges. If it is possible to see Robertson's vision of Jamaican landscape as a recapitulation of an imagined African origin, his depiction of Coalbrookdale displaces the labour that might reasonably be associated with the West Indies on to the picturesque heartland of England. In turn, the vision of the metropolitan landscape as industrial displaces the idyllic values conventionally attached to it by pastoral poets and artists such as Francis Wheatley (figure 24), with their idealized representations of English peasantry. To complete the circle of displacement, precisely at this period these values were projected by Abolitionists onto an imagined Africa. William Collins's poem *The Slave Trade* (1788) and George Morland's paintings and engravings produced after it, *Execrable Human Traffic* (1788) and *African Hospitality* (1791), are set on the African coast. They gain their emotional power by setting up a stark narrative contrast between, on the one hand, the barbaric treatment of Africans at the hands of white slave-traders, who rupture the natural sanctity of the innocent African family, and on the other, the sympathetic rescue and reception by African natives of a shipwrecked white European family. These works repudiated the idea of Africans as primitive savages by representing them as innately beneficent and humane beings in harmony with nature, in a deliberate inversion of the perceived meanings of civilized refinement and primitive savagery.[65] In a cycle of translations and assimilations, the conventional metropolitan pastoral mode was adapted for the Abolitionist cause through the evocation of a pastoral Africa; while a surrogated Africa inhabited the transformation of the sugar colony into a creolized pastoral landscape, a representation in the service of plantocracy and empire.

So, what form of identity is offered in Robertson's landscape representations of Jamaica? I have suggested that they are both anterior and supplementary to the production of a creole identity for the West Indian gentleman-planter. The tensions and contradictions inherent in this figure are elided or disguised in the referral to the landscape, which is thus also represented as creolized. Just as Beckford's ideal creole identity is produced from an illusory hybridization of the Eurocentric construct of the *beatus ille* with the alien and corrupt exoticism of the colonial environment, so the creolized landscape is formed out of the jarring conjunction of a poetic pastoral beauty with the sublime otherness of the slave colony, an aesthetic alliance which is always on the verge of implosion owing to the surrogated presence of the politics of slavery.

W. J. T. Mitchell has argued that the semiotics of landscape in the European visual tradition represent landscape as a progressive, diachronic unfolding from

'convention' to 'nature', a gradual approximation of the representation(s) of landscape to the supposed 'reality' of landscape, in which the distinction between representation and reality is elided, and that this elision served the ideological ends of imperialism.[66] I have argued here that the semiotics of imperial landscape operate synchronically also, as a series of displacements, surrogations, differences and references between the imagined and actual spaces of empire, which represent the relation between metropolis and empire as simultaneously one of connection and disjunction, of similarity and difference. This dualism was played out in the figure of the colonial gentleman, the 'real West Indian', whose identity, produced in the interstitial void between civilization and savagery, was projected on to the colonial landscape he inhabited, cultivated and contemplated.

Notes

I should like to thank Dian Kriz for her invaluable comments on earlier drafts of this essay.

1 Terry Eagleton, *The Ideology of the Aesthetic* (Oxford, Blackwell, 1991), pp. 13–69.
2 See, in particular, John Barrell, *The Dark Side of the Landscape: The Rural Poor in English Painting 1730–1840* (Cambridge, Cambridge University Press, 1980); David Solkin, *Richard Wilson: The Landscape of Reaction* (London, Tate Gallery, 1982); Michael Rosenthal, *Constable: The Painter and his Landscape* (New Haven and London, Yale University Press, 1983); Ann Bermingham, *Landscape and Ideology: The English Rustic Tradition, 1740–1860* (Berkeley, University of California Press, 1986); Andrew Hemingway, *Landscape Imagery and Urban Culture in Early Nineteenth-Century Britain* (Cambridge, Cambridge University Press, 1992); Kay Dian Kriz, *The Idea of the English Landscape Painter: Genius as Alibi in the Early Nineteenth Century* (New Haven and London, Yale University Press, 1997).
3 David Hancock, *Citizens of the World: London Merchants and the Integration of the British Atlantic Community, 1735–1785* (Cambridge, Cambridge University Press, 1995), pp. 347–75, 431–45. For the social status of the planter against the background of attitudes to new wealth generally, see James Raven, *Judging New Wealth: Popular Publishing and Responses to Commerce in England, 1750–1800* (Oxford, Oxford University Press, 1992), pp. 208, 221–48.
4 On the character of the planter see Michael Craton, *Sinews of Empire: A Short History of British Slavery* (London, Temple Smith, 1974), pp. 199–207; D. Hall (ed.), *In Miserable Slavery: Thomas Thistlewood in Jamaica, 1750–86* (London, Macmillan, 1989).
5 The fullest biographical account of Beckford is given in R. B. Sheridan, 'Planter and historian: the career of William Beckford of Jamaica and England, 1744–1799', *Jamaican Historical Review*, 4 (1964), 36–58.
6 Anon., *A Short Journey in the West Indies, in which are Interspersed, Curious Anecdotes and Characters* (London, 1790), vol. 2, p. 138.
7 Keith Sandiford, *The Cultural Politics of Sugar: Caribbean Slavery and Narratives of Colonialism* (Cambridge, Cambridge University Press, 2000), pp. 118–49.
8 Anon., *A Short Journey*, pp. 138–43.
9 Anon., *A Short Journey*, p. 138.

10 Anon., *A Short Journey*, p. 141.

11 Anon., *A Short Journey*, pp. 141–2.

12 Sandiford, *Cultural Politics*, pp. 118–19.

13 William Beckford, *A Descriptive Account of the Island of Jamaica* (London, 1790), vol. 1, pp. 299–304.

14 Janet Schaw, *Journal of a Lady of Quality*, ed. Evangeline Walker Andrews and Charles McLean Andrews (New Haven, Yale University Press, 1934), p. 91, cited in Elizabeth A. Bohls, 'The aesthetics of colonialism: Janet Schaw in the West Indies, 1774–1775', *Eighteenth-Century Studies*, 27 (1994), p. 374 and n. 27.

15 See Dian Kriz's essay in this volume.

16 On the population of colonial Jamaica, see Edward Brathwaite, *The Development of Creole Society in Jamaica 1770–1820* (Oxford, Clarendon Press, 1971), pp. 105–75.

17 W. J. T. Mitchell, 'Imperial landscape', in W. J. T. Mitchell (ed.), *Landscape and Power* (Chicago and London, University of Chicago Press, 1994), p. 10.

18 Sandiford, *Cultural Politics*, pp. 132–3, 138–9.

19 Beckford, *Descriptive Account*, vol. 1, pp. 227–8.

20 On the stereotypical association of African slaves with music and dance, see Roger D. Abrahams and John F. Szwed (eds.), *After Africa: Extracts from British Travel Accounts and Journals of the Seventeenth, Eighteenth, and Nineteenth Centuries concerning the Slaves, their Manners, and Customs in the British West Indies* (New Haven and London, Yale University Press, 1983), p. 26. On Brunias's images, see Kay Dian Kriz, 'Marketing mulatresses in the paintings and prints of Agostino Brunias', in Felicity Nussbaum (ed.), *The Global Eighteenth Century* (Baltimore, Johns Hopkins University Press, forthcoming); Beth Fowkes Tobin, *Picturing Imperial Power: Colonial Subjects in Eighteenth-Century British Painting* (Durham NC and London, Duke University Press, 1999), pp. 139–73; Hans Huth, 'Agostino Brunias, Romano: Robert Adams' "Bred Painter"', *Connoisseur*, 151 (1962), pp. 265–9.

21 Beckford, *Descriptive Account*, vol. 1, pp. 254–5. There may be an underlying anxiety discernible here concerning fugitive slaves, since the Maroon population of Jamaica, comprising largely runaway slaves and who had been a thorn in the side of the British authorities for several decades, took refuge in the inland hills and forests of the island, where they were largely undetectable, emerging to conduct forays and assaults upon the colonial residents and troops. The association of woodland with labouring class rebellion and lawlessness was, therefore, a strong one: see Mavis C. Campbell, *The Maroons of Jamaica 1655–1796: A History of Resistance, Collaboration and Betrayal* (Granby MA, Bergin and Garvey, 1988). Such an association was, of course, already long-established in the metropolitan context: see Stephen Daniels, 'The political iconography of woodland in later Georgian England', in Denis Cosgrove and Stephen Daniels (eds.), *The Iconography of Landscape: Essays in the Symbolic Representation, Design and Use of Past Environments* (Cambridge, Cambridge University Press, 1988), pp. 43–5.

22 Beckford, *Descriptive Account*, vol. 1, p. 255. It might also be supposed that the heightened black/white contrast would aid surveillance of the slaves, in rendering them more conspicuously visible from a distance. Beckford's aesthetic appreciation would then be subtended by a marked strategic, hegemonic dimension.

23 Karen O'Brien, 'Imperial georgic, 1660–1789', in Gerald MacLean, Donna Landry and Joseph P. Ward (eds.), *The Country and the City Revisited: England and the Politics*

of Culture, 1550–1850 (Cambridge and New York, Cambridge University Press, 1999), pp. 160–79.

24 O'Brien, 'Imperial georgic', p. 172.

25 O'Brien, 'Imperial georgic', p. 176.

26 O'Brien, 'Imperial georgic', pp. 175–6.

27 See the range of texts cited in Abrahams and Szwed (eds.), *After Africa*.

28 Sandiford, *Cultural Politics*, pp. 141, 128–32.

29 This is further suggested by the fact that the painting was completed some four years after Hearne had returned from the West Indies, and was not therefore painted on the spot, but would have been executed after earlier sketches and drawings. The female figure of the foreground group, for example, is a reworking of another Antiguan view, *The English Barracks, Antigua* (private collection): see David Morris and Barbara Milner, *Thomas Hearne 1744–1817: Watercolours and Drawings* (Bolton, Bolton Museum and Art Gallery, 1985), cat. no. 5, p. 41. It might be comparable, in this sense, to William Hodges' paintings completed for the Admiralty on his return from Cook's second voyage to the Pacific, produced after work completed on the spot, but which were meant to offer retrospective poetic reflections upon, and syntheses of, his experience on the voyage: Rüdiger Joppien and Bernard Smith, *The Art of Captain Cook's Voyages*, vol. 2: *The Voyage of the Resolution and Adventure 1772–1775* (New Haven and London, Yale University Press, 1985), pp. 59–65.

30 Morris and Milner, *Thomas Hearne*, p. 41.

31 Beckford, *Descriptive Account*, vol. 1, pp. 90–141.

32 An exception to this was Beckford of Somerley, who is said to have indulged in 'painting the sublime of the Torrid Zone': Anon., *A Short Journey*, vol. 2, p. 146. It is possible also that Edward Long produced scenes of Jamaica: his *History of Jamaica* (1774) contains plates depicting various aspects of the landscape, which are inscribed 'Isaac Taylor sculpt', indicating that Taylor was the engraver rather than the original draughtsman of the images. The lack of any other signature would suggest that they were the work of the author.

33 Beckford, *Descriptive Account*, pp. 35–41.

34 Beckford, *Descriptive Account*, p. x.

35 It would not be unusual for an author to make use of much earlier engravings in illustrating a text: Bryan Edwards, in the third edition of his *History, Civil and Commercial, of the British Colonies in the West Indies* (London, J. Stockdale, 1801), introduces engravings after paintings by Agostino Brunias of the 1770s–1780s.

36 Beckford, *Descriptive Account*, p. 22.

37 Anon., *Jamaica, a Poem, in Three Parts. Written in that Island in the Year MDC-CLXXVI. To which is annexed, A Poetical Epistle from the Author in that Island to a Friend in England* (London, 1777), lines 153–67; Anon., *A Short Journey*, vol. 1, pp. 75–80.

38 Anon., *A Short Journey*, vol. 1, pp. 77–8. Cf. the descriptions in Beckford, *Descriptive Account*, vol. 1, pp. 22–31.

39 Anon., *A Short Journey*, vol. 1, pp. 79–80.

40 A similarity to Rubens' *The Watering Place* is most apparent in *A View in the Island of Jamaica, of the Spring-head of Roaring River on the Estate of William Beckford Esq.*, engraved by James Mason. A painting of the same title was exhibited by Robertson at the 1775 Society of Artists exhibition.

41 *St. James's Chronicle* (10 May–13 May 1777), p. 2.

42 It is worth noting that Robertson was not only familiar, of course, with the conventions of Italian landscape painting, but had visited Rome and depicted its monuments: see the watercolour drawing of *Colosseum, Rome with Arch to the Left* in the Yale Center for British Art, New Haven.

43 O'Brien, 'Imperial georgic', p. 175.

44 Sandiford, *Cultural Politics*, p. 145.

45 Beckford, *Descriptive Account*, p. 230.

46 Schaw, *Journal*, p. 91, cited in Bohls, 'Aesthetics of colonialism', p. 374.

47 Gainsborough, undated letter to William Jackson, cited in *The Letters of Thomas Gainsborough*, ed. Mary Woodall (Bradford, Lund, Humphries and Co., 1963), p. 99.

48 Sandiford, *Cultural Politics*, p. 128.

49 *Thoughts on the Slavery of the Negroes* (London, James Phillips, 1784), pp. 9–10.

50 Joseph Roach, *Cities of the Dead: Circum-Atlantic Performance* (New York, Columbia University Press, 1996).

51 Roach, *Cities of the Dead*, pp. 2–3.

52 Anthony Pagden, *European Encounters with the New World: From Renaissance to Romanticism* (New Haven and London, Yale University Press, 1993), pp. 51–87. See also Stephen Greenblatt, *Marvelous Possessions: The Wonder of the New World* (Chicago, University of Chicago Press, 1991).

53 Anon., *A Short Journey*, vol. 1, p. 80.

54 Anon., *A Poetical Epistle, From the Island of Jamaica, to a Gentleman of the Middle-Temple*, dated Kingston, Jamaica, 20 May 1776, in Anon., *Jamaica, A Poem*, p. 42.

55 Anon., *A Poetical Epistle*, p. 43.

56 The six engravings after Robertson, all published 1 February 1788 by John and Josiah Boydell, are of the following subjects: *A View of the Iron Bridge, in Coalbrook Dale, Shropshire. Taken from the bottom of Lincoln Hill*, engraved by Francis Chesham; *The Mouth of a Coal Pit near Broseley in Shropshire*, engraved by Francis Chesham; *A View of the Iron Bridge, Taken from the Madeley Side of the River Severn*, engraved by James Fittler; *A View of Lincoln Hill, with the Iron Bridge in the Distance*, engraved by James Fittler; *An Iron Work, for Casting of Cannon: and a Boreing Mill*, engraved by Wilson Lowry; and *The Inside of a Smelting House at Broseley Shropshire*, engraved by Wilson Lowry. They are illustrated and discussed in Stuart Smith, *A View from the Iron Bridge* (Ironbridge, Ironbridge Gorge Museum Trust, 1979), nos. 27–32.

57 Only *A View of the Iron Bridge, Taken from the Madeley Side of the River Severn* contains no explicit depiction of labour or factory production (in the form of smoking chimney-stacks), but this plate carries, instead, a lengthy inscription detailing how the Iron Bridge was manufactured.

58 Arthur Young, *Tours in England and Wales*, entry for 13 June 1776, cited in Barrie Trinder (ed.), *'The Most Extraordinary District in the World', Ironbridge and Coalbrookdale: An Anthology of Visitors' Impressions of Ironbridge, Coalbrookdale and the Shropshire Coalfield* (London, Phillimore with Ironbridge Gorge Museum Trust, 1977), p. 33.

59 Mitchell, 'Imperial landscape', p. 17.

60 Smith, *Iron Bridge*, p. 31.

61 Roger Anstey, *The Atlantic Slave Trade and British Abolition 1760–1810* (London, Macmillan, 1975), pp. 10, 21–2.

62 George Perry, *A Description of Coalbrookdale ... with Perspective Views thereof* (c.1758), cited in Trinder, *Extraordinary District*, p. 18. For details of wage rates in 1776, see Young, *Tours in England and Wales*, p. 33.

63 My thanks to Dian Kriz for pointing this out to me.

64 The supposedly 'natural' indolence of slaves was, of course, a commonplace assertion among planters and their metropolitan supporters. See James Walvin, *Black Ivory: A History of British Slavery* (London, Fontana Press, 1993), pp. 237–8, 328.

65 For these and other works produced in the cause of the anti-slavery movement, see Hugh Honour, *The Image of the Black in Western Art*, vol. 4: *From the American Revolution to World War I*, part 1: *Slaves and Liberators* (Cambridge MA and London, Harvard University Press, 1989), pp. 67–72; Marcus Wood, *Blind Memory: Visual Representations of Slavery in England and America 1780–1865* (Manchester and New York, Manchester University Press, 2000), pp. 36–7; J. R. Oldfield, *Popular Politics and British Anti-Slavery: The Mobilisation of Public Opinion against the Slave Trade 1787–1807* (Manchester and New York, Manchester University Press, 1995), pp. 167–72.

66 Mitchell, 'Imperial landscape', p. 17.

John Gabriel Stedman, William Blake, Francesco Bartolozzi and empathetic pornography in the *Narrative of a Five Years Expedition against the Revolted Negroes of Surinam*

Marcus Wood

Slavery, in some of its workings, is too dreadful for the purposes of art. A work which should present it strictly as it is would be a work which could not be read. (Harriet Beecher Stowe, *The Key to Uncle Tom's Cabin* (London, [1853]) p. 1.)

Through aesthetic principles or stylization ... the unimaginable still appears as if it had some ulterior purpose. It is transfigured and stripped of some of its horror, and with this injustice is already done to the victims. (Theodore Adorno, quoted *Writing and the Holocaust*, p. 179.)

Introduction to a taboo – slavery and pornography

Many factors have enforced the taboo over approaching the relationship between slavery and pornography in American and European cultures. Firstly there is the problem of suitable qualification. Experts on Atlantic slavery and the cultures of Abolition seem to know, and to want to know, very little about pornography and the development of the pornographic industries in Europe in the eighteenth and nineteenth centuries. Historians of pornography, who until the 1980s were not openly embraced within the intellectual communities of Europe and America, have not turned to a serious study of Atlantic slavery.[1] Indeed, given the recent proliferation of what might be seen as a new cultural history of pornography, focused on the late eighteenth and early nineteenth centuries, the black body is massively conspicuous by its absence.[2]

Lynn Hunt, one of the most influential of the new cultural historians charting the evolution of the pornographic in the period 1750–1850, sees pornography as a

site of cultural contestation.[3] The emergence of a pornographic industry, and of a pornographic counter canon, is seen as contingent upon the shifting culture wars between oppressors/censors and pornographers/free thinkers. Hunt's big contribution is to emphasize some ways in which pornography is culturally relative. She rightly insists that the Western pornographic industries emerged when they did, and took the forms they did, partly because of the economic and political contexts of the late eighteenth and early nineteenth centuries. Simply put, the argument boils down to the assertion that the Enlightenment and the French Revolution created intellectual and political pressures ensuring that Western pornography developed in certain ways.[4] Yet there are some disconcerting absences in this work, of which the black body is one of the most troubling.

Hunt's introduction to the highly influential collection of essays *The Invention of Pornography* is a methodical account of the formation of a pornographic canon within eighteenth-century France and England. Yet as I read it a question kept recurring to me: what of the pornography focused on the slave body that went uncontested and unrepressed? This is pornography that, unlike the explicitly politicized pornographies directed against the clergy or aristocracy in the fallout from the French Revolution, had no clear basis in satire. It is also pornography that has never been called pornography, which is not to say that it hasn't been *seen* or enjoyed as pornography.[5] It is the very invisibility of plantation and slave pornographies to the societies that produced them, and to subsequent Western audiences, that must be scrutinized. What does it mean that detailed pornographic accounts of child torture and sexual abuse (an area of pornography with which *The Invention of Pornography* also refuses to deal) are very rare in eighteenth-century pornography generally, yet frequently occur both in Sade's work and in abolition print and pamphlet literature? The recent historiography of eighteenth-century pornography uncovers the power and class influences that went into setting up definitional frameworks for the pornographic. Yet the method has its dangers. Reconstructing lists of pornographic texts by scrutinizing the records of the censors, and then restricting the cultural analysis of the pornographic to those texts, is to remember the pornographic through the prescriptions of censorship.[6] The purpose of such forensic categorization is to establish what the official censors in the late eighteenth or early nineteenth centuries saw as pornographic. The limitation of this work is that it is bound by those very frameworks of censorship that it purportedly critiques. The direct consequences of such an approach can be to avoid whole areas of pornography on the grounds that such areas were not seen as pornography by the society that produced them. This has particularly serious implications for the representation of the colonial body. Because eighteenth-century cultural production objectified or commodified the slave body, and, in terms of pornographic codification, officially refused the slave body the status of pornographic victim, does that mean that we should continue to follow suit?

There is a lot of abolition propaganda, both written and in the form of single-sheet prints and oil paintings, that treats the slave body (any gender, any age) as punishment object or fetish in directly exploitative and eroticized ways, which are

blatantly pornographic.[7] What is pornography? Pornography is difficult to define, and no single definition is watertight. Here are three definitions, which are helpful for the purposes of this discussion. One: a depiction with sexual elements

> in which there is clear force, or an unequal power that spells coercion. It may be very blatant, with weapons of torture or bondage, wounds and bruises, some clear humiliation … It may be much more subtle: a physical attitude of conqueror and victim, the use of race or class difference to imply the same thing, perhaps a very unequal nudity, with one person exposed and vulnerable while the other is clothed. In either case there is no sense of equal choice or equal power … pornography is about power and sex-as-weapon … its message is violence, dominance or conquest.[8]

Two: pornography is present (i) where the victim is represented as a dehumanized sexual object, thing or commodity, (ii) where the victim is represented as a sexual object which enjoys pain or humiliation, (iii) where the victim is represented as an asexual object cut up, or mutilated or physically hurt, (iv) where the victim is depicted in postures of sexual submission or sexual servility, including postures inviting penetration, (v) where body parts are exhibited such that the victim is reduced to those parts, (vi) where the victim is shown penetrated by objects or animals, (vii) where the victim is shown in scenarios of degradation, injury, torture, shown as filthy or inferior, bleeding, bruised, or hurt in a context that makes these conditions sexual.[9] Three: 'pornography is material that explicitly represents or describes degrading or abusive sexual behavior *so as to endorse and/or recommend the behaviour as described*'.[10] Taking these definitions as a benchmark the following discussion suggests ways in which it might now be possible to see the extent to which late eighteenth-century English culture was producing mainstream publications depicting the black body in pornographic ways. The motive behind the work is not simply to 'out' as pornographic works that have hitherto been considered 'respectable'. Of deeper significance is the attempt to explain why it was, and why it has remained, so difficult for the West to see what it has done to the black body.

Stedman's *Narrative* as a test case

Is the eroticization and fetishization of bondage within the literatures of slavery necessarily pornographic? In the following pages Stedman's *Narrative of a Five Years Expedition against the Revolted Negroes of Surinam* is used to provide some ways of addressing this question. This text and the copper plate engravings accompanying the words constitute an intriguing test case. The *Narrative* exists on the edge, an edge that cuts across several areas of publishing including abolition polemic, pro-slavery discourse, exotic travelogue, sentimental novella, Romance, *bildungsroman* and pornography. As such it is a particularly useful text with which to question the practice of defining pornography within isolated historical contexts. In the present discussion I have chosen Stedman's book and its engravings, particularly those by William Blake and Francesco Bartolozzi, specifically because

they raise tricky questions relating to the trans-historical nature of aesthetics, torture and the fetish. The images I am going to analyse are particularly charged in the present context because they stand in complicated relation to what the late eighteenth-century art market constructed as, and what many art historians still construct as, 'high art' categories. Academic oil painting and sculpture represented the acme of 'high art', and copper plate engraving existed outside and below these categories and was seen more as an artisanal skill than an art. Yet both Blake and Bartolozzi, the two engravers who made all the images in the following analysis, constitute special cases in terms of their relationship to the high art market, and to high art tradition and stylistics.

Blake, of course, was like no other engraver before or after him. Blake cannot now easily be seen, even in his jobbing commercial work, as an artisan engraver. He eschewed oil painting with a wonderfully eccentric set of arguments, and consequently ruled himself out of the academic painting market. Yet he was of course a painter in watercolour and used his own peculiar form of tempera. His engravings – and even in the context of the Stedman pieces he produced works of creative transposition – and the formal vocabulary that he used are developed out of what are now considered to be canonic sites of high art. These include medieval cathedral tomb sculpture, the work of Michelangelo (in all media) and the paintings of Raphael (which Blake would only have seen in the form of engraved reproductions). Consequently Blake's Stedman engravings are fine prints, produced by a practising painter whose mind was deeply saturated in canonic Western art and literature.

Bartolozzi's relation to high art is just as complicated as Blake's. Bartolozzi studied history painting for three years at the Florentine Academy, under the tutelage of Ignazio Hugford. Having trained primarily as a painter it was only after his first trip to Rome that he became articled to an historical engraver in Venice at the age of eighteen. Bartolozzi continued throughout his career to pursue painting, although the sensational success of his stipple prints left him little time, and he was one of the first to be nominated as a member of the Royal Academy, on the grounds that he was a painter as well as an engraver. Bartolozzi consequently approached printmaking via his experience and practice as a history painter deeply immersed in the masterpieces of the Florentine Renaissance. He brought to engraving a formal ambition and a knowledge of the Italian masters unique among English print makers of the period. The celebrated series of large stipple engravings, which Bartolozzi made after Holbein's drawings of the court of Henry VIII, show him to have possessed a unique sensibility as an engraver. Holbein's court portraits, with their mesmeric economy of line and apparently ruthless honesty, should be beyond the power of stipple engraving to reproduce. Their conversion resulted from Bartolozzi's inspirational use of the grain stipple technique, as opposed to the colder and more mechanical cluster technique.[11] Bartolozzi's act of transposition raised engraving to a new interpretational level, which it was never to reach again.[12]

The work that both men produced for Stedman consequently enjoys a liminal relationship with high art, and their engravings of Surinam slave subjects make

interpretational demands that more blatantly pornographic and aesthetically low-grade material describing slave torture, do not. The *Narrative* emerges as a deeply disturbing work, which produces beautiful images of eroticized torture. The words and engravings in the *Narrative* have now generated several extended discussions by literary scholars. It has, however, never been hinted, let alone strongly argued, that these materials may involve a pornographically exploitative stance in their relationship to slavery, and to the ritualized punishment of the black body, male and female.[13]

'never Poor Devil felt more than I on this occasion': Stedman's *argumentum ad misericordiam* and homoerotic moral sentiment

Is the frontispiece (figure 29) to the *Narrative* a pornographic image? I think that it is; it is certainly highly erotic, but the manner in which it simultaneously sentimentalizes, sexualizes and trans-sexualizes the body of the black victim at the moment of death has pornographic elements. The virtually naked black abandons himself to death before the voyeuristic attention of a beautiful clothed young white man, while the white man stares straight at us and asks us to enjoy the spectacle of his own sentimental fantasy. The accompanying lines of verse demand that we see the real victim here as Stedman, because of his painful susceptibility to emotional empathy. It is not the black who feels the death pangs but Stedman himself: 'Unhappy youth while bleeding on the ground; 'Twas *Yours* to fall – but *Mine* to feel the wound'. This is the appropriative essence of the man of sensibility. The victim's sufferings are only relevant in the degree to which they stimulate empathetic suffering in the observer, a movement which is complicated when the victim's suffering is the direct result of action by the observer.

This peculiar emotional mechanism goes off frequently within the literary persona Stedman developed while composing his 1790 manuscript. In fact, Stedman goes to almost ludicrous extremes in order to demonstrate his capacity to feel. During the battle in which the black in the frontispiece is butchered, Stedman describes himself shooting with his eyes closed, because he has been overcome by an excess of sensibility. Meanwhile, his colleague in arms is shooting five or six 'Hottentots' with a single blast:

> While I honestly Acknowledge that in Place of like Mr. *Sparman* who kill'd 5 or 6 Hottentots at one shot – Even at this Moment my Sensibility Got so much the Better of my Duty, And my Pity for these poor miserable, ill treated people Was such, that I Was rather induced to fire with Eyes shut.[14]

This attitude is quite simply absent from matter-of-fact journals Stedman kept nearly twenty years earlier when serving on the spot as a soldier. He thinks nothing of brutally punishing and killing blacks and white soldiers alike.[15] Yet in the 1790 manuscript Stedman's capacity for true sentiment saturates the accounts of abuse both of slaves and animals.

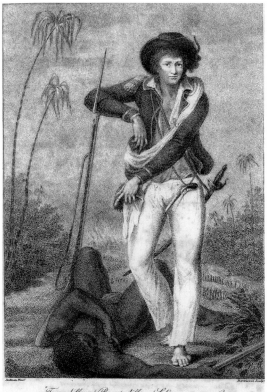

29 Francesco Bartolozzi, 'From different Parents
different Climes we came', hand tinted stipple
engraving; from John Stedman, *Narrative of a Five
Years Expedition against the Revolted Negroes of
Surinam* (London, 1796).

In order to understand how and why this happens, eighteenth-century moral theory concerning sentimentality is crucial. Stedman was writing within an intellectual context in which the spectacle of pain had suddenly been aesthetically theorized in new ways. Pain was at the centre of debates over aesthetic experience and its description and ascription in the area of colonial race theory.[16] Stedman's contemporaries were deeply concerned with the question of how the perception of another's pain opened the way for sympathetic and sadistic projection.[17] Response to another's pain was the touchstone of sentiment and is a central concern of Gothic fiction, and of much Romantic poetry, including some of Wordsworth's greatest.[18] Pain was also becoming intensely eroticized in new ways in the late eighteenth century, Sade's work providing the most spectacular and extreme articulation of an immensely complicated and widespread phenomenon.[19] How one responded to the spectacle of suffering was the true test of the man or woman 'of feeling', and consequently of what defined a civilized consciousness. The ability to empathize with another's pain is set up as the supreme test of humanism, and in Burke as a true test of the 'sublime' experience. The sympathetic capacity is seen above any other to separate the human from the brute or the savage. Yet Stedman was also writing at a time when the Stoic ideals of endurance and fortitude in the face of extreme suffering had been powerfully revived.[20]

Sentimental empathy and stoic endurance, rather than Christian martyrological ecstasy, are the two poles underpinning the most influential and highly sophisticated eighteenth-century discussion of the relation of the perception of pain between the sufferer and the witness: Adam Smith's *Theory of Moral Sentiments*. In his *Narrative* Stedman creates an erotics of pain that finds its centre in the black slave body. Smith's *Theory* provided the theoretical parameters defining Stedman's thought and vision.[21]

Stedman places his own perceptual capacities at the centre of his text, and particularly at the centre of the accounts of torture, many of them intensely sexualized, that it contains. Smith's theory is the essential key to unlock the specific mechanisms that have made parts of the *Narrative* function as algolagnistic psychodrama. Two hundred years before Elaine Scarry came to a very similar conclusion, Smith was to present extreme pain as an untranslatable experience, and, perhaps more significantly, as an experience that cannot be recovered by the victim but only by the spectator: 'Nothing is so soon forgot as pain. The moment it is gone the whole agony of it is over, and the thought of it can no longer give us any disturbance. We ourselves cannot then enter into the anxiety and anguish we had before conceived'.[22] While pain is seen to exist in an immediate and isolated present, its very incommunicability makes it into the key site for the individual witness's exploration, or testing, of his or her capacity for sympathy. Smith places sympathy as the central motive force in the development of morality. Stedman's compulsive and sexualized accounts of the extreme physical abuse of slaves, and the images that accompany them, can be read, as his contemporaries would have read them, against this central premise of Smith's theory of moral sentiments.[23]

The first page of Smith's meditation on the dynamics of sympathy sets out, with a ruthless clarity, the essentially competitive and voyeuristic basis of sentimental theory. The paragraph is worth quoting in full because it establishes a perceptual world in which Stedman's pornographic accounts of slave torture, and their accompanying engravings, operate:

> As we have no immediate experience of what other men feel, we can form no idea of the manner in which they are affected, but by conceiving what we ourselves should feel in the like situation. Though our brother is upon the rack, as long as we ourselves are at our ease, our senses will never inform us of what he suffers. They never did, they never can, carry us beyond our own person, and it is by the imagination only that we can form any conception of what are his sensations. Neither can that faculty help us to this any other way, than by representing to us what would be our own, if we were in his case. It is the impression of our own senses only, not those of his, which our imaginations copy. By the imagination we place ourselves in his situation, we conceive ourselves enduring all the same torments, we enter as it were into his body, and become in some measure the same person with him, and thence form some idea of his sensations, and even feel something which, though weaker in degree, is not altogether unlike them. His agonies, when they are thus brought home to ourselves, when we have thus adopted and made them our own, begin at last to affect us, and we can then tremble and shudder at the thought of what he feels for as to be in pain or distress of any kind excites the most excessive sorrow, so to conceive or to imagine that we are in it, excites some degree of the same emotion, in proportion to the dullness or vivacity of the perception.[24]

The communicability of pain through empathetic fantasy could not be set out more transparently. We are all imprisoned within 'our own perception'. This means that our senses can never realize or communicate precisely what constituted, consti-

tutes or will constitute another person's traumatic suffering under torture. Consequently, the only way of drawing near to the sufferer's experience of pain is to mimic it, to fantasize it, using imagination. This assumption is finally based on the premise that an observer's (viewer's, voyeur's, witness's) sympathetic response to another person's pain lies in a gesture of extreme psychic masochism. It is the duty of the sympathetic imagination to try and appropriate the victim's pain to such a degree that we 'enter' that person's body.

Stedman's *Narrative*, text and engravings, is a sentimental text in precisely Smithian terms. Blake's and Bartolozzi's engravings of abused slave bodies provide iconic sites that invite the viewer to fantasize his or her own fictions of torture. It is the duty of the sympathetic gaze to try and take over the body of the black victim through a supreme empathetic effort. For, as Smith stresses in that challenging and terrifying final phrase, we can get close to the victim's pain only 'in proportion to the dullness or vivacity of the [individual viewer's] perception'. Stedman's text lays out an essentially competitive theory of *co*-miseration nicely encapsulated in the challenge: 'never Poor Devil felt more than I on this occasion'. The spectacle of extreme physical suffering is the ultimate test for the capacities of the sentimental imagination, but also shades very easily into pornographic fantasy.

The great chain of suffering: slaves, monkeys and mercenaries

One year before Stedman completed the 1790 manuscript of the *Narrative*, Jeremy Bentham placed the ability to suffer at the centre of his theory of moral development. In a famous passage he thought about the animal creation and stated: 'The question is not, can they reason? Nor, can they talk? But *can they suffer?*'[25] Stedman unequivocally answers this question in the biggest sentimental set piece in the *Narrative*. Here the emotional sensitivity of Sterne's *Sentimental Journey* is grotesquely grafted onto the figure of the great white hunter to produce a tableau that works in sinister ways to equate tortured animal body with tortured slave body.[26] In the 1776 *Journal* Stedman simply wrote 'I shoot 2 large apes'.[27] When he came to rework the event for the 1790 manuscript he wrote the following account:

> I lay'd my Piece to my Shoulder and brought him down from the Tree plump in the Stream but may I never again be more Witness to such a Scene, the Miserable Annimal was not dead but mortally Wounded, thus taking his Tail in both my Hands to end his torment, I swong him round and knock'd his head against the Sides of the Canoo with such a force, that I was covered all over with blood and brains; but the Poor thing still continued alive, and looking at me in the most Pitiful manner that can be conceived, I knew no other Means to end this Murder than by holding him under Water till he was drown'd, while my heart felt Seek on his account; here his dying little Eyes still Continued to follow me with seeming reproach till their light gradually forsook them and the wretched Creature expired. never Poor Devil felt more than I on this occasion, nor could I taste of him or his Companion when they were dress'd[28]

Again the victim's suffering is not really important, it is incidental to the depth of feeling aroused in Stedman 'never Poor Devil felt more than I on this occasion'. But here there is a contrast between imaginative worlds that should be kept apart but which Stedman, in the act of creative recollection, forces into an uneasy union. Stedman is seeking to reconcile the irreconcilable, the world of macho, mercenary and military violence, which he represents as Captain John Stedman in the early 1770s, and the world of hyper-sensitized empathy that he embodies as John Stedman, author and man of feeling, in 1790. The eighteenth-century physician, George Cheyne, stated 'there are as many and as different Degrees of *Sensibility* or of *Feeling* as there are degrees of Intelligence and Perception in *human* creatures … One shall suffer more from the Prick of a *Pin*, or *Needle*, from their extreme sensibility, than others from being run thro' the Body'.[29] Stedman impossibly marries both extremes.

Stedman made a drawing for his frontispiece, and then Francesco Bartolozzi, technically the most subtle engraver in Europe during the age of sensibility, transformed the design into a seductively hazy, high-quality, stipple engraving.[30] The collaboration produced an exploitative art image out of the violent and sexualized death of a black male victim. An ex-slave fighting to maintain his liberty and butchered by a mercenary force, which included this lovely looking young white officer, becomes an icon upon which Stedman may project, ten years after the event, a vicarious form of pain.

Stedman's own text deals cursorily with the remarkable image opening his *Narrative*. The image in the foreground only merits a single line of actual description in the text, and it occurs in the context of the aftermath of the only real fight that Stedman had with the rebel slaves:

> Upon the Whole, to Draw this Picture Were a fruitless attempt, thus I Shall only say that the incessant Noise of the Firing, Mixed With a Confused Roaring, Hallooing, Damming and Sinking, the Shrill Sound of the Negro Horns, the Crackling of the Burning houses, the Dead & Wounded all Weltering in Blood, the Clowd of Dust in Which we were involved – And flames and Smoak Ascending; were such a Scene of Beautiful Horror / if I may use the Expression / as would not be unworthy of the Pencil of Hogarth – And Which I have faintly tried to Represent in the Frontispiece, Where I may be seen After the Heat of the Action Dejectedly Looking on the Body of an Unfortunate Rebel Negro Stretch'd at my feet.[31]

We do not know from this if Stedman killed the black man himself. What we do know is that he considers the whole thing, the noise of the maroon settlement burning and of negro horns, the carnage, his own lament over a single corpse, to amount to a 'beautiful horror'.

The frontispiece is a bizarre fusion of violence and passivity, and in this sense disconcertingly mimics the emotional dynamic within the passage on the killing of the monkey, just quoted. Stedman also writes within the emotional dynamic of the bondage relationship. The clothed Stedman, with naked feet, hands, face and

chest, stands erect and dominates the composition. For all his languid concern, and delicate emotion, Stedman embodies a dominant violent white male colonizing sexuality. His hat carries a burning fuse, the origin of the fire that rages in the background. Stedman's small pistol hangs across his groin, the barrel resting where his penis would be if hanging out of his breeches, and points down directly between the legs of he black man. Stedman's cutlass swings out behind his thigh, the tip reappears beyond his left knee, hanging between the black's open legs. The swinging curve of the sword is precisely mirrored by the length and curve of Stedman's left arm, which ends with a beautifully tapering white index finger mirroring the point of the sword. There is an extraordinary tension between the two bodies: the black all vanquished, supine, feminized and available nudity, the white clothed and full of points, and pointing. Yet at no point are the actual bodies allowed to touch. The only contact the two bodies enjoy is through the barrel of the gun, the biggest phallic object of them all. The muzzle of the gun is propped against Stedman's elbow, the breech of the barrel rests up along the outside of the black's left thigh and knee. The only other point at which a physical contact between white and black flesh almost occurs is Stedman's toe. Stedman's text fetishizes his own feet in the context of his health: he claims the act of going barefoot saves him from a variety of tropical diseases. Elsewhere he gives a detailed, and overtly fetishized, account of the torture of his feet by his mulatto mistress Joanna, in order to pick out the chigoe flies from under his toenails.[32] Here his delicately stippled naked white feet are planted close to the black body in a spatial well between the rebel slave's out-flung thigh and arm.

Everything about the composition sets up questions, and tensions, regarding the nature of the relationship between the pale Stedman, lovely in his concerned pity, this beautiful, naked, black victim, and the viewer/voyeur. The black man inclines gently towards us; he looks languid, contemplative and relaxed. He lies in a state of abandonment more reminiscent of a Correggio nymph receiving the transformed power of a lover God, than of a big, powerful, black corpse on the battlefield. The black man's sexualized passivity is extreme. He is only one of two black figures in the whole book shown lying down. In fact there are very few figures of recumbent naked young black men in the whole of the eighteenth-century Western visual archive.[33] The black legs are parted, and in the coloured version of the print his pubic hair is very visible, although his genitalia are not. In extreme foreshortening, a white loin-cloth cuts off the view of his genitals, and with legs spread makes him appear female or at least androgynous. As Stedman points down at this black body, the message is that it is there for the taking.

A black female bondage icon for the 'Sympathizing Reader'

When we come to the treatment of the female slave body in Stedman's text there are equally strong arguments for seeing both images and texts as involved in the pornographic exploitation of female punishment. Nudity and the torture of female slaves

are set out as the very first thing Stedman sees and responds to when he steps on to South American land. As the frontispiece was the first image in the book representing a black man, so the first image in the book showing a black woman is a representation of torture, 'A Female Negro Slave, with a Weight chained to her Ancle' (figure 30). As with the frontispiece, it was the star engraver employed on the project, Bartolozzi, who produced the plate. The effect of this decision is important, for Bartolozzi worked almost exclusively in the very expensive, technically refined, and laborious technique of stipple. As opposed to line engraving, this method involved building up the image out of a myriad of tiny dots of different depths, the varying depths giving different intensities of ink when printed. It is a technique

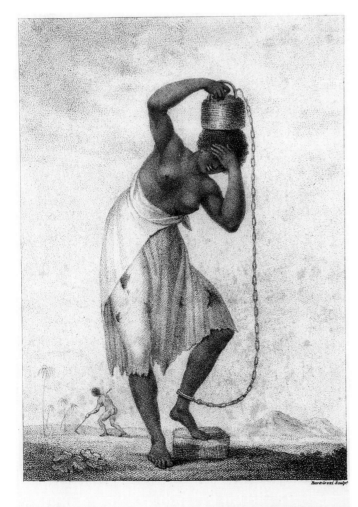

30 Francesco Bartolozzi, 'A Female Negro Slave, with a Weight chained to her Ancle', stipple engraving; from John Stedman, *Narrative of a Five Years Expedition against the Revolted Negroes of Surinam* (London, 1796).

A Female Negro Slave, with a Weight chained to her Ancle

capable of infinite tonal subtlety, and consequently ideal for the description of tonal
gradations in the depiction of black skin. The soft, slightly out of focus effects that
result, and the lack of hard outlines, are well suited to the conventional description
of the female nude. This means that, in Bartolozzi's representation of the semi-
naked form of the tortured female slave, the plate has a highly sensuous quality,
which the woman's combination of pain and shyness (as she shields her eyes from
our gaze) only serves to exacerbate. Stedman's text constitutes his first account of
seeing a black slave:

> When stepping on Land the first object I met was a most miserable Young Woman in
> Chains simply covered with a Rag around her Loins, which was like her Skin cut and
> carved by the lash of the Whip in a most Shocking Manner. Her Crime was in not
> having fulfilled her Task to which she was by appearance unable. Her punishment to
> receive 200 Lashes and for months to drag a Chain of several Yards in length the one
> end of which was … a weight of 3 score pounds or upwards. She was a beautiful
> Negroe Maid and while I was Meditating on the shocking Load of her Irons I myself
> nearly escaped being rivitted by Fascination – I now took a draft of the wretched
> Creature upon paper which I here present to the Sympathizing Reader.[34]

For Stedman this eroticized vision of the tortured black female body holds an
obsessional power. Whereas in his journal he had created the myth that it was his
own eyes which hypnotically 'fasquinated' the female sex, here it is the body of the
female victim which turns the relationship upside down, and Stedman is 'rivitted
with Fascination'.[35] The woman herself is an unstable subject: she begins as an
'object', she is then a 'miserable Young Woman', then 'a beautiful Negroe Maid'
and finally a 'wretched Creature'. Stedman, as ever, shifts between an objectifying
gaze that tends to animalize and dehumanize the black female body as 'object' and
'Creature' and a highly wrought sentimentalized empathy that clothes the black
victim in an elaborately romanticized diction. His vision is suspended between two
truths: firstly, the certainty that the slave is, in legal terms, an object or commodity,
and secondly, the certainty that the slave is a suffering being.[36]

Stedman, in fact, manages an ingenious fusion of the slave body as both object
and sentient being. The woman exists as an object for 'meditation', as a visual stim-
ulant for Stedman's unending reserves of sentiment. There is also, even here, the
perverse sense that he is vying with her to see who can suffer the more, the victim in
her torture, or the sympathetic voyeur in his ability to think himself into her pain.
This comes out explicitly when Stedman tells us that 'she was a beautiful Negroe
Maid and while I was Meditating on the shocking Load of her Irons I myself nearly
escaped being rivitted'. This is a very revealing sentence in terms of the way it
allows one to enter the essentially pornographic approach of Stedman to this spec-
tacle. It is also a sentence which was completely cut out from the 1796 published
edition.[37] It is not clear if his 'meditation' is a fantasy of sadism or masochism; is he
turning himself into the master or the slave here? He is, of course *free* to play at
being both.

The Bartolozzi design makes several deviations from the text, which alter the sexual chemistry. The provocative shredded rag around the woman's loins is expanded into a substantial skirt-like cloth. He has also introduced a minute and totally naked black male slave in the background to emphasize the woman's partial nudity and her proximity to the viewer. As with Blake's flagellated Samboe slave, on to whom the shredded loin-cloth has been transposed (figure 31), she is very much in the foreground; this is *in your face* abuse. Bartolozzi's biggest innovations relate to the woman's gestures, and it is these which tilt the engraving over into the pornographic. Firstly, she is shown lifting the enormous iron weight above her head. Why is she doing this? In terms of her comfort it seems a pointless and

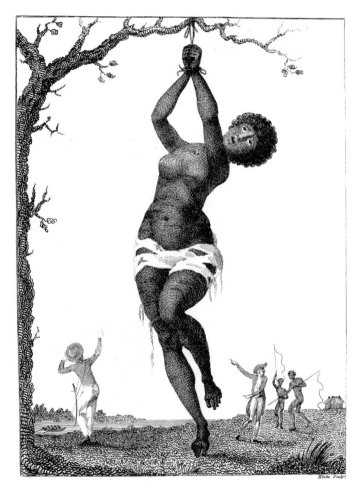

31 William Blake, 'Flagellation of a Female Samboe Slave', copper engraving, from John Stedman, *Narrative of a Five Years Expedition against the Revolted Negroes of Surinam* (London, 1796).

Flagellation of a Female Samboe Slave.

difficult gesture. If it has no practical point, however, it affects how her body is presented to the view. It brings the bondage objects that afflict her centre stage: her black flesh, her softly stippled feminine hand, grasps the cold iron, and the action allows the connected chain to float out in space and fall in a satisfying parabola, to rest around the shackle on her provocatively raised ankle, which for some reason is placed on a small block or pedestal. The victim is put on display; the small pedestal, the weight, the gesture itself, all have the effect of sculptural display.

While Bartolozzi has this 'beautiful Negroe Maid' provocatively give with one hand, he counterbalances this by having her provocatively take away with the other. While the lifting of the weight advertises her beauty, her torture and her pain, her other hand is raised to hide her eyes. What she is hiding her gaze from is open to question, presumably from Stedman's gaze, and Stedman's gaze became Bartolozzi's gaze and is now, finally the gaze of the viewer. The gesture has one main effect, to celebrate the victim's powerlessness in the face of the viewer's hungry eyes. The fact that her gesture emphasizes that this forced display is against her will only makes it the more exciting. In the way the image demands that her visual promiscuity be gesturally underlined the image again moves into the pornographic domain.

So where do Stedman and his engravers leave us with regard to the pornographic content of a book that sends out such mixed messages concerning race, sex and torture? At the opening of this discussion of the engravings I asked if the first one was pornographic, and in conclusion the same question can be asked of the final plate, 'Europe supported by Africa and America' (figure 32). The editors of the recent edition of the 1790 manuscript bring a modest gaze to bear when they consider this image; they see 'demure but unmistakable sensuality'.[38] Does this image emanate merely such a healthy eroticism? Stedman introduces the image with the following words:

> Going now to take my last Leave of *Surinam* after all the Horrors & Cruelties with which I must have hurt both the *Eye* & the *heart* of the Feeling reader, I will Close the Scene with an Emblematical Picture of *Europe* Supported by *Africa* & *America* Accompanied by an Ardent Wish that in the friendly manner as they are Represented they may henceforth & to all Eternity be the Prop of each other.[39]

On one level we are not talking about real women at all, but national emblems. Yet the women Blake engraves are very flesh and blood, they are as sensual and desirable as Goya's wonderfully fleshy angels in the church of San Antonio de la Florida, painted at exactly the same time.[40] It is only the relative body colours and physiognomies that describe the continents through racial identity; the bodies, *as bodies*, are physically interchangeable.

In erotic terms the print works around the fact that Europe is the centre of attention, not just compositionally but in tactile terms. The Blake–Stedman collaboration has constructed a classic male sexual fantasy involving the sensual (lesbian?) embrace of three naked women all with the same lovely figure but of different skin colour and hair type. The two non-whites wear ornamental bands (picked out in gold on both arms in the dramatic coloured version); the white

woman has no bands. She is the centre of the other women's attention, and while Europe holds the hand of Africa and the shoulder of America, the hands of Africa and America stroke Europe's body and reach towards her breasts, the fingers straining from all directions.

At this level the image, although clearly prioritizing Europe's desirability within a race hierarchy, is simply erotic. What throws the scene into another sexualized space is the manner in which Stedman demands that the viewer look on this image as a visual antidote. The opening sentence of the passage just quoted sets up a complicity between author and reader that is sinister and binding, and is a celebration of the success of a sadistic mission. Stedman is certain that in describing the 'Horrors and

32 William Blake, 'Europe supported by Africa & America', hand tinted copper engraving; from John Stedman, *Narrative of a Five Years Expedition against the Revolted Negroes of Surinam* (London, 1796).

Europe supported by Africa & America.

Cruelties' of slave abuse he has damaged us perceptually and emotionally, in 'both the *Eye* & the *heart*'. There is also an implicit threat in the term 'Feeling reader', in that if we could not respond to his sado-masochistic reconstructions of slave bondage and abuse, then it is not his fault as a pornographic artist but ours as a *non*-'Feeling reader'. The sensual image of perfect female physical harmony we now see is given to us as a reward for what we have suffered/enjoyed while looking at, and reading about, the torture scenes. Stedman manages to cast a retroactive spell over how we read the engraving, and the image of Africa in particular.

The final image is a triumphant example of a technique that runs throughout the text and shows how conscious Stedman is of the way he can orchestrate the sadism in his work by interspersing it with long passages of anthropological or naturalistic description, or with the love story of his reconstructed relationship with Joanna. He earlier ruminated: 'I wish to diversify the Sable Scenes of Horror, by the more cheering Sunshine of Content, And to variegate this Work in such a manner / if possible / as to make it please both the Stern Grim Philosopher, and the Youthful, the beautiful and innocent Maid'.[41] Of course the idea that it is only the tough and male 'Stern Grim Philosopher' who will be 'pleased' by the Sable Scenes of horror is, to put it kindly, disingenuous. There is an extent to which the sentimental Captain John Stedman is gloating over a further fantasy, the fantasy of the 'Youthful, the beautiful and innocent Maid' in England, seeing images and reading words describing naked male and female slaves tortured to death in extremely deviant ways. It is a fantasy that would not have displeased Sade. It is also worth remembering that in the aesthetic world of the sublime – which Stedman, as a man of 'Feeling', inhabits – the description of the tortured black body carries a double charge: there are special reasons for singling out 'Sable Scenes of horror'.

Burke set out a series of ground rules for the aesthetic and emotional response to horror in his *A Philosophical Inquiry into the Origin of our Ideas of the Sublime and the Beautiful* (1757), which is useful here. Two distinct areas productive of sublime experience are fused in the image of the tortured black. Firstly Burke went so far as to suggest that blackness actually assaulted the eye, that to see black was physically, physiologically painful: 'it may appear on inquiry, that blackness and darkness are in some degree painful by their natural operation, independent of any associations whatsoever'. Burke cites the example of a boy, blind from birth, who regained his vision and tells us that the 'first time the boy saw a black object, it gave him great uneasiness; and that some time after, upon accidentally seeing a negro woman, he was struck with great horror at the sight'. Burke stands at the imaginative extreme of a tradition that is associational and empirical; black is of its essence melancholy and terrifying. Secondly Burke isolates as a source of the sublime the experience of watching torture; or as he puts it, 'Whatever is fitted in any sort to excite the ideas of pain ... is a source of the *sublime*; that is, it is productive of the strongest emotion which the mind is capable of feeling'. If these two stimuli are fused, then it is clear that the aesthetic effect of looking at a black body being tortured is, in the world of sublime experiences, pretty much unbeatable.[42]

In the example of the final plate, however, Stedman goes even further and demands that the reader view this little piece of concluding 'Sunshine of Content' through recollection of the scenes of 'Sable ... horror.' He insists that his scenes of sexualized violence against blacks cannot finally be resisted. His reader can, in narrative terms, run, but cannot hide; he has turned light into dark. This young African woman embracing a lovely white woman, is very like the beautiful young woman in the foreground of the slave coffle in the plate 'Group of Negros, as imported to be sold for Slaves' (figure 33); she is also a very close visual relation of the flagellated Samboe slave (figure 31). The young black woman with the 'come hither' look (while Europe gazes demurely at the ground, America looks us straight and solemnly in the

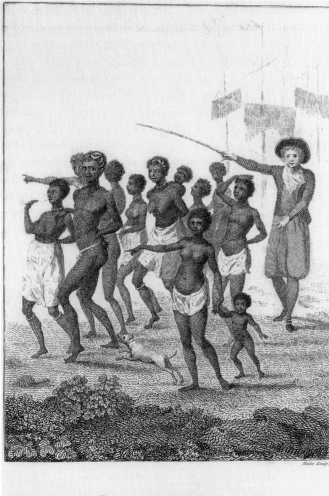

33　William Blake, 'Group of Negros, as imported to be sold for Slaves', copper engraving; from John Stedman, *Narrative of a Five Years Expedition against the Revolted Negroes of Surinam* (London, 1796).

Group of Negros, as imported to be sold for Slaves.

eye) exists in a different narrative and teleological space to the other two nudes. No other naked white women exist in the engravings within the *Narrative*. What is represented is the young female black African slave body repeatedly, ritualistically and pornographically punished. In this sense even at its conclusion, as Stedman calls up the horrors before his imagined reader's eyes, the text places the black female body in a space connected with extreme punishment and sexual abuse.[43]

Stedman, when dealing with the torture and sexual abuse of slaves, operates in a world of pure fantasy, where all suffering and sexually motivated violence occurs so that it can be measured against his perceptual abilities to enter into it. He is like some gargantuan method actor always trying to get inside the experience of the victim, male or female, animal or slave, always trying to eat up their suffering, so that in the end he can play their part better than they did. Despite surface similarities, as a pornographer he stands at the opposite extreme from the Sadean male protagonist, who cultivates a cold Epicurean approach to the perpetration of sexual crime. Sade delights in the extremity of his ability to objectivize; Stedman delights in the intensity of his ability to empathize. Stedman does not perpetrate any Sadean crimes, at least not the Stedman who emerges in the 1790 *Narrative*. Yet, his approach to the description of sexual crime is in many ways more perverse than Sade, and certainly requires a higher level of complicity on the part of the reader. Stedman witnessed multiple slave tortures on an almost daily basis at one point of his existence. He then, nearly two decades later, cultivated a state of mind where he could produce extended fantasies, which re-fashioned these memories. Stedman had also produced in the 1770s a series of on-the-spot visual records of what he saw. These sketches are now mostly lost, yet during the production of the *Narrative* they were passed on to a series of highly skilled commercial engravers, including Blake, who then had the job of re-making them for the commercial market place. The accounts of slave abuse, which emerge in the combination of text and image, are sentimental artefacts. They are designed to be enjoyed both by Stedman and by his audience, as fantastic spaces, or spaces for fantasy. As we have seen with Burke, and as the Gothic genre asserts at its core, to fantasize about torture, to attempt imaginative submersion in that space, is a sublime experience. When the reader performs such fantasies around the body of the hanging slave, or the whipping of the 'sambo' girl it is also a pornographic experience. Rhetoric can be applied to describe horror in any number of ways; there are many pornographies of pain and many arts of violence. The meeting of Stedman's, Bartolozzi's and Blake's delicate fantasies with the facts of plantation slave torture produced an aesthetically poisoned chalice.

Notes

1 Standard texts on late eighteenth- and nineteenth-century pornography are Stephen Marcus, *The Other Victorians: A Study of Sexuality and Pornography in Mid-Nineteenth Century England* (New York, Basic Books, 1966); Ronald Pearsall, *The Worm in the Bud: The World of Victorian Sexuality* (London, Weidenfeld and Nicolson, 1969);

Michael Mason, *The Making of Victorian Sexuality* (Oxford, Oxford University Press, 1994).

2 This absence is evident in the two landmark collections of essays on the eighteenth- and nineteenth-century origins and political functioning of pornography: Lynn Hunt (ed.), *Eroticism and the Body Politic* (Baltimore and London, Johns Hopkins University Press, 1991) and Lynn Hunt (ed.), *The Invention of Pornography: Obscenity and the Origins of Modernity, 1500–1800* (New York, Zone Books, 1993).

3 Lynn Hunt, 'Introduction: obscenity and the origins of modernity, 1500–1800', in Hunt (ed.), *Invention*, pp. 9–45.

4 The Enlightenment effect on the development of pornography is summarized in Hunt (ed.), *Invention*, pp. 30–5. For the French Revolution see pp. 301–39. See also Vivian Cameron, 'Political exposures: sexuality and caricature in the French Revolution', in Hunt (ed.), *Eroticism and the Body Politic*, pp. 90–108.

5 Hunt (ed.), *Invention*, p. 42.

6 See particularly Hunt (ed.), *Invention*, pp. 14–45.

7 Marcus Wood, *Blind Memory: Visual Representations of Slavery in England and America 1780–1865* (Manchester and New York, Manchester University Press, 2000), pp. 43–5, 152–71, 260–3.

8 Gloria Steinem, 'Erotica and pornography: a clear and present difference', in Laura Lederer (ed.), *Take Back the Night: Women on Pornography* (New York, Bantam Books, 1982), pp. 21–5 (23). For a survey of definitions of pornography past and present see Cheris Kramarae and Paula S. Treichler, *A Feminist Dictionary* (Pandora Press, London and Boston, 1985), pp. 344–8.

9 Adapted from the definition in Andrea Dworkin and Catherine A. MacKinnon, *Pornography and Civil Rights: A New Day for Women's Equality* (Minneapolis, Organizing against Pornography, 1988) pp. 138–9.

10 H. E. Longino, 'Pornography, oppression, and freedom: a closer look', in Lederer (ed.), *Take Back the Night*, pp. 26–43 (29).

11 The standard work on Bartolozzi's life and printing techniques remains Andrew W. Tuer, *Bartolozzi and his Works: A Biographical and Descriptive Account of the Life and Career of Francesco Bartolozzi, R.A.*, 2 vols. (London and New York, 1883).

12 Tuer, *Bartolozzi*, vol. 1, pp. 1–25, 82–7.

13 Standard treatments of Blake's images of slave torture are David Erdman, 'Blake's vision of slavery', *Journal of the Warburg and Courtauld Institutes*, 15 (1952), pp. 242–52; David Erdman, *Blake: Prophet Against Empire* (Princeton, Princeton University Press, 1969), pp. 157, 228–42, 291; Albert Boime, *Art in An Age of Revolution* (Chicago, Chicago University Press, 1987), pp. 339–40; Steven Vine, '"That mild beam": Enlightenment and enslavement in William Blake's *Visions of the Daughters of Albion*', in Betty J. Ring and Carl Plasa (eds.), *The Discourse of Slavery* (London, Routledge, 1994), pp. 50–7; Anne Rubenstein and Camilla Townsend, 'Revolted Negroes and the devilish principle: William Blake and the conflicting visions of Boni's wars in Surinam, 1772–1796', in Jackie di Salvo, G. A. Rosso and Christopher Hobson (eds.), *Blake: Politics and History* (New York, Garland, 1998), pp. 273–301. None of them raises the possibility that the work might be pornographic. The only discussion to prioritize sexualized violence in a discussion of certain of the Surinam plates is Anne K. Mellor, 'Sex, violence, and slavery: Blake and Wollstonecraft', *Huntington Library Quarterly*, 58 (1997), pp. 345–70.

14 Stedman (1790) p. 405. Stedman's text now exists in two distinct forms. The first is *Narrative of a Five Years Expedition against the Revolted Negroes of Surinam: Transcribed for the First Time from the Original 1790 Manuscript* (Baltimore and London, John Hopkins University Press, 1988). This is the recently edited text of Stedman's original fair copy manuscript. It is this text that forms the basis of the following analysis, and it is referred to as Stedman, 1790. The second is *Narrative of a Five Years Expedition against the Revolted Negroes of Surinam in Guiana on the Wild Coast of South America; from the Year 1772–1777*, 2 vols. (London, J. Johnson, 1796). This is referred to as Stedman, 1796. There is also a further and earlier account of Stedman's time in Surinam: *The Journal of John Gabriel Stedman 1744–97 Soldier and Author Including an Authentic Account of his Expedition to Surinam in 1772*, ed. Stanbury Thompson (London, Mitre Press, 1962). It is referred to as Stedman, 1962.

15 Stedman (1962), pp. 132, 134, 137, 139, 145, 159, 161.

16 For race and sentimentalism see Srinivas Aravamudan, *Tropicopolitans: Colonialism and Agency, 1688–1804* (Durham NC, Duke University Press, 1999), pp. 133–4, 312, 315.

17 The best survey of the intellectual, aesthetic and medical cross-currents relating to eighteenth-century pain theory is Steven Bruhm, *Gothic Bodies: The Politics of Pain in Romantic Fiction* (Philadelphia, University of Pennsylvania Press, 1994), pp. 1–29. For Smith's centrality to colonial texts, see Anita Rupprecht, 'Civilized sentience and the colonial subject', unpublished DPhil thesis, University of Sussex, 2000, pp. 37–59, 131–40.

18 James H. Averill, *Wordsworth and the Poetry of Human Suffering* (Ithaca and New York, Cornell University Press, 1980). For Wordsworth and sensibility, see Bruhm, *Gothic Bodies*, pp. 30–2, 45–8, 50–60.

19 For the relation of Sade's erotic pain theory to English sensibility, see Bruhm, *Gothic Bodies*, pp. 2–5. For the eroticization of flagellation in the eighteenth century, see Lawrence Stone, 'Libertine sexuality in post-Restoration England: group sex and flagellation among the middling sort in Norwich 1706–7', *Journal of the History of Sexuality*, 3:1 (1992); Wood, *Blind Memory*, pp. 260–75; Karen Halttunen, 'Humanitarianism and the pornography of pain in Anglo-American culture', *American Historical Review*, 100:2 (1995), pp. 308–9.

20 For the marriage of sentimentality and stoicism in the imagery of the French Revolution, see Bruhm, *Gothic Bodies*, p. 25.

21 Smith's Theory was a book he compulsively re-edited and altered from its first edition of 1759 to the elaborately revised and expanded sixth edition of 1790, published the same year that Stedman finished the manuscript of the *Narrative*. For the sustained popularity of this work in Britain, France and Germany see Adam Smith, *The Theory of Moral Sentiments*, eds. D. D. Raphael and A. L. Macfie (Oxford, Clarendon Press, 1976), pp. 32–3, which provides a complete list of editions, and for the continuing influence, see Rupprecht, 'Civilized sentience', pp. 136–42.

22 Smith, *Theory*, p. 29. For the capacity of pain to destroy language see Elaine Scarry, *The Body in Pain* (London and New York, Oxford University Press, 1985), pp. 29–50.

23 A recent study of Stedman's *Narrative* treats the relation between sentimentality and slavery: Tassie Gwilliam, '"Scenes of Horror", scenes of sensibility: sentimentality and slavery in John Gabriel Stedman's *Narrative of a Five Years Expedition against the Revolted Negroes of Surinam*', *English Literary History*, 65:3 (1998), pp. 653–73.

24 Smith, *Theory*, p. 9.

25 Jeremy Bentham, *Introduction to the Principles of Morals and Legislation* (London, T. Payne and Son, 1789), p. 32.

26 Stedman's sympathetic response echoes Yorick's cry on seeing a caged starling, 'I vow I never had my affections more tenderly awakened': Lawrence Sterne, *A Sentimental Journey* (London, Oxford University Press, 1968), p. 71.

27 Stedman (1962), p. 131.

28 Stedman (1790), p. 141.

29 Quoted in G. J. Barker Benfield, *The Culture of Sensibility: Sex and Society in Eighteenth-Century Britain* (Chicago, University of Chicago Press, 1992), p. 9.

30 For a subtle analysis of the fashionable Italianate qualities of Bartolozzi's style and of the way they infuriated Stedman see Rubenstein, 'Revolted Negroes', p. 293.

31 Stedman (1790), p. 406

32 Stedman (1790), p. 284.

33 The other black recumbent figure in the *Narrative* is in 'The Execution of Breaking on the Rack'. For naked black males in harem pornography, see Hugh Honour, *The Image of the Black in Western Art*, vol. 4: *From the American Revolution to World War I*, part 2: *Black Models and White Myths* (Cambridge MA and London, Harvard University Press, 1989), pp. 181–3.

34 Stedman (1790), p. 39.

35 'I had a Je ne say qwoy about me, of the fasquinating kind, which attracted the girls as the eys of the Rattlesnake attrakts Squirls, and unaccountably persuades them to submission': Stedman (1790), p. xviii.

36 For a sensitive discussion of how this central tension between slave as object and sentient being works itself out in nineteenth-century American slavery literatures, see Saidiya V. Hartman, *Scenes of Subjection: Terror, Slavery, and Self-Making in Nineteenth-Century America* (Oxford and New York, Oxford University Press, 1997).

37 Stedman (1796), vol. 1, p. 15.

38 Stedman (1790), p. lx.

39 Stedman (1790), p. 618.

40 Goya: *The Frescoes in San Antonio de la Florida* (Skira, Switzerland, 1969), plates 98–9.

41 Stedman (1790), p. 116.

42 Edmund Burke, *The Writings and Speeches of Edmund Burke*, ed. Paul Langford (Oxford, Clarendon Press, 1985–1997), vol. 1, pp. 295, 216.

43 For examples and a zealously extended commentary see Andrea Dworkin, *Pornography: Men Possessing Women* (London, Women's Press, 1981), pp. 210–17.

REVOLUTIONIZING
ATLANTIC IDENTITIES

Food chains: French abolitionism and human consumption (1787–1819)

Darcy Grimaldo Grigsby

Perhaps the most famous African in the history of French art is the one atop the rising wave of men in Théodore Géricault's *Raft of the Medusa* of 1819 (figure 34).[1] This beautiful figure seen from behind occupies the privileged apex of the picture's pyramidal composition. Held up by the collective body of shipwrecked men, this man buoyantly gestures towards the distant ship at the horizon with a swirl of white cloth. His action represents, therefore, the narrative as well as compositional

34 Théodore Géricault, *Raft of the Medusa*, 1819, oil on canvas, 490 x 716cm.

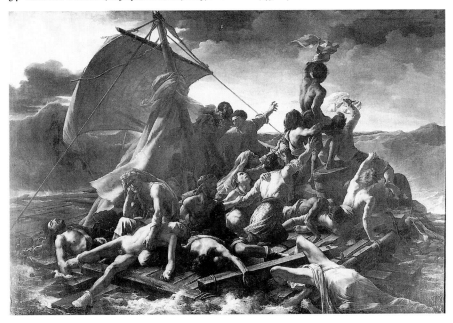

climax of Géricault's epic picture. If the men on the raft are to be rescued, the gesturing black man must be seen. Indeed the gamble of those who chose to raise him high was that *they* would be seen (and saved) because *he* would be. Yet this man long remained unnoticed or at least unspoken. Despite his pictorial prominence and remarkable beauty, none of the critics reviewing the picture in 1819 mentioned him. No less than three decades elapsed before he entered textual commentary. Charles Blanc was the first to note him in 1845.[2] It took a century and a half for art historians to consider this black man crucial to the picture's meaning. Only in the last dozen years has the figure become the centrepiece of art historical reconstructions of Géricault's Liberal abolitionist politics.[3]

Although he early introduced a black man to his cast of shipwrecked men, Géricault had not initially imagined such a figure to play a prominent role in his composition. The dark-skinned man who crowns the final painting's surging group markedly differs in pose from his antecedents. If this figure in the finished picture is lifted high and seen from the back, his head level and his arms open wide, the black man who appears in at least five preparatory drawings and an oil sketch is portrayed in profile, his head lifted upward, his clasped hands raised as if in prayer. When his lower body is visible, he is shown kneeling (figures 35, 36). This essay concerns itself with Géricault's preliminary supplicating figures seen in profile with upraised clasped hands, figures whose invisibility was once triply guaranteed by their race, by their formulaic blankness, and by the painter's eventual recourse to other poses.

I begin by asking why Géricault repeatedly introduced such figures to his preliminary versions of the *Raft* and what the praying black man could and could not signify in a scene of shipwreck off the coast of Senegal. Most simply, the mechanical reiteration of the profile figure in study after study betrays its origins as a codified symbol. Géricault was rather unimaginatively relying on abolitionist iconography, most

35 Théodore
Géricault, Study for
Raft of the Medusa,
1818–19, ink on paper,
21 x 26cm.

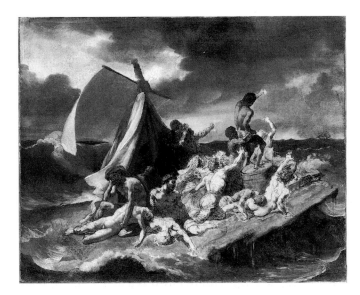

36 Théodore
Géricault, Study for
Raft of the Medusa,
1818–19, oil on canvas,
65 x 83cm. The black
man with his hands
clasped is the highest
figure just to the right
of the mast.

famously the shackled, kneeling black nude with lifted hands, that had originally
been devised by English abolitionists and subsequently appropriated by the French
Société des Amis des Noirs in 1787 (figure 37).[4] Here was the emblem used to identify
the *Société*'s publications. When
Géricault chose to insert such a figure
within his projected history painting
he relied on the era's most familiar rep-
resentation of a black man and also sig-
nalled his allegiance to the cause of
abolition. Géricault was embedding
the politics of abolitionism within his
picture of a shipwreck off the coast of
Senegal. This is hardly surprising.
Indeed, his choice fully accorded with
the point of view of those Liberals who
made the maritime disaster a *cause
célèbre*. The shipwreck of the *Medusa*
had been seized as an opportunity not
only to criticize the Bourbon
Restoration government generally but
to condemn its complicitous sanction
of the slave trade. The immensely pop-
ular shipwreck narrative by two sur-
vivors of the raft, Jean-Baptiste-Henri
Savigny and Alexandre Corréard,
explicitly called for the trade's end:

37 'Ne suis-je pas ton frère?' ['Am I not your
brother?'], seal of the *Société des Amis des Noirs*, 1788,
engraving.

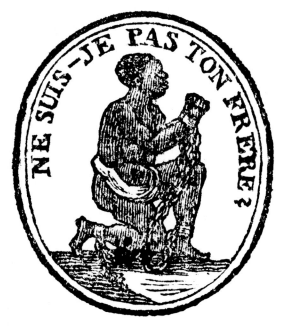

'L'Abolition de la traite. Voilà le principe fécond en conséquences qui doit commander à tout gouvernement éclairé de se hâter de changer tout son systême colonial'.[5] ('The Abolition of the Slave Trade: this is the principle, pregnant with consequences, which should induce every enlightened government speedily to change its whole colonial system'.)

Incorporating the trademark of the abolitionist society within a history painting would seem to secure its abolitionist message. The problem was that the kneeling black figure meant to represent the abolition of the slave trade necessarily underscored the condition of slavery, its passivity and mute dependence.[6] Although abolitionists may have intended their symbol to utter 'abolition', that utterance depended upon the identification of the kneeling black body with the slavery from which he needed to be freed. Because abolitionist prints were the most prominent depictions of blacks, they inadvertently perpetrated a visual conflation of black bodies with bondage. Chains corroborated that enslavement. While the shackles in these images could implicitly be removed, emancipation was none the less construed in the future tense, as a desired possibility not a self-evident condition. In the *Amis des Noirs* symbol, the caption 'Ne suis-je pas ton frère?' ('Am I not your brother?') proposed a familial equity – a fraternity between white and black men. The construction 'am I not … ?' was intended, moreover, to encourage an affirmative response. Nevertheless an interrogative, by definition, cannot foreclose the possibility of a denial on the part of the addressee ('No, you are not my brother'). Unlike an affirmative enunciation ('I am a man and your brother'), the abolitionist query required – we might say pleaded for – affirmation. The interrogative in itself enunciated a debate, indeed pivoted on its edge, and left the power to formulate an answer fully on the side of the implied white addressee. Built into the query was the risk of the answer 'no'. According to these images, black bodies were destined to remain subordinate until the query was finally answered in the affirmative by the white respondent.

The kneeling position of supplication in prints suggested, moreover, not only subordination and disempowerment but also semantic dependency. The beseeching black figure in profile came to be identified with the *Société des Amis des Noirs* but it had also been used redundantly in texts and images to represent slaves in a variety of narrative situations. Against the kneeling black alternately stood the beatific rescuer, the paternalistic benefactor (colonist or abolitionist), the cruel master (figure 38), the slave trader, even the father denying paternity. In all cases, the kneeling black man was the object to be acted upon. In such prints, the parameters of the debate, its implied statements and answers – 'free me', 'yes, I will free you' or 'no, I will beat you' – were formulated in the space surrounding the kneeling black figure who, opaque and unchanging, represented mute materiality – the black race to be acted upon.[7] The kneeling slave did not so much 'say' or 'express' imperatives like 'free me' as the white protagonist's response, 'I will not free you' or 'I will free you' retrospectively attributed to him speech acts. Captions like 'Am I not your brother?' were required to endow the kneeling black with

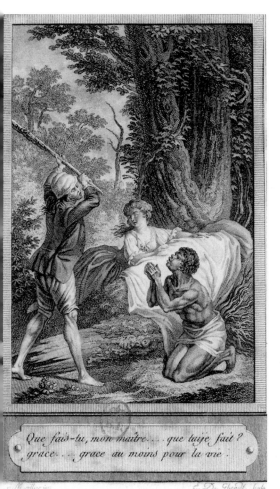

Que fais-tu, mon maître ... que taije fait ?
grace ... grace au moins pour la vie .

38 'Que fais-tu, mon maître ... que taije fait? grace ... grace au moins pour la vie' ['What are you doing, my master ... what have I done to you? mercy ... mercy at least for my life'], engraving; from Pierre Viaud, 'Naufrage et aventures de M. Pierre Viaud, Natif de Bordeaux, Capitaine de Navire', in *Voyages Imaginaires* (Paris, 1787).

speech, but, as caption, this utterance too could seem the emanation of French authorship on the black man's behalf rather than that of the black man himself. It was difficult to depict a black person's capacity to speak.

The beseeching black figures in Géricault's preliminary studies were therefore formulaic and familiar, clearly enunciating black slavery, yet at the same time mute about the narrative implications of their bondage. Given the extent to which the contextual frame determined the signification, one might say 'the fate', of the suppli-cating black, we should ask what frame the subject of the *Medusa* may have provided. As the Savigny and Corréard publication makes clear, abolitionism was certainly one such context. But the event, while providing a vehicle for the expression of abolitionist sentiment, was also a shipwreck.

Shipwrecks were so commonplace in the eighteenth and nineteenth centuries that their narratives were common knowledge. When the frigate the *Medusa* foundered on the reefs off Senegal, the survivors faced the frightening prospect, continually evoked in shipwreck accounts, of being eaten by 'savages' on shore.[8] Senegal was, in fact, particularly associated with shipwrecks as well as the savage torture of survivors by hostile inhabitants of the continent, specifi-cally the Moors. But black Africans were also identified with cannibalism throughout the eighteenth century and the French Revolution.[9] In the reactionary days of the Consulate and Empire, the identification was so common that Louis Marie de Grandpré felt compelled to devote the introduction of his 1801 publica-tion of a *Voyage to the West Coast of Africa* to its refutation.[10] Africans, he reassured his audience, were not cannibals. In fact, these blacks feared the inverse: they

believed that European slavers ate men. According to Grandpré, everything on board French slave ships confirmed black Africans' worst fears: the sailors drinking blood-red wine, the salted and darkened dried meats which 'leur paraître des débris de leurs semblables'[11] ('seemed to them debris of their same kind'). Grandpré's account aptly conjures the prevalence of fears of cannibalism at moments of cultural contact. In tales like his, cannibalism was a particularly fraught and panicked site of cultural misunderstanding. More specifically, it engendered a paranoid misreading of the most banal everyday signs: coals, wine, dried meat. Cannibalism was also remarkably unanchored, sliding from one constituency to another. The fear was shared, but the perpetrator was elusive. Men were being eaten but who ate whom was entirely uncertain.

That uncertainty made no space safe after shipwreck. If the unhappy persons on the *Medusa* feared landing on the coasts – and they certainly did – the illusion of safety among their own community could hardly be sustained even as a hope. Cannibalism may have been associated with the savages on shore but it was also a well-known tactic of survival among Europeans in states of crisis, particularly those off-land in that liminal space of the sea. Savigny and Corréard relied on the familiarity of shipwreck narratives in which cannibalism was ubiquitously featured. Take this example from a compilation of shipwreck accounts published both in 1815 and 1818: 'je n'attendais qu'à mesure que les horreurs de la mort s'approcheraient, nous nous dévorerions les uns les autres'.[12] ('I expected that as the horrors of death approached, we would eat one another'.) According to Savigny and Corréard, abandonment immediately conjures the unspoken terrors of starvation which certainly included cannibalism. 'Après la disparition des embarcations, la consternation fut extrême. Tout ce qu'ont de terrible la soif et la faim, se retraça à nos imaginations'.[13] ('After the disappearance of the boats, the consternation was extreme. All the terrors of thirst and famine arose before our imaginations'.) The imagined scenarios that abandonment provokes, not just 'famine' but the 'terrors of famine', had been rehearsed in many texts prior to their own.

As warring accounts of what exactly transpired on the raft of the *Medusa* make clear, the survivors of that maritime disaster could either be heroized as martyrs to an incompetent and reactionary government or be condemned as vile, self-serving cannibals. Although Savigny and Corréard were careful to indicate that the lowly soldiers and sailors were the first to resort to the eating of human flesh, the officers desperately holding out until a later point when the meat was cooked, Sander Rang, the champion of the lower classes and harsh critic of Savigny and Corréard, specifically asserted that the officers were the first to begin eating men. Rang's narrative was not published until the twentieth century but D'Anglas de Praviel's *New and Impartial Account of the Shipwreck of the Frigate The Medusa* was published in 1818. At the centre of Praviel's attempt to discredit Savigny and Corréard was his identification of these men with cannibalism. For example, after landing his lifeboat on the coast, Praviel gathered his fellow survivors together

and offered them a speech meant above all to distinguish their behaviour from that of the men on the raft:

> Mes braves amis, le malheur nous poursuit ... [L]a mer nous a vomis dans un désert où nous ne trouverons peut-être aucune ressource contre la soif et la faim, montrons du courage et ésperons tout de la Providence. S'il faut succomber en proie aux besoins les plus pressans, sachons mourir; respectons sur-tout les droits de l'humanité; qu'on ne dise jamais de nous: des Français ont bu le sang de leurs frères, ils se sont rassasiés de leur chair, des Français ont été anthropophages.[14]
>
> (My brave friends, misfortune pursues us ... [T]he ocean vomited us on to a desert where we may find ourselves without any resource against thirst and hunger, let us demonstrate courage and hope all from providence. If it becomes necessary to succumb to the torments of the most pressing needs, let us know how to die; let us respect above all the rights of humanity; let it never be said of us that some Frenchmen drank the blood of their brothers; they gorged themselves on their flesh; some Frenchmen were cannibals.)

There is much to say about this extraordinary passage, but first let me point out the strategic importance of Praviel's syntax. His negating frame – 'let them never say of us' – permits him to list in stark affirmative statements, the truth of those other Frenchmen on the raft: some Frenchmen drank the blood of their brothers, some Frenchmen gorged themselves on their brothers, some Frenchmen were cannibals. No other text states this fact so baldly and French cannibalism is only brought into language by purporting to negate it.

Corréard had expressed shock and anger that the survivors of the raft could be misrecognized as odious rather than sacred.[15] Praviel, by contrast, had no difficulty explaining why, for example, the colonial governor's daughter was repelled by the men who survived thirteen days at sea on the raft:

> Dans leurs fureurs Savigny et Corréard s'écrient: 'quel est donc notre crime aux yeux de Mlle Schmalz?' Leurs crimes! ils ne doivent en chercher d'autres que l'horreur que devait inspirer à des êtres sensibles la vue des hommes qui, pour se sauver, s'etaient entr'égorgés et nourris de la chair de leurs semblables.[16]
>
> (In their fury, Savigny and Corréard cry out: 'what then is our crime in the eyes of Mademoiselle Schmalz?' Their crimes! they do not need to search for any other than the horror necessarily inspired in sensible beings by the view of men who, to save themselves, cut each other's throats and nourished themselves with the flesh of their self-same.)

The men on the raft were found, Praviel emphasized, 'couchés sur les planches, les mains et la bouche dégouttantes encore du sang des malheureuses victimes, le mât du radeau tapissé de lambeaux de chair, leurs poches remplies de ces chairs dont ils s'étaient rassasiés'[17] ('lying on the boards, hands and mouth still dripping with the blood of their unhappy victims, shreds of flesh hanging from the raft's mast, their pockets filled with these pieces of flesh upon which they had gorged themselves'). Praviel insisted that the survivors of the raft were frightening men. They were frightening because they were changed; insiders returned to shore as outsiders.

Shipwreck made highly uncertain who was and who was not a cannibal. Moors and Africans may have been associated with such barbarism, but shipwrecked Europeans were famously willing to indulge their hunger regardless of taboos to the contrary. Returning to the supplicating black figures in Géricault's preparatory studies, we are now able to appreciate their semantic instability. On the one hand, these figures could seem to plead 'Save us', thereby identifying their own fate with the fate of the shipwrecked Frenchmen. Their prayer could be interpreted as on everyone's behalf. There is evidence that black men sometimes played this role in actual maritime crises. During a storm of 1818, for example, an American ship's crew asked a black man to pray for them, thereby deferring, according to historian W. Jeffrey Bolster, to the association of 'devotion at sea with blackness'.[18] The memoir of a survivor of this shipwreck contrasted the black man's kneeling pose of prayer to the verticality of the other crew members: 'The [black] cook knelt down where he could secure himself, the rest of us holding upon our feet, and [he] prayed most feverently [sic] for God to protect and save us from the dreadful, raging storm'.[19] In the context of shipwreck, however, kneeling black figures could seem less to plead on behalf of a multi-racial collectivity whose destiny was shared than to cry out 'Save me from them'. Such dark-skinned men had every reason to do so. The practice of cannibalism among shipwrecked persons often adhered to extant social hierarchies: the most socially marginalized person was frequently eaten first. Among British shipwrecks in the eighteenth century, for example, the chosen victims included black slaves as well as Portuguese and Spanish men.[20]

If the distinction between 'Save us' and 'Save me from them' is subtle, the difference between the utterances 'Free me' and 'Do not eat me' is not. Yet the figure of the kneeling black man was deployed to convey both in late eighteenth- and early nineteenth-century French images. The very year the *Société des Amis des Noirs* adopted the English symbol, a published shipwreck account featured the same figure in one of its illustrations (figure 38). Like the abolitionist icon, the black man in this print kneels with hands raised as if in prayer, his head turned in profile, but here the black man is juxtaposed to two elegant white protagonists, a man and a woman, in a verdant landscape setting. In Pierre Viaud's sensationalist tale, the three voyagers have been cast upon an island and face starvation. Ultimately, the white man and white woman decide to eat the black slave, the most subordinate person in their social hierarchy. The caption to the illustration reads: 'Que fais-tu, mon maître ... que taije fait? grace ... grace au moins pour la vie' ('What are you doing, my master ... what have I done to you? mercy ... mercy at least for my life'). The black figure thus signifies not only 'Do not beat me', as the caption tells us, but also, as the accompanying narrative clarifies, 'Do not eat me'.

In Viaud's text, the prospect of starvation elicits the same justifications for cannibalism deployed by so many shipwrecked authors, including Savigny and Corréard:

> Dans ce moment les plus noires idées m'agitoient. Est-il quelqu'un, me disois-je, qui jamais se soit vû réduit à la même extrémité que moi? ... Il me vint aussi-tôt à l'esprit

les aventures de quelques voyageurs, qui éloignés de leur route par la tempête, retenues dans des mers inconnues par des vents contraires, surpris quelquefois par des calmes, ont vu épuiser leurs provisions sans pouvoir les renouveller; je songeai qu'après avoir souffert la faim jusqu'à la dernière extrémité, ces malheureux n'avoient pas eu d'autre ressource que de sacrifier l'un d'eux pour le salut de tous, & que le sort avoit choisi quelquefois la victime qui devoit, en perdant la vie, soutenir celle de ses compagnons, en leur donnant son corps même pour aliment.[21]

(At this moment the blackest ideas agitated me. Is there anyone, I said to myself, who was ever reduced to the same extremity as me? ... In my soul, I soon thought of the adventures of some voyagers who, distanced from their route by tempest, retained in unknown seas by contrary winds, surprised sometimes by periods of calm, watched their provisions dwindle without being able to replenish them; I dreamed that after having suffered hunger to the last degree, these unhappy persons had no other resource but to sacrifice one of themselves for the health of all and that fate sometimes chose the victim who had, in losing his life, to sustain that of his companions in giving them his own body as nourishment.)

That the accounts by Viaud and by Savigny and Corréard have so much in common indicates the extent to which these narratives and their legitimations of cannibalism were codified by 1816. All shipwreck victims, it becomes clear, immediately thought of shipwreck accounts; their behaviours were therefore responsive to textual precedents.

The decision by the white man and white woman to eat a black slave conformed, as we have seen, to current practices. Within Viaud's text, it was also naturalized by his language. The author's 'blackest' thoughts of cannibalism lead him to recognize the sheer rightness of exercising black necessities on black bodies. Even as the slave master proposes the sheer logic of such a correlation, he is compelled momentarily to admit the possibility of its irrationality, only however to return to the most brutal fact of the institution of slavery: black slave bodies belong to their masters and 'serve' them they must.

Lorsque ces aventures terribles se présenterent à mon imagination, mes yeux égarés tomberent sur mon nègre; ils s'y arrêterent avec une espece d'avidité: il se meurt, m'écriai-je avec fureur, la mort la plus prompte seroit un bienfait pour lui; il va y suc-comber lentement; tous les efforts humains sont insuffisans pour l'en garantir; pourquoi sa mort ne me seroit-elle pas utile? Cette réflexion affreuse, je l'avouerai, ne révolta pas mon imagination; ma raison étoit aliénée; elle éprouvoit la foiblesse de mon corps ... Quel mal serai-je, continuai-je encore? Il est à moi; je l'ai achetté pour me servir; quel plus grand service peut-il jamais me rendre?[22]

(When these terrible adventures presented themselves to my imagination, my wan-dering eyes fell upon my negro; they were arrested there by a kind of avidity: he will die, I cried with fury; the most prompt death would be a kindness to him; he will suc-cumb to it slowly [anyway]; all human efforts are insufficient to protect him from it; why shouldn't his death be useful to me? This horrific reflection, I swear, did not revolt my imagination; my reason was alienated; it proved the weakness of my body ... How wrong would I be, I continued anew? He belongs to me; I bought him to serve me; what greater service could he ever render me?)

To own is to consume in whatever way one chooses. Subsequently, the white woman sanctions the white master's decision through insidious pantomime. After she weakly calls out to him: 'je jetai les yeux sur elle; elle porta les siens sur mon nègre, me le montrant de la main, elle les retourna sur moi d'une manière terrible, & fit une geste plus expressif encore que j'entendis'.[23] ('I turned my eyes to her; she moved hers to my negro, and pointed to him, she returned her eyes to me in a terrible manner and made an even more expressive gesture which I understood'.) The circuit of gazes evoked here maps a triangulated set of power relations as well as a transaction of property: the white man looks upon (his) white woman who looks upon (their) black slave who is sacrificed as the most subordinate term of exchange in their social economy. The woman's violence is circumscribed to vision and gesture but it prophesies and invites the slave master's.

That answering violence on the part of the Frenchman is the subject of the illustration. Placed between white and black man, the woman's body turns towards the slave, linking the master to him, but her gaze turns up towards the master, thereby re-enacting the movement he has just made when raising the club. Inexplicably, from the whiteness of her illuminated neck and chest flows an immense sheet of white cloth which highlights and enframes the slave's upper body and also suggests the ritualistic marking of a site of human sacrifice. That sacrifice is registered on the slave's body only insofar as the fanning arteries in his neck are repeated in the force of rivulets – ostensibly tree roots – radiating explosively from his back. Viaud's narrative, by contrast, was neither so discreet nor metaphoric and I will spare readers its perversely detailed, stage-by-stage account of the murder, bleeding, butchering, drying and consumption of the slave. The narrative disturbingly couples such self-evidently pornographic culinary details with repeated appeals to sensibility (the master's 'tears flow' momentarily because he cannot 'resist affection' for his slave, for example). This repellant – one might say 'distasteful' – combination of horror and sentimentality may account for its evident popularity; the story was published in 1770, 1780, 1787 and again in 1827.

Viaud's text is at once more repugnant and more conventional than Géricault's picture. It also may explain why Géricault chose to excise a woman from the final painting of the *Raft of the Medusa* despite having included a female figure in several preliminary drawings of mutiny.[24] Within a narrative inclusive of cannibalism and sacrifice, a triadic structure (white male, black male, white female) unlike a binary (white male, black male) proposes conflicting sets of alliances at the expense of a single term. Should gender trump race or vice versa? In early nineteenth-century France, the outcome of this conflict was, of course, already prescribed: alliances of race were expected to take priority over alliances of gender. Viaud's shipwreck account conformed to this priority. By contrast, Géricault's final painting, like the actual events on the raft, shockingly proposed the inverse: white and black men survived and the white Frenchwoman known to have been on the raft (and depicted in a few preparatory sketches) was sacrificed. In *Raft of the Medusa*, gender alliance was privileged – implicitly – over racial alliance. A collectivity of black and white

brothers replaced the solidarity among white men and white women inscribed in Viaud's illustration.

The image of the kneeling black man thus appears in two radically different narratives and politics. The implied statements 'We will free you' and 'We will eat you' could hardly be more antithetical. It is quite right to distinguish the benevolent abolitionist addressee of the *Amis des Noirs*' emblem from the villainous slavemaster in Viaud's story. That the same kneeling, supplicating black figure could serve both narrative purposes makes us fully appreciate the challenges facing those Frenchmen who championed black men's rights against those who claimed they had none. An abolitionist iconography was not easily come by. It would be wrong, however, to presume that the discourses of abolition and of cannibalism had nothing to do with each other. The shared pictorial term points to a shared rhetoric. In both scenarios slaves are objects upon which whites act as they choose. The overlap exceeds the shared term of slavery, however. In fact, the trope of cannibalism was fundamental to abolitionist discourse, providing antislavery spokespersons with the quintessential image of victimization. Assimilating the martyrdom of slavery to the martyrdom of being eaten seemed especially effective to many abolitionists including Savigny and Corréard who, at the end of their narrative, cry out that French trade with Africa should no longer nourish 'ces horribles marchés de chair humaine'[25] ('these horrible marketplaces in human flesh').

Abolitionists understood the power of identifying the slave trade and the colonial economy it enabled – mere abstractions to French citizens in the metropole – with vivid somatic experiences. In their attempt to link the consumption of colonial commodities to the slave labour that had manufactured them, abolitionists proposed their identification in rhetorical conjurations of cannibalism that continually slipped between the metaphorical and the literal.[26] Take for instance another print featuring a black man and two elegant white persons. Like the *Amis des Noirs*' emblem and the image in Viaud's narrative, the illustration to Voltaire's *Candide* also dates to 1787 (figure 39). Accompanying Voltaire's condemnation of the planters' violence in Dutch Surinam, this picture is captioned 'C'est à ce prix que vous mangez du sucre en Europe' ('It is at this price that you eat sugar in Europe'). In the picture, the story's protagonist and valet stand silhouetted against a sunny tropical landscape, replete with palm trees, and look aghast at the black figure enveloped in the shadowy foliage at right. Their gaze invites our own inspection of a man whose calm, almost smiling – one might say 'sweet' – visage and broad muscular chest ill prepare us for the startling discovery that his hand and leg have been amputated, a form of punishment enacted daily on colonial plantations according to anti-slavery writers. The wooden leg and still bandaged stump of arm attest to assaults over a prolonged duration and still ongoing.

According to this image, eating sugar in Europe depends on the progressive consumption of the black man's body in the tropics. The illustration correlates the two forms of ingestion without claiming their equivalence. None the less, the

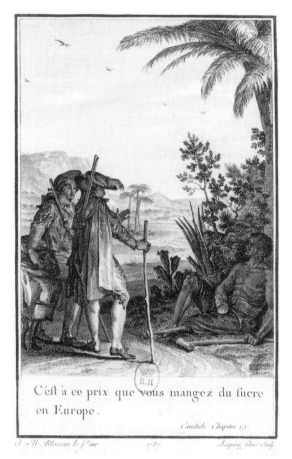

C'est à ce prix que vous mangez du sucre
en Europe.

Candide Chapitre 19

J. M. Moreau le j[e]me 1787 Baquoy filius Sculp[t]

39 'C'est à ce prix que vous mangez du sucre en Europe' ['It is at this price that you eat sugar in Europe'], engraving; from Voltaire, *Candide* (Paris, 1787).

shock derives from the discrepancy between the coolly banal, if accusatory, statement of the text – 'You eat sugar' – and the inordinate violence registered upon a benignly passive human body. The imaginative effort required to relate the two disturbingly incongruous textual and visual statements is the basis of the illustration's rhetorical power. We are asked to imagine the act of eating sugar as somehow removing limbs. Sipping, drinking and chewing bring us in to intimate intercourse with a stranger's body in the process of blunt dismemberment and consumption. Scandalously, our sweet white pleasures occur – in curiously magnified and arbitrary form – on the black man's body.

The illustration to *Candide* is unusual but its correlation of the consumption of colonial products and slaves' bodies was not. In 1776, for example, the Enlightenment *philosophe* and later Revolutionary Condorcet had demanded the boycott of sugar because 'il faut renoncer à une denrée souillée du sang de nos frères' ('it is necessary to renounce a commodity contaminated by the blood of our brothers').[27] If Condorcet's remark is ambiguous about the precise nature of this contaminating infusion of sugar by black blood, a 1789 abolitionist publication *Le More-Lack* left no doubt that Europeans were actually consuming the bodies of slaves: 'Non, je crains pas de le dire, on ne boit pas en Europe une seule tasse de café qui ne renferme quelques gouttes du sang des Africains'[28] ('No I am not afraid to say it, we don't drink a single cup of coffee in Europe that does not contain a few drops of African blood'). Drinking blood was a commonplace image – in 1795 an antislavery spokesperson called colonists 'ces vampires des Colonies qui, dans des vases précieux, buvsient [*sic*] le sang africain transformé en liqueurs spiritueuses'[29] ('these vampires of the colonies who from precious vases drink African blood transformed into spirituous liquors') – but colonial consumption

was also figured as the tearing open and ingestion of the slave body as meat: 'As-tu donc oublié qu'il se sont nourris de la chair de tes frères pendant quatre ans?'[30] ('Have you forgotten that [these colonists] nourished themselves on the flesh of your brothers for four years?') In his abolitionist publication, *An Enquiry concerning the Intellectual and Moral Faculties, and Literature of Negroes* of 1810, the outspoken Revolutionary Abbé Grégoire described colonists and slave traders not only as 'merchants of human flesh' but as carnivorous 'white tygers in human form'. Conflating meat, blood and wealth, Europeans were, according to Grégoire, men who 'tear the bodies of unhappy negroes, and suck gold from their blood'.[31] Grégoire also devoted pages to the condemnation of planters' notorious reliance on man-eating substitutes, vicious dogs brought from Cuba to attack and to eat the rebel slaves in Saint-Domingue during the Revolutionary era: 'Oh! that it had pleased God to cause the waves to swallow up these devourers of human flesh'.[32]

Proslavery colonists were not in the least bit squeamish about returning the insult. If slave-owning planters could be accused of being 'black-eaters', it was simple enough to call abolitionists 'blancophages' (white-eaters).[33] The most scathing response to abolitionists' continual reliance on cannibalistic imagery was a reply in 1810 to Grégoire's publication of the same year. Nine years before Géricault exhibited his picture, the anonymous author of *Cri des Colons contre un ouvrage de M. l'Evèque et Senateur Grégoire* (*Cry of the Colonists against a Work by Bishop and Senator Grégoire*) mocked abolitionists' dependence on the horror of cannibalism, pointing out their own hypocritical erotic pleasures in consumption: 'Je les ai vus, ces négrophiles de mauvaise foi, savourer avec volupté du café dans lequel ils avoient mis avec profusion, ce sucre qui, selon eux, est teint du sang des malheureux Africains'[34] ('I have seen them, these negrophiles of bad faith, savouring with voluptuousness coffee in which they have put with profusion, this sugar which, according to them, is tainted with the blood of unfortunate Africans').

This author was not satisfied, however, simply to turn abolitionists' accusations of cannibalism against them. To do so would have been complicit with their premise that ingestion was subject to moral distinctions dependent upon an empathetic identification with the object to be eaten. Instead this colonist wanted to prove that such humanitarian arguments failed to maintain the crucial hierarchical distinctions without which morality collapses into mindless sensibility. Grégoire had invited such a counter-charge when, responding to racists who 'placed [blacks] in the scale of beings, between man and the brute', he argued that even beasts of burden such as horses should be humanely treated.[35] The author of *Cri des Colons* understood that the continuous chain of sensate beings acknowledged by Grégoire's shift from humans to animals could render the abolitionists' reliance on the trope of horrific cannibalism all but indefensible. If Grégoire could move from the sufferings of black slaves to the sufferings of horses, this author would continue his perilous descent:

Mais, si le cheval est la plus belle conquête de l'homme, ne pourrions-nous pas
avancer que le boeuf est la plus utile? Pourquoi donc l'évêque Grégoire ne
soliciteroit-il pas un règlement en leur faveur? N'est-ce pas le comble de l'ingratitude
de la part des hommes, de se nourrir d'un pain arrosé de leur sueur[?]. Que disons-
nous? du sang de ces quadrupèdes malheureux que les laboureurs percent impitoy-
ablement ... et les vendre quand ils sont vieux ... à un barbare boucher qui ... vend les
lambeaux encore fumans au philosophe Grégoire, qui en fait faire de la soupe, et aux
sensibles Anglois, qui en font faire des *roast beef*.[36]
(But if the horse is the most beautiful conquest of man, couldn't we advance that the
cow is the most useful? Why doesn't Bishop Grégoire solicit a regulation on their
behalf? Isn't it the height of ingratitude on the part of men to nourish themselves on
bread soaked in [the] sweat – what are we saying? – in the blood of these unfortunate
quadrupeds that labourers pierce pitilessly and sell when old to a barbaric butcher
who sells still smoking shreds to the philosophe Grégoire who makes soup out of
them and to the sensitive Englishman who makes *roast beef* from them?)

After proceeding to the wrongful consumption of birds, the writer concludes his
carnivorous progress with the most rudimentary animal life he could imagine:

On nous a assuré que M. Grégoire aimoit les huîtres et qu'il en mangeoit beaucoup:
mais ce sensible philosophe songe-t-il bien qu'il dévore impitoyablement des ani-
maux tout vivans? Est-ce parce que la nature leur a refusé la faculté d'exprimer la
douleur qu'ils ressentent lorsqu'on les mange? Faut-il donc être dévoré parce que
l'on est stupide[?][37]
(We have been assured that M. Grégoire loves oysters and that he eats a lot of them:
but does this sensitive *philosophe* realize that he pitilessly devours still-living animals?
Does he do so because nature has refused [oysters] the ability to express the suffering
they feel when they are eaten? Must one be devoured because one is stupid[?])

The answer is, of course, yes. Yes, one must be devoured because one is stupid. The
implied argument here is that oysters, like birds and like cows, must be devoured
because, although sentient, they are not human. But the criterion of intelligence
introduced here also insidiously implicates those men deemed by him to be a lesser,
that is, a 'stupid', race. Even as he mocks the cannibalistic trope for its sloppy sensa-
tionalist literalism, this proslavery writer suggests that to eat slaves – whether
metaphorically or literally – accords with the natural order of things. Faced with
abolitionists' levelling of difference, the author of *Cri des Colons* was determined to
reinstate hierarchy.

Abolitionists continually castigated slave traders and proslavery colonists for inap-
propriately treating men like animals; this was Condorcet's point in 1776, for
instance. But the charge that proslavery colonists failed to establish appropriate
distinctions could be turned against the abolitionists themselves, particularly given
that they continually relied on such conflations in their own mimicry of slavery's
violence. It was abolitionists who said that humans were 'flesh', and that drinking
coffee or eating sugar entailed the consumption of men's bodies. It was they who

assimilated unlike (and unequal) entities in their poetics of victimization. Thus the author of *Cri des Colons* could denounce abolitionists' failure to maintain rightful hierarchical and moral boundaries. According to this proslavery colonist, what mattered most was the categorical difference between the human and the non-human. The question, he insinuated, should have been to which category blacks belonged. Of course, for men like the author of *Cri des Colons*, the answer to that question did not require speaking. Slavery in itself proposed that blacks were not human because – the reasoning is circular – it enacted that dehumanization. Dehumanization legitimated the racial hierarchy it perpetrated. Take for example this argument by an eighteenth-century legal theorist:

> This word [slave] withdraws all the rights of humanity from the being to which it is applied. He is no longer a man: he is, according to circumstances, an instrument with feelings or an acting beast of burden ... Save for the fact that he still walks on two feet, save [also] that he knows not how to moo or neigh, and that no use of his flesh or skin is made upon death, there is no longer any difference between him and an ox, or a horse.[38]

A beast of burden is, as the author of *Cri des Colons* well understood, also food to be ingested. In the economy of colonial consumption, the black man was therefore to be eaten.

Both abolitionists and proslavery colonists could accuse each other of fostering confusions between men and lesser beings, between humans and the edible. But this confusion in kind is perhaps better described as endemic to the colonial economy itself. Texts – proslavery and abolitionist alike – betrayed anxieties about the ways colonial commerce created unravelling intimacies and interdependencies between masters and slaves, between whites and blacks, between metropole and colony. For instance, the abolitionist who wrote *Le More-Lack* in 1789 boldly denounced colonists' consumption of blacks but also offered a more ambiguous parable. Two years after the aforementioned images of kneeling slaves, this author told the story of a starving slave who was 'réduit à une si grande misère, qu'il mangea de la chair crue & corrompue des boeufs ou des animaux morts de maladies' ('reduced to such an extreme misery that he ate raw and corrupted meat from cows or animals who died from illnesses'). Crushed by 'une faim dévorante' ('a devouring hunger'), the slave begged for the help of a rich colonist drinking coffee on his terrace. The planter refused to feed him: 'Ce Nègre infortuné, en se retirant, ne put s'empêcher de lui dire: Toi, qui boire mon sang, refuser la vie à moi, & faire battre moi'[39] ('This unfortunate negro, upon leaving, could not stop himself from saying to him: you who drink my blood, refuse me life and beat me'). In *Le More-Lack* hunger and ingestion are entirely mismanaged. Already drained by the colonist who drinks his blood, the slave is deprived of healthy animal meat and wrongly ingests 'corrupted' flesh which in turn threatens, by its failure to sustain him, to permit his own hunger finally to devour him.

It becomes clear that the interdependencies of the food chain, once contaminated by slavery, lead to a confusion of subjects and objects. Orderly hierarchy is

replaced by a criss-crossing matrix of perverting appetites. Corruption travels from one (oral) consumer to another. Significantly, this author, while condemning the institution of slavery, insisted upon the need for a gradual emancipation because to grant sudden freedom to the slaves would both destroy the colonies and leave slaves without means of subsistence; they would become 'brigands always ready to devour us'.[40] The devouring hunger to which abandoned slaves were subjected – the hunger that ate them – would turn outward to the only available object: 'us'. According to this abolitionist, colonists ate slaves, but freed slaves, if not adequately fed, would eat colonists. Within the colonial economy, cannibalism was a perpetual threat.

A proslavery spokesperson in 1802 suggested, moreover, that cannibalism threatened not only white men's survival but racial difference itself. In his published condemnation of 'nigrophilisme', Baudry-Deslozières decried the cannibalistic nomenclature persistently deployed by abolitionists to describe colonists like himself:

> Sont-ce enfin les Colons qui, suivant les expressions aussi triviales que perfides des Negrophiles, sont les *vendeurs de chair humaine*? Non, sans doute, ce sont les Européens ... dans le nombre desquels on compte beaucoup de ces Nigrophiles qui, après s'être engraissées de cette *chair humaine* et de celle des Colons, viennent blanchir les Nègres et noircir les Blancs pour leur unique intérêt personnel.[41]
> (Is it ultimately the colonists who are, according to Negrophiles' expressions that are as trivial as they are traitorous, the *sellers of human flesh*? No, without doubt, it is the Europeans ... among whom one counts many of these Negrophiles who, after fattening themselves with this *human flesh* and with that of the colonists, whiten Negroes and blacken Whites for their own personal interest.)

'Black-lovers' eat both black and white flesh and their reckless, undiscerning act of consumption leads to the dismantling of racial identities. The text's conjuration of the act of indiscriminate cannibalism produces a metamorphosis of races, 'whitened Negroes' and 'blackened Whites', which leaves uncertain whether cannibalism makes black and white races simply change places, thereby leaving black and white intact, or whether the altered coloration of both produces a median that undoes racial polarization all together.

When Géricault chose to paint the shipwreck of the *Medusa*, a ship transporting Liberal abolitionist-colonists to Africa, and to contemplate the problem of cannibalism among white and black men, he, wittingly or unwittingly, situated his enunciation in a highly trafficked rhetorical field. Cannibalism was an expansive and volatile metaphor, commonly deployed both by proslavery and antislavery writers, both by Royalists and Liberals, to describe the wrongful consumption of men (by one's opponents whether Bonaparte, slave traders, abolitionists or rebel slaves). Cannibalism had been identified in the early modern period with the savages inhabiting the places outside the borders of civilization – those monstrous black Africans and Moors and Caribes on shore. But cannibalism became in the era of the slave trade

and abolitionism in the late eighteenth and nineteenth centuries an insidiously mobile, perpetually contaminating trope: the butcher shops at the heart of Africa hallucinated by Europeans (figure 40) had moved to the slave markets at its shores and on to slave ships and into the colonies. The early modern image of the remote butcher shop where human beings were dismembered, sold and consumed by alien, even inhuman, savages is, I would argue, the image that haunted the European imagination and forced abolitionists to re-script who butchered whom. The consumption of Africans was feeding Europe and Europeans knew it and they argued about what it meant. In their argument they attempted to anchor the directionality of cannibalism (to insist that Africans ate Europeans or that Europeans ate Africans), but in the slave economy, cannibalism seemed to drift everywhere, to implicate one and all. Europeans were accusing one another of the wrongful ingestion of flesh.

The rupturing of the human body into meat was the unavoidable by-product of the objectification of slavery. So too was the repugnance that such rupturing engendered. Baron de Wimpffen in his comments on Saint-Domingue on the eve of the French Revolution could not contain his revulsion towards slaves; against his conscious intentions, he had to blame them. In Wimpffen's text, black bodies are inherently prone to disintegration. Opened by wounds, they will not heal. Ruptured African bodies lead Wimpffen across the atrocities of the Middle Passage to an image of a butcher shop trafficked by Europeans:

> Soit vice naturel ou mauvais régime, ils ont, en général, la masse du sang si corrompue, que la plus légère blessure ne tarde pas à devenir une plaie presque incurable. Si à ce vice originel on ajoute les maux qu'ils contractent nécessairement dans un trajet de mer, pendant lequel ils croupissent des mois entiers parqués comme le bétail dans un entrepont humide et mal aéré, on ne sera pas étonne que, maltraités au moindre signe d'impatience ou de douleur, mal nourris, consommés de chagrin ou

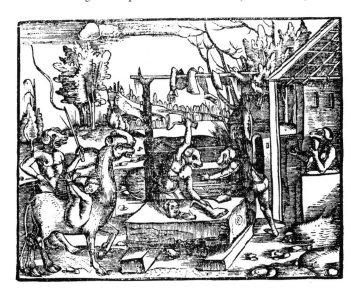

40 Lorenz Fries,
*Dog-headed Cannibals
Butchering Human
Flesh*, 1525–7,
woodcut.

dévorés de rage, il périsse des cargaisons entières de ces malheureux, avant d'avoir atteint la plage où ils doivent être vendus, et où la plupart d'entre eux, dans la persuasion qu'on ne les achéterait pas comme la viande de boucherie, s'ils ne devaient servir au même usage, se croient destinés à être mangés.[42]

(Owing either to a habit of body, naturally bad, or to an unwholesome regimen, the mass of their blood is so corrupt, that the slightest scratch soon degenerates into a most dangerous wound. If to this original vice we add the infirmities they necessarily contract in the middle passage; where they are crowded for months together, like sheep at the fair ... we shall not be astonished to find that, cruelly treated at the slightest symptom of impatience, wretchedly fed, wasted by chagrin, and devoured by rage, whole cargoes of these unhappy beings perish before they reach the shores where they are doomed to be sold; and where the greatest part of them, persuaded that they would not be bought like flesh in a market, if they were not intended to be used in the same way, firmly believe they are destined to be eaten.)

Wimpffen offers a glimpse of the ways slavery engendered not only atrocity but a sickening sense of a pervasive bodily corruption (sick blood) and violation (dangerous wounds).[43]

Cannibalism could not be disassociated from the colonial slave economy nor from the difference of slaves' dark bodies. But Europeans' queasiness derived in the end not from the alienation inspired by racial difference but from the perceived sameness – the ways violence and consumption and coerced passivity, the disassembling of bodies into meat and buttocks, levelled difference. We might think of Kurtz's 'the horror! the horror!' in Conrad's *Heart of Darkness* but these stories underscore less a sense of the unknown and unknowable than a visibility, a commonplaceness and a banality – the banality of butcher shops – which were all the more disturbing. The butcher shop once veiled at the heart of Africa was now in the broad daylight of Europe as well as its colonies. And black bodies once butchered resembled white ones. This fact was discomfiting. It was also radical.

I have drawn attention to the sickly satiated imagery surrounding cannibalism as a metaphorical outcome of slavery in order to illuminate the vulnerability of the abolitionist rhetoric deployed by men such as Grégoire, Savigny, Corréard and Géricault. The question in 1819 was whether cannibalism could also be deployed to describe rightful incorporation. For Liberals and abolitionists, cannibalism enacted in its very enunciation that desired incorporation of black men into the (white) body politic. 'Flesh', in its brute, dumb indifference to crucial, traditional, hierarchical distinctions, rendered all men equivalent. As self-evidently problematic – and criticized – as the trope of 'flesh' had proven to be, it had its power. The risk of allying a cause with the odious and repugnant was, Géricault and abolitionists seemed to have agreed, worth taking. The hysteria of Baudry-Deslozières' proslavery text betrays the sheer efficacy of the strategy; in this racist's tract as in some Salon criticisms, the consumption of 'flesh' threatened to annihilate racial difference itself. Advocates of equality among blacks and whites in 1819 were compelled to face and to use the repugnance it inspired.

The butcher shop, the trade in 'flesh', the cannibalism of the slave economy, all led to an imagery of violated, opened bodies – bodies treated as meat. Against such evocations of bodily dismemberment and consumption, the figure of the kneeling, praying black man appears remarkably reassuring: at once whole, intact, discrete, and bounded. That the figure was formulaic and monosyllabic only underscores its status as a discrete and unified entity. The supplicating black nude was passive and vulnerable too, of course, mute in his way, but he was also distinct relative to the whites who were invited to act upon him. It turns out that the kneeling black man in profile was a unit oscillating between man, beast and food, but he was a unit none the less. While we might presume that Géricault ultimately rejected the figure because of this oscillation between abolitionist sentiment and cannibalist appetite, I would conclude otherwise. I believe Géricault wanted his picture precisely to pivot on such ambivalence. He rejected the kneeling profile figure not because it oscil-lated but because it remained fixed. The abolitionists' rhetorical uses of canni-balism could not adequately be represented by the discrete supplicating figure in profile; this victim who would either rise up – attaining freedom – or be relegated to eternal subordination. Only the black man disassembled as human flesh along with white men could attain, perversely and disturbingly, a form of equality (that is, equivalence).

In the final picture of the *Raft of the Medusa*, the profile figure has dropped his hands and stands alert near the mast (where he prayed in the Louvre oil study), thereby sharing the verticality and alertness of the privileged figures of Savigny and Corréard. Barely noticed by today's commentators, this reserved, quiet, and obser-vant figure has been upstaged by the African raised high and made active, the man waving to the rescuing ship, the man made to communicate on behalf of all. Freedom's height is euphoric and charismatic in this picture, but the painter inten-sified its impact by raising the black man to the top of a pyramid whose base is con-stituted by the ambiguously entangled dead, dying and living body parts which flicker in and out of the light and shadow, in and out of whiteness and blackness.

That horizontal entanglement, what one 1819 critic called a 'fricassee', charac-terizes the picture's foreground and also one of the picture's most riveting figure groups. In the right middle-ground, a third black man, also ignored by Géricault's contemporaries, collapses on to and wraps around the lower body of a white man straining to rise and see the vehicle of his salvation. It is here that Géricault incor-porates his famous limb studies, those pictorial meditations on tactile intimacy won at the price of collapsed hierarchies, even the hierarchies between top and bottom, sentient and insentient, living and dead, men and flesh. The final painting registers the fragmentation of the limb studies not only in the horrific uncertainty of its Caravaggesque flickering chiaroscuro, but in this compositional configuration where the black man falls limp upon the white man's buttocks, his hand seen in profile falling open, palm up, cupping around the white man's foot, the sole out; the protruding bony point of the knee of the submerged man in the foreground echoes the Montpellier study's crooked elbow as well as the knobby knee receding at upper

left. This is also where the raft's only weapon, the axe, lies stained a sinister dark red. There is no gaping joint here but the beam of the raft serves as a substitute, severed bluntly, ropes spilling out like tendons.

Géricault's initial reliance on the emblem for the *Amis des Noirs* invites a traditional art historical tracking of an iconographic motif, in this case the praying black man, but the final painting's achievement, like that of most great paintings, is to thematize the implications of abolitionist rhetoric in ways that exceeded any given figural motif, and instead pervaded the composition as a whole. In Géricault's *Raft of the Medusa*, the martyrdom of cannibalized men simultaneously represented the crime and a utopian, egalitarian, racial blindness. The beautiful black man at the apex of the pyramid was meant to be seen; his ascendance to liberty required his triumphant visibility. By contrast, the radical levelling of victimization entailed, strangely, an invisibility, an equivalence. Flesh one and all.

Notes

1 This essay develops aspects of Chapters 1 and 4 of my book, *Extremities: Painting Empire in Post-Revolutionary France* (New Haven and London, Yale University Press, 2002); for my extended interpretation of Géricault's picture, see Chapter 4. Recent key analyses of the picture include, most helpfully, Maureen Ryan, 'Liberal ironies, colonial narratives and the rhetoric of art: reconsidering Géricault's *Radeau de la Méduse* and the *Traite des Nègres*', in *Théodore Géricault. The Alien Body: Tradition in Chaos* (exhibition catalogue, University of British Columbia, Vancouver, 1997), pp. 18–51; Germain Bazin, *Théodore Géricault: étude critique, documents et catalogue raisonné* (Paris, Wildenstein Institute, 1994), vol. 6, pp. 7–164; *Géricault* (exhibition catalogue, Paris, Grand Palais, 1992); Régis Michel (ed.), *Géricault: Louvre conférences et colloques* (Paris, La Documentation française, 1996); Norman Bryson, 'Géricault and "masculinity"', in Norman Bryson, Michael Ann Holly and Keith Moxey (eds.), *Visual Culture: Images and Interpretations* (Hanover NH, Wesleyan University Press, 1994), pp. 228–59; see also Lorenz Eitner, *Géricault: His Life and Work* (London, Orbis, 1983), pp. 8–77; Lorenz Eitner, *Géricault's 'Raft of the Medusa'* (London, Phaidon, 1972). Unless otherwise stated, all translations are mine.
2 Albert Boime, 'Géricault's *African Slave Trade* and the physiognomy of the oppressed', in Michel (ed.), *Géricault: Louvre conférences et colloques*, vol. 2, pp. 561–93.
3 See Ryan, 'Liberal ironies'; Hugh Honour, *The Image of the Black in Western Art*, vol. 4: *From the American Revolution to World War I*, part 1: *Slaves and Liberators* (Cambridge MA and London, Harvard University Press, 1989), pp. 119–26; and Albert Boime, *The Art of Exclusion: Representing Blacks in the Nineteenth Century* (Washington, Smithsonian Institution Press, 1990), pp. 51–61.
4 On the Wedgwood medallion which was the origin of this design, see Mary Guyatt, 'The Wedgwood slave medallion: values in eighteenth-century design', *Journal of Design History*, 13:2 (2000), pp. 93–105.
5 Alexandre Corréard and Jean-Baptiste-Henri Savigny, *Naufrage de la frégate la Méduse, faisant partie de l'expédition du Sénégal en 1816; relation contenant les evénemens qui ont eu lieu sur le radeau, dans le désert de Sahara, à Saint-Louis et au camp de Daccard ...*

Entièrement refondue et augmentée des notes de M. Brédif (Paris, 1818), p. 314. Quotes in this essay are from the English edition, *Narrative of a Voyage to Senegal in 1816; Undertaken by order of the French Government* (London, Dawsons of Pall Mall, 1818); here pp. 311–12.

6 Guyatt, 'The Wedgwood slave medallion,' p. 100, also emphasizes the subordination of the black figure in this image: 'even though this unsophisticated mode of representation was designed to gain the viewer's sympathy, that the slave is depicted surrendering to the white man's will also suggests a condescending attitude towards him and his kind.' Linda Colley in *Britons: Forging the Nation 1707–1837* (New Haven, Yale University Press, 1998), p. 376, similarly emphasizes how 'safe' is the slave's kneeling position: 'Slaves, in short, did not threaten ... [B]estowing freedom upon them seemed therefore purely an act of humanity and will'.

7 See Saidiya V. Hartman, *Scenes of Subjection: Terror, Slavery, and Self-Making in Nineteenth-Century America* (Oxford and New York, Oxford University Press, 1997), p. 21.

8 On the theme of cannibalism generally, see Frank Lestringant, *Cannibals: The Discovery and Representation of the Cannibal from Columbus to Jules Verne* (Berkeley, University of California Press, 1997); and also Maggie Kilgour, *From Communion to Cannibalism: An Anatomy of Metaphors of Incorporation* (Princeton, Princeton University Press, 1990).

9 See, for example, Bory de Saint-Vincent, *Essais sur les îles Fortunées ... ou Précis de l'histoire générale de l'archipel des Canaries* (Paris, an XI [1803]), p. 198; cited in M. J. Morenas, *Précis historique de la traite des noirs et de l'esclavage colonial* (Paris, 1828), pp. 74–5. The rhetoric preceded the Consulate of course; see Milly, *Discours sur la question relative à liberté des nègres, prononcé en l'assemblée générale du district des Filles-Saint-Thomas* (Paris, 1790), who describes the 'flesh markets' of the Gold Coast and quotes a voyager: 'The Amicos eat their slaves; human flesh is as common in their markets as beef is in ours': cited in Elizabeth Colwill, 'Sex, savagery, and slavery in the shaping of the French body politic', in Sara E. Melzer and Kathryn Norberg (eds.), *From the Royal to the Republican Body: Incorporating the Political in Seventeenth- and Eighteenth-Century France* (Berkeley, University of California Press, 1998), pp. 198–223.

10 Louis Maria Joseph de Grandpré, *Voyage à la côte occidentale d'Afrique, fait dans les années 1786 et 1787* (Paris, an IX [1801]), vol. 1, pp. iv–xiii.

11 Grandpré, *Voyage*, pp. xi–xii.

12 Jean-Baptiste Eyriès (ed.), *Histoire des Naufrages de Deperthes* (Paris, 1815 and 1818), vol. 3, pp. 81–2.

13 Savigny and Corréard, *Naufrage de la frégate la Méduse*, p. 84; *Narrative of a Voyage to Senegal*, p. 72. Charlotte Dard, *La Chaumière africaine, ou histoire d'une famille française jetée sur la côte occidentale de l'Afrique, à la suite du naufrage de la Frégate la Méduse*, p. 72, also conjured the passengers eating one another as soon as the *Medusa* grounded on the reefs: 'On commença dès lors à se regarder d'un air farouche, comme prêts à s'entre-dévorer, et à se repaître chacun de la chair de son semblable'.

14 D'Anglas de Praviel, *Relation nouvelle et impartiale du Naufrage de la frégate La Méduse* (Paris, 1818), pp. 287–8.

15 Both sides were exploiting an identification of women with sensibility. On women and the abolitionists' rhetorical reliance on cannibalism in England, see Charlotte Sussman, 'Women and the politics of sugar, 1792', *Representations*, 48 (1994), pp. 48–69.

16 Praviel, *Relation nouvelle et impartiale*, p. 308.

17 Praviel, *Relation nouvelle et impartiale*, p. 309.

18 W. Jeffrey Bolster, *Black Jacks: African American Seamen in the Age of Sail* (Cambridge MA, Harvard University Press, 1997), p. 125.

19 Bolster, *Black Jacks*.

20 A. W. Brian Simpson, *Cannibalism and the Common Law: The Story of the Tragic Last Voyage of the Mignonette and the Strange Legal Proceedings to which it gave Rise* (Chicago, Chicago University Press, 1984), pp. 122–4.

21 Pierre Viaud, *Naufrage et aventures de M. Pierre Viaud, Natif de Bordeaux, Capitaine de Navire* (Paris, 1770 [reprinted 1780, 1787, 1827]), pp. 216–17.

22 Viaud, *Naufrage*, pp. 218–19.

23 Viaud, *Naufrage*, pp. 218–19.

24 See Linda Nochlin, 'Géricault, or the absence of women', *October*, 68 (1994), pp. 44–59.

25 Savigny and Corréard, *Naufrage de la frégate la Méduse* p. 317; *Narrative of a Voyage to Senegal*, p. 314.

26 See Sussman, 'Women and the politics of sugar, 1792'.

27 Condorcet, *Remarques sur les 'Pensées' de Pascal* (1776), in *Oeuvres*, ed. François Arago (Paris, Didot, 1847), vol. 3, p. 648. Cited in Joseph Jurt, 'Condorcet et les colonies', *Proceedings of the Fifteenth Meeting of the French Colonial Society. Martinique and Guadeloupe, May 1989*, eds. Patricia Galloway and Philip P. Boucher (Lanham, University Press of America, 1989), pp. 9–21; p. 10.

28 Lecointe-Marsillac, *Le More-Lack, ou essai sur les moyens les plus doux et les plus équitables d'abolir la traite et l'esclavage des Nègres d'Afrique, en conservant aux Colonies tous les avantages d'une population agricole* (Paris, 1789); reprinted in *La Révolution française et l'abolition de l'esclavage* (Paris, Editions d'histoire sociale, 1968: a facsimile of 89 publications), vol. 3, p. vii.

29 *Moniteur Universel*, 139 (7 February 1795), p. 569.

30 P. J. Leborgne, *Ci-devant Commissaire de la Marine aux Iles du Vent de l'Amérique, à Janvier Littee, homme de couleur, Député de la Martinique* (6 vendémiaire, an III [27 September 1794]), p. 4. There is evidence that slaves understood their brutalization by masters as either enacting or threatening cannibalism; see Orlando Patterson, *Slavery and Social Death: A Comparative Study* (Cambridge MA and London, Harvard University Press, 1982) p. 338, and Hartman, *Scenes of Subjection*, pp. 4–5.

31 Abbé Grégoire, *An Enquiry Concerning the Intellectual and Moral Faculties, and Literature of Negroes*, ed. Graham Russell Hodges, trans. David Bailie Warden (Amronk NY, M. E. Sharpe, [1810] 1997), p. 27.

32 Grégoire, *An Enquiry*, pp. 20–2.

33 See for example Félix Carteau, *Soirées Bermudiennes ou Entretiens sur les événemens qui ont opéré la ruine de la parties française de l'isle Saint-Domingue* (1801), p. 57, who argues that 'negrophiles' like the *Amis des Noirs* acted with 'so much fury and barbary as to merit the name of inhuman *Blancophages* [white-eaters] better than that of friends of men'. The paired slurs, 'Negrophile' and 'Blancophage', correlated the love of blacks, a charge resonant with illicit sexual associations, with the consumption of whites. Both acts were implicitly construed as wrongful (and ambiguously correlated) forms of communion. See also Pierre H. Boulle, 'In defense of slavery: eighteenth-century opposition to abolition and the origins of a racist ideology in France', in Frederick

Krantz (ed.), *History from Below: Studies in Popular Protest and Popular Ideology in Honour of George Rudé* (Montreal, Concordia University, 1985), pp. 221–41.

34 Anon., *Cri des Colons contre un ouvrage de M. l'Evêque et Senateur Grégoire, ayant pour titre de la littérature des nègres, ou réfutation des inculpations calomnieuses faites aux colons par l'auteur, et par les autres philosophes négrophiles, tels que Raynal, Valmont de Bomare, etc. Conduite atroce des Nègres et des Mulâtres qui ont joué les premiers rôles dans les scènes tragiques de S. Domingue, et dont l'évêque Grégoire préconise les qualités morales et sociales* (Paris, 1810), p. 127.

35 Grégoire, *An Enquiry*, pp. 26–7.

36 Anon., *Cri des Colons*, pp. 190–1.

37 Anon., *Cri des Colons*, p. 193.

38 Simon-Nicolas-Henri Linguet, *Théorie des loix civiles* (1767), in *Oeuvres* (London, 1774), vol. 5, p. 40, cited in Boulle, 'In defense of slavery', pp. 226–7.

39 Lecointe-Marsillac, *Le More-Lack*, pp. xxi–xxii.

40 Lecointe-Marsillac, *Le More-Lack*, p. xiii.

41 Anon., *Cri des Colons*, pp. 105–6.

42 Baron de Wimpffen, *A Voyage to Santo Domingo, in the Years 1788, 1789, and 1790*, trans. J. Wright (London, 1797), pp. 225–56, cited in Joan Dayan, *Haiti, History and the Gods* (Berkeley, University of California Press, 1995), p. 200.

43 Add to Wimpffen's flesh market, to the well-known use of human-eating dogs and to Viaud's narrative, an anecdote recorded by Moreau de Saint-Méry in which a white woman upon seeing three well-dressed mulattas in Saint-Domingue exclaims, 'Look at these rotten pieces of meat! They deserve to have their lace cut flush with their buttocks and to be sold on the fish table at Clugny Market!' In this case, butchering affords the white women the means to dehumanize women of colour with whom they competed. Cited in Dayan, *Haiti, History and the Gods*, p. 222.

The Oath of the Ancestors by Lethière 'le mulâtre': celebrating the black/mulatto alliance in Haïti's struggle for independence

Helen Weston

Les anciens adversaires se tendirent la main et cette généreuse étreinte décida de l'indépendance d'Haïti[1]

In September 1822 Guillaume Guillon-Lethière painted a double portrait to commemorate the occasion, in 1804, when Alexandre Pétion, the famous mulatto general, and Jean-Jacques Dessalines, the equally famous black slave rebellion leader, swore an oath to fight together in friendship and to establish independence for the people of Saint-Domingue (figure 41).[2] Saint-Domingue would thereafter be known by the name of Haïti given by the island's indigenous ancestors.[3] The two men, together with a number of other generals not shown in the painting, swore firstly to prevent Napoleon, and any other oppressor, from ever re-instating slavery in the island,[4] and secondly to uphold Haïti's first Constitution. Broken chains of slavery can be seen at the feet of the two military leaders. The oath is sworn over the tablets of the law and these are blessed by the hands of Jehovah in the upper section of Lethière's composition, the name written in Hebrew in a triangle of light. The outline of a liberty bonnet can be seen above the writing on the tablets and the words 'Liberté', 'Loix' and 'Constitution' are clearly discernible. The painting was presented to the people of Haïti in memory of this glorious moment in the island's history. In March 1823 the painting was taken by one of the artist's sons to Port-au-Prince in Haïti, where it hung in the cathedral and was gradually lost sight of by Europe.[5] It was not until 1991 that it was located again and eventually brought to France for cleaning and for restoration work to be carried out.[6] It now hangs in the presidential palace in Port-au-Prince, Haïti.

The interest of the painting lies in three areas. First, the precise moment being commemorated is still perceived by many as perhaps the most important occasion in the island's history. It also had a much wider impact. David Nicholls notes: 'Independence was declared and maintained by men who saw Haïti as a symbol of

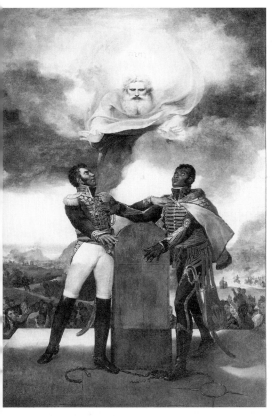

41 Guillaume Guillon-Lethière, *The Oath of the Ancestors*, 1822, oil on canvas, 334 x 228.9cm.

redemption for the whole of the African race'.[7] Second, it acknowledged the uniting of black and mulatto military forces, that crucial bonding of men of colour in the homosocial space of the battlefield, without which the slave rebellions and overthrow of white colonialism in Saint-Domingue would almost certainly never have succeeded. Third, it was painted by a mulatto living and working in Paris at a time of considerable prejudice against 'men of colour'. Lethière's mother was black, his father white. On this one occasion the artist signed his work 'G. Guillon Le Thière né à la Guadeloupe', thus drawing attention to his place of birth in the Caribbean, suggesting a sense of identification with – and support for – those represented in the image.[8] He also drew attention to his place within the Guillon family and to the fact that, until the age of forty, Lethière was disallowed by his father from using any but the generic name, sometimes written Le Thiers, 'the third-born', as his surname. By celebrating the crucial moment of alliance between non-white people like himself, Lethière was joining the abolitionists of 1794 who, at the time of the February decree which abolished slavery in the colonies, had also called for an end to the *ancien régime* notion of 'aristocracy of the skin' ('l'aristocratie cutanée').[9] For Lethière, sometimes referred to as 'le mulâtre', such a notion labelled him as unequal in rights and recognition to his father's other sons.[10] Yet, as indicated by the signature, the painting was done in Paris and, by this time, the artist had had the same formal education and had, for the most part, been given the same form of recognition for his talent and expertise, as any white Frenchman.

Haïti by this date had become a potent symbol of black dignity, black liberation and human equality, centred on the continuing question of skin colour and its significance. In 1804, when Dessalines came to power, blackness was closely identified with nationality. To be a Haïtian citizen was to be – and to identify oneself as – black. Even those white German and Polish groups who had fought with the liberation movement were to be referred to as 'black'.[11] The Constitution also proclaimed that

no white, whatever their nationality, would be admitted into Haïti as a land- or prop-
erty-owner. Nor would they be permitted to acquire property.[12] During the course of
the eighteenth century, under French rule of the wealthy, plantation-owning *grands
Blancs*, and in different ways during the period of slave rebellions on the island, the
blacks and the mulattoes had often been on opposing sides, perceiving colour as a
determining factor in power control. The eventual loss to France of her most lucra-
tive colony was thus largely the result of the black/mulatto alliance. The recognition,
through commemoration, of the alliance's new leaders' determination to prevent
that threat of enslavement from recurring, is the subject of this painting. On the face
of it the painting would seem to be a profoundly anti-French statement. It is of
course an indictment of colonial slavery that had been sanctioned under the *ancien
régime*, and a celebration of the revolutionary moment of abolition in 1794, from
which Saint-Domingue's freedom fighters took inspiration. It is, above all, specifi-
cally anti-Bonapartist, for the decree of abolition proved to be a false dawn of liberty.
It was not universally applied and by 1802 Napoleon had reinvoked the infamous
Code Noir and adopted a decree forbidding blacks and mulattoes to set foot in
France.[13] In 1801 he sent his troops under the leadership of his brother-in-law,
General Leclerc, to regain control of the island and re-establish slavery, and to rid
France's colonies of 'these gilded Africans'.

Among those originally fighting with Leclerc was Alexandre Pétion, a light-
skinned, so-called mulatto, born in Port-au-Prince, who had gained a high reputa-
tion as a military leader. His orders were to win over the mulattoes to the French
side. Toussaint-L'Ouverture had failed to achieve this alliance for France.[14] Pétion
shared in the capturing of the fortress of Crête-à-Pierrot, despite the efforts of
Dessalines's tenacious troops. Meanwhile, Toussaint, who had often vacillated in
his attitude to Napoleon, was tricked by him and shipped off to France, later held in
a cell in the Jura where he starved and froze to death. The French army had lost
large numbers and was severely demoralized. The decisive defection then came in
September, when Pétion left the French to join Dessalines's forces. (This
prompted Leclerc to take revenge on the rebels. He ordered the massacre of 1,200
soldiers in October.) Another mulatto general, Clervaux, joined them, as did Henri
Christophe and Nicolas Geffrard, all uniting under Dessalines and thus producing
large armies with trained leaders in the north and west of the island. Leclerc died in
November, having failed to put down the rebellions; on the contrary, blacks and
mulattoes had been brought together against him under the French. His replace-
ment, General Donatien Marie-Joseph de Vimeur Rochambeau, began a pro-
gramme of systematic extermination of blacks and mulattoes by burning,
drowning, shooting, tracking with dogs, and other forms of atrocities, against
which Dessalines retaliated with equal ferocity.[15]

The crucial union was seen to be that between Pétion and Dessalines and the
crucial ritual the oath-swearing by the generals. In part this act commemorated the
declaration of an end to slavery demanded by their 'ancestors' in France ten years
earlier. Dessalines and Pétion were both promising to lead their people to a new life,

a promised land of freedom. As such they unite symbolically under another ancestor, Moses, to whom God made a similar oath to lead His chosen people out of bondage to the Egyptians to the promised land.[16] Hence the presence in Lethière's painting of Jehovah handing down the tablets of the law to the people's leaders.

In 1802, after the signing of the Peace Treaty of Amiens, Napoleon had declared that all who resisted Leclerc would be seen as traitors. Fratricidal wars were also supposedly at an end in France and he exhorted the islanders to acknowledge their French nationality and rejoice with their European brothers.[17] That former slaves should have qualms when ordered to accept their oppressors as brothers appeared not to concern Napoleon. That they might also resist the call to rally round the troops of his sister's husband did not concern him either.[18] Punishment would descend on such traitors and 'devour them like the flames devour dried-up sugar canes'.[19] These threats did not work. The combined efforts of Dessalines, Pétion and Christophe released the island's inhabitants from French rule. Those followers of Napoleon and those royalists divested of property in Saint-Domingue, who recorded their memoirs and attempted to state the case for reclaiming this territory, perceived the events that culminated in Leclerc's defeat as a total catastrophe. Paul Roussier's introduction to Leclerc's memoirs is characteristic of this response. It is a lament for the loss of France's greatest colony, therefore of her place as a commercial force in the world, and of the first French colonial empire, begun by Richelieu and Colbert during the reign of Louis XIV.[20] This appears to have been the dominant line in French royalist publications in the 1820s and until 1825, when Charles X would eventually grant, rather than recognize, Haïti's independence. Yet in 1822 this enormous double portrait not only commemorated, but actually glorified the men and the actions that brought about this loss to France.

42 'Tremblez Tyrans', 1793, flag, painting on red silk.

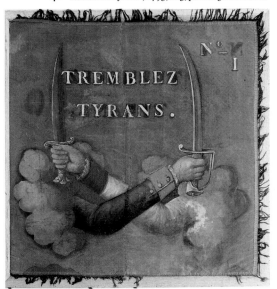

How then was it possible for Lethière to produce such an affirmative image of Haïtian independence in Paris at the time of Louis XVIII's restored Bourbon monarchy, which still refused to recognize self-rule in Haïti? The painting proclaimed republicanism and celebrated the defeat of the French imperial and monarchical efforts to reclaim its colonial power from an army of former slaves. In doing this, Lethière drew consciously on the visual culture of the 1790s revolutions, such as the flag design of 1793 showing the amalgamation of different armies united against tyranny (figure 42). Soldiers'

arms are crossed in solidarity, as are those of Dessalines and Pétion in Lethière's painting. Furthermore, Lethière subverted an earlier *ancien régime* tradition of pictorial representation where French control and possession over its colonies had been proudly paraded. François Hubert Drouais's portrait of *Le Comte de Vaudreuil* of 1758, in which the young aristocrat points in proprietorial fashion to a map of Saint-Domingue, of which his father was then governor, is a case in point (figure 43). The seemingly gratuitous inclusion of the theatrical bits of armour to which his left leg points, indicates a lack of serious consideration for the military profession. He is clearly more at ease in his lavish court apparel that befits a man of taste. Nothing could create a stronger contrast with the foppish, balletic and effeminate gesture of the Comte de Vaudreuil than the virile, oath-swearing gestures and stances of the two men in Lethière's painting. The latter represents the bonding between two former adversaries, each representative of large armies, heroes elevated above the crowds on the platform of the altar of patriotism. The inevitable references by Lethière to earlier Davidian oath scenes, such as *The Oath of the Horatii* and *The Tennis Court Oath*, with their unequivocal and centralized force of union and embrace, encourage straightforward ideological foreclosure in interpretation of *The Oath of the Ancestors*.

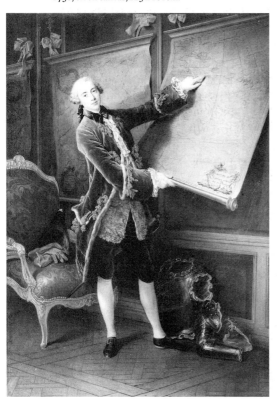

43 François-Hubert Drouais, *Le Comte de Vaudreuil*, 1758, oil on canvas, 225 x 161cm.

The painting is about heroic, virtuous refusal of tyranny and despotic rule and it is redolent of French republican imagery of the 1790s. In particular it recalls Lethière's own painting of contemporary history, *La Patrie en danger* (1799 Salon, figure 44).[21]

La Patrie en danger too shows fraternal embrace and military solidarity in the name of the Republic, in the face of foreign invasion, presumably referring, however obliquely, to the armies of the second coalition of England, Austria and Russia, gathered in the spring of 1799. Of particular interest for present purposes is that, among the official representatives of the French people seated in the front row on the left of the composition, nearest to the spectator, is what appears to be a 'man of colour' with distinctive short curly hair. Further down the line is a black man, likewise shown in profile. It is possible that for these two figures and their

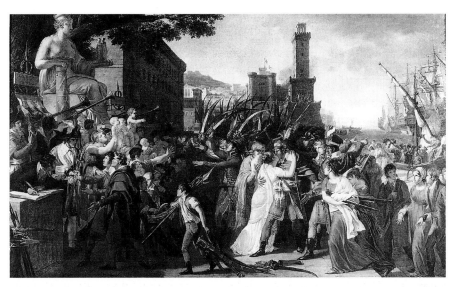

44 Guillaume Guillon-Lethière, *La Patrie en danger*, 1799, oil on canvas, 59 x 100cm.

nuances in skin colour Lethière was drawing on the medallion portraits of the members of the Corps Législatif, engraved 'au physionotrace' by François Gonord in 1799,[22] which showed, among the many members of the *conseil des anciens*, three representatives from Saint-Domingue: Mentor (figure 45), a black born in Martinique who, in 1797, replaced Jean-Baptiste Mars Belley at the end of his term of office,[23] Annecy and Tonnelier (figure 46).[24] Significantly, in the context of the present chapter, the publication of the six pages of medallion portraits was curtailed by Napoleon's coup of 18 brumaire (9–10 November 1799).[25] Only one month after the exhibition of *La Patrie en danger*, Napoleon overthrew the *Directoire régime* and replaced devotion to the republic and its sovereign people with the people's submission to his personal rule and ambition. In Saint-Domingue he immediately undermined the authority of Toussaint; he had Mentor struck off the list of deputies[26] and he set about reinstating slavery in the colonies. Lethière was a great friend and protégé of Napoleon's brother, Lucien Bonaparte, Minister of the Interior and Ambassador to Spain. In 1801 he was invited to accompany Lucien to Madrid to help him select works for a collection of paintings. Lethière found it expedient to put his sketch for *La Patrie en danger* to one side. This enrolment of volunteers wearing David's costume designs of 1793–94 was not only too supportive of an earlier revolutionary moment, but it also included black and mulatto officials in its front ranks of politicians. To some extent *The Oath of the Ancestors* allowed Lethière to complete unfinished business. In 1822, by then an established academic painter in France, he returned to the republicanism of his earlier works, while reasserting his own racial origins and allegiances.

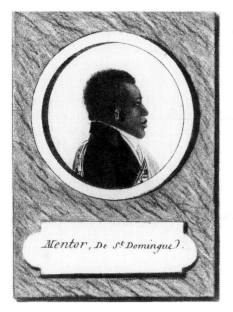

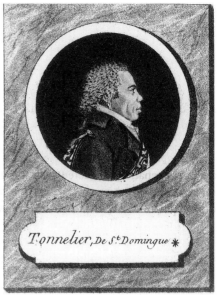

45 François Gonord, 'Mentor, de St. Domingue',
detail from a sheet of profile portraits of members of
the Legislative Body in Year 7 (1799), mezzotint.

46 François Gonord, 'Tonnelier, de St. Domingue',
detail from a sheet of profile portraits of members of
the Legislative Body in Year 7 (1799), mezzotint.

To be black, even though *affranchi*, in the colonial era counted against an indi-
vidual's social status more than if he or she were light-skinned but still enslaved.[27]
Colour prejudice was so powerful that the mulatto slaves regarded themselves and
were generally regarded by others as superior to free blacks, even if the latter were
land-owners. The deep-rooted racialism, as a factor of colour prejudice, which was
an inevitable feature of life in the colonies in the eighteenth century, did not sud-
denly change when independence was declared. According to Moreau de Saint-
Méry, whose works were widely read in France, the label 'mulatto' meant that
49–70 parts of one's blood were white. It was 'better' than being a 'sacatra', a 'griffe'
or a 'marabou', but not as 'good' as being a 'quarteron', a 'métif' (or 'métis'), a
'mamelouc' or 'sang-mêlé'.[28] In the last named there could be as much as 125–7
parts white, but this still made these people non-white. Up to the time of the
Revolution this barred them from holding certain posts; and the whites of Saint-
Domingue insisted on the notion of slavery as an inherited stain that would forever
mark anyone of mixed blood. By the time Napoleon declared himself First Consul,
Julien-Joseph Virey, in his *Histoire naturelle du genre humain* (1801) had come up
with a slightly different tabulation, driven by a heavier moralizing imperative and
stronger prejudice against people of colour and their innate capabilities.[29]
Alexandre Pétion was the son of a white man and a mulatto mother, which,
according to Virey's tabulations, would make him a 'terceron saltatras', a pejorative
term that derives from the French 'sauter en arrière', meaning a jump-back or

throw-back. Born Alexandre Sablès, he changed his name to Pétion in identification with and emulation of the white Frenchman, Jérôme Pétion de Villeneuve, Deputy for Chartres, Mayor of Paris in 1792–93, and author of *Discours sur les troubles de Saint-Domingue* in 1790, in which he defended Abbé Grégoire and the Society of the Friends of Blacks.[30] By contrast, Dessalines as a slave was named Duclos by his first white master, which was changed upon his being sold to a black slave-owner called Dessalines. While Dessalines was intent on reversing the colour prejudice and giving most official appointments to blacks, Pétion kept a balance between black Africans and a range of 'men of colour' in his government.

In France by 1822 there was a strong climate of mixophobia, fears of hybridity and miscegenation that dated back to the early years of the century and which were fuelled by those whites who had held office, lived and suffered in Saint-Domingue during the troubled years and who now, with the return of a monarchy, felt emboldened to retaliate.[31] This was not just a fear of degeneration of the pure white race, which had of course been a regular subject of debate for taxonomists in the so-called days of Enlightenment. It was a fear of extending rights and thereby power to the very 'coloured' people who could otherwise be exploited for the production of luxury goods from the colonies. This fear had already found expression in written texts by men of mixed blood, and in the political arena of the Constituent Assembly in May 1791, when men of colour born of freed fathers and mothers gained certain rights, especially voting rights, in the colonial assemblies.[32]

Abbé Grégoire had been a prominent campaigner in 1789 for rights of freed blacks and men of colour with his *Mémoire en faveur des gens de couleur*. A 1791 engraving, *Discussion sur les hommes de couleur* (Paris, Bibliothèque Nationale), representing the discussions held in the Constituent Assembly which culminated in a decree of 15 May 15 1791, shows Brissot, a member of the Society of the Friends of Blacks, releasing the men of colour from chains. Above the whole scene hover figures of Jérôme Pétion as allegory of Justice, Robespierre as Humanity, and Abbé Grégoire as Reason.[33] Antoine Barnave rescinded this decree in September of the same year, but the mulattoes' struggle for rights and equality continued. In Guadeloupe and Martinique, still by 1833, the right to vote and have a voice in the governing of the colonies was denied to all but white men. Non-whites such as Lethière were identified as inferior inhabitants without equal rights of citizenship. In France, Grégoire renewed his efforts on behalf of blacks and men of colour. He was briefly elected as Deputy for l'Isère in 1819 until his enemies had him dismissed, but he continued to work and write for the cause of gradual abolition and to campaign against colour prejudice.[34]

An example of ferocious hostility towards the mulatto is to be found in the account of the slave rebellions in Saint-Domingue by L. J. Clausson, arch-royalist, who signed himself 'propriétaire et ancien magistrat au Port-au-Prince'.[35] He blames the defeat of the French by the slave rebels entirely on the mulattoes,[36] as did Baron Pamphile de Lacroix in his *Mémoires*. Clausson refutes a number of pro-abolition texts and vilifies Grégoire, blaming him for inciting 'negroes' to revolt.

His main purpose was to insist on the necessity for France to reclaim Haïti as its legitimate possession. Failure to do so would result in the loss of crucial commercial gain for France and its navy. Commending the colonial appeal to Louis XVIII to reinstate the former colonial regime, he called on artists to produce appropriate antidotes to the poison propagated by men of colour and their liberal supporters, those former members of the Society of the Friends of Blacks, who, he claimed, persisted in rallying round Grégoire in 1819.[37] Lethière's painting stands as a rebuke to such claims and demands and such negative perception of Haïti's continuing assertion of independence. As we shall see, in 1822 Grégoire recommended the painting to Jean-Pierre Boyer, the then President of Haïti.

Werner Sollors notes:

> Black–white interracial love and family relations have been – especially in the modern period, from the French and Haïtian Revolutions to the aftermath of World War II – a subject to elicit censure and high emotions, or at least … nervousness.[38]

In the day-to-day running of family and public affairs, he explains, there was often conflict between family and race that might end in the denial of paternity of black or coloured children. A coloured child of a white father would be classified as racially different and would not therefore fall in with the conventional patrilineal system. There had to be a decision over recognition of an illegitimate, coloured child's place within the family and that child's rights to an education and standing, equal to other legitimate members of the same family.

Guillaume Guillon-Lethière was born at Sainte-Anne in Guadeloupe on 10 January 1760, the illegitimate son of Pierre Guillon, a white man born in Martinique and working as a *Procureur du roi*, and Marie-Françoise, known as 'Pepëye', a black freed slave. There are portraits of Guillaume by Louis-Léopold Boilly, and of him and his whole family by Jean-Auguste Dominique Ingres, which consistently indicate that he was perceived as light-skinned. Otherwise, he was of large stature and had frizzy hair. The conflict between, on the one hand, paternalism that would usually tend toward denial of slave status as befitting any member in the hierarchy of the patriarchal family, and, on the other, legitimacy appropriate to free, dependent members of a household, was precisely a problem for Lethière's father. He already had two legitimate sons and it was not until 1799 that he agreed to allow his illegitimate son to use the paternal name, Guillon. Until the age of forty Guillaume was known as Le Thiers, Letier, Le Tiers, or Le Thière, all of which simply mean the Third-born.[39] He is sometimes referred to as 'Lethière le mulâtre'. On the other hand, when, at the age of fourteen, Lethière made it clear that he wished to be a painter, his father took him to France and enrolled him in the drawing school in Rouen in 1774, under Jean-Baptiste Decamps. In other words, even while denying him the right to use the family name, his father was concerned for his son's education and to support him from an early stage in his chosen career.

Lethière's career does not seem to have suffered as a result of him being of mixed blood. He won three prizes in Rouen and was accepted into the Royal Academy

under Gabriel-François Doyen in 1777. He won the Second Grand Prix de Rome in 1784, and embarked on a serious career as a history painter. He gained a prize for the half figure and from 1786 until 1791 he was in Rome as a *pensionnaire*.[40] He returned to Paris in 1791 and began exhibiting at the Salons. His sister, Andrèze, married a mulatto, Emery Labranche, who went on to achieve fame for his part in the rebellion in Guadeloupe in the home town of Sainte-Anne in 1802.[41] Since Lethière shared basic republican ideals with Lucien Bonaparte, as opposed to the later values adopted by Napoleon, he accepted the post of advisor in building up a collection of Spanish art, and indeed remained on friendly terms with Lucien all his life, even calling his third son Lucien, in 1802.

From 1807 to 1816 Lethière was Director of the French Academy in Rome, appointed by Lucien Bonaparte. He spent these years working on his major history paintings, for which he had made drawings in the 1790s.[42] This training as a history painter in the French tradition is still in evidence in *The Oath of the Ancestors*. He was decorated with the order of *La Réunion* by the Governor General in Rome in 1814. Back in France in 1816, his name was proposed for election to the Institut. Though entry to the Institut had been refused to a mulatto at this date by Louis XVIII,[43] two years later Lethière was elected to the Institut with the king's approval, and was decorated with the cross of the Legion of Honour. In 1819 he was appointed a Professor at the Ecole des Beaux Arts. He had, on his return from Rome, also opened a studio in Paris to rival that of Gros and in 1822 he was given a large studio space in the Institut where he worked on *The Oath of the Ancestors*.[44]

In these circumstances of royal protection it is hard to understand how the pro-republican, pro-mulatto/black victory sentiment of Lethière's painting could have been acceptable, unless, that is, it could be seen as part of an official trend moving toward support for abolition, or unless the negotiations with President Boyer over France's recognition of Haïti's independence were felt to be a foregone conclusion. Although France had passed laws against the slave trade, these were not put into practice or in any way enforced. Under the Restoration those who supported abolition were cast by anti-abolitionists as dangerous Jacobins, since it was the Robespierrist Jacobin government that had originally decreed abolition of slavery in the colonies. Reports of horrendous occurrences in the transatlantic ferrying of slaves began to have some impact, however. That of the *Rodeur*, a French ship sailing to Guadeloupe in 1819 with a cargo of slaves, was reported by Benjamin Constant to the Chamber of Deputies in 1821. It concerned slaves who had been blinded by a disease while on board ship and who were thrown overboard in order to claim insurance money, rather than kept alive when they were unsaleable as merchandise. This obvious case of reduction of human life to a commodity, for the benefit of white men and women's taste in luxury goods, could not be ignored. Also, in 1823, the Académie Française held a competition, announced the previous year, for a poem on abolition of the slave trade. This followed the translation of Clarkson's *The Cries of Africa (Le Cri des Africains)* in 1821, an edition of which had a preface

by Grégoire. Constant made another speech in the Chamber of Deputies in 1822, as did the Duc de Broglie in the Chamber of Peers in 1823, condemning the trade.[45] There were thus conspicuous voices of discontent with the views of the colonists, which helped to create a climate in which Lethière's painting could give positive expression to the Haïtian constitution, which outlawed slavery.

In addition, by the time the painting was completed both Dessalines and Pétion had been dead for some years, as had their successor, Henri Christophe. It was easier to hail dead men as heroes, however tarnished their reputation. Dessalines was the one primarily responsible for the forthright statements of hostility to the French in 1803–4. His slogan on taking power in the island was 'Independence or Death! ... Peace to our neighbours, but anathema to the name of France'.[46] It was he who had gained a wide reputation for extreme violence against whites in Saint-Domingue.[47] In addressing the crowds on the occasion of the declaration of Independence, Dessalines stirred hatred against the French by referring to them as vultures, a cruel and barbaric people.[48] Deploying all the fervour of familiar French revolutionary rhetoric, he urged the generals to intimidate the French and keep them forever out of the island:

> And you, treasured men, fearless generals who, ignoring your own misfortunes, have resurrected liberty through the spilling of your own blood ... Let us terrify all those who might dare to take it away from us again: let us begin with the French: May they tremble as they approach our shores, if not from the memory of the cruelty they once perpetrated here, at least from the terrible resolution that we will take to commit to their death all French-born men who sully this land of liberty with their sacrilegious footsteps.[49]

He went on to declare himself Emperor but was assassinated shortly afterwards in October 1806, in an ambush seemingly ordered by a mulatto and black faction from the South, including in its number his friend, Alexandre Pétion.[50] Haïti split into a southern republic and a northern state. Pétion led the former and Christophe the latter, styling himself as King Henri I in 1811.[51] Pétion was named President for life in 1816, in 1818 nominating Major General Jean-Pierre Boyer as his successor, while Henri reigned from his palace at Sans Souci until his death by suicide in 1820. Only after January 1822, when Boyer had taken the eastern part of the island – going on to rule the whole of Hispaniola until 1843 – could there really be any representation of Haïti as united.

It was thus during the beginning of Jean-Pierre Boyer's presidency of the Republic of Haïti that Lethière painted Haïti's declaration of independence of 1804 and the triumph of the black–mulatto union. There had been a move by the French government in 1821 to propose internal self-government for the island under a French protectorate, but this was rejected by the Haïtians. Nevertheless, there was much rumour about the possibility that Boyer and some of his close mulatto associates were secretly prepared to yield to some kind of French protection or even sovereignty, since they feared recurrence of black revolts. Of all the leaders since

independence, Boyer was the most inclined to keep his government confined to a mulatto élite. Liot, who had given details of the transport of Lethière's painting to Haïti,[52] reported that Boyer had told him of his willingness to consider French sovereignty, but that public opinion would be against it.[53] In the end Boyer rejected it as an option, but, as Pétion had done before him, he made it clear to the French that he would compensate the dispossessed planters of Saint-Domingue.[54] It was the mulatto historian, Baudrun Ardouin, a senator in Boyer's government at the time, who negotiated the financial settlement with France, to the tune of 150 million francs' indemnity payable to the dispossessed French planters, and it was on this condition that the royal ordinance of 7 April 1825 eventually granted Haïti's independence. The effect of this was to render Boyer's position ambiguous. In some representations of him he is seen as striking a deal with the French, when in fact conditions were imposed upon him. In Jean Charles Develly's 1825 image, he is almost on bended knee in gratitude to Charles X's emissaries to Saint-Domingue, as he and other inhabitants of the island hail and receive the French almost as liberators (figure 47). A bust-length portrait of Boyer, dating from 1818, shows, beneath the familiar cloud formations already seen in the flag design, *Tremblez Tyrans*, a black hand being clasped by a white hand, the latter clearly covered in a lace cuff. It is not the clasp of fellow soldiers but rather the handshake of a royalist representative. The text beneath gives all credit to Boyer for putting an end to slavery.[55] And yet, in the year following recognition, Boyer's *Code rural* left most Haïtians in just that condition.[56] This *Code* was in direct opposition to Dessalines's plans for distribution and ownership of land among the peasants.

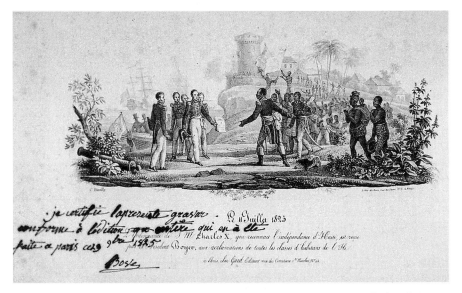

47 Jean-Charles Develly, *Le 11 juillet 1825. L'Ordonnance de S.M. Charles X, qui reconnaît l'indépendance d'Haïti, est reçu par le Président Boyer, aux acclamations de toutes classes d'habitans* [sic] *de l'Ile*, 1849, lithograph.

Lethière's painting was thus conceived and produced at a time when better relations between the metropolis and former colony were being established. It seems likely, however, that it was to function as a reminder to Boyer, lest he forget that Haïti was indebted to Dessalines as much as to Pétion, and that in the interests of the island's unification it would serve Boyer well to be identified with this image of alliance of the mulattoes with blacks. In view of this we should not be surprised to learn that Abbé Grégoire, given the force of his feelings about enslavement of blacks, seized the chance to recommend the painting to Boyer, through the intermediary of his friend, the botanist Morénas. For it was Morénas who accompanied Lethière's son carrying his father's painting to Haïti in 1822.[57] Although there is reason to believe that Dessalines was involved in voodoo practice,[58] both he and Pétion declared Catholicism the official religion of the island. The painting should not necessarily be seen as a cry of defiance against the catholic religion of France. The presence of Jehovah asserts the holy status of the tablets of law, as God's hands echo those of the military leaders below. These in turn hand on the law to the outstretched arms and hands of the people, and this certainly bears some resemblance to the preliminary text before the articles of the Constitution drawn up by Dessalines, to which the generals put their signatures.[59] At the same time, the Old Testament texts on the history of Judaism were still incorporated in the Roman Catholic Church ritual, in the recitation of the Ten Commandments.[60] None of this should lead us to interpret the painting as a variation on that *ancien régime* pictorial convention of the (usually genuflecting) black figure, eyes raised in gratitude toward the liberating white, paternal benefactor or protective, monarchical mother figure of the Church and Crown. For, although it is the case that Dessalines's forward leg is at an angle as if he is about to bend on one knee (whereas this is not at all the case for Pétion), he is on a level with Pétion and in every way shares equal status with him.

In 1822 it was possible for Lethière to remind Haïti's inhabitants of the prophetic words of Baron Pompée Valentin de Vastey, a respected and learned mulatto from the northern part of Haïti, former member of Toussaint's army, advisor to Christophe and tutor to his eldest son, but hated and feared by the whites and mulattoes of the island and eventually murdered by Boyer's troops. De Vastey had represented the position of Christophe's kingdom and had asserted that Haïti's independence came about through a world-wide colonial revolution in which 'five hundred million men, black, yellow and brown, spread all over the surface of the globe, are reclaiming the rights and privileges which they have received from the author of nature'.[61] The 'author of nature' was not to be confused with the clergy of colonial Saint-Domingue, whose preaching of submission he considered to have done untold damage in reinforcing the degradation of slaves. The 'author of nature' for De Vastey, and as represented by Lethière, was the one referred to by Dessalines and his generals as the Supreme Being, who created equality between all men.

Jehovah's presence and the startling light and dark effects must also be seen, surely, as a reprise of the imagery of the most radical and most democratic of France's

La Constitution Republicaine, semblable
aux tables de Moyse, sort du sein de la
Montagne au milieu de la foudre et des
éclairs.

Paris rue de la Barillerie ch

48 Louis-Jean Allais, *La Constitution Républicaine, semblable aux tables de Moyse, sort du sein de la Montagne au milieu de la foudre et des éclairs*, 1793.

own constitutions during the revolution, that of 1793. The print by Louis-Jean Allais, *La Constitution Republicaine, semblable aux tables de Moyse, sort du sein de la Montagne au milieu de la foudre et des éclairs* (figure 48), is representative of this imagery of 1793. It commemorated the festival of Unity and Indivisibility, held on 10 August 1793, which date, in turn, marked the anniversary of the collapse of an oppressive monarchical regime. The festival was organised by Jacques-Louis David to inspire a nation through a primitivist spectacle of regeneration and to enflame the people with hatred for the tyrant. In both Allais's print and Lethière's painting the new constitutions are compared with the tablets that Moses received on Mount Sinai. Both declared instant death to their enemies, proposing the kind of summary justice to be found in the Old Testament.[62] Lethière does not allow us to forget those ancestors of 1793. Only now, the interlocking arms and swords of the amalgamated armies that opposed tyranny and swore fraternity in 1793 (figure 42) are inflected with the appeal derived from the Commandments, to 'Love thy neighbour as thyself', which 'neighbour' in Haïti would be any black or coloured inhabitant of the island, of whatever origin. In 1822 it was an appeal that could even be perceived as extending to the French, in a way that was not possible during Dessalines's empire.

The references of this word 'ancestors' are, therefore, first of all to the promise sworn by the God of Moses' ancestors, to free the Israelites from enslavement by the Egyptians; second to the oath sworn by the French republicans in 1793, to give freedom and equality to all men and, in 1794, to abolish slavery in the colonies; and third, to the oaths sworn by Dessalines and Pétion to keep the people of Haïti free. The resumption of the name Haïti also brings into play the memory of the island's ancestors, those earliest inhabitants of Ayti. These are all referred to by Lethière, by way of David's *Oath of the Horatii* and Lethière's own patriotic oath of the volunteers. The artist here equates modern Haïtians of African or mixed-race origin, like himself, with heroes of a classical past. Not for him the ambivalence of attitude to the mulatto that Delacroix would evince in *The Massacres of Chios* two years later, as Darcy Grimaldo Grigsby has shown.[63] It is small wonder that Delacroix's work

should have provoked hostility from among the philhellenic factions. The dejected, defeated, despondent mulatto in the foreground of his painting was far from the concept of the heroic ideal representation of victorious white warrior from ancient Greece or Rome. By contrast, Lethière's work was unequivocal in its celebration of Haïti's coloured heroes in the battle against European domination. For these heroes a characterization that might suggest the degrading effects of former enslavement, or point to recent racialist theories of ugliness, was out of the question. These ancestors are Lethière's own ancestors. This is a story of transculturation and of men of mixed and many origins. This large portrait/history painting is deeply committed to the glorification and celebration, not mere commemoration, of the triumph of the mulatto intervention in France's inglorious colonial history in the Caribbean. As a painting by a light-skinned mulatto from Guadeloupe who had nevertheless fully integrated into French academic life, it was condoned by France and welcomed by Haïti. As propaganda in 1822 it could work both ways, either to rally forces around Jean-Pierre Boyer and his reunited Haïti and encourage a *rapprochement* with France, or to promote the *noiriste* position and applaud Jean-Jacques Dessalines as a symbol of the black/mulatto alliance that brought the slave rebellions against France to a triumphant conclusion. However one reads it, it is to be hoped that the painting will be part of the celebrations in the year 2004, which will mark the bi-centenary of the declaration of Haïti's independence, and that Lethière will also at that point be counted among illustrious ancestors who played their part in celebrating the advances in Haïti, as well as in France, towards the abolition of slavery and colour prejudice, and who contributed to world-wide recognition of Haïti's liberation from colonial domination.

Notes

1 'These two former opponents shook hands and their reconciliation decided the independence of Haïti', cited in J. N. Léger, *Haïti, her History and her Detractors* (New York and Washington, Neale Publishing Co., 1907), p. 129.

2 'Jurons à l'univers entier, à la postérité, à nous-mêmes, de renoncer à jamais à la France, et de mourir plutôt que de vivre sous sa domination! De combattre jusqu'au dernier soupir pour l'indépendance de notre pays!', cited in Baubrun Ardouin, *Etudes sur l'histoire d'Haïti* (Paris, 1853–60), vol. 6 (1856), p. 29.

3 Saint-Domingue is the name of the French colony comprising the western third of the island during the period 1697–1803. Haïti is the independent republic consisting largely of the former French colony of Saint-Domingue, but also of the eastern part of the island from 1822–44. Ayti referred to the whole of the island in pre-Columbian times.

4 Article 2 of the 1804 Constitution.

5 See the pamphlet published by the Louvre in conjunction with the Society of the Friends of Lethière, text compiled by Christiane Naffah, Geneviève Capy, Florent Laballe, Florence Delteil, Jean-François Bardez, at the time of its exhibition in Paris, 1998, and for which M. Edouard Pommier was primarily responsible: 'Le 20 mars

1823, Liot, agent secret au service de Clermont-Tonnerre, ministre des Colonies et de la Marine, adressait un document "secrette" (*sic*) sur lequelt on pouvait lire: "Sur un navire français du Havre nommé l'Alliance en ce moment au Port-au-Prince ... Un autre jeune homme, M. Lethiers, fils du Peintre de ce nom est venu au Port-au-Prince; il avait spéculé sur un tableau représentant un noir et un mulâtre s'embrassant, foulant aux pieds des fers et se jurant fidélité sur l'autel de la patrie une amitié éternelle." C'est donc le fils de Lethière qui a accompagné le tableau en Haïti.' This document charts the history of the work from the time of its discovery in 1991 to its display in the Louvre in 1998 and gives an account of the restoration work undertaken in Paris with the co-operation and authorization of the Haïtian government. See also Geneviève Capy, 'Guillaume Guillon-Lethière' unpublished *thèse de doctorat*, 3 vols, Université de Paris-Sorbonne (Paris-IV), 1998.

6 For a long time the painting was thought to have been burned during a fire in the cathedral in Port-au-Prince in Haïti.

7 David Nicholls, *From Dessalines to Duvalier: Race, Colour and National Independence in Haïti* (Warwick University Caribbean Studies; 3rd edn, London and Basingstoke, Macmillan, 1996), p. 1.

8 The full signature and date appear at the base of the stone tablet and above the broken chains of slavery: 'G. Guillon Le Thière né à la Guadeloupe, An 1760, Paris, 1822, 7pbre.'

9 This phrase was used by Camboulas in his speech to the National Convention, session of 3 February 1794. See *Le Moniteur*, no. 137 (17 pluviôse, year 2 (5 February 1794)); cf. *Réimpression de l'ancien Moniteur; seule histoire authentique et inaltérée de la Révolution française*, vol. 19 (Paris, 1848), p. 385.

10 For discussion of the conflicts between family and race often resulting in denial of 'white' paternity of 'black' children, see Werner Sollors, *Neither Black nor White yet Both: Thematic Explorations of Interracial Literature* (New York and Oxford, Oxford University Press, 1997), pp. 44–7.

11 Article 13 of the 1804 Haïtian Constitution.

12 Article 12 of the 1804 Haïtian Constitution.

13 The *Code Noir* was introduced into France in 1685, twelve years before the French first occupied the western part of Saint-Domingue. It identified slaves as furniture or property of a master and detailed the rights of the master to administer corporal punishment of the most severe kind, and to mutilate and kill disobedient slaves. The *Code* was finally withdrawn in 1848, when slavery was once and for all abolished by France.

14 For more information on Dessalines and his contact with Toussaint, see C. L. R. James, *The Black Jacobins: Toussaint L'Ouverture and the San Domingo Revolution* (London, Secker and Warburg, 1938).

15 Thomas Madiou, the 'noiriste' historian of Haïti, always maintained, in Dessalines's defence, that his barbarism was only deployed in reaction to colonial barbarism. See Thomas Madiou, *Histoire d'Haïti* (Port-au-Prince, Editions Henri Deschamps, [1847–48] 1989). On Rochambeau's reputation for inhumane treatment of blacks, see Henri Louis Castonnet des Fosses, *La Perte d'une colonie: la révolution de Saint-Domingue* (Paris, 1893), p. 334.

16 Exodus VI, verse 8, 'And I will bring you into the land concerning which I did swear to give it to Abraham, to Isaac, and to Jacob; and I will give it to you for an heritage: I am the Lord.'

17 See letter from Le premier consul aux habitants de Saint-Domingue, dated 17 bru-
maire, an 10 de la république française (8 novembre 1801) cited in François-Joseph
Pamphile, baron de Lacroix, *Mémoires pour servir à l'histoire de la révolution de Saint-
Domingue* (Paris, 1819), vol. 2, pp. 79–80.

18 For an account of Leclerc's expedition to Saint-Domingue, see *Lettres du Général
Leclerc, commandant en chef de l'armée de Saint-Domingue en 1802*, int. Paul Roussier
(Paris, Librairie Ernest Leroux, 1937).

19 Cited in Pamphile de Lacroix, *Mémoires*, p. 80.

20 Paul Roussier, 'Introduction' to *Lettres du Général Leclerc*, pp. 7–10, p. 7: 'la rupture
avec la France, la séparation complète, définitive, l'abolition totale du passé, la colonie
de Saint-Domingue avait cessé d'exister, son nom même était perdu.'

21 This was first identified as a painting by Lethière by Susan Siegfried. For a discussion
of the painting see Philippe Bordes and Alain Chevalier, *Catalogue des peintures, sculp-
tures et dessins* (Vizille, Musée de la Révolution Française, 1996), pp. 90–3. Lethière had
submitted a painting on the burning of the emblems of feudalism for the Concours de
l'an II. That work and this scene of the enrolment of volunteers were closely related to
the radical phase of the revolution.

22 I am indebted to Alain Chevalier for drawing my attention to these portraits and for
providing me with photographs.

23 For a discussion of Girodet's *Portrait of C. Belley, Ex-representative of the Colonies*, see
Helen Weston, 'Representing the right to represent: The *Portrait of Citizen Belley, Ex-
representative of the Colonies*, by A.-L. Girodet', *RES* 26 (Autumn 1994), pp. 83–99;
and Tony Halliday, *Facing the Public: Portraiture in the Aftermath of the French
Revolution* (Manchester and New York, Manchester University Press, 1999),
pp. 106–13.

24 On these portraits see Henry Vivarez, 'Un précurseur de la photographie dans l'art du
portrait à bon marché – Le Physionotrace', *Bulletin de la société le vieux papier* (Lille,
1906), pp. 18–26.

25 Each page had twenty medallion portraits, each set against simulated marble sur-
rounds. See Bibliothèque Nationale, Département des Estampes, *Un siècle d'histoire de
France par l'Estampe, 1770–1871, Collection De Vinck. Analytical inventory by
François-Louis Bruel*, nos. 6666–6669, Book IV (Paris, Bibliothèque Nationale, 1970),
pp. 18–19.

26 See Hugh Honour, *The Image of the Black in Western Art*, vol. 4: *From the American
Revolution to World War I*, part 1: *Slaves and Liberators* (Cambridge MA and London,
Harvard University Press, 1989), p. 109.

27 On the compexities of the skin colour question in the late eighteenth century, see
Didier-Renard, 'Vivre blanchement: les hommes de couleur libres et la Révolution
française', in Gérard Chianéa (ed.), *Les Droits de l'homme et la conquête des libertés*
(Grenoble-Vizille, Presses Universitaires de Grenoble, 1988), pp. 257–63.

28 M.-L.-E. Moreau de Saint-Méry, *Description topographique, physique, civile, politique et
historique de la partie française de l'Isle de Saint-Domingue*, 2 vols. (Paris, Société
Française d'Histoire d'Outre-mer, [1797] 1984). See also Pamphile de Lacroix's adap-
tation of Moreau de St Méry's tabulation: 'Note relative à la population de couleur', in
Mémoires, pp. ix–xi. Moreau de St Méry's theories retained currency in the 1820s, as
evidenced by Victor Hugo's novel, *Bug-Jargal* (1826) in which he adopts the former's
racial classification system. See Sollors, *Neither Black nor White*, p. 120.

29 To have one black and one white parent still meant to be a 'mulatto'. To have a white parent and a mulatto parent was to be a 'terceron saltatras', with a three-quarters white, one-quarter black mix: J.-J. Virey, *Histoire naturelle du genre humain: ou recherches sur les principaux fondemens physiques et moraux*, 2 vols. (Paris, 1800). According to Virey, black and mulatto parents produced a 'griffe' or 'zambo'; to be of white and terceron parentage was to be seven-eighths white; black and terceron parents produced a seven-eighths black offspring or 'quarteron'; black and quarteron produced quinteron saltatras and white and quarteron produced 'quinteron' with fifteen-sixteenths white. The 'progression' towards whiteness meant clearing the blood of the stains of slavery and inferiority.

30 Jérôme Pétion, *Discours sur les troubles de Saint-Domingue* (Paris, 1790), pp. 32–5.

31 Letters from *préfets* and ministers of justice in various departments of France to the local mayors notifying them of the Government's intention to refuse permission for any interracial marriages testify to this prejudice.

32 See J. M. C. Américain, Sang-mêlé, *Précis des gémissements des sang-mêlés dans les colonies françoises* (Paris, chez Baudouin, Imprimeur de l'Assemblée Nationale, 1789). See also the *Motion faite par M. Vincent Ogé, jeune, à l'Assemblée des Colons, habitans de Saint-Domingue, à l'Hôtel de Massiac, Place des Victoires* (1791).

33 See Weston, 'Representing the right to represent', pp. 87–8, for a discussion of this anonymous print.

34 Grégoire's book, *De la littérature des nègres*, published in Paris in 1808, was controversial in raising awareness of the cultural achievments of non-white men and women, slaves or otherwise. In 1818 he also published in Paris his *Manuel de piété, à l'usage des hommes de couleur et des noirs* and it is clear that Grégoire kept the people of Haïti and their successes in mind.

35 L. J. Clausson, *Précis historique de la révolution de Saint-Domingue: réfutation de certains ouvrages publiés sur les causes de cette révolution. De l'état actuel de cette colonie, et de la nécéssité d'en recouvrer la possession* (Paris, 1819). Clausson was in Saint-Domingue for six years and took part in Leclerc's expedition.

36 'La révolte des nègres et l'incendie des habitations ont été l'ouvrage des hommes de couleur, instruments d'un part se disant animé de l'amour de l'humanité', Clausson, *Précis historique*, pp. 21–2.

37 Clausson, *Précis historique*, pp. xi–xii and 124.

38 Sollors, *Neither Black nor White*, p. 4.

39 On Lethière, his life and work, see Association des amis de Guillaume Guillon-Lethière (ed.), *Guillon Guillaume-Lethière*, exhibition at Centre des arts et de la culture, 1991, Point-à-Pitre, catalogue; G.-Florent Laballe and Geneviève Capy (eds.), *"Le Serment de Ancêtres" de Guillaume Guillon-Lethière, Peintre d'Histoire, 1760–1832*, exhibition at Fort-Delgrès, Basse-Terre, 18 April–28 May 1998, catalogue; Capy, 'Guillaume Guillon Lethière'; Charles Blanc, 'Guillaume Guillon Lethière', in C. Blanc *et al.*, *Histoire des peintres de toutes les écoles: depuis la Renaissance jusqu'à nos jours* (Paris, [1849]–76), vol. 3 (1865), p. 2; Alexandre Privat d'Anglemont, *Paris anecdote: les industries inconnus* (Paris, 1860), pp. 172–3.

40 By this time he had an illegitimate son, Alexandre, who went to fight against the English to liberate Martinique, dying in the attempt.

41 See A. Lacour, *Histoire de la Guadeloupe* (Basse-Terre, Société d'Histoire de la Guadeloupe, 1960). Lacour writes that without Labranche, the town of Sainte-Anne would have been taken by insurgents and its inhabitants massacred.

42 These included *Brutus Condemning his Sons to Death*, begun in 1788, a sketch for which was shown in 1801, and *The Death of Virginie*, finally shown in the 1831 Salon, a preparatory drawing for which was shown in the 1795 Salon.

43 A similar case seems to have been Chevalier de Saint-Georges, a mulatto from the West Indies who was refused the directorship of the Opéra. See G. Florent-Laballe, *Guillaume Guillon-Lethière, Exhibition Catalogue*, 1992, unpaginated: 'un peu plus tôt on a bien refusé la nomination à la tête de l'Opéra du Chevalier de Saint-Georges (Cat. No. 76), brilliant musicien, uniquement parce qu'il est, comme Lethière, d'origine antillaise et mulâtre'.

44 Among Lethière's pupils were men from Guadeloupe whose presence probably encouraged him to work on this painting – Benjamin de Rolland, Jean-Baptiste Gibert, Jean-Abel Lordon.

45 See Honour, *Image of the Black*, pp. 126–30 for further discussion of this period.

46 'Le nom de français lugubre encore nos contrées ... Paix à nos voisins, mais anathème au nom français, Haine éternelle à la France: voilà notre cri.' See Madiou, *Histoire*, vol. 3, pp. 104–6; Ardouin, *Etudes*, vol. 6 (1856), pp. 26–9 for the full text of Dessalines's speech; Maurice A. Lubin, 'Les premiers rapports de la nation Haïtian avec l'étranger', in *Journal of Inter-American Studies*, 10:2 (April 1968), p. 278.

47 See, for example, a very negative portrayal of Dessalines in Don Juan Lopez Candelada (ed.) De la gazeta de esta N.E., *Vida de J.J. Dessalines, gefe de los negros de Santo Domingo; con notas muy circustanciadas sobre el origen, caracter y atrocidades de los principales grefes de aquellos reveldes desde el principio de la insurreccion en 1791*, tran. from original French, *La Vie de J.J. Dessalines, chef des Noirs révoltés de Saint-Domingue*, ill. Bonneville (Paris, Louis Dubroca, An XIII [1804]).

48 At the time of the declaration of Independence, Dessalines spoke of the need for the white man's blood to be spilled to mark the occasion: 'Pour dresser l'acte de notre indépendence, *il faut la peau d'un blanc* pour servir de parchemin, *son crâne* pour écritoire, *son sang* pour encre, et *une baïonette* pour plume'. See Ardouin, *Etudes*, vol. 6, p. 24.

49 'Et vous, hommes précieux, généraux intrépides, qui, insensibles à vos propres malheurs, avez resuscité la liberté en lui prodiguant votre sang ... Effrayons tous ceux qui oseraient tenté de nous la ravir encore, commençons par *les français* ... Qu'ils frémissent en abordant nos côtes, sinon par le souvenir des cruautés qu'ils y ont exercées, du moins par la résolution terrible que nous allons prendre, de dévouer *à la mort* quiconque *né Français*, souillerait de son pied sacrilège le territoire de la liberté'. See Ardouin, *Etudes*, vol. 6, pp. 27–8.

50 For details of Dessalines's death and mutilation, and for an excellent recent discussion of Haïti's religious history, see Joan Dayan, 'Haiti, history, and the Gods', in Gyan Prakash (ed.), *After Colonialism: Imperial Histories and Postcolonial Displacements* (Princeton and Chichester, Princeton University Press, 1995), pp. 66–97.

51 Christophe's portrait was painted by Richard Evans, a pupil of Thomas Lawrence in 1818 (Port-au-Prince, Musée du Panthéon National) and reveals all his ambitions to base his life-style and the governing of Haïti along the lines of European practice. See Honour, *Image of the Black*, pp. 108–11, ill. 58.

52 See note 5.

53 See Nicholls, *From Dessalines to Duvalier*, pp. 64–5.

54 As Joan Dayan points out in 'Haïti, History and the Gods', p. 71, such a sense of
 indebtedness towards the descendants of colonial torturers would have made
 Dessalines turn in his grave.

55 'Longtemps le peuple haïtien / Avait vu dans les fers, perpetuer sa race: / Au rang des
 nations il prend aujourd'hui sa place, / Boyer, du nègre esclave a fait un citoyen'. Boyer
 resigned in 1843 and eventually died in Paris in 1850.

56 See Dayan, 'Haïti, history and the Gods' pp. 71–2.

57 See Yves Bénot, 'Grégoire défendeur de la cause des Noirs dans les revues de la
 Restauration', in Y. Bénot and M. Dorigny (eds.), *Grégoire et la cause des noirs
 (1789–1831): combats et projets* (Paris, Société Française d'Histoire d'Outre-mer,
 2000), pp. 153–62, p. 158, note 15.

58 See Gustave d'Alaux, *L'Empereur Soulouque et son empire*, cited in Dayan, 'Haiti, his-
 tory and the Gods', pp. 76–7.

59 'We, H. Christophe, Clerveux, Vernet, Gabrart, Pétion, Geffrard, Toussaint Brave,
 Raphael, Romain, Lalondrie, Capoix, Magny, Daut, Conge, Magloire, Ambroise,
 Yoyou, Jean Louis François, Gerin, Moreau, Fervu, Bavelais, Martial Besse; As well in
 our own name as those of the people of Hayti, who have legally constituted us faithful
 organs and interpreters of their will, in presence of the Supreme Being, before whom
 all mankind are equal, and who has distributed so many species of creatures on the sur-
 face of the earth, for the purpose of manifesting his glory and his power by the diversity
 of his work: in the presence of all nature, by whom we have been so unjustly and so long
 a time considered as outcast children: Do declare, that the tenor of the present consti-
 tution is the free, spontaneous, and invariable expression of our hearts, and the general
 will of our constituents.'

60 It has been suggested that the visual source for the figure of Jehovah is Guido Reni's
 ceiling decoration for the Chapel of the Assumption in the Quirinal palace in Rome,
 which Lethière could have studied during his period in Rome, when he was part of a
 commission to restore the palace in 1811 in anticipation of Napoleon's arrival. See note
 5, 1998 leaflet, p. 3.

61 See Nicholls, *From Dessalines to Duvalier*, p. 45.

62 Contemporary prints and broadsides drew parallels between Mount Sinai and the
 Montagne or Mountain of Liberty. In a print by Pierre-Michel Alix, *Le Triomphe de la
 Montagne*, 1794, a pair of fiery tablets on the mountain shoots down bolts of lightning
 at France's enemies.

63 Darcy Grimaldo Grigsby, 'Whose colour was not black nor white nor grey, But an
 extraneous mixture, which no pen Can trace, although perhaps the pencil may':
 Aspasie and Delacroix's *Massacres of Chios*', *Art History*, 22:5 (December 1999), pp.
 676–704.

Index

Note: page numbers in *italic* refer to illustrations; works of art or literature may be found under makers' names.